THE CINEMA OF YAKOV PROTAZANOV

Global Film Directors

Edited by Homer B. Pettey, Professor of Film and Comparative Literature at the University of Arizona, and R. Barton Palmer, Calhoun Lemon Professor Emeritus of English at Clemson University

Volumes in the Global Film Directors series explore cinematic innovations by prominent and emerging directors in major European, American, Asian, and African film movements. Each volume addresses the history of a director's oeuvre and its influence on defining new cinematic genres, narratives, and techniques. Contributing scholars take a context-oriented approach to evaluating how these directors produced an identifiable style, paying due attention to those forces within the industry and national cultures, that led to global recognition of these directors. These volumes address how directors functioned within national and global marketplaces, contributed to and expanded film movements, and transformed world cinema. By focusing on representative films that defined the directors' signatures, these volumes provide new critical focus upon international directors, who are just emerging to prominence or whose work has been largely ignored in standard historical accounts. The series opens the field of *new auteurism* studies beyond film biographies by exploring directorial style as influencing global cinema aesthetics, theory, and economics.

Recent titles in the Global Film Directors series:

F. Booth Wilson, *The Cinema of Yakov Protazanov*
Leslie Barnes and Joseph Mai, eds., *The Cinema of Rithy Panh: Everything Has a Soul*
Nam Lee, *The Films of Bong Joon Ho*
Jim Leach, *The Films of Denys Arcand*

THE CINEMA OF YAKOV PROTAZANOV

F. BOOTH WILSON

RUTGERS UNIVERSITY PRESS
New Brunswick, Camden, and Newark, New Jersey
London and Oxford

Rutgers University Press is a department of Rutgers, The State University of New Jersey, one of the leading public research universities in the nation. By publishing worldwide, it furthers the University's mission of dedication to excellence in teaching, scholarship, research, and clinical care.

Library of Congress Cataloging-in-Publication Data

Names: Wilson, F. Booth, author.
Title: The cinema of Yakov Protazanov / F. Booth Wilson.
Description: New Brunswick, New Jersey : Rutgers University Press, [2024] | Series: Global film directors | Includes bibliographical references and index.
Identifiers: LCCN 2023041204 | ISBN 9781978839144 (paperback) | ISBN 9781978839151 (hardback) | ISBN 9781978839168 (epub) | ISBN 9781978839175 (pdf)
Subjects: LCSH: Protazanov, I͡Akov Aleksandrovich, 1881–1945. | Motion picture producers and directors—Soviet Union—Biography. | BISAC: PERFORMING ARTS / Film / History & Criticism | ART / Film & Video
Classification: LCC PN1998.3.P77 W55 2024 | DDC 791.4302/32092 [B]—dc23/ eng/20231201
LC record available at https://lccn.loc.gov/2023041204

A British Cataloging-in-Publication record for this book is available from the British Library.

Copyright © 2024 by F. Booth Wilson
All rights reserved
No part of this book may be reproduced or utilized in any form or by any means, electronic or mechanical, or by any information storage and retrieval system, without written permission from the publisher. Please contact Rutgers University Press, 106 Somerset Street, New Brunswick, NJ 08901. The only exception to this prohibition is "fair use" as defined by U.S. copyright law.

References to internet websites (URLs) were accurate at the time of writing. Neither the author nor Rutgers University Press is responsible for URLs that may have expired or changed since the manuscript was prepared.

∞ The paper used in this publication meets the requirements of the American National Standard for Information Sciences—Permanence of Paper for Printed Library Materials, ANSI Z39.48-1992.

rutgersuniversitypress.org

For Grace

CONTENTS

	Abbreviations	ix
	Note on Transliteration	xi
	Introduction: A Proto- and Protean Filmmaker	1
1	A Mobile Career	19
2	The Politics of Literary Adaptation	47
3	Revolutionary(-era) Traditionalism	74
4	Abroad at Home	109
5	Making Comedy Serious	135
6	The Didactic Voice from Tolstoy to Lenin	160
	Conclusion	186
	Selected Filmography	193
	Acknowledgments	197
	Notes	199
	Bibliography	217
	Index	225

ABBREVIATIONS

ARK/ARRK: Association of Revolutionary Cinematography / Association of Workers of Revolutionary Cinematography

Comintern: Communist International

Glavrepertkom: Main Repertory Control Committee

Gosfilmofond: State Film Foundation

GTsMK: State Central Museum of Cinema

IAH: German Acronym for Workers' International Relief (Russian Mezhrabpom)

Kadet: Constitutional Democrat

Komsomol: Young Communist League

KPD: Communist Party of Germany

Mezhrabpom: Russian Acronym for Workers' International Relief (German, IAH; English, WIR)

Mezhrabpom-Rus': Film studio collaboration between Workers' International Relief and Rus'; later Mezhrabpomfilm

Narkompochtel: People's Commissariat for Posts and Telegraphs

Narkompros: People's Commissariat of Education

NEP: New Economic Policy

NKVD: People's Commissariat of Internal Affairs, successor of OGPU (Joint Chief Political Directorate) and precursor to KGB (Committee for State Security)

ODSK: Society of the Friends of Soviet Cinema

OGPU: Joint Chief Political Directorate; precursor to NKVD (People's Commissariat of Internal Affairs)

OsvAg: Information Agency of the Okhrana (Department for Protecting Public Security and Order)

RAPP: Russian Association of Proletarian Writers

RGAKFD: Russian State Documentary Film and Photo Archive

RGALI: Russian State Archive for Literature and Art

RGASPI: Russian State Archive for Social and Political History

RSFSR: Russian Soviet Federative Socialist Republic

Soiuzkino: All Union-Combine for the Cinema and Photo Industry

Soiuzdetfilm: All-Union Children's Film Studio

UFA: Universum Film-aktiengesellschaft, German film studio

Uprofbiuro: County Bureau of Trade Unions

Uzbekgoskino: Uzbek State Film Studio
VGIK: All-Union State Institute of Cinematography
WIR: Workers' International Relief (IAH in German; Mezhrabpom in Russian)
ZAGS: Registry Office

Materials cited in Russian archives follow the standard abbreviations:

f.: *fond* (archive)
op.: *opis'* (list)
d.: *delo* (file)
l.: *list/listy* (page/pages)

NOTE ON TRANSLITERATION

In the course of research, I have known this director by quite a few names: Yakov or Iakov Protazanov in English; Iakov or Jakov, and even Jacques, Protasanoff in French; Jakow, and even Jacob, Protasanow in German. For this first career-length study in English, I have prepared the main text with the primary goal of making it accessible to a general readership at the cost of some inconsistency in how it renders Russian names and words in English. I follow the names of Russian authors writing in English as published and the most conventional, commonly used English spellings of well-known people and places. These include not only historical figures such as Joseph Stalin and Pyotr Tchaikovsky but also names that are familiar to those with an interest in film history—most crucially, Yakov Protazanov himself. I also spell many common Russian names to match their English counterparts (e.g., Alexander instead of Aleksandr, Maria instead of Mariia) and remove the apostrophe corresponding to the Russian soft sign for many commonly used words in English-language literature on Russian film (e.g., *film* instead of *fil'm* in Mezhrabpomfilm). For Russian-language material in the notes and appendixes, I follow the American Library Association and Library of Congress's (ALA-LC) romanization system in a simplified form without diacritics.

THE CINEMA OF YAKOV PROTAZANOV

INTRODUCTION
A Proto- and Protean Filmmaker

On February 9, 1945, the Soviet Union's All-Union State Institute of Cinematography (VGIK), the world's oldest film school, turned its attention to film history. At that moment, no one better represented it than Yakov Alexandrovich Protazanov, the Soviet Union's oldest and most prolific film director. He emerged as one of the first Russian filmmakers and, even more remarkably, had consistently released films for over thirty years, enjoying a successful career under both the tsar and the Communist Party. The decision to invite him to deliver a lecture about prerevolutionary cinema perhaps signaled the return to business as usual at the school after its recent arrival home from wartime evacuation in Almaty and the beginning of the Red Army's march to Berlin. Or perhaps the organizer, film historian Nikolai Lebedev, gleaned what others knew already. Having hypertension for years and suffering a heart attack during his trip back to Moscow from Tashkent, Protazanov was not going to be around much longer. He died just weeks later. It was the last time to hear from one of the pioneers of early cinema in Russia, an era that already seemed like ancient history to its students and that scholars like Lebedev were only beginning to study in earnest.

As he began his lecture to a group of aspiring filmmakers, Protazanov, born in 1881, underscored just how different his life had been at their age: "We young people at the end of the previous century did not have the opportunity to be concerned about our choice of profession. [...] Answering the question, 'What will I be?' that so concerns Soviet youth today was a destiny reserved only for a fortunate few."[1] He had witnessed not only the birth of a new medium and art form but also the revolutionary transformation of society that had created opportunities for the students gathered that day—at a tremendous cost in resources, suffering, and lives. This book examines how that transformation shaped Protazanov's work as a leading screen artist and a unique observer of his era.

Protazanov felt the effects of the revolutionary era most in his migrations away from and back to Russia. Having become disillusioned with a career as an engineer that his parents had expected of him, Protazanov traveled around Europe some in his youth before landing a job in Moscow at one of the many businesses renting foreign films for Russian viewers. By 1911, he had directed his first one-reel silent film, *The Convict's Song* (*Pesnia katorzhanina*). Following the success of it and other films such as *The Bought Husband* (*Kuplennyi muzh*, 1913) and *The Departure of a Great Old Man* (*Ukhod velikogo startsa*, 1912), Protazanov paired up with stage director Vladimir Gardin to become the chief directing team at Thiemann & Reinhardt, one of Russia's main cinema firms. Together, Protazanov and Gardin made scores of films in popular genres. Their adaptation of Anastasiya Verbitskaya's bestselling novel *The Keys to Happiness* (*Kliuchi schast'ia*, 1913) pulled in more profits than any other Russian film before the revolution and almost single-handedly proved that Russian feature-length films were commercially viable. At the start of World War I, bans on foreign films spurred rapid growth in Russian film production to make up for the shortage, and Protazanov was well situated to benefit. Already a leading director, he moved to a new studio started by an energetic young businessman, Joseph Ermolieff. The firm's reputation rose quickly due to its profitable pieces of entertainment and artistically ambitious features. Protazanov's film versions of Pushkin's *The Queen of Spades* (*Pikovaia dama*, 1916) and Tolstoy's *Father Sergius* (*Otets Sergii*, 1918), both made with actor Ivan Mozzhukhin, came to exemplify the prerevolutionary tradition of Russian cinematic art. After the revolutions of 1917, Protazanov accompanied the company westward to avoid the impending civil war and continue their work. His films, such as *A Narrow Escape* (*L'angoissante aventure*, 1920) and *Justice d'abord!* (1921), helped make Mozzhukhin the biggest movie star in 1920s France. Though Protazanov's biggest successes of the late tsarist era generated interest, he failed to land a permanent position in the tough French film market. He followed a wave of émigrés to Berlin in 1922 and parlayed his past successes into a contract with the Universum Film-aktiengesellschaft (UFA), a massive German cinema trust that rivaled the biggest studios in Hollywood. Protazanov might have directed a few canonical films of the blossoming Weimar film industry, but in 1923, he made the surprising decision to return to the Soviet Union.

It was not the most sought-after location among his peers, but there were many opportunities for experienced filmmakers. The "first propaganda state" was also the first that exploited the raw appeal of movies among the masses to fashion a revolutionary culture.[2] It constructed the first centrally planned, state-controlled film industry to be one mighty weapon in its arsenal of mass-produced culture. Leading Bolsheviks, including Joseph Stalin, envisioned it equaling—no, surpassing—the scale of the Hollywood studios, churning out

endless products that not only delighted peasant and proletarian audiences but prepared them to be productive subjects of a socialist empire. Stalin was so preoccupied with cinema that he gradually assumed a role in administering much of the film industry himself, screening almost every film before its release, specifying revisions and reedits for many, "suggesting" ideas to studio leadership, and even encouraging directors to cast his favorite actress, Lyubov Orlova, in leading roles. Movies have provided many of the defining images attached to the revolutionary project, whether they be shots from Sergei Eisenstein's experimental epic *October* (*Oktiabr'*, 1928) that are regularly passed off as documentary footage from 1917 or musical sequences of cheerful *kolkhoz* peasants that serve as ready-made signifiers of Soviet kitsch. Soviet cinema emerged at the intersection of the twentieth century's most ambitious sociopolitical experiment and its quintessential form of popular culture. Its development as an industry and art form is permanently entangled with the revolutionary legacy.

The Soviet film industry had its fair share of talent in the 1920s, many of them barely out of their teenage years and getting their first shot at filmmaking. Historians and cinephiles most remember young cinéastes like Lev Kuleshov, who was eighteen years old when he was leading his famed workshops. These ambitious filmmakers enjoyed a patron in the emerging Soviet state for their radical aesthetic experiments. Prompted by the success of *Battleship Potemkin* (*Bronenosets Potemkin*, 1925) and *Mother* (*Mat'*, 1926) in foreign distribution, sympathetic British, American, and European critics saw a group of young filmmakers—Sergei Eisenstein, Vsevolod Pudovkin, Alexander Dovzhenko, Dziga Vertov, and others—as exemplars of an avant-garde, distinctly Soviet approach to cinematic art. Those celebrated filmmakers doubted that Protazanov, a "bourgeois specialist" who did not experience the Russian civil war, could make his work relevant in the radically new society the Bolsheviks envisioned. They were wrong. His 1924 science-fiction blockbuster *Aelita* has gradually become one of the best-remembered films from a vibrant period of cinematic art. He was responsible for one of the most successful pieces of political propaganda, *His Call* (*Ego prizyv*, 1925); one of its best films about the civil war, *The Forty-First* (*Sorok pervyi*, 1926); two of its most popular comedies, *The Case of the Three Million* (*Protsess o trekh millionakh*, 1926) and *St. Jorgen's Day* (*Prazdnik sviatogo Iorgena*, 1930); one of its first sound films, *Tommy* (*Tommi*, 1931); and one of its most influential adaptations of Russian theater, *Without a Dowry* (*Bespridannitsa*, 1936). No director, young or old, came close to matching Protazanov's number of productions, range of genres, and consistent popularity with audiences.

The history of Soviet cinema has always been attentive to how a particular group of artists—each with different styles, different ideas, and different personalities—shaped Soviet culture in a way that was distinct from reductive understandings of communist ideology. In a history dominated for many years

by a "totalitarian" thesis, we should not take that for granted. In his recent collection of essays, Evgeny Margolit has further loosened Soviet cinema's attachment to state power or political ideology. He claims its defining feature is the experience of two generations of sincere, politically engaged artists, the first forged during the revolution and the second during the Great Patriotic War. He even provocatively marks the end of Soviet cinema in 1970, when the aging believers lost ground to a new generation of cynics.[3] Focusing on these film artists has preserved some of the revolutionary pathos underlying Soviet culture, despite the grossly distorted image of the world it presented and the noxious tendencies it reinforced. But it has disadvantages too. No one today would be satisfied with a history of any other aspect of Soviet society and culture that told the story from only the perspective of the revolutionaries. This book revisits a central moment in both film history and world history through the career of a director who was not born Soviet but only *became* Soviet after considerable effort—like the vast majority of those who lived within its borders.

The combined oeuvres of the canonical directors of the Soviet avant-garde have attracted far more scrutiny and analysis than the entire other output of the Soviet film industry, and writing today remains overwhelmingly focused on them. Protazanov's films, in contrast, have received exactly two book-length studies. The first appeared shortly after his death in 1945, when his career abroad and prominence in the tsarist-era industry made him suspect in the xenophobic climate of postwar "high" Stalinism. Moisei Aleinikov, former studio chief who employed Protazanov, gathered and edited collections of memoirs first published in 1948. He then used them and his own memories as the basis for the first study of his films, released in 1961.[4] In keeping with the times, Aleinikov shored up Protazanov's nationalist credentials. He portrayed him as an exemplar of a Russian realist tradition that presaged features of the officially sponsored aesthetic of socialist realism—a common argument used to rehabilitate prerevolutionary art. Aleinikov was vague about what this realism entailed, but it was sober, wholesome, socially engaged, and thoroughly Soviet in its values. He championed Protazanov's faithfully rendered adaptations of Russian literature that brought this edifying material to the masses. Aleinikov dispensed with Protazanov's entire stint abroad in a single ellipsis, no doubt due in part to his own significant ties to foreign film companies and personal involvement in recruiting the director.[5] The second major study, *Iakov Protazanov* (1973), was the sole work in film history by Mikhail Arlazorov, a scriptwriter, journalist, and popular science author who spent most of his career writing about Soviet aviation. He admirably reconstructed many details of Protazanov's life abroad that were absent in Aleinikov's book from his thorough look at extant documents and interviews with surviving relatives. Nevertheless, the book was constrained by Soviet-era ideological norms for writing both history and criticism, and

while he called attention to many not exactly orthodox themes in Protazanov's films, he was not trained nor particularly conversant in film studies, by then well developed in the Soviet Union as *kinovedenie*.[6] Arlazorov's book, now over fifty years old, is the last career-length study of Protazanov's films, despite numerous writers on Soviet cinema acknowledging him as a major gap in scholarship.

With *glasnost'* and the collapse of the Soviet Union, Russian scholars had the opportunity to explore previously taboo topics and correct many falsifications in the lives and work of artists that had been canonized by the regime, leading the same careers to dominate research. In contrast, European and Anglophone scholars—many of them starting in the social sciences, "mainline" history, or fields otherwise outside of film studies—began looking at Soviet cinema history from the outside and noticing different features—namely, those that more resembled the capitalist entertainment industries that they were more familiar with. A new wave of English-language scholars—including Richard Taylor, Ian Christie, Denise J. Youngblood, and Vance Kepley—challenged the narrative that centralized the careers of Eisenstein, Pudovkin, and others and emphasized how Soviet cultural administrators, both in the New Economic Policy and under Stalin, had aspired to a genuinely entertaining product and were expected to garner an audience to sustain the industry's operation.[7] These scholars all showed renewed interest in Protazanov, especially Youngblood, who dedicated a full chapter to his 1920s films in *Movies for the Masses*, which generally argued that "the film culture of the NEP was predominantly and aggressively 'bourgeois'" and saw the director as "a testament to the tenacity of the old tradition and the adaptability of its leading practitioner."[8] These scholars valued Protazanov precisely for what he was *not*: a strident revolutionary, a self-styled artist, nor an ambitious aesthetic theoretician—that is to say, not the image of a Soviet director set by the likes of Eisenstein or Vertov. Much of this research began before "archive fever" in Soviet history after 1991 and Western scholars' "discovery" of prerevolutionary cinema at the 1989 Pordenone Silent Film Festival. The latter of these events validated this revisionist narrative, as it added almost a decade of commercially "bourgeois" cinema in Moscow during which Protazanov had been a leading filmmaker.[9]

These scholars' depictions of Protazanov's films converged with that of Arlazorov, who emphasized their sheer number and variety and the flexibility of his approach to his craft. This view persists today. Scholars and enthusiasts of Soviet cinema see his films as too stylistically eclectic, too thematically inconsistent—too "Prot-ean," as a few have punned[10]—for a study to yield many insights into the personality of their creator. Thus was the conclusion of the most significant event in "Protazanov Studies" in four decades, a 2007 scholarly conference dedicated to his work at Russian state film archive Gosfilmofond.[11] More than anything, participants celebrated the diversity of his oeuvre; no one attempted to account for its transformation over the decades. In a roundtable

discussion where scholars debated how to categorize him as a director, Vladimir Zabrodin analogized him to the capable craftsman seen in other national film industries: "Protazanov was a professional who took instructions and, as a point of professional honor, did what his studio and viewers expected. He had no social prejudice, or if he did, it was a purely private matter. He had no aesthetic preferences, or if he did, he never declared them. He had ties neither to the avant-garde nor to traditionalism. He proceeded from the culture that was close to him."[12] Other participants were not as quick to call him a "studio" director, but all agreed he had a remarkable talent to adapt his films to changing circumstances. He did not invent any major new cinematic techniques, but he could capably "pilfer" from any style to suit his needs. He was, as Yuri Tsivian put it, a "surprisingly talented opportunist" or even a "proto-postmodernist" (graciously resisting another pun).[13] Given his prominence, longevity, and flexibility, Protazanov is no typical Soviet filmmaker. But as Zabrodin points out, consider him in a broader international context and he seems common, even unremarkable. He was a reliable metteur en scène like those who provided the foundation for the Hollywood studio era: Lloyd Bacon, Michael Curtiz, Henry Hathaway, Victor Fleming, and Clarence Brown. If lacking a strong personal style, they enjoyed long, productive stints competently making pictures no worse than the sum of their original ingredients. Sometimes they even delivered bona fide classics like Curtiz's *Casablanca* (1942).[14] By studying a "normal" Soviet film director, we can understand what was "normal" about Soviet cinema, which is no less important than the many ways it was not.

Writers have been hesitant to claim a deep, personal vision in Protazanov's films in part due to the lack of biographical information. Aleinikov based his studies on their personal friendship; Arlazorov on the few documents and relatives that remained thirty years after his death. Due to the death of Protazanov's only son, Georgi, late in the Great Patriotic War, there are no descendants of the main Protazanov line. Testimony from his collaborators and friends that Aleinikov collected and published roughly at the same time as his own studies are all valuable but were edited by him and therefore suspect in their choices of inclusion and exclusion.[15] But most importantly, Protazanov was a notoriously taciturn director working concurrently with some of the most garrulous ones in film history. In contrast to manifestos, reviews, analyses, and theoretical writings about cinema by the likes of Sergei Eisenstein, Vsevolod Pudovkin, and Lev Kuleshov that each fill multivolume collections, Protazanov said practically nothing about his work. He sat out of the debates raging among filmmakers in the 1920s that culminated in the Cultural Revolution. In 1928, the literary journal *On Literary Guard* sent a written survey to major film directors about the relationship between cinema and literature and the role of criticism. In contrast to other directors' page-length treatises, Protazanov's response was only a few sentences:

"I like to read literary criticism because it doesn't criticize me. For that reason, I read film criticism with less pleasure."[16] Toward the end of his life, he explained: "I am stingy with my words because I consider a director's best words to be those on the screen. Only in the darkness of the screening room, with thousands of eyes fixed on one point, can a director speak most clearly and expressively, for it is easiest for him to speak in his native language."[17] Interviewed in anticipation of a new film, he frustrated reporters by giving the most banal answers to questions, refusing to be baited into revealing more. By the late 1930s, in the increasingly monitored industry, he could capably mimic the tinny, strident tone of Bolshevik pronouncements in a way that seems designed to bore the reader.[18] Protazanov's self-effacement has been seen as a strategic move to avoid controversy and distinct political affiliations in an increasingly volatile film industry, though there is no direct evidence attesting to this intention.

Yet others' recollections suggest a character far different from his tight-lipped demeanor in print. His quip about literary criticism gives a hint of a droll sense of humor. His peers regularly remark about his open, charismatic, and extremely likable personality. Those who witnessed him at work emphasize his skill at managing the different people on a film set. Over his career, he worked with nearly every major Russian film actor of his time, launching the careers of Ivan Mozzhukhin, Igor Ilyinsky, Nikolai Batalov, and many more. Protazanov's peers regularly mentioned his collaborative and inclusive attitude to the creative process. Actors, in particular, appreciated his working assumption that their insights would reshape the script during the production process and his ability to make the daily work on set seem to organically progress without him controlling it—even though they knew he was. All his peers also credited him with an outstanding sense of what typical film viewers wanted to see for entertainment. Asked to briefly describe Protazanov, critic Viktor Shklovsky responded, "He knew his audience" (*Znal zritelia*).[19] For him and many others, this was a backhanded compliment. The most ideologically driven avant-gardists understood their task as not to please audiences but to transform them. Their attitude reflected a broader paternalism among Bolshevik elites bordering on contempt for the unenlightened. Typical filmgoers were not the best judges of what they should see, and a director who catered to them was suspicious. Yet while Protazanov was cagey about many things, he was always forthright about his desire to make genuinely entertaining films.

Despite Protazanov's self-conception as a popular entertainer, his reputation as a congenial collaborator, and the diversity of his films, I argue that they also manifest a distinct personal vision. Analyzing and interpreting his films in greater depth than ever before, this book takes seriously his claim that a director's most important statement is on the screen through a sustained auteurist reading of his oeuvre. Peter Wollen describes this traditional methodology in film studies as an

"operation of decipherment" that identifies an "author code" as a textual feature of a group of films with the same director.[20] Protazanov is, if anything, precisely the kind of director designed for this treatment. After all, as Wollen reminds us, the critical strategy assumes that this "author code" is hidden rather than self-evident, requiring the work of a critic to elucidate it. In European and American criticism, the auteurist project sustained its energy not from a desire to celebrate directors with the best-known signatures (though there was no shortage of that) but to highlight directorial contributions in seemingly run-of-the-mill films where they were not immediately obvious, always with the assumption that the "author code" is more present in some works rather than others due to the complex institutional structures involved in film production.[21]

Protazanov worked in multiple nations over a period in which one empire collapsed, an unprecedented political project brutally reshaped one-sixth of the world's population, and—no less importantly—the motion picture as a medium of expression came into existence. I am equally interested in how his films reflected and responded to these developments as the consistency of his vision. The call for film studies scholars to "look beyond the text" has become a cliché, but it is true that we are interested in more than constructing an authorial presence in these texts. We also want to understand Protazanov's role as a director and how he was affected by his era. This task requires considering the relationship among him, the formal features of his films, and historical causation. Directors have little impact or choice over many aspects of their films. They respond to the creative initiative of other artists working with them, fiats by studio management, limitations in resources and technology, and sheer day-to-day contingencies. They start with certain intentions and change them constantly in the process of creation. As I analyze films and describe this "author code," I will focus on its chronological development both in relation to broad trends in cinematic art and the shifting industrial circumstances that furnished each film's immediate production context. This approach is vital: Protazanov was not a director who went into a film with a sharply defined vision of the final product. Nearly everyone who worked with him remarks on the way he treated his collaborators as cocreators. He welcomed contributions from his actors, cinematographers, and screenwriters throughout the stages of production.[22] Yet Protazanov himself also enjoyed significant cultural recognition among critics and even audiences. His name regularly appeared in advertisements for films he directed—often in the largest typeface, and in some cases, even without the names of star actors.[23] In the poster for his 1926 film, *The Forty-First*, designed by Grigori Borisov and visible in part on the cover of this book, it is Protazanov's own visage that dominates the frame and not that of any actor in the film. In keeping with what we know about his typical working practices, I treat him as a "final filter" on all the collaborative creation that occurs on

a film set. Though not the impetus of every feature of these films, he is ultimately responsible for their form. I treat this authorial intention not as a discrete mental phenomenon prior to the process of creation but as a pattern of behavior.[24]

The notion of a "final filter" underlies the way I approach historical topics and have proceeded in my investigation of the varying social, political, economic, technological, and cultural contexts surrounding these films. I adopt David Bordwell's "concentric circles" model for the relationship between historical causation and cinematic artifacts. This model focuses on "proximate" causal factors to account for aspects of cinematic form. The visible and audible features of a film are an immediate product of decisions made in a specific production context. The work on one film over days, weeks, or months is shaped by the systematic procedures of a film industry necessary for it to sustain its operations. These, in turn, open up to the social, economic, and political transformations of the revolutionary era.[25] Macrolevel shifts in society, politics, and culture are reflected in film form insofar as they are mediated by the specific conditions of the film industry and its professional cultures. I take a film and its immediate production context as a starting point for historical inquiry and work outward to the broader historical context as necessary. As a source base, I look to memoirs of eyewitnesses, studio documents and correspondence, industry discourse as reflected in its trade press, and critical reception of films. My project attends to the broad sociocultural shifts of the revolutionary era surrounding Protazanov as he worked, but I prioritize understanding how these manifested locally.

Rather than theoretical coherence or historical accuracy, the most serious obstacle to this approach is the dearth of surviving films. Protazanov was prolific, but the majority of the films he is known to have directed are lost, and many of those that do survive are missing significant amounts of footage. According to the most thorough filmography, about forty-four films survive in a mostly complete state out of the one hundred twelve he is known or believed to have directed—about 39 percent. The different phases of his career are not equally represented in that total. A mere fifteen films of the sixty-eight from his prerevolutionary period survive in significant form (about 22 percent). His emigration period, the least examined of his career, is somewhat better represented in six films out of fifteen (about 40 percent). In contrast, all eighteen films from his Soviet period survive in their entirety due to better institutional procedures for preservation.[26] Since Arlazorov's last career-length study, six mostly complete titles have resurfaced that fill in significant gaps in his pre-Soviet output. The unevenly distributed gaps in available films, however, raise the question of what we can conclude about an author code based on a limited sample. Protazanov was at his peak during the prerevolutionary period, precisely when the majority of films are not available today. A systematic examination of all

available Protazanov films in chronological order would lend his Soviet period unequal weight based on the fortuities of preservation instead of the logic of his career. Fortunately, this book's purpose is not to account for all of Protazanov's works in the manner of a catalogue raisonné but to extrapolate and define an authorial presence from what we have, with appropriate attention to what we lack. The scattered survival of Protazanov's films informs the approach this book takes to their critical examination. I mention almost all surviving films in passing but focus on particular ones in detail to illustrate the topic at hand. I also give special attention to the recently rediscovered films being discussed for the first time in print.

When I started this project, I shared previous critics' views that Protazanov lacked a strong artistic temperament. Yet as I looked closer, I found that there is indeed something consistently "Protazanovian" about his films. As he adapted to changing nations and regimes, he returned to preferred stylistic techniques and gravitated toward stories and themes that resonated with him, or at least had worked in the past. This book's central thesis is that Protazanov's films represent the perspective of one who experienced the revolutionary era as a dislocation. From the moment he left Russia in 1919, through his return, and ending only at his death, he was a displaced, mobile author analogous to other exile, emigrant, and diasporic artists in cinema and beyond. He exemplifies one who, as Edward Said describes, "exists in a median state, neither completely at home with the new setting nor fully disencumbered of the old, beset with half-involvements and half-detachments, nostalgic and sentimental on one level, an adept mimic or a secret outcast on another."[27] There are understandable political reasons why this aspect of his creative vision remains unexplored. During Protazanov's life, the stakes for conforming to the vision of a new socialist society were high. Neither he nor his peers wanted to suggest that he was alien to it. More fundamentally, as Soviet scholars dutifully followed Marxist precepts, they used a class framework to identify mentalities rather than ethnicity or nationality, where migration is a more salient issue. But it is telling that no peer or later critic ever made the case for his deep, lasting conversion to the communist cause. "Protazanov's relationship with the revolution was rather complicated, like that of many other honest intellectuals. With varying degrees of intensity, each of them went their own way of 'walking in agony,'" wrote Soviet critic Mark Kushnirov in 1971.[28] His films were regularly criticized as bourgeois and ideologically suspect. Even sympathetic observers tended to see his conversion as partial or incomplete. One assessment of him in the 1920s deemed him a director who "began his career before the revolution, but who over the past seven years has transformed into a sphinx."[29] Director Leonid Trauberg used the vivid language of self-criticism (samokritika) to describe his mentality: "Protazanov is struggling with himself to root out the traces of the Ermolieff-Khanzhonkov tradition.

Introduction 11

For this, he has a massive reserve of energy he spends with the utmost utility. Every atom of his energy goes into the struggle against personal backwardness. In this struggle there will be both defeats and victories."[30] My argument has been frankly expressed before, if only in passing. In a 1994 foreword to some republished letters, Viacheslav Rebrov remarks that Protazanov "remained, in the depths of his soul, in essence, an 'interior emigrant'" and that he "never found his place" in the Soviet Union.[31] Though this attitude is subtle, and more salient in some works than others, I argue that it suffuses his films and becomes apparent when they are seen in relation to each other.

Though his dislocation does not fit the traditional labels—exile, diaspora, emigration—Protazanov's experience shares much with similarly mobile filmmakers, past and present. My study draws inspiration from two related bodies of film criticism. The first is the extensive interest in the formative role of immigrants in studio-era Hollywood, especially numerous German artists fleeing the Nazi regime. The parallels between Protazanov and his counterparts who arrived in America at a similar moment are striking. Take the exemplary case of Ernst Lubitsch. He and Protazanov were born about three years apart and entered the film industry in the early 1910s—Protazanov with his first feature in 1911, Lubitsch with his first acting role in 1913. Both had personal connections with and fervent admirations for the leading theatrical regisseurs of their respective countries: the former the Moscow Art Theater's Konstantin Stanislavski; the latter the Deutsches Theater's Max Reinhardt. While their bodies of work prior to emigration have many differences, both achieved unparalleled reputations based on a mixture of literary adaptations, big-budget spectaculars, and comedies. In 1923, both were working at UFA in Berlin, and months after Protazanov repatriated, Lubitsch left to take a job in Hollywood, where he would stay for the rest of his career. Paul Davidson, the producer of Protazanov's sole UFA film, *Pilgrimage of Love* (*Der Liebe Pilgerfahrt*, 1923), in fact had been one of Lubitsch's regular collaborators. Both he and Lubitsch made remarkable adjustments to their new situations. The latter abandoned the stagey monumentalism of his German silent films in favor of the crisp, efficient mode of Hollywood storytelling. The former added avant-gardist tropes to his mix of stylistic strategies and reoriented his basic approach to shooting a scene around montage. Neither merely followed new trends; both helped create the conventions associated with their national film industries.[32] Both adapted to sound filmmaking with ease and, to different degrees, recentered their reputations around comedy. And both met premature deaths in their fifties due to natural causes shortly after the end of World War II while at work on major productions—Protazanov in 1945, Lubitsch in 1947.

But their work has received different treatment from critics. Lubitsch is one of the canonical Hollywood filmmakers, a leading artist during his lifetime who later ascended to Andrew Sarris's "Pantheon" in his seminal *The American*

Film Industry. Contemporary critics and later scholars have been interested in Lubitsch's experience as a Jewish émigré who, despite his professed love of his new country, was the butt of lighthearted jokes for his thick accent and rudimentary English. Critics have credited his position as an outsider for his films' detached, gentle treatment of human affairs and their Continental, permissive attitudes toward sexual matters that challenged—and sometimes subverted—the puritanical Production Code Administration. In his films' settings, critics have sensed no shortage of nostalgia for the "Old Europe" of his youth that disappeared with the First World War. Lubitsch in effect recreated an artificial version of the glamorous milieu of debonair aristocrats in what he called "Paris, Paramount."[33] Protazanov shares with Lubitsch a similarity in attitude that Peter Bagrov calls simply their "irony."[34] This multifaceted (and much abused) term is appropriate for describing how Protazanov's films display an ambivalence toward their subject matter unusual for a Soviet filmmaker. Margolit writes, "In this romantic epoch Protazanov stood alone. He was an ironic skeptic—a skeptic of classic European stock. In our cinema he is more European than any of his contemporaries."[35] His films sometimes treat the sacred revolutionary cause with a palpable sense of distance, as an observer of, rather than a participant in the construction of Soviet socialism. They remain fixated on a vision of a cosmopolitan, prerevolutionary European Russia of high cultural achievement, even as they ridiculed it mercilessly. While his peers searched for the most simple and forceful way to convey a single, ideological message, Protazanov reveled in mixed, contradictory, or multilayered ones. Sometimes, his films offered audiences space for unorthodox, even subversive interpretations.

The second body of literature I draw from is the critical interest in transnational directors in the contemporary era of globalization, with particular attention to waves of outward migration from the postcolonial Global South and the former Eastern Bloc. Studies of filmmakers from the waves of *beur* North African emigrants in France, Turkish *gastarbeiter* in Germany, and second-generation Asian and Afro-Cuban communities in the United Kingdom have enriched what we think of as those national cinema traditions, as have studies of the prominent Hong Kong, Mexican, and Korean filmmakers in the quintessentially global cinema, Hollywood.[36] Hamid Naficy's pioneering study, *An Accented Cinema: Exilic and Diasporic Filmmaking,* catalyzed much of this interest when it offered a comprehensive and comparative view of directors in liminal, transcultural spaces and drew attention to their recurring themes, production and distribution strategies, narrative and genre structures, and stylistic predilections. Naficy treats migrant directors as "situated but universal" figures sharing an "accented style" that "helps us to discover commonalities among exilic filmmakers that cut across gender, race, nationality, and ethnicity, as well as across boundaries of national cinemas, genres, and authorship," thus shifting common critical frames

of reference.[37] This book echoes Naficy's insistence that this mode of criticism must be equally attentive to the formal features of texts and the specific material and social conditions of their authors as historical individuals.

Soviet cinema is one category that would benefit from this shift in orientation. While "White" or "first-wave" émigrés (*emigranty pervoi volny*)—that is, those leaving in the wake of 1917 due to opposition to the Bolshevik regime—generally represent postrevolutionary outward migration, both literary and film studies have moved toward a more inclusive notion of emigration. The experience of dislocation is defined by an interstitial and intercultural space, not a geographic one. It is inherently unstable and likely to receive different labels with the passage of time, new historical events, and identity formations: the same person in *exile* for political reasons might *emigrate* multiple times, become part of a *diaspora* when joined by a critical mass of others in a similar situation, only to eventually assume a hyphenated *ethnic* identity in national circumstances amenable to it. Protazanov's case is typical in how a mobile career has both a temporal and spatial element. Yet this space is one within a human society and social relationships. One can remain an exile despite making a long-desired homecoming, only to find it no less foreign there than in one's adopted country. Indeed, one can be an exile despite not leaving at all, as mass migrations sunder communities and are equally experienced as a loss at home. Exile is defined by what Said calls an "unhealable rift forced between a human being and native place, between the self and its true home: its essential sadness can never be surmounted."[38]

Critical interest in artists with such identities has produced an array of categorizations, and it is worth clarifying the language I will be using to convey this distance and dislocation. I will use a variety of terms, with the most common being "emigration," which serves as a neutral descriptor of movement across borders, and "exile," which draws attention to the initial political impetus for this movement. I use terms such as "inner exile" or "inner emigration" to describe either Protazanov's psychological predisposition or his textual presence in surviving Soviet films. This concept has been controversial in literary studies. The *locus classicus* is the debate between German authors who fled the Nazi regime and those who stayed but insisted they were not collaborators.[39] Questions of moral status and political alignment have therefore been central to exile's conceptualization. While Naficy's book primarily examines "exterior" exiles, it does include a category of "inner exile." His usage refers to directors politically disenfranchised in their home countries, his specific example being postwar Soviet-Armenian director Sergei Parajanov, who was in prison from 1973 to 1977.[40] However, scholars in several areas have extended its use to artists, including filmmakers, who were not at direct odds with the governing regime but estranged from its dominant ideology in a meaningful if less stark fashion. This usage is common in studies of the art of Eastern European communist nations. Melinda

Szaloky, for example, has claimed that Hungarian cinema after the communist takeover fits all the markers of an exile cinema produced *within* its borders.[41] This book follows these precedents for a metaphorical deployment of the terms "inner exile" and "inner emigration."

But let me be clear: Yakov Protazanov was no dissident. While I will argue that his films sometimes convey hesitation or ambivalence and are not reducible to the official ideology of the party-state, his voice is, no doubt, that of one of the most privileged members of Soviet society. He received a number of prestigious awards, regular salary bonuses, a cushy Moscow apartment, and regular access to the creature comforts of the *nomenklatura* class, including visits to the posh Caucasian "health resort" in Gagra, Georgia, beloved by Stalin and other Party leaders. Yet a binary of "collaborators" and "dissidents" rarely captures the attitudes present in individual artists. Protazanov's work across this long revolutionary period captures this ambiguity and calls attention to the complexity of cultural production from the perspective of artists that some today are predisposed to view according to a Manichean moral schema. Despite the traumatic experience of exile, some artists *do* adapt to their new circumstances, for better or for worse. In contrast to the emphasis on marginal, alternative, or otherwise oppositional modes of cinema emphasized in studies of migrant directors, he calls attention to their presence in the mainstream national cinemas, including the state-administered mass culture of the Soviet Union with its underlying political rationale. Like the German refugees in Hollywood's studio era, Protazanov reminds us that outsiders can and do propagate dominant views of their host nation and even have a hand in shaping them.

This book thus restages a key moment in the history of cinema as an art form with an emphasis on one of its defining features then and now: its transnationality. "National cinema" has always been a problematic term for the Soviet Union's imperial formation. Protazanov's career offers a chance to put the emergence of its revolutionary content and aesthetics in a comparative, transnational framework that has been proposed as essential for understanding Soviet culture, which was neither a simple outgrowth of "totalitarian" ideology nor a separate and "abnormal" process of modernization. The lives and artistic careers of the many mobile, cosmopolitan personalities that influenced it have proven useful for understanding these dynamics.[42] In the year of the centenary of 1917, some scholars proposed that, as the question of worldwide Marxist revolution subsides, the Russian Revolution might best be interpreted in terms of the "failed states," "regime changes," and "color revolutions" that continue to define international relations.[43] Today, the most enduring effects of wars, revolutions, and social collapse often prove to be the massive groups of people they expel from their homes, and the way they reconfigure the worldwide ethnoscape, rather than substantive change in power hierarchies. Though the viewpoint

of the mobile, migrant subject has rarely been an explicit topic, transnational exchange has always been a key component of our understanding of Soviet cinema.[44] Its central figures looked to Hollywood films both as an inspiration for popular cinema and an embodiment of capitalist ideology. They borrowed freely from its techniques while deploying them in ways that would have never occurred to a Hollywood filmmaker. In contrast to the *Amerikanshchina* of the canonical Soviet filmmakers, Protazanov—Margolit's "most European" Soviet filmmaker—draws attention to Soviet cinema's recurring points of continental contact, including the joint German-Russian studio that employed him, Mezhrabpom. He first explored film production in France, received formal training in Italy, admired ambitious Scandinavian features, and made movies that sometimes enjoyed commercial success throughout Europe, whether he was working there or in Russia. For Protazanov, Hollywood movies were never the obvious reference point. No less than Soviet cinema, his career allows us to narrate the history of the transnational, cosmopolitan cinema of "Film Europe" that has been researched with a greater point of gravity in Germany, France, and the United Kingdom.[45]

It also sheds light on this transnational exchange in *popular* cinema for a mass viewership, in contrast to the modernist avant-garde that is far better represented in current literature despite its limited audience and marginal presence in economic terms. Despite Protazanov's exceptional position, there are reasons to think that his films reflected something broader than his own perspective. They played on screens throughout the emerging empire and were noted for their popularity. As they entertained, they tapped into the emotions of viewers from a diverse set of backgrounds who came to be known monolithically as "the Soviet audience." Eisenstein, Pudovkin, and Vertov were all fundamentally at home in the revolution. They desired, welcomed, celebrated, and contributed to the transformations of the era with all its intoxications and traumas. In both their films and their theoretical writings, they are supremely confident in the justice of their cause and the validity of their ideas—even when forced to alter the latter soon after. Protazanov's career reflects how disorientation was central to the revolutionary experience. Starting in 1917, the new Soviet society reputed its past, changing the names of streets to fit revolutionary topics, destroying monuments that celebrated the old order, and canonizing a new set of socialist heroes. The date on one's calendar changed overnight and the key landmarks of one's hometown not long after. Daily interactions took place in a strange new language with unfamiliar terms like "pilot," "bourgeois," "physical culture," and "dialectical materialism." To participate in public life, one needed to learn to "speak Bolshevik."[46] Even if many Russians welcomed the new chapter, this did not make it any less bewildering. The transformation was like being suddenly transported to a different country, both for those who celebrated

this event and enthusiastically assimilated and for those who were pushed to the margins of society, or worse. Protazanov's experience of national-political dislocation, and the way it shaped the content of his films, suggests the similarities between the processes of self-fashioning that both emigration and revolution have in common. "Reinvention," writes Sheila Fitzpatrick, "is what revolutions are all about."[47]

The organization of this book balances the synchronic and diachronic analysis of Protazanov's films, with each of its chapters simultaneously considering both his work's enduring features and its transformation across his migrations. Chapter 1 takes the most straightforwardly chronological approach as it traces his biography with particular emphasis on his life-altering decision to return to the Soviet Union in 1923. As it narrates his birth, entrance into the film industry, emigration, repatriation, later career, and death, it makes the case for his status as a literal and then internal exile. After the first chapter contextualizes Protazanov's career, the subsequent chapters move to specific topics across his entire corpus of films to elucidate the signs of his underlying authorial presence in it. Though each chapter covers his entire work from a different perspective, they emphasize a particular phase and analyze in depth specific films that most vividly illustrate their concerns. Their arrangement maintains a certain chronological structure, with the earlier chapters including more discussion of his prerevolutionary silent-era career and the latter ones more on his films after the transition to sound and the centralization of the Soviet film industry under Stalin.

Chapter 2 focuses on the topic of adaptation, both to understand Protazanov's approach to this aspect of his craft and to understand how his films participated in broader discourses about the role of mass culture during the revolutionary era. Protazanov's film adaptations of classic Russian literature—such as *The Queen of Spades* (1916), his version of Alexander Pushkin's short story—were an integral part of the prerevolutionary film industry's strategy to raise its cultural status and ease pressure from social reformers and government administrators hostile to commercialized entertainment. A close analysis of *Father Sergius* (1918), based on Leo Tolstoy's 1911 novella, shows how this adaptation reflected a wave of iconoclasm unleashed in 1917 that ultimately saw such literary films decline in number and centrality in the film industry. Then a discussion of *Without a Dowry* (1936), Protazanov's adaptation of Alexander Ostrovsky's 1879 play, illustrates how classics returned to the screen as part of the Stalinist regime's new championing of Russian literature to create cultural cohesion and provide models for cultured consumption. I emphasize that none of Protazanov's major adaptations were "straight" interpretations of the original texts but reworked and reshaped them out of consideration of both the politics of the moment and the recent experiences of his audience members.

After this examination of how Protazanov and his films participated in broad discussions related to mass entertainment and cultural hierarchy, chapter 3 begins a deeper examination of his artistic craft by focusing on his eclectic and multifaceted visual style, especially in his silent films. The standard history of film art emphasizes how the Russian Revolution transformed the style of films to the extent that they barely resembled those produced under the tsar. The chapter argues that, in contrast to his reputation as an old-fashioned "traditionalist," Protazanov was a major participant in the era's artistic ferment, attending to the innovations of his peers and even exploring certain cinematic techniques in advance of them. Like an immigrant to a new country must cultivate new linguistic skills, his migrations catalyzed new developments in his films' style. While working in new studios in new nations, Protazanov learned new cinematic techniques, but they did not fundamentally displace the old. While covering examples from films across the 1910s–1930s, the chapter focuses in particular on *Aelita* (1924), his most famous film. While exceptional in his oeuvre in many respects, it exemplifies his "omnivorous" approach to cinematic form and evidences all of the aesthetic strands of his work in the silent era.

Chapter 4 follows this discussion of Protazanov's films' style with their content, in the sense of their narrative and thematic elements. Here his status as an exilic artist becomes most vivid as I focus on a dramatic shift in his work beginning in his films made during emigration and persisting into his Soviet period. Drawing on analogous studies of migrant filmmakers such as Naficy's, the chapter interprets his films as commentaries on his own process of dislocation and assimilation into a new culture—sometimes subtly, other times overtly. It focuses on *A Narrow Escape* (*L'angoissante aventure*, 1920), produced literally in transit from Russia to Paris during the Ermolieff company's flight from the Russian civil war, and the two films made immediately after his repatriation when his loyalties were under scrutiny, *Aelita* (1924) and *His Call* (1925). Protazanov's regular stories involving border crossing and travel, his fascination with villains and other characters who do not conform to the official vision of the Soviet future, and his characters' regular use of disguise, imposture, and trickery all testify to how his films were personal works about his own experience.

These exilic topics span Protazanov's work across many genres but come to the foreground in his comedies. Chapter 5 takes up the issue of how this author code relates to the question of genre by focusing on one in which he had the most lasting influence in the Soviet era. Protazanov's comic films were immediately popular, stayed on screens long after their initial release, and have been central to his reputation for critics who have wanted to celebrate his particular talents. His work in this genre reflected both his commitment to popular entertainment for a mass audience and his perspective as an outsider looking

upon the Soviet experiment as an observer rather than a part of its leading vanguard. The diversity of his comic films, the kinds of humor employed in each, and the varying degrees of favor each received from contemporary critics and the cultural bureaucracy were influenced by the shifting ideological rationale for comedy in the Soviet Union, the administrative structure performing oversight of the film industries, and the different representational norms for how one showed the Soviet Union vs. a foreign country on screen.

Building on these previous discussions, chapter 6 takes up the broad issue of cinema's mode of address and its transformation from early cinema, through mainstream narrative cinema, the Soviet avant-garde challenge to it, and the transition to sound. It focuses on how Protazanov's films, across his career, directly addressed the viewer in some fashion in some of their most memorable and unusual moments. In the silent era, they regularly presented abstract, often allegorical images detached from the worlds of his films' stories in the manner of an intertitle or text. Then in the sound era, he found a functional replacement for these techniques in his deployment of a human voice that spoke directly to the viewer. As it examines the issue of Protazanov's films' mode of address, the chapter sketches an alternative genealogy to the one dominant in the field of film studies that emphasizes how Soviet avant-garde filmmakers looked to early cinema as a source of inspiration and instead foregrounds how both prerevolutionary and revolutionary filmmakers were intrigued by the didactic potential of the medium to uplift, educate, and inculcate desired values. The chapter concludes with Protazanov's most elaborate combination of education and entertainment in the sound era in one of his most impressive and underappreciated comedies, *Marionettes* (*Marionetki*, 1934), which combines an instructional pamphlet on the emergence of fascism in Europe with a lightly comic musical revue and puppet show.

1 · A MOBILE CAREER

Though critics have hesitated to read Protazanov's films as personal works, it has not been for lack of information. A basic understanding of the director's trajectory from Russia back to the Soviet Union provided a frame of reference for all his peers who saw his films on their original release. Even if fixated on class identities and political loyalty, their interpretations were biographical and auteurist in that minimal sense. Today, we have ample opportunity to explore Protazanov's personal life. In the mid-1970s, shortly after the death of Protazanov's wife, Frida Vasilievna Protazanova, family members donated two large suitcases full of family documents that are the basis for the collection at the Central Museum of Cinema.[1] Protazanov and his family members corresponded regularly when he was away from their home in Moscow, such as when he was shooting on location or treating his hypertension at various health resorts. The largest collections date from their period of emigration (1920–1923) and from the late 1920s onward. While fragmentary, they provide a rare glimpse of the subjective experience of moments well known from official documentation, journalism, and other sources related to his professional life. While these letters are generally light on the creative explorations he was making in his films, passing remarks clarify questions of fact and provide context for his decisions. The most important of these was his biography-defining decision to repatriate, which transpired when he was living in Berlin while the family was still in Paris.

EARLY LIFE

Protazanov's family exemplifies a particular group of "bourgeois intelligentsia" growing in the last years of the Russian Empire.[2] Louise McReynolds coined this seemingly contradictory term to capture how the most dynamic parts of Russian society around the turn of the twentieth century were often, on one hand, nonconforming or out of place but, on the other, also typically gaining wealth and stature in a growing modern economy. She sees this class as being especially formative in the beginnings of mass culture. The roots of the Protazanov

family—often spelled Protozanov in earlier generations—are in Kyiv and Bronnitsy, a small village on the outskirts of Moscow. The future director was born into the pious, traditional merchant class ridiculed in Russian literature of the nineteenth century—and eventually in his own films.[3] His father, Alexander Savvich (often Savel'evich) Protazanov, carried the hereditary title of "Honored Citizen" (*pochetnyi grazhdanin*) that had initially been conferred on his grandfather, Yakov Ivanovich Protazanov.[4] This social position inaugurated under Catherine II is often associated with merchants and is typically seen as one of the imperial government's attempts to foster a middle class.[5] Alexander Savvich spent most of his career working at the Shibaev firm, a leader in the Russian oil industry, where he was an accountant or some type of clerk (*doverennoe litso*). Despite this respectable profession, Arlazorov suspects that he may not have been quite so traditional in mindset, drawing from family lore that he had "the hair of a poet" in his youth. The feature that stands out is his love of reading and massive collection of books, both of which young Yakov would take after.[6] In one of the two surviving letters from father to son, both written on Shibaev company stationary, Alexander grants the fifteen-year-old Yakov permission to accompany him to an 1896 exhibition, presumably the All-Russian Exhibition in Nizhny Novgorod. These gatherings of merchants were known as major sites for cultural novelties, including being some of the earliest places for the demonstration of early cinema in Russia. Arlazorov speculates that this may have been the first place that the future director encountered his trade, and while we have no more information to verify this claim, the fact that the family preserved this brief message suggests that it was an important one.[7]

The director's mother, Elizaveta Mikhailovna Vinokurova, had even better claims of being from a "cultured" (*kul'turnyi*) background. She was born into a prominent and prosperous Moscow merchant family. While not the same caliber as the wealthiest art patrons—such as the Ryabushinskys and Morozovs, well known for their impact on late imperial culture—the Vinokurovs had some connections to the cultural and intellectual life in the city. Elizaveta had learned to speak French and read at the Elizabeth Institute of Noble Maidens, an elite boarding school for girls. Yakov mentions actors and other figures of the Russian theatrical world as a constant presence in their household, including Elizabeth's older brother, Uncle Sergei Mikhailovich Vinokurov. Their close friends, the Sadovskys, were one of the major families associated with the Maly Theater. Protazanov even claimed connections to the Moscow Art Theater's Konstantin Stanislavski through the latter's family business in silver.[8] Elizaveta had some nonconformist tendencies of her own. How she and Alexander met when he was a student is unknown, but her father, Mikhail, disapproved of their marriage on the principle that he ought to finish school and get a job before they tied the knot. But after the family patriarch died, the young couple only waited a month

to get married despite his last wishes. Their branch thus had resources at hand but was far from wealthy, and Elizaveta and Alexander may very well have qualified as "downwardly socially mobile." It seems clear that their general values were not far afield from those of the intelligentsia, prominent in typical histories of Russia. Membership in this group was more a question of outlook and political beliefs than a specific position in the social order.

But if willing to buck convention at times, the family was quite traditional in one respect. Elizaveta and the Vinokurovs were devout followers of mainline Russian Orthodoxy. The merchant families of the time included quite a few Old Believers, a sect that resisted earlier Petrine-era reforms. Though many Old Believers were employed at the Shibaev company and at many enterprises that the Protazanov and Vinokurov families must have been connected to, the records for both families were in the mainline church. Elizaveta's letters to young Yakov are full of mentions of churches and monasteries, where she enjoyed strolling over the years, and motherly scolding to keep the faith. Once, when visiting family while Yakov was away in Kyiv, she passed along the greetings of his grandmother, who wondered if he ever went to church or wore his cross.[9] Perhaps these letters show signs of him rejecting his family's faith, even this early in life. As a director, Protazanov gravitated toward film topics that involved criticism of religious institutions and explored the paradoxes of religious faith, such as his Tolstoy-related films *The Departure of a Great Old Man* (1912) and *Father Sergius* (1918). After his return to the Soviet Union, he criticized the church with Marxist-Leninist venom in films such as *The Case of the Three Million* (1926) and *St. Jorgen's Day* (1930). Those who knew Protazanov were often hesitant to say too much about his political beliefs, and no one in the industry ever credited him with a passionate conversion to Soviet ideology, but nearly all attest that he was a sincere atheist, like many intellectuals of his time.

The privileges afforded through membership in the Protazanov-Vinokurov family plus the seemingly nonconforming and unambitious orientations of his parents explain young Yakov's paradoxically rigid education. One of those privileges was a stipend left by Great-Uncle Nikolai Ilyich Ushakov for him and his siblings to attend school—the boys at the Moscow Commercial School, the girls at the Elizabeth Institute for Noble Maidens where Elizaveta once attended. The stipends were limited to these two options, and it seems that young Yakov's parents had no means to provide another. Thus, despite his parents' love of arts and culture, it was taken for granted that he would attend the Moscow Commercial School, with its preprofessional curriculum designed for future accountants, engineers, and entrepreneurs rather than one designed for future painters and poets. The school especially emphasized foreign languages, and it must have been here that Protazanov cultivated his particular skill in French that served him well in the film industry. Having begun attending at age twelve and

finishing with good grades in 1900, at the age of eighteen, Protazanov seems to have absorbed the discipline emphasized there and aspired to be an engineer. Upon beginning his career, though, he was subjected to both professional and personal pressures he had not anticipated. In 1899, Alexander Savvich became seriously ill, left his job, and never worked to support the family again. Sergei Mikhailovich Vinokurov, Yakov's thespian uncle, began a poorly conceived project to build another house on the family's plot, which drove the family into debt and led to the bank taking ownership. Losing ownership of one's home carried a heavy stigma among the merchantry and exerted a considerable psychological toll on the Protazanov family's self-perception. The end result was that young Yakov and his sisters were sent to work to pay off debts and maintain the family's dignity at the stage of life he had expected to be earning his independence.[10]

Yakov reconsidered his future life as an engineer that he had assumed up to this point—an option available to only a few in the turn-of-the-century Russian Empire, which would not last two more decades. At a certain point, it seems he broke down and quit his job, deciding it would be better to spend his day idly. A stroke of luck enabled him to spend some time and money "finding himself." Alexander Savvich's aunt, Efrosinia Yakovlevna, died in 1900, leaving a sizable inheritance to all her relatives that paid out gradually over a few years. Protazanov opted to use the cash to go traveling to "continue his education."[11] From 1904 to 1906, he left Russia six times and toured the major cities in Europe: Berlin, Warsaw, and Vienna; then Milan and Geneva; then back to Berlin and Paris. "Everyone is very interested to learn why you left for abroad so suddenly," Elizaveta wrote to Yakov while he was abroad. "Even when the society ladies asked [sister] Nina, she answered that you went for some business, that you went as a representative of some trading house, and then in turn when they asked me what trading house, they didn't want to believe that I knew nothing about it."[12] But perhaps Protazanov's vague statements about a future business enterprise were honest after all. In Paris, he visited the grounds of Pathé's facilities in Vincennes, the most industrialized film production site in the world at that time. This would not have been a typical tourist destination, so it seems almost certain that cinema must have been more than a passing interest over the years. Arlazorov speculates he was drawn to the way that the cinema industry combined commerce, his background, and art, his passion.[13] Whatever the case, by the time the money for his "further education" ran out, Yakov had found a sense of purpose.

ENTERING THE FILM INDUSTRY

Upon returning to Moscow, Yakov Protazanov found work through his sister Valentina, who worked at an insurance company called New York run by the entrepreneur Yakov Davydovich Sommerfeld. Sommerfeld's two sons had just

begun a new cinema firm called Gloria, along with their friend Karl Könnecke. Protazanov joined Gloria as it set up shop in Dom Popov on Pyatnitskaya Street, in the merchant's area of Moscow. He had a variety of tasks at the new company, the most important of which was to use his excellent French to communicate with a mysterious, non-Russian-speaking Spaniard named Serrano who presented himself as an experienced cinematographer but proved to be, like many in the chaotic early Russian film industry, simply a confidence man.

Gloria provided the first opportunity for Protazanov to direct. Some filmographies mention him in connection with three films in 1909–1910, but one does not appear to have been released, and his alleged participation in the other two is uncertain.[14] Protazanov himself considered his first directorial work *The Convict's Song* (1911), his first surviving film. Some of Protazanov's first contacts at Gloria would stay with him for the rest of his life—most importantly, his wife, Frida Vasilievna Könnecke, the sister of business partner Karl (whom Protazanov usually calls Charles in surviving correspondence). Yakov and Frida married in 1911, and their only son, Georgi, was born two years later. Yakov and Charles are not known to have collaborated on any projects, but they remained in contact for the rest of their lives, leading parallel careers throughout Europe during the silent era. After some impressive profits, Gloria attracted the interest of Russo-German partners Paul Thiemann and Friedrich Reinhardt, whose ventures began as distributors of films produced by Nordisk (Denmark), Ambrosio (Italy), and Vitagraph (United States). Their company came to control about one-third of Russian film rentals by the early 1910s and merged Gloria and several other small production companies to form one of the major studios of the prerevolutionary era, Thiemann & Reinhardt.[15] On the basis of the success of *The Convict's Song*, Protazanov earned more opportunities to direct and quickly established himself. Thiemann & Reinhardt paired him with Vladimir Gardin, a stage actor, to create its leading directing team that churned out one-reelers, then features, in a variety of genres.[16] Gardin depicted their working relationship as one where he was in charge of performance and dramaturgy, while Protazanov handled technological issues. This is plausible given their different backgrounds, but Protazanov's reputation as a director has long been based on his talent with actors, and there is reason to think it developed quickly. Directing pairs were common in the early 1910s in film industries around the world; they typically did not have a rigidly defined division of labor.[17] Protazanov also continued to direct one-reelers on his own, and after the success of *The Bought Husband* (1913), the firm sent him to Ambrosio's studio in Turin to learn more about its production methods. Few of his works from this period survive, but based on the information we have, their topics, genres, and source material ran the gamut, from stage plays, to songs, to original stories, to straightforward reproductions of dance acts and other performances. Without a doubt, though, in business terms, the most

important film Gardin and Protazanov directed was *The Keys to Happiness* (1913). After the very successful runs of Nordisk's melodramas with Asta Nielsen and the Italian superproduction *Quo Vadis?* (1913), Thiemann & Reinhardt produced their own multireel feature based on Anastasiya Verbitskaya's extremely popular series of novels. The film broke all records for ticket sales for a Russian film. Aside from a few tantalizing fragments, however, the film itself is lost, so we cannot examine how it adapted Verbitskaya's novel, which is now considered a vital text for understanding late imperial Russian culture.[18]

The basic features for a stable film industry were in place in Russia by 1913. The Russian Empire's subsequent entrance into the First World War catalyzed massive growth. The German advance disrupted distribution lines throughout Europe so that French, British, and later Italian films became hard to import. A Russian trade embargo completed in early 1915 banned the import of German films entirely. But the audience, seeking escape during difficult times, only increased in size. The number of theaters continued to grow, even when excluding the populous regions of the western Russian Empire that came under German control. The established Russian firms rapidly expanded production to make up for the scarcity of films available to show on those screens, and numerous entrepreneurs entered film production. In 1913, 129 films were produced in Russia; by 1916, that number was 499. Natively produced films, which had been at best an insignificant portion of those shown in Russia prewar, made up about 80 percent of those on movie screens from 1914 to February 1917. Moreover, between 1913 and 1914, the majority of these films grew from short-length (one reel, sometimes two) to feature-length.[19]

It is common to see the years of the Great War as the time of the true flowering of prerevolutionary Russian cinema, and indeed, most of its best-known films were produced at this time. Russian firms cultivated their own stars and genres, directors developed their own distinctive styles, and the general scale of filmmaking became more ambitious. However, the film industry was not unaffected by the impending social collapse of the state and economy. To make up for the sudden scarcity of films, studios kicked into overdrive, often at the cost of film quality. Protazanov mentions entire features shot in a single day and scripts adapted from works of literature in a single night.[20] The war environment encouraged sensational subject matter and jingoistic ideology. Studios could never find enough film stock or qualified workers; theaters could never find enough completed films or projectionists. Both often resorted to worn-out films and inexperienced personnel to fill the gap. Much of the new activity in the industry came from speculators and scam artists with little interest in exploiting the situation to make a quick profit.[21] A wave of anti-German sentiment against Thiemann & Reinhardt culminated in the destruction of much of the studio's Moscow facilities during a 1915 pogrom. The company struggled to maintain operations when

(German) Paul Thiemann went into exile, and his wife, Elizaveta, took over the company. Protazanov may have been looking for an opportunity to make an exit for some time, and he finally parted ways when the studio began to decline. Initially, he and Gardin had planned to become independent producers and open their own enterprise, but they were unable to secure financing. After Thiemann & Reinhardt's problems, Joseph Ermolieff, an ambitious new cinema entrepreneur, lured Protazanov to his studio for a then-unprecedented salary of 12,000 rubles and combined his talents with the biggest Russian star, Ivan Mozzhukhin, whom he poached from the Khanzhonkov studio for an even bigger sum.[22] Ermolieff had begun to work in the film industry as a distributor of Pathé films in the Rostov-on-Don region. Despite the worldwide dominance and massive production capacities Pathé had achieved a decade prior, by the mid-1910s, the company had been steadily moving out of film production to focus exclusively on distribution, a more stable and powerful segment of the industry. World War I would end it and other French companies' supremacy in the world film market. After it became difficult to move films between Russia and France, Ermolieff took over what remained of Pathé's Russian distribution network and purchased its former production studios in Moscow. By 1915, it was the third most powerful studio, along with Khanzhonkov and Drankov.

Supported by their films' profits, Russian studios' production wings expanded and could begin to consider feature films made with much higher budgets and longer production schedules. Protazanov continued to work in many genres but now had the opportunity to make films that aimed to garner cultural prestige. His adaptations of Dostoevsky's *Demons* (*Nikolai Stavrogin*, 1915; lost) and Pushkin's *The Queen of Spades* (1916; examined in chapter 3) are the most famous, both based on similar versions of these stories for the stage and employing the most advanced technologies available at that time. They set the standard for respectable, artistic cinema. Little information about the inner workings of studios survives but suggests that Russian filmmaking became somewhat more rationalized in the last years of the war. Protazanov was a single head director charged with managing a unit every day, and in this respect, Ermolieff's system had a more "vertical" division of labor than those prior to the war years. Protazanov credits his regular "troupe" of actors as one reason they could manage to make films at this pace. At the industry's brief economic peak in 1915–1916—also peak years in the Russian economy generally that would not be surpassed until well into the 1930s—Ermolieff had four production units, each known by its director, working simultaneously to produce enough films to satisfy the market: one under Protazanov, who was something like the "A" director, and three smaller, low-budget units under Cheslav Sabinsky, Georgi Azagarov, and Alexander Volkov.[23] Protazanov portrays Ermolieff as a shrewd manager of money, who kept close tabs on day-to-day expenses. In a passing remark, he claims that

one of Ermolieff's rules was that a scene requiring more than fifty meters of film stock would receive a higher budget for its production. This policy led Protazanov and other filmmakers to prolong scenes to reach this duration so that they could have more resources for decorations and costumes.[24] This remark about a "fifty-meter threshold" is an intriguing suggestion that the tableau style associated with prerevolutionary cinema—with its long takes, slow acting, and opulent settings—had some basis in studio budgeting practices. Protazanov's comments suggest that producer Ermolieff had a laissez-faire attitude toward directors he trusted and did not impose much control over the aesthetic form of films. Surviving scripts indicate some control over production expenses but are far too sketchy to have been used to supervise content. Once the directors and actors met on set, they had to elaborate on many of the details of the scene in question and could alter it significantly. Star Ivan Mozzhukhin insisted on some role in the screenwriting process, and Protazanov credits him as a major creative source of much of the content of their films together, even for those in which he does not receive explicit screenwriting credit.[25]

Protazanov was the most prominent director in this growing field of Russian mass culture. The only directors that equaled him in stature were Evgeni Bauer at the Khanzhonkov studio, who died tragically in an accident on set in early 1917, and Vsevolod Meyerhold, the legendary avant-garde theater director who started working in cinema in 1915 but only completed two films.[26] But even at this high point of his career, there were obvious reasons to temper optimism. Though the audience for movies continued to grow, the Russian economy was collapsing. Firms were turning to stranger and stranger places to find usable film stock. The industry was attracting increasing attention from the tsarist regime, which was eager to use cinema's influence to prop up support for itself and its unpopular war. Had Protazanov ended his career with the revolution, he would still have had a major place in the history of the medium. But unlike Bauer and Meyerhold, he would go on to be a major European, and then Soviet, film director too.

THE FLIGHT TO EUROPE

The tsarist regime had long regarded cinema as a culturally noxious institution, so as the situation on the war front became more desperate, it is not surprising that, from their perspective, the talents of one of its leading directors would have more utility in military service than in directing popular entertainment. As a "second-class warrior" (*ratnik vtorogo razriada*)—that is, his family's sole male heir—Protazanov was initially not obligated to serve. But in September 1916, not long after he had learned his father had died of a cerebral hemorrhage, Protazanov was drafted. However, he would not see much if any combat: he soon fell ill

and was sent back to his family in Moscow. Then allegedly through the influence of one of his regular collaborators, the actress Olga Gzovskaya, he was able to perform his service as a director. While Protazanov's stint in the Russian army was not long, it did mean that, technically, he witnessed the February Revolution in 1917 as a soldier, like so many others.[27] All in the film industry rejoiced at the news of the tsar's abdication, and many had no particular antipathy to the Bolshevik regime that seized power in October. With its establishment of censorship and nominal "worker's control" of cinema in March 1918, however, the major studios' leaders began to fear the impending nationalization of their companies. Ermolieff packed up all the studio's valuable filmmaking equipment and shifted operations to its facilities in Yalta on the southern Crimean coast. Protazanov and company continued to shoot material as they traveled, even though prospects for the sale of new films continued to decline. Later that year, the studio welcomed the formation of the Volunteer Army (Dobrovoltsy)—the "Whites"—in Yekaterinodar (now Krasnodar). Daily affairs remained stable in Crimea in 1918–1919 while the Whites held firm control. The Volunteer Army also formed a short-lived propaganda wing, the OsvAg (Osvedomitel'noe Agentsvo; Informational Agency), which provided some much-needed opportunities for the refugee film studios. The head of the office, Vladimir Amfiteatrov-Kadashev, envisioned a politically engaged popular cinema not so unlike that of the Soviet Union years later. They subsidized Ermolieff to make feature films with anti-Bolshevik themes. These films are hard to document today because they were destroyed by the Red Army, but it is clear that Protazanov directed some. Based on some newspaper reports, Protazanov's big-budget agitational feature *The Golgotha of Women* (*Golgofa zhenshchiny*, 1919) attracted local attention for its impressive scale of production. But after an initial burst of energy, the plan died out because few cinema theaters were operating.[28]

Joseph Ermolieff's business trip to France in April 1919 to explore opportunities farther west suggested little hope in the Whites' prospects and the firm's future business in war-torn Russia. By the time he returned next January with a deal to move the studio, the Whites' decisive defeats in South Russia and disunity in the ranks of their leaders had forced them to retreat to their last Crimean stronghold. When General Pyotr Wrangel ordered the evacuation of military staff and civilians in 1920, most of the Ermolieff studio followed the mass exodus to Constantinople. Protazanov, his wife, Frida, and their son, Georgi, joined the company like many family members of the studio staff. The group stopped briefly in Constantinople and continued to Marseilles, then Paris, where they and other Russian exiles became the most visible diaspora of interwar Europe. The circumstances that brought somewhere between one and two million Russians abroad—more than one hundred thousand in Paris alone—had been similar, but the émigré community represented nearly every political sympathy, from

former members of the tsar's cabinet to liberally inclined "fellow travelers."[29] In émigré memoirs, one senses how the Russians thought of the migration as a temporary sojourn, even a bad dream. Few entertained the possibility that the Bolshevik government would hold power for long, and some continued to disavow it even late in the 1920s.[30]

Joseph Ermolieff restructured his studio as a joint-stock company, Ermolieff-Cinéma, in 1920. Its lack of contact with other nations during World War I had one immediate advantage: the possibility of distributing its back catalog in new markets. Much of Protazanov's past work from 1915 to 1918—including *Father Sergius, The Queen of Spades, Satan Triumphant* (*Satana likuiushchii*), *No Bloodshed!* (*Ne nado krovi!*), and *The Beggar Woman* (*Nishchaia*)—appeared on European screens in the early 1920s.[31] Yet the greatest beneficiary of these films proved to be Ivan Mozzhukhin, who continued to appear in star vehicles directed by Protazanov, such as *A Narrow Escape* (*L'angoissante aventure*, 1920) and *Justice d'abord!* (1921). The long-term contract Mozzhukhin received from Ermolieff not only committed his talents and name to the studio for its stability but created an incentive to raise his public visibility.[32] By 1925, he was the biggest French movie star and took advantage of his new fame to take a directing role, first in *L'enfant du Carnaval* (1921) and then in *Le Brasier Ardent* (1924), which would become a seminal influence on the French cinematic avant-garde. Upon arriving in Paris, Joseph Ermolieff made a deal with Pathé to rent its unused studio in Montreuil-sous-Bois, and by early May 1920, they were rolling film there. They also got down to completing some of the work begun in Yalta. Though the company proved to have longevity in France, its number of productions was only a fraction of its output before the revolution. The contingencies of travel rendered the working processes at Ermolieff more casual and artisanal than their increasingly factorylike techniques before 1917. Productions probably changed hands throughout the move. French journalists, who covered Ermolieff through the lens of White emigration generally, often described a certain *espirit du corps* that led Russians to regularly collaborate with one another.[33] The unstable French film industry, however, necessitated more transitory employment practices. Ermolieff tended to give short-term contracts for about five weeks with a weekly salary, a year with a monthly salary, or the duration of one film.[34] Protazanov now worked on a film-by-film basis.[35] The Russian staff at the company held ties from their shared fortunes more so than a formal working arrangement through contracts.

In material terms, the uncertainty of the Protazanovs' future had its first and most lasting effect on the question of finding a place to live. The director had no doubt accumulated wealth over his years as a leading figure in the Russian culture industry, but it was unclear what he would earn in the future. The first surviving letters are addressed to 3 rue de Fleurus, in the fashionable

Saint-Germain-des-Prés neighborhood of the sixth arrondissement. The weekly salons hosted by Gertrude Stein just a short walk up the street have come to serve as a defining image of expatriate Paris of the 1920s. Yet the Protazanovs began looking for a new place almost immediately because it was too expensive.[36] After searching all around Paris and even some close suburbs, such as Ivry-sur-Seine, the family eventually found something more affordable in the same neighborhood. Yakov, Frida, and Georgi were hardly in a state of penury, with Frida noting some of her trips to department stores, such as Aux Trois Quartiers, Printemps, and Felix Poutin.[37] Yet the complaints about prices, requests for money, and concerns about not being able to pay the maid suggest a tenuous hold on this kind of lifestyle.

The future was never certain in the French film industry. By the time the Russians arrived after the end of World War I, it had settled into a seemingly permanent state of fragmentation and crisis. Massive firms Pathé and Gaumont, who had pioneered mass film production in 1900–1915, had moved out of production entirely to focus on distribution, leaving the production sector consisting of dozens of short-lived companies. The Protazanovs' surviving correspondence paints a picture of constant interaction with a network of compatriots to find the next film project. While Frida had connections to the Russian filmmaking world her entire life through her brother, Karl—it was, after all, how she and Yakov met in the first place—in Russia, her role in the family had been limited to the domestic sphere. In Paris, though, she increasingly played more of a management, even talent-agent-like role as she socialized with the other émigrés that they knew and regularly advised her husband on career choices. She relayed what she had learned from meeting with figures such as Alexander Volkov, Alexander Loshakov, and Fyodor Burgasov. "It seems that the atmosphere at Ermolieff is very difficult," she relayed to him in passing in late 1921, suggesting that the financial uncertainty at the firm was beginning to take its toll on the staff there.[38]

Indeed, the firm faced regular bouts of financial trouble and was staying afloat largely thanks to star Mozzhukhin. It eventually needed to seek additional investors and found them in Alexandre Kamenka and Noë Bloch, two wealthy expatriates who had been in France since long before 1917. For unknown business or personal reasons, Ermolieff himself would cede the company to them and join a wave of Russian migrants moving to Berlin. Upon his departure, Kamenka and Bloch would rename the company Les Films Albatros, which became one of the most durable and consistently successful French production companies until the Nazi invasion and occupation. By the mid-1920s, however, much of the company's Russian presence had dissipated. With the exception of a few prominent players, such as Mozzhukhin, the firm was distinguishable from other French firms more due to its longevity and innovation rather than its ethnic identity.[39] But Protazanov did not participate in Albatros's successes. His stint with

Ermolieff-Cinéma would last all of eight months before he decided to part ways. In October 1920, the Parisian émigré newspaper the *Latest News* reported that Protazanov had left to become the main director in a new company producing "exclusively films of a literary character" founded by Paul Thiemann, formerly one half of the Thiemann & Reinhardt company that had employed the director prior to World War I.[40] Thiemann spent some time in Italy following the revolution but now was looking to get into the French market. Protazanov's relatively quick departure from Ermolieff-Cinéma has led some scholars to speculate that he was losing influence in the company in favor of younger directors, such as Alexander Volkov or Viktor Turzhansky.[41] Or perhaps Protazanov felt a professional duty to Thiemann, given their past history and Protazanov's abandonment of the company when it ran into trouble at the outset of the Great War. Thiemann's company, however, proved short-lived, and Protazanov was forced to move on within a year.

By late 1921, Protazanov was considering trying his luck in Berlin, and the next summer, he left to test his odds and prepare the path for Frida and Georgi eventually joining him. It was a common trajectory. With the rapid devaluation of the reichsmark, Russian émigrés, regularly relying on a stockpile of wealth but unstable or even no income, regularly exploited the purchasing power of their franks, and eventually, many moved to Berlin for the lower cost of living. The Protazanovs had been taking advantage of the German currency situation at least as early as 1921 if not before.[42] The White Russian population's center of gravity shifted from France to Germany over those few years. A 1923 article in the Parisian émigré newspaper the *Word* reported that in Berlin, there were sixty Russian bookstores, twenty-five restaurants, twenty banks, seven cinema firms, four theaters, four newspapers, sixty importing companies, and twelve cultural organizations.[43] These numbers speak to the more than 100,000 Russians living there by late 1922. Rapid inflation also created a number of speculative bubbles, including one in nightlife entertainment that created opportunities for any performer with a "Russian" act.[44] Inflation also worked to the film industry's advantage, as it encouraged rapid investment in capital goods. German studios went from relatively underdeveloped in the early 1910s to having the biggest spaces and most cutting-edge equipment by the early 1920s. The word that filmmakers had it much better in Berlin than in Paris was circulating among the émigré community. "Gobe says a good cameraman can get 2000 marks a day in Germany," Frida wrote to Yakov on November 1, 1921. "He says you would sell like hotcakes. . . . Perhaps there are fewer good directors there."[45] Protazanov scoped out this claim and, two weeks later, relayed that a good director could get 30,000 marks for one film.[46] He managed to get a meeting with UFA's Erich Pommer, by now the most powerful producer on the continent, and signed a one-film contract to direct

what would become *Pilgrimage of Love*, released at the beginning of 1923. Unlike Protazanov's earlier projects with ties to other émigrés, Pommer installed him into a more carefully managed studio-system-like formation with its own experienced German employees. *Pilgrimage* seems to have been generally successful despite little heralding in the trade press or in later film history.[47] Following a decent enough run for the film, Protazanov met again with Pommer in the hopes of parlaying his work into a permanent contract. But he remained on a film-by-film basis. No doubt there were multiple factors that prompted Protazanov to repatriate, but the most salient was an attractive opportunity in Soviet Russia far exceeding what was available in Berlin.

THE BIG DECISION

Protazanov's return to the Soviet Union in 1923 is the defining event of his biography. When initially leaving Russia as it descended into chaos, he was simply following the Ermolieff studio so as to maintain relative stability; in contrast, repatriating was a deliberate, uncommon, and personal decision. With the adoption of the New Economic Policy and the Treaty of Rapallo, which established business relations between the Soviet Union and Weimar Germany, the atmosphere in Russia relaxed considerably. Now faced with the task of rebuilding and modernizing the country, the Communist Party desperately needed more engineers, managers, and other kinds of white-collar professionals to supplement the "technical specialists" it continued employing from the tsarist regime. Protazanov's ongoing search for job security brought him into contact with Soviet agents in Berlin. As early as 1922, he met a certain "Bolshevik from Ukraine" under orders to recruit him.[48] But the decisive meeting was a whole year later, with Moisei Aleinikov, now the nominal manager of the Rus' Artistic Collective. While visiting Berlin to promote Rus''s *Polikushka* and solicit foreign investment for the film industry, Aleinikov was also under orders from Commissariat of Enlightenment head Anatoly Lunacharsky to attempt to recruit the accomplished director. Protazanov likely remembered him from Ermolieff before its departure, when Aleinikov was the editor of the company's journal *Proektor* and could often be found in the studio while Protazanov was shooting his big-budget literary adaptations. Now Aleinikov was the most experienced businessman at Rus', soon to be Mezhrabpom-Rus' (surviving documents often call him an "engineer"). Aleinikov, later Protazanov's first biographer, provides the most direct eyewitness testimony about his decision to return to Soviet Russia. He attended the Berlin premiere of *Polikushka*, where the two met and agreed to a dinner date. As he tells it, Protazanov was motivated more than anything by nostalgia for the motherland:

I found the table I had reserved by telephone. The waiter had laid it out precisely for Russian *zakuski*: Russian vodka, Russian unpressed caviar on ice, salmon with lemon, Kerch herring with onions, and hot potatoes "in a uniform."

Soon Protazanov appeared. He approached the table, looked at it, smiled, and said:

—Well, it's all clear!

I poured from the bottle.

—To a meeting in Moscow!?

Choked up, Protazanov managed to say:

—I have a contract with UFA with an advance for 1,000 dollars.

He spoke his words with a hint not of humor, but of depression.

But just a few months later, Protazanov had gotten out of the obligation and returned to Moscow with his family.[49] Mezhrabpom offered the permanent contract that Protazanov had been seeking for several years.

Aleinikov probably takes some liberties in describing Protazanov's emotional state to fit the nationalistic emphasis of his study. For one, surely it was not so difficult to find decent *zakuski* in Berlin, given its Russian presence.[50] There are some hints that, despite Protazanov being something of a Europhile, returning to Moscow was a matter of personal desire. In a letter to Frida on April 7, 1923, he wrote, "[Aleinikov's] proposition appeals to me, owing to the conditions of work, co-workers and resources, working location, and my own liking [*mne po dushe*]. We've discussed all of this, and it is too much to write in this letter."[51] Protazanov seems to be expressing here that he had some deeper desire to return but only does so in juxtaposition with the more tangible advantages it might have and perhaps an intentional tinge of irony in the way he so forcefully pairs sentiment with crass materialism. There is a tantalizing, brief mention of his and Frida's past conversations. Were they desiring to return and simply looking for the right opportunity? Or were they more hesitant? What disadvantages did each see in staying in Germany? Were the two not in full agreement? Whatever the case, there is little trace of nostalgia in the subsequent letters they fired off as they came to their decision. Protazanov seems to have deferred to Frida's ultimate judgment: "I beg you, think this over and contact me *immediately*. It's your choice—Moscow or Berlin. Keep in mind that in Berlin we won't perish, either."[52] Both got in touch with Russian acquaintances to assess the living conditions in Moscow; there were now many who could compare it with Berlin. Protazanov's brother-in-law, Mikhail Petrovich Aristov, put him in touch with a "merchant of the old type" he knew who claimed that life was actually better in many respects in Moscow than in Berlin. "Life in Moscow is not at all the way that it is portrayed in *The Wheel* [*Rul'*]," Protazanov reported to Frida on May 25, referring to a major publication for liberal émigrés typically critical of anything Soviet.[53]

There was one major exception: a severe housing shortage that would no doubt be unwelcome news for a couple who had spent considerable time and energy moving over the past few years. Yakov made a special point of negotiating for a good apartment. Aleinikov offered him one in a brand-new building being constructed at 20 Novaia Basilovka, near Petrovsky Park and the Mezhrabpom-Rus' studio itself, where Aleinikov himself took up residence just a floor below and which Protazanov jokingly referred to as "Villa Frida" for many years to come.[54] That space was the property of the company and appears as a special budget item in the studio's yearly reports.[55]

Did Protazanov desire to return, in part, because his political attitudes changed during his years abroad? It cannot be ruled out, but the historical record suggests more than a hint of opportunism in his decision. Protazanov's only other explanation came near the end of his life, during a lecture to students at VGIK. In a brief question-and-answer session, when one student asked him directly, Protazanov responded cryptically that in Germany, "business dealings acquired an unpleasant odor, and the politics became unacceptable for me."[56] We can only speculate about what he might have been referring to. Whatever the case, Protazanov was clearly aware of the political rationale for strengthening the Soviet film industry and intended to fall in line. His understanding is best evidenced in his tangential connection with a notable Berlin group called *Smena vekh* (changing directions), whose members were generally left-leaning members of parties that had opposed the Bolsheviks and supported some form of constitutional democracy, such as the Constitutional Democrats (Kadets) and the Union of 17 October (Octobrists). Though unable to fully embrace Marxism, they had grown more conciliatory by 1923 and now were willing to credit the October Revolution as a progressive development that the Russian intelligentsia should support. The Bolsheviks made ties with these *smenavekhovtsy* to encourage repatriation in their chief journal *Nakanune* (*On the Eve*).[57] Despite some success in recruiting professionals and technicians, however, *Smena vekh* attracted few converts among prominent artists and intellectuals. The most notable was writer Alexei Nikolayevich Tolstoy, who moved from Paris to Berlin at roughly the same time as Protazanov. He attracted criticism for an open letter in *Nakanune* that called on readers "to do everything to help the latest phase of the Russian Revolution take a direction that will enrich Russian life."[58] Tolstoy met with Maxim Gorky shortly afterward and moved to the Soviet Union, eventually severing ties with *Smena vekh* in favor of a more mainstream political affiliation.[59]

Though it is plausible that Protazanov was in contact with Tolstoy in Berlin, there is no evidence concerning their relationship. But Tolstoy must have been on Protazanov's mind as he returned to Moscow and decided on his next project. He initially considered some more established texts, including *Tsar Fyodor*

Ioannovich, an 1868 historical drama written by Alexei *Konstantinovich* Tolstoy. However, Protazanov decided on *Aelita*, a recently published science-fiction adventure novel written by none other than Alexei (Nikolayevich) Tolstoy. Tolstoy's controversial letter appeared just before *Aelita* was published in three installments in the Soviet journal *Red Virgin Soil* (*Krasnaia nov'*). In November 1922, he read excerpts at a celebration of the fifth anniversary of the revolution, attended by prominent Soviet writers, including Vladimir Mayakovsky. Protazanov knew that this choice would be understood as a declaration of his loyalties. But as will be discussed in chapter 3, after more than a year in production and an unprecedented sum of money spent on a Soviet film, the effects of *Aelita* on Protazanov's career were far more complicated than that.

PROMINENCE AT MEZHRABPOM

Protazanov's experience in commercial filmmaking was well suited to the emphases of the New Economic Policy (NEP), which Lenin and others believed to be a strategic retreat from the ultimate goal of bringing socialism to Russia. After the civil war, misguided policies under War Communism, and a devastating famine, the Soviet economy was in shambles in the early 1920s. In response, the Bolshevik government incorporated more principles of private enterprise and the free market to get it back on its feet. Privately owned companies could accumulate profits much as they had before the revolution, while entrepreneurs derisively known as "NEPmen" enriched themselves and garnered more influence in society. While it did help rebuild the economy, it also provoked constant anxiety among committed communists that their ambitious project was backsliding. They fretted that "bourgeois" ideology was "infecting" the population and even leadership. When compared with later years under Stalin's dictatorship, the NEP offered a more pluralistic and outward-looking phase of cultural life in the Soviet Union. However, one should not overestimate this comparative cultural freedom. Though the Bolsheviks were still nominally invested in the internationalist foundation of communism, the chances of a worldwide revolution they had assumed was imminent in 1917 had almost completely subsided by 1921. By 1924, if not earlier, it was abundantly clear that the Communist Party would be taking the leading role in defining Soviet culture through the institutions it controlled. Katerina Clark has written of a "quiet revolution" in intellectual life, whereby competing intellectual and artistic movements gradually sharpened their distinctions and came into conflict. The heated debate on finer points of ideology in the pages of cinema-related journals reflected a real struggle for resources and positions of influence. The Party ultimately arbitrated these conflicts and, by the end of the decade, empowered a younger, less highbrow, more parochial generation. As Clark and others have pointed out, too,

Soviet censorship was most lenient during the preceding period of War Communism (1918–1921) and became more restrictive with each passing year in the 1920s.[60] The New Economic Policy also involved a transition from past tsarist culture to the brutal years of the First Five-Year Plan and Cultural Revolution.

Protazanov became the backbone of the new Soviet studio Mezhrabpom-Rus'—its most prolific and experienced filmmaker.[61] This enterprise was a unique product of the era's internationalism and relative economic liberalism. The 1921 Russian famine prompted the founding of the aid organization International Arbeiter-Hilfe (IAH, called Workers' International Relief, IWR, in English; shortened in Russian from Mezhdunarodnaia rabochaia pomoshch' to Mezhrabpom). The Communist International sent Willi Münzenberg, the former leader of the Youth Communist International recently released from prison, to Berlin with the goal of uniting all related left-wing aid organizations that had formed to alleviate mass starvation and reduce dependence on charity from capitalist states. In this stated goal, the IAH clearly failed due to its belated timing and contentious left-wing politics.[62] It therefore shifted its emphasis to promoting global solidarity in broadly conceived terms, including producing commercial goods, running orphanages, and providing strike relief. Most importantly, it became a leading propaganda organization: it published newspapers, held rallies, circulated bulletins, hung posters, exhibited radical art, staged workers' theater productions, and produced and screened films. The IAH's interest in feature films grew out of its programs of issue-based documentaries at its network of workers' clubs, which rivaled the largest European theater chains. The IAH's commercial presence complemented the need of the Soviet film industry to raise foreign capital to rebuild.

To make propaganda and commercial films, the IAH looked into a partnership with a Russian film company, with which it would be easier to produce the films abroad without interference from the German government. With the beginning of the NEP, privately managed film distributors in the USSR such as Sevzapkino and Proletkino began to grow. After surveying several firms, Münzenberg made a controversial decision to partner with Rus', the surviving studio with the strongest ties to the prerevolutionary industry, citing its "experience, connections, technical personnel, and unique import rights."[63] Founded in 1916 by the Moscow Old Believer merchant Mikhail Trofimov, Rus' had been such an undercapitalized, minor player in the tsarist-era industry that it lacked the resources to join other firms in Crimea in 1918 and became the only one to continue any kind of operations in Moscow. During the civil war, the remaining artists and professionals who had not emigrated gravitated toward it. After bringing together the IAH and Rus' to form Mezhrabpom-Rus', Münzenberg was active in its activities from time to time, primarily to solicit assistance among other high-ranking Party members. Noted Italian communist Francesco Misiano, who

spoke no Russian and had no experience in the film business, was in charge of all of the day-to-day IAH operations for its numerous enterprises. He delegated the oversight of cinema-related activities to other staff, including Boris Malkin, Yuri Friedmann, and Friedrich (Fritz) Platten, in a constantly shifting institutional structure.

This chain of authority eventually reached Moisei Aleinikov, the production chief at Rus' who continued to be responsible for studio activities for the rest of the decade. His management style and approach to the creative process set the tone for the fledgling studio. Scholars have portrayed Aleinikov as the closest thing in the Soviet Union to a studio chief cast in the mold of the Hollywood head of production, with Natalie Ryabchikova going so far as to call him the first Soviet "producer."[64] Given Aleinikov's relatively modest standing at the Ermolieff company prior to its emigration, his relationship with Protazanov was probably more one of admiration than friendship when they had their fateful meeting in Berlin. But the two grew close over the ensuing years. They lived in apartments in the same building and regularly played chess or ping-pong when both were in Moscow and not consumed with work.[65] In addition to his talent and experience, Protazanov's outsized standing at Mezhrabpom-Rus' no doubt was owed in part to Aleinikov's personal favor. But Aleinikov's business background and Jewish ethnicity attracted suspicion. Protazanov's career at Mezhrabpom-Rus' must be understood in the context of the specific politics of the Soviet film industry, where this company was exceptional in a number of respects. It was the only privately owned firm that had survived the civil war and could now operate as such under the terms of the NEP. The company's partnership with the IAH meant that, rather than Soviet bodies, it operated under the aegis of the Communist International, which gave it additional advantages, including the ability to deal in hard currency abroad and import studio equipment and film stock, both hard to come by in Soviet Russia. Its impressive distribution network across Europe, sister distribution companies such as Prometheus formed in a partnership with the German Communist Party (KPD), and ability to make occasional deals with sympathetic commercial distributors gave it an edge in attracting potentially lucrative foreign audiences for most of the 1920s. No one in the Soviet film industry, even Mezhrabpom's harshest critics, denied that it was Russia's most effectively administered film company. Yet this was in part a result of structural advantages other firms did not enjoy and created resentment.

Protazanov's years as Mezhrabpom-Rus' (later Mezhrabpomfilm) are where we have the most detailed picture of his professional identity because all of these films have survived. But this picture is also deceptive. Protazanov's reputation was actually at its highest point in prerevolutionary Russia, which was also when he finished the most films. In contrast, in the 1920s, he enjoyed preeminent

standing, but his work, while consistently popular with audiences, was quickly overshadowed by films from his younger, avant-garde peers, such as Sergei Eisenstein or Vsevolod Pudovkin, which garnered unprecedented attention for their boldness and originality, even if these features did not always translate into success with audiences, especially the peasants and proletarians underlying the political rationale for developing the film industry. The ambition to construct a new mode of dynamic, politically didactic cinema drove much of the discussion among film artists, whether it be staking a position on the relationship between ideology and aesthetics or considering the finer points of film style. But if less prominent in headlines, Protazanov completed an impressive corpus of films and was handsomely compensated for it. After the success of *The Forty-First* in 1927, the studio leadership voted to give him a guaranteed bonus for every feature film he completed. Many other studio staff received a similar prize, but Protazanov had the largest.[66] Even as late as 1930, after the impressive achievements of the younger generation of Soviet directors, Protazanov was still classified in Mezhrabpom's "first group" of directors, analogous to "A picture" director at a Hollywood studio. Only Pudovkin had risen to join him there.[67]

What his younger peers had in vaulting ambition, creative energy, and revolutionary zeal, Protazanov compensated for in the experience he had amassed in unforgiving commercial industries for over a decade. Those who witnessed him at work emphasized his efficiency and competence. Perhaps the best testimony is from Vladimir Nemoliaev, who directed in the 1930s–1950s and—while training at GTK, then the state film school—was asked to assist Protazanov. He describes a precise mixture of interpersonal kindness and professional brutality that defined the day-to-day atmosphere on set:

> For a serious blunder, he did not scold the employees, he only approached a person and said, patting on his shoulder, "Why you, my dear?" And "my dear" understood well that he was no longer the crew worker from that moment.
>
> I had always been fascinated with that trait in Yakov Alexandrovich's character: how could he, such a nice person, have such an attitude to people. After all, everyone can make mistakes. . . . In Kislovodsk, when we had already become friends, I asked him about that at one point. "In our profession, little Volodya, one cannot make a mistake. It costs too much."[68]

The remark is a telling one, suggesting he had internalized many of the economic pressures from his earlier experience. Mezhrabpom-Rus' suffered from the same systematic problems in the Soviet film industry and economy. Studios struggled to acquire equipment and find personnel with basic technical and management skills. Regular internal review committees noted that, while it was in the best shape of any Soviet cinema firm, daily work was a far cry from

"rational production." The studio was badly overemployed with workers at all skill levels idle much of the time. A 1929 review committee recommended cutting 35–40 percent of the studio's staff across the board. Films consistently went over their allotted budgets, and IAH leadership demanded that the studio find a way to reduce costs. Protazanov enjoyed a privileged standing among the staff in large part because, in contrast to most of Mezhrabpom's other directors, he consistently completed films on time and within their allotted budget.[69] A 1925 report chastised directors for wasting electricity by leaving the lights on when not filming. But it made sure to except "Comrade Protazanov" from this group. This was no routine comment: the same report never singled out another director for their work, either in a positive or negative sense.[70]

Memoirs from those who worked with Protazanov regularly describe a favorable atmosphere for creation that he cultivated with them and seems to have led many actors and cinematographers to seek out opportunities in his films. The collection edited by Aleinikov regularly paints the picture of a director who made his collaborators feel like they were following their own creative impulses while, nevertheless, subtly shaping all of the different activities into a harmonious whole. Without fail, though, anyone describing Protazanov at work mentions one particular personality quirk. He was known for carrying a conductor's baton or a short stick similar to one; memoirists usually call it a *palochka* (the same word used for a magic wand, chopsticks, and other smallish rod-shaped instruments), sometimes a *trostochka* (small cane or walking stick). Oleg Leonidov recalled, "It helped him think and find the necessary rhythm. In my twenty years of knowing him, I never once saw Yakov Alexandrovich without his baton—whether working on a script or on set. In moments of creative inspiration he would raise it high above his head, then use it to pierce a cigarette box, and then wave it with the special confidence and precision of a fencer with a rapier."[71] In these memoirs, the *palochka* plays the role of a phallic token of creative potency or, like the dozens of handkerchiefs John Ford chewed through while directing, a nervous tic at moments of intense thought.[72] Later scholars have used this idea of directing like a musical conductor to illustrate the careful control directors could exert over actors' movements—when to move one's eyes, pause, take a step forward, strike a pose of grief or fury—in the pictorialist approach to performance in the silent era.[73] Collaborators regularly claim that he used the little sticks as part of his own interpersonal performance. He was known for breaking *palochki* in half in a dramatic gesture over the course of shooting when cast or crew displeased him. Some say he did this in anger, but Nemoliaev emphasizes that "he just broke his stick with a cracking sound, and the experienced director assistant slipped him another one right away."[74] The *palochka* seems to have been one way in which Protazanov reconciled the seemingly contradictory facets of his

personality—his apparent openness in the creative process with his managerial efficiency.

But by the late 1920s, Protazanov's impressive output was beginning to take its toll. In a letter to Frida, dated November 23, 1927, he mentions arriving at a sanatorium in Kislovodsk—the first evidence of his declining health.[75] For the rest of his career, he spent a considerable amount of every year at various rest resorts in the Caucasus. The administrators of Mezhrabpom were well aware of Protazanov's health issues and demanded some of these visits. Meeting notes in late 1928 mentioned that he had been sent on a mandatory rest vacation to Gagra, a resort in Abkhazia, due to "extreme exhaustion" connected to the "strain of work on *The White Eagle*."[76] Gagra was popular with many elite Communist Party members, including Stalin himself, so it is tempting to see this concern with his health as largely a cover for enjoying the vacation privileges of the emerging Soviet *nomenklatura* classes. Yet not all of the resorts Protazanov visited were so luxurious. In Kislovodsk, for example, he was denied a private room he requested, received fairly modest accommodations, and generally described the experience as "alienating and uncomfortable."[77] And if the purpose of these visits was to provide rest, it did not deter him from working on scripts, which he did at every opportunity. Even during the interim of "strain" in Gagra in late 1928–1929, for example, he worked on the script for *St. Jorgen's Day* (1930).

Whether due to a traditional mindset, a protective instinct, or a more self-interested desire for refuge, Protazanov generally attempted to keep his family at some distance from his career, which, given his stature in the industry, was not a simple matter. After being quite involved in the informal social world of émigré filmmakers in Europe, Frida seems to have increasingly taken on a more traditional role as a wife and mother. After the return to the Soviet Union, there are far fewer surviving letters between the two discussing art and literature and a few complaints of boredom on Frida's part.[78] An even more complex dynamic was at play with Georgi, who grew up watching his father's outstanding career and occasional exposure to the exciting world of famous artists of the Soviet screen and stage. It was inevitable that Georgi would think about entering the film world himself. Over the years, he regularly shared his opinions on the latest Soviet releases and offered his own thoughts on what projects his father ought to consider.[79] But after casting Georgi as a young boy in *Pilgrimage of Love*, his sole film appearance, it appears the director instead wanted to discourage him from pursuing a career in the area. It is hard to judge, based on their surviving correspondence, if his way of doing so was tactful or cruel. Georgi pursued a career as an engineer while still looking for opportunities in the film world, holding out hope his father's influence might help him land one—he pointed out on several occasions how many other directors had done the same with their own children.[80] Protazanov never denied him that hope but tended to slow-walk any

40 THE CINEMA OF YAKOV PROTAZANOV

requests Georgi made or avoid making any definite promises, ultimately with the
expectation that the engineering track would exert enough gravitational force to
pull him away.

ADAPTING TO THE STALINIST SCREEN

We have no additional information about why Protazanov would have discour-
aged his son from pursuing the same career to which he so passionately devoted
himself. But Georgi's ambitions coalesced about the time he came of age in the
late 1920s and was considering the next step in his education. Surely his father's
opinion was strongly affected by the changes he was observing in the Soviet
film industry. Having solidified political control of the Party gradually over the
decade, Stalin dubbed a sudden change in economic direction in the country in
1928–1929 the "great turning point" or "great break" (*velikii perelom*). The rela-
tively laissez-faire New Economic Policy was replaced with an aggressive push
for centralizing economic management and rapidly building the industrial
base for "socialism in one country." The All-Union Conference on Cinema
in March 1928 announced the basic intentions the party-state had for its
film industry over the ensuing decade. Resolutions called on the industry to
reduce its reliance on foreign imports, build a domestic infrastructure to replace
them, and create a central administrative body to strengthen oversight over
film content. In 1930, Soiuzkino was formed, headed by Boris Shumyatsky, a
longtime Party functionary. Though having no previous experience in the film
industry, he laid out a vision for a Soviet equivalent of Hollywood that would
manufacture mass entertainment on a similar scale. Over the next decade, he
would become more and more involved with the daily affairs at the film studios
through both official and unofficial channels.[81] For the entire NEP era, the indus-
try had been subject to regular criticism that its output too closely resembled
the commercial products of capitalist nations and thus implicitly validated their
ideology. However, the 1928 conference also echoed regular criticism that avant-
garde works by Eisenstein, Pudovkin, Vertov, and others, despite their ideologi-
cal bona fides, did not appeal to the Soviet masses. By endorsing only films that
conveyed an appropriate political message in an entertaining, broadly accessible
form, the conference also marked a new era of scrutiny over the styles and genres
of the films to be produced.

Changes in the industry were also animated by the fierce impulses of a cul-
tural revolution, which aspired to remove the influence of "bourgeois" special-
ists like Protazanov and other class enemies in favor of those with genuinely
socialist values and proletarian backgrounds. The rapid construction of new
cinema infrastructure included an ambitious attempt to train a new genera-
tion of workers and artists with humble origins. But the anticipated new crop

of proletarian cinéastes never materialized, and by 1934, plans for replacing the previous generation of directors were abandoned. The industry shifted its focus to the *vospitanie*—inculcation of desired communist values—of established directors.[82] Those who toed the line and made successful films that conformed to political ideology could expect special rewards, including higher income and access to restricted living and recreational spaces. Meanwhile, the many graduates of the new Soviet film education programs rarely found work in the industry. Their opportunities would only decline as the number of productions shrunk each year, and they lost out to senior directors.[83]

Given Mezhrabpomfilm's unusual origin and position in the industry, the new vision entailed particularly extensive changes there. Foreign ties were at the core of its structure at a time when studios were under orders to eliminate them. While the studio survived for a time, it became subject to the same scrutiny and oversight as the other cinema firms, and by 1931, most of its foreign operations had come to an end.[84] At this time, purges of studio staff at all levels became a regular feature of activity at Mezhrabpom, with the first initiated in 1929 and followed by a two-year gauntlet of review commissions by multiple agencies, culminating in one by the Central Bureau of the Communist Party.[85] According to Jamie Miller, this initial wave of purges across the film industry was ambivalent and not especially effective at reshaping its overall activities. Stated reasons why staff were targeted varied from anti-Party inclinations to vaguer claims of lack of discipline or idleness. While some staff were dismissed and a few were imprisoned, most often they were moved to another position at another studio or section of the film-related bureaucracy. The desire to remove "non-Soviet" influences was always tempered by the valuable skills possessed by artists and administrators and the difficulty of finding qualified staff to replace them.[86]

The secret police, Party organizations, and commissions involved with the purges no doubt would have taken a long look at Protazanov, but despite his period living abroad and seeming political indifference, there is no evidence that they seriously considered dismissing him or worse. Yet they did target some of his collaborators, including Vladimir Shveitser, who cowrote *St. Jorgen's Day* (1930), *Marionettes* (1934), and *Without a Dowry* (1936). The initial purge commission at Mezhrabpom recommended his firing in 1929 due to alleged "anti-Soviet" sympathies and lack of work ethic, yet no one followed through. He remained the head of the script department of the studio and continued working with Protazanov and other major directors there for the rest of the decade. By far the most important target of the purges with regard to both Protazanov and Mezhrabpom itself was studio chief and "producer" Moisei Aleinikov, who lost his right to vote on the official board and then was subsequently dismissed. But in a reflection of the unpredictability of the process, it only took one year for him to find a new position as deputy leader of the sound cinema department at

Soiuzkino itself, and he would go on to be a studio consultant at Mosfilm.[87] The loss of the uniquely capable administrator was a huge blow to Mezhrabpom, and Protazanov felt the effects more than anyone. The two's personal connection was no doubt one major reason for his privileged status among the directors there; in his absence, Protazanov's standing at the studio sharply declined. Perhaps characteristic of his envisioned role at the studio was his assignment in 1931 of *Tommy*, a short, low-budget, "agit-prop" film in contrast to his more prestigious blockbusters of the 1920s. Yet *Tommy* was also one of the first Soviet films with synchronized sound; it was produced concurrently with *Road to Life*, which is typically credited as the first Soviet sound feature, and appeared on screens only three months later. It seems he was still among the more reliable choices to work with the expensive, cumbersome sound equipment.

After the Nazis seized power in 1933, the days of the Berlin-based IAH itself were clearly numbered. When the solidarity organization was ultimately dissolved in 1936, Mezhrabpomfilm was reorganized as Soiuzdetfilm, a studio oriented toward producing films for children and youngsters. As Protazanov continued on at the new studio, the instability and capriciousness of the film industry's central management reached a fever pitch. Stalin lost faith in central cinema administrator Shumyatsky around 1938.[88] He was subsequently purged from leadership, executed, and replaced with the hardliner Semyon Dukelsky, who had risen through the ranks of the Voronezh branch of the NKVD, the secret police. After less than two years of chaotic and ineffective management, Dukelsky was replaced by Ivan Bolshakov, who managed the industry with a lighter touch but mostly recreated similar dynamics as under Shumyatsky.[89] Shumyatsky was not the only leader who perished in the secret police's staggering campaign of mass violence known as the Great Purges, or Great Terror. Starting in 1936–1937, the purges became deadlier and animated by the suspicion that their targets were not simply insufficiently socialist in their values but actual spies or saboteurs participating in a Nazi fifth column. Some administrative staff from the industry had their careers—and sometimes their lives—ended. Like Shumyatsky, two main executives at Mezhrabpomfilm, Yakov Zaitsev and Boris Babitsky, were executed in 1938. Most of those in the industry targeted were administrators or other higher-ups, seemingly for personal reasons or past allegiances rather than their performance in the industry. Film artists, in contrast, received comparatively light treatment, with some important and notable exceptions, such as Mezhrabpomfilm director Konstantin Eggert (and actor in *Aelita*), who was imprisoned in a state labor camp until the 1950s. Films in production were altered, completed ones were shelved, denouncements made, and filmmakers publicly ridiculed, but most continued their careers.[90]

Protazanov's resilience during the Great Terror proves no easier to explain than any other victim or survivor. Certainly, his lengthy stint abroad during the

civil war would have raised suspicion. Foreign connections seem to have been one of the most common features of victims, as they could provide a pretext for charges of espionage. But Protazanov escaped a similar fate as Vladimir Nilsen, a talented and prominent cinematographer who had worked on films by both Eisenstein and Grigori Alexandrov and was arrested and executed in January 1938, possibly due to his marriage to an Italian actress. It may be that Protazanov's talent protected him, as it did before. Perhaps his resolute silence on political matters and lack of allegiance with any of the avant-garde factions in the 1920s paid off. Perhaps his likable personality mentioned by many of his contemporaries helped him avoid making enemies. Whatever the causes, though, his fate reflects the capriciousness and chaos of how the Great Terror affected every sphere of Soviet society at its time.

No less worrisome than the turnover in many cinema administrators and talent was the increasingly close attention to the content and form of films by the party-state—even Stalin personally. Protazanov, like every other filmmaker of the era, had repeated run-ins with the increasingly difficult censorship system. New agencies for the oversight of film content and approval for film projects proliferated and intensified scrutiny of film content. In 1934, his script for a proposed adaptation of Chekhov's *The Chameleon*—which he had also adapted just a few years before in *Ranks and People* (*Chiny i liudi*, 1929)—was not approved for production. Later, Shumyatsky personally intervened to force him to change the ending of *Without a Dowry* (1936).[91] His worst experience, however, was *On Love's Strangeness*, which began production in 1934 and will be discussed in more detail in chapter 5. This lighthearted comedy had worked its way through the production process without much difficulty and would have had Shumyatsky's personal approval. It was then screened for the Central Committee's Propaganda Department, a non-industry-based censorship board that viewed almost every film from 1936 to 1937, which refused to approve the film because it was "antiartistic, plotless, extraordinarily weak in its direction and performances, and vulgar in some episodes."[92] Rather than a specific ideologically problematic component, the censors claimed that the characters were insufficiently Russian or Soviet—a regular charge leveled at films that meant both everything and nothing. It seems the film's focus on the romantic foibles of young people simply lacked the requisite seriousness for a Soviet product.

By the late 1930s, Protazanov was working on not only fewer films but also ones in which he had less emotional investment. His health problems had not eased, despite many trips to the Caucasus, and ultimately led to a stroke while working on his innovative sound comedy *Marionettes* (1934)—and eventually his death. But much of the source of his malaise lay with the new management at the studio. While he continued his career, his projects were subject to far more oversight and less creative freedom than before, and the new leadership simply

did not hold him in as high regard. The production process had also slowed down; the average production time for a film at Mezhrabpom went from about three months in the late 1920s to nearly a year a decade later.[93] It was difficult for even the most industrious and lucky filmmaker to make one film every year. Protazanov responded to the situation by taking on more administrative tasks at the studio and simply accepting directing roles on projects in which he had relatively little interest for leverage to work on films he was developing himself. While his work is competent there, and some signatures remain, they lack the personal interest of his earlier films.

That is not to say there were no bright spots in his creative life. The most notable is *Without a Dowry* (1936), an adaptation of Alexander Ostrovsky's play and a deeply personal project for the director. After an interest in the early 1930s in satirical comedy, which never received the acclaim he had hoped for, in his last years, Protazanov looked to literary adaptations. But aside from *Without a Dowry*, none of these projects came to fruition. He planned an adaptation of *Anna Karenina* with the participation of Vladimir Nemirovich-Danchenko and several actors from the Moscow Art Theater. Shumyatsky, who seems to have taken a personal interest in the project, decided that Protazanov was not a good fit and took him off it. Protazanov then threw himself into an adaptation of Charles Dickens's *Oliver Twist*, a "dream project" according to biographer Mikhail Arlazorov. He completed the screenplay, received approval, and began shooting before the project was abruptly canceled. Dukelsky, newly appointed at Soiuzkino, had restructured the year's thematic plan, disrupting many productions. Protazanov was switched to *The Seventh-Graders*, a film he directed out of professional obligation and with little personal interest. Then in 1939, he was assigned *Salavat Yulayev*, a historical-biographical film about the Bashkir national hero from the era of the Pugachev Rebellion, based on a novel by Stepan Zlobin and Galina Spevak and modeled on the socialist realist classic *Chapaev*. Though it was "not his dream," Protazanov directed it competently. That dream now was an adaptation of Ostrovsky's comedy *Wolves and Sheep* (*Volki i ovtsy*). It too would never come to fruition.[94]

There was also a bright spot in his personal life, though not one that pleased his family or bolstered his reputation. At this time, Protazanov began a protracted and passionate love affair with the young actress Nina Alisova, with whom he first worked on *On Love's Strangeness*. In her private diaries written many years later, Alisova gives the impression of being completely smitten and intimidated by the attention of a well-established, much older director whom she admired. She describes meeting Protazanov for the first time when finishing work on the former film and celebrating on a boat in Yalta some time in November 1934, when Protazanov approached her and "said some seductive words," leading her to immediately retreat. She was nineteen years old—two years older than

Protazanov's son. She claims it was the first time she "felt love" but later qualifies this by saying it was like that for "a father's friend."[95] The relationship was deeply meaningful for both and continued for the rest of his life. She credits him as not only a lover but a "wise teacher" who was essential for the development of her career in both practical and artistic senses.[96] No doubt, Protazanov's decision to cast Alisova as Larisa in *Without a Dowry* (1936) was her major career break. Though she stayed quiet about the affair in the years after Protazanov's death, it seems that it was an open secret well known at the time and among future cinéaste and historians of Soviet cinema. We have little information about how it affected his friends and family and also no evidence of any prior or subsequent affairs. Yet it seems unlikely that it would have escaped the notice of Frida Protazanova. In an interview with Viacheslav Rebrov, Protazanov's great-niece, Alla Aglitskaya, mentioned "jealous scandals" that arose periodically between the two, in which he would say to her, "If you've had enough, tell me, I'll take my hat and cane and go."[97]

A TRAGIC ENDING

But if Protazanov's infatuation with Alisova had led him to take his immediate family for granted, after Nazi Germany's invasion of the Soviet Union in June 1941, these became precious once again. That August, Georgi, who had been working at the Apatity Mountains House of Tourism in Kirovsk, Murmansk, entered military training to serve.[98] After an initial phase of correspondence that month laying out the situation, the family lost track of him by the end of the year and spent the rest of the war attempting to get news about his fate. Yakov and Frida also separated. As the Nazi soldiers got uncomfortably close to Moscow in 1941, much of the film industry's personnel was evacuated east, setting up base in the smaller national studios of the Soviet republics outside of Russia. Protazanov was sent to Tashkent, Uzbekistan. The national studio there had been founded in 1925 as Star of the East (Shark Yulduzi) then in 1936 renamed Uzbekfilm under the ownership of the national cinema organization Uzbekgoskino. Production was on a much smaller scale than in Russia, but the studio had released a respectable two dozen or so feature films over the past two decades. The newly rechristened Tashkent Film Studio now hummed with activity following the influx of talent from Moscow, including directors like the Vasiliev brothers, Ilya Trauberg, and Mikhail Romm, whose presence marginalized the local Uzbek film artists.[99] Though documentary production was the priority, the industry put significant energy into producing feature films to raise morale both at the front and at home. Protazanov's last film, *Nasreddin in Bukhara* (1943), would apply the trickster-comedy model of some of his earlier films to local traditions—or at least, how they had come to be imagined. Though

46 THE CINEMA OF YAKOV PROTAZANOV

based on a novel by Leonid Solovyov and using Russians in face paint for many of the main roles, some have credited Protazanov for his greater interest in local culture and employment of more Uzbek workers in comparison to his peers. This may in part explain why he was awarded the title of Distinguished Artist of the Uzbek Soviet Socialist Republic for his work there.[100]

Just weeks before Victory Day, Yakov and Frida finally received confirmation of what they had feared: Georgi had perished at the front. It is hard not to draw a connection between this new sorrow, Protazanov's ongoing health problems, and the mere months he had left to live. In June 1945, he wrote to Frida, who was in a health resort, that he felt in good health when he finally returned to *Villa Frida* near Petrovsky Park, now seemingly empty of people but full of kitchen gardens and foliage.[101] But soon after, Protazanov entered Moscow's Botkinskaia hospital for treatment and died on August 8, 1945, at the age of sixty-four, spending his last days continuing work on the script for a film adaptation of Ostrovsky's *Wolves and Sheep*. Protazanov received the honor of burial at Moscow's Novodevichy Cemetery among many other Russian and Soviet elites. In the ensuing years, he would be joined by many war heroes, often honored with full-scale statues of them brandishing a sword and shield or accompanied by an airplane propeller. So too would many screen artists, their headstones sometimes draped with stony perforated film strips. In contrast, the formative director is memorialized in an austere set of flat rectangular stones stating simply, "YAKOV PROTAZANOV: FILM DIRECTOR." Not even the dates of his life are given. He has earned a place among the most influential Russians but seems to have little that defines him as an artist or person.

But the following chapters argue that this seeming silence or lack of definition is no coincidence. Protazanov made an enormous contribution to Russian cinema but was never in step with its Soviet successor, even as he succeeded as well as any filmmaker there. He willingly served the political demands made of artists but out of necessity rather than conviction. Trauma was a universal part of the revolutionary experience; for him, it was dislocation in both a literal and metaphorical sense. While given an enviable existence in Moscow, Protazanov could never hope to join the true revolutionary class and never made a serious effort to. He went from the consummate *kulturträger* who defined Russian intellectual culture at its peak in the late imperial era to an outsider whose services were always solicited with suspicion and subjected to regular criticism. Protazanov's personal viewpoint was defined by an ambivalence only a fool would have advertised. But in the following chapters, I argue that one sees it in his films themselves, where his voice is a defining element as much as the genres he worked in and the talented actors with whom he collaborated. Protazanov had a defined artistic vision as much as any accomplished auteur, though it was a complex and multifaceted one.

2 · THE POLITICS OF LITERARY ADAPTATION

Protazanov's longtime screenwriter and close friend Oleg Leonidov emphasized that his competence as a director stemmed from his erudition as an intellectual: "He was never in a state of thoughtless idleness. He constantly read and studied the work of this or that writer, this or that era, this or that philosophical or political problem. He had a stunning memory. He could perfectly repeat a poem he heard only once for the first time."[1] His surviving letters are full of literary quotes and remarks about recent trips to the theater to see the latest renditions of classic plays. All of his peers described him as an authentic member of the Russian intelligentsia, regardless of what they thought of his films and whether they saw this as laudable. As he moved to different countries and adjusted to different cultural regimes, the Russian literary tradition provided a sense of stability in his purpose as an artist.

The growth of cinema, however, disrupted the foundations of Russian culture initially laid by this elite class. Rising literacy, expanding urban spaces, new possibilities for social mobility, and more disposable income positioned far more Russians to be able to consume culture if not completely participate in its dialogue. Optimistic intelligentsia saw in mass media a way to shape the sensibilities of the lower classes for their benefit but feared that the profit motive would coarsen prized traditions and distort native folk customs. Meanwhile, industrialists hoped that a wholesome kind of mass culture might discourage workers from drunken revelry that made them show up to the factory floor late and sluggish. Proponents became preoccupied with raising the population's level of *kul'turnost'*, "culturedness," which connected a civilization's growth with the internalized norms of its subjects, especially in manners of speech, dress, and public behavior.[2] The same basic premise of cultural uplift continued to hold sway among the Bolsheviks, who were drawn from the same intellectual class that had initiated these projects and wanted to bring culture to the proletarian class they claimed to represent for its enrichment, advancement, and enjoyment.

Though the question of culture and art had been only a minor topic in Marxist theory, the Party's assumption of power and ensuing mission to not simply manage but construct an authentically socialist society lent their effort different emphases than their precursors. For one, the need to mobilize the population to win a civil war, rebuild basic infrastructure, and establish support for the new regime brought an increasingly utilitarian orientation to cultural matters vividly illustrated in Lenin's famous remark that "literature must become part of the common cause of the proletariat, 'a cog and a screw' of one single great Social-Democratic mechanism set in motion."[3] That pragmatism included a desire to maintain a tight grip on the creation and distribution of culture so that it achieved those ends. But Marxist ideology also posited, if not deeply explored, that the dominant "bourgeois" culture that had shaped intellectuals themselves was ultimately rooted in class identities stemming from the capitalist mode of production. The ascendance of the proletarian class would presumably involve new cultural norms, displacing those of the past. A more radical and aggressive interpretation of this premise underlaid a diverse group of avant-garde cultural and artistic movements that sought to demolish "bourgeois" culture while taking an active hand in shaping what the new "proletarian" culture would become. This approach reached its most aggressive peak in the Cultural Revolution of 1928–1932. Yet it had no particular adherents among the major Bolshevik leaders, including Stalin himself, who seems to have supported its proponents at that time for political reasons without any particular sympathy for their ideas.[4] Major Soviet leaders continued to reiterate that the "cultural level" of the working class was low and settled for a pluralistic approach to artistic forms.

After the iconoclastic fervor during the revolutionary uprising and efforts toward a proletarian avant-garde, in the 1930s, the Stalinist state increasingly championed traditional Russian culture as a more palatable alternative to contemporary culture from Western Europe and America finding its way into the Soviet Union—whether it be commercialized entertainment or high modernism.[5] Under the label *kul'turnost'*, Soviet leaders also used the connection between high culture and consumerism to validate the increasing embourgeoisement of elites and the aspirations for material advancement of those rising up the ranks.[6] Mastery of old Russian high culture was a mark of distinction, a rationale for material privileges, and an acceptable form of leisure. But in the process, classic works of Russian literature became victims of what Evgeny Dobrenko has called "the disaster of middlebrow taste." It is well known that the party-state shaped aesthetic norms and carefully edited culture according to its ideological and political needs. But for Dobrenko, what made it truly diabolical was how it proceeded *from* the tastes of the masses rather than *above* them. Soviet administrators of culture were, if anything, preoccupied with mass literature and art being accessible to the typical consumer, as testified by their numerous surveys

The Politics of Literary Adaptation 49

of readers. Soviet artists were simultaneously pressured, on one hand, to conform their creations to officially endorsed understandings of art and life and, on the other, to a homogenous "average" level of cultivation. For Dobrenko and many other critics, past and present, the resulting content could not be anything other than "gray" and lifeless.[7]

Thus, despite their different ideological precepts, regimes under both the tsar and the party saw the energetic interaction, interpenetration, and hybridization of traditional Russian high culture and mass media. Protazanov was central to this process throughout. More than anything, he is associated with bringing the achievements of Russian literature to the mass viewer as moving images. He pioneered genres like the biopic and the literary adaptation first in the prerevolutionary years as the industry made a play for respectability then once again in the Stalinist 1930s when artists returned to the goal of making citizens more *kul'turnyi* (cultured). Soviet-era critics regularly championed these works to redeem Protazanov from others that seemed less edifying. His career is therefore instructive in the changing dynamics of this culture industry. What did making works of literature accessible to the masses mean, in practice, for a director tasked with writing and staging a work in a new medium? How did the shifting ideologies transform the Russian culture constructed by the film industry?

To address these questions, this chapter turns to Protazanov's celebrated screen adaptations of classic Russian literature. Like all Russian directors, Protazanov was in the constant presence of state power. Yet in accordance with Dobrenko's "middlebrow disaster," Protazanov's sense of what was comprehensible to his audience proved equally, if not more fundamental, to how he reworked texts for the screen. His career lasted as long as it did because both the prerevolutionary and Stalin-era film industries shared this orientation. It is undeniable that the increasingly centralized control of culture smoothed out the rougher edges of Protazanov's adaptations and narrowed their range of possible meanings. But in contrast to Dobrenko's claim that Stalinist literary adaptations eliminated both the artist's and viewers' interpretation, I argue that Protazanov's adaptations are more multivalent than past critics have appreciated.[8] Even in the late 1930s, his films based on the Russian literary heritage reflected his ironical perspective on revolutionary events, interest in doubled layers of meaning, and a provocative streak that always defined his work. This chapter focuses on two exemplary films: *Father Sergius* (1918), his adaptation of Leo Tolstoy's novella, and *Without a Dowry* (1936), his version of Alexander Ostrovsky's play.[9] In both cases, Protazanov focused on aspects of the original texts he thought would garner attention and engage the emotions of his anticipated audience. Initially, his approach reflected the strong commercial imperatives in the competitive prerevolutionary film market. But in 1917 and after, it also participated in an iconoclastic culture that eventually pushed classic literature out of favor for much of

the 1920s. When he returned to it during the emergence of sound cinema, his work then reflected a society now more interested in building new monuments than destroying old ones. Throughout, decisions about how to adapt texts were influenced by state power and involved alteration and simplification of the originals that bothered—and continue to bother—literary scholars. Protazanov was a quintessential film director in his manner of thinking in terms of immediate, sensuous images. When considering what he could and should preserve of the past Russian heritage, he focused on what was visually salient and memorable, if sometimes superficial.

RESPECTABLE ENTERTAINMENT

The suddenness with which storefront movie theater houses appeared on every street of major cities at the turn of the century was staggering. They whetted an insatiable hunger for new films, and production companies looked everywhere for ideas. What is perhaps most interesting about this period of cinema is the sheer variety of sources they drew upon for film scenarios. In addition to the common adaptations of novels and plays, movies' ongoing connection with a variety of entertainment venues like vaudeville houses, music halls, cafés, and cabarets inspired reproductions of visually striking performances commonly found in those spaces. The one-reel format (about fifteen to twenty minutes) and mixed program at most cinema halls also made the medium well suited to adapting shorter-form works. In addition to adaptations of novels or plays, early filmmakers just as often adapted poems, popular songs, and comic strips. It is clear that companies involved in the film business began to woo more respectable, middle-class viewers very early. This was for obvious business reasons, as appealing to their tastes could garner greater returns than those with little disposable income. Equally important, however, was theaters' and studios' need to defend themselves from reformist groups concerned about the effects of motion pictures on public morality.[10] While concern about growing film production in other Western European countries was at least tempered by the belief that good business was ultimately good for the nation, the majority of Russian cultural authorities still were strongly traditional in mindset and anticapitalist in values. With the onset of World War I, it did not help that the vast majority of films had been foreign and a large proportion of them German.

Protazanov's work offers a remarkable cross section of what appeared on Russian cinema screens prior to the revolution. Looking over his filmography, we see films based on short stories (Anton Chekhov's "The *objet d'art*"), plays (Alexander Amfiteatrov's *The Destruction of Polotsk*), operas (Vladimir Rebikov's *The Christmas Tree*), poems (Alexei Apukhtin's "The Broken Vase"), and Russian folk songs ("I'll Harness My Three Best Dark Brown Horses"). Well into

the 1910s, Protazanov also directed short, simple reproductions of popular performances in the spaces of urban popular entertainment like the nightclub or *café-chantant*. Novels adapted included controversial recent Russian popular fiction, such as Evdokia Nagrodskaia's *The Wrath of Dionysius* and Anastasiya Verbitskaya's *The Keys to Happiness*, but also works by golden age writers like Dostoevsky and Chekhov and European authors such as Guy de Maupassant and Kazimierz Przerwa-Tetmajer. Confirming what Denise Youngblood has tabulated, his selections reflect a broader gravitation toward realist, accessible works thought to be most popular with urban audiences, especially those by Alexander Pushkin and Leo Tolstoy.[11]

Historians are far more used to discussing the effects of state ideology on Soviet cinema than its tsarist predecessor, but the Russian Empire had an ideological basis for its rule too. It was the embodiment of a "Third Rome" under the sovereignty of God's earthly representative, the Romanov dynasty. And while its interventions in affairs of cinema were more modest than the Bolsheviks', it was not wholly inattentive. Prior to the February Revolution, censorship of films—like that of literature, theater, and other art forms—fell under the aegis of the Holy Synod in Petersburg. Religious authorities' priorities, along with their method of enforcement, granted the evolving system a haphazard character. Yuri Tsivian has argued that the leaders of the Russian Orthodox Church were of such stringently traditional mind that they believed cinematic representation was inherently blasphemous. Rather than attempting to remove socially undesirable messages from films, religious reformers focused on banning the medium entirely. In the meantime, they held its corrosive potential at bay by keeping it from representing, and thereby corrupting, the most sacred institutions: the Orthodox Church and the monarchy. Proceeding from this principle had unusual effects from the perspective of public morality; provided a film did not involve those topics, almost any degree of perversity was tolerated.[12] The Orthodox Church's means of enforcing censorship further encouraged a preoccupation with discrete images in a film rather than its thematic content or story. The Holy Synod in Petrograd worked through local organs, often police stations, that made inconsistent decisions. A special municipal executive in the major cities published a book with a list of banned films and images of shots from them so that they could be identified. Initially, as little as one unacceptable image in a film was grounds for complete prohibition.[13] By the mid-1910s, the film industry had learned to self-censor the most stringently banned subjects. A 1916 pamphlet for new cinema entrepreneurs informed them of material that could not be shown on screen: "Jesus Christ, the Virgin Mary, Holy Angels, and Saints"; "blessings in the name of Christ"; "exterior views of cathedrals of any denomination or statues with the images of Saints"; "interior views of cathedrals"; "cemeteries, graves, funerals, burials, and soldiers

killed in battle"; "sacred objects, banners, and any Church utensils"; "icons and crosses, when placed in the corner of a room, if the objects surrounding them are offensive"; "Orthodox religious processions"; "worship services of any Christian denomination"; "religious rites and sacraments, except for non-Christian weddings"; "any Orthodox clergy."[14] Hence prerevolutionary films are evacuated of the trappings of piety that defined the daily experience of the vast majority of Russians at this time.

With the explosion of the industry at the beginning of World War I, the studios accumulated resources but also attracted increasing attention from authorities. The Ministry of Interior Affairs surveilled major film companies at least as early as 1912, though it is unclear if industry employees and leadership were aware.[15] As conditions in the country declined and more turned against the tsar, reactionary elements at high levels of government proposed extreme measures to maintain power. In a brochure titled "The Cinema as Imperial Regalia," V. M. Dement'ev proposed that in order to eliminate "films of a foreign, even international character completely foreign to the Russian people and to Russian nature," the government should "expropriate all privately owned businesses for the treasury and operate them on a completely monopolistic basis under which officially-sponsored sales shall occur."[16] Minister of Interior Affairs Alexander Protopopov proposed not merely direct state management of all cinema affairs but additionally the limitation of its use "for the development of healthy political and social views among the people" and "to ameliorate the worsening animosity of various classes and strengthen patriotism and monarchist ideas among the people."[17] Judging by the trade press, most in the industry seem to have taken for granted that it would not be able to avoid increased oversight and pushed instead for a comparatively more favorable arrangement.

In this context, the film studios had a particular need to bolster their reputations by producing literary adaptations. Trade journals had initially emphasized the popularity of the genre, but as the war dragged on and the government became more antagonistic, they portrayed literary productions as a form of educational cinema, often including it in lists of edifying documentaries and scientific films. By 1915, a wave of big-budget literary adaptations appeared with stars and personnel drawn from well-known theatrical venues. Films such as Evgeni Bauer's *A Life for a Life* (*Zhizn' za zhizn'*), an adaptation of Georges Ohnet's *Serge Panin* at Khanzhonkov, and Meyerhold's *The Picture of Dorian Gray* at Thiemann & Reinhardt corresponded to the peak year of production for the film studios. Shortly after beginning work at Ermolieff, Protazanov produced an adaptation of Dostoevsky's *Demons* titled *Nikolai Stavrogin*, lost today. The production corresponded in time with a similar adaptation of *Demons* as a stage play performed at the Moscow Art Theater. Aleinikov credits this film with more experimentation with film form that had not been possible in Protazanov's earlier films. *The Queen*

of Spades, produced in late 1915 and first distributed in early 1916, continued these ambitions. The Ermolieff studio spent an unprecedented amount of money and time on the film and even constructed a new Winter Pavilion in which to shoot it.[18] The choice of subject for the film no doubt attempted to capitalize on Sergei Rachmaninoff's recent staging of Tchaikovsky's opera version of Pushkin's story at the Bolshoi Theater, which Protazanov saw and admired.[19] The film based most of the costumes and sets on the contemporary opera version to exploit audiences' potential familiarity with them.[20] But rather than following the typical practice of the film industry and basing the film on the text of the opera, in which the protagonist Hermann becomes obsessed with a magical "Secret of the Three Cards" out of love for a young woman, Liza, Protazanov returned to Pushkin's short story, where he does so out of a simple desire to cheat at gambling, acquire wealth, and raise his social stature. Oleg Leonidov, who mentions that the story was chosen to address the politics of the period, interprets the film as a criticism of war profiteering due to the prominence of ephemeral riches.[21] Given that Pushkin's Hermann is a Russified German, one suspects the film also wanted viewers to draw a connection between his thirst for power and status leading to the folly of pursuing illusory wealth and that of the German Empire now advancing on the Eastern Front. Yet the success of Protazanov's big-budget adaptations among critics and audiences did not alter the declining trajectory between the film studio and the government.

FATHER SERGIUS IN REVOLUTION

Reactionaries in the tsar's cabinet seemed to have the upper hand, but they failed to put any significant measures into action before they were interrupted by the February Revolution, which unleashed a powerful wave of revolutionary iconoclasm in popular culture. Richard Stites describes the spontaneous vandalism that targeted images of the old tsarist order, whether it be portraits, statues, or any kind of art associated with the regime. Nearly all of the revolutionary movements attacked Orthodox traditions, and an anticlerical strain was prominent even among the faithful. The urge to destroy the past to make way for the future did not completely die down for years. In many cases, it actually ran against Bolshevik attempts to preserve cultural traditions.[22] February's biggest implication on the film industry was the immediate collapse of the tsarist system of censorship. Filmmakers seized on the opportunity to include previously forbidden images and address previously taboo subjects. Sensational anti-Romanov films, often focusing on widely circulating rumors and conspiracy theories about Rasputin and various ministers, appeared in droves. Industry leaders expressed concern that this new wave of films would permanently damage the industry's reputation and attempted to form organs of self-censorship. The completely

unregulated state did not last long. Around April 1918, the Bolsheviks began to reestablish official censorship of films on principles more analogous to those in other countries. In June 1918, the Moscow Cinema Committee and Narkompros formed a Review Commission (Prosmotrovaia Kollegiia) tasked with reviewing both new and old films to distinguish those with educational value from those that played to "the vulgar tastes of the crowd."[23]

Even when making films not immediately concerned with political or religious subject matter, directors, including Protazanov, could not resist the chance to include previously banned material. Sometimes it was due to sheer novelty; sometimes it veered into agitprop. In the opening scene of *No Bloodshed!* (1917), an angry mob invades the office of the political police. As they ransack the room, one takes down the portrait of the tsar and smashes it, tearing a hole in the canvas. The iconoclastic thrill extended beyond films with revolutionary subjects to even literary adaptations. A curious example occurs in Protazanov's *Little Ellie* (*Maliutka Elli*, 1918), an adaptation of Guy de Maupassant's *La Petite Roque*, which explores the psyche of a mayor who rapes and murders a young girl from his town. The film treats only the second part of the original short story and makes the characters English instead of French. Mayor Renardet becomes Mayor Norton, played by Ivan Mozzhukhin. The ethnic transformation is even more perplexing when considering set details in his home. In the opening scene, a group of men join Norton in his house, where they drink from German beer steins. In the right background, a wooden model of a two-headed eagle is visible, a sign that is used in a number of heraldic seals at this time but most notably the Russian imperial seal (in an ostensibly English home). In a later scene, Norton, contemplating suicide, lurches around this same room. In a paroxysm of guilt, he turns his back to the camera and makes an ambiguous gesture directly at this piece of set decoration. It is hard to know what a viewer of the period might have made of this strange moment, but the association between a child murderer and the imperial seal is certainly not flattering.

Protazanov's most famous literary adaptation from the era, *Father Sergius*, belongs firmly to this atmosphere after February 1917 to a degree not captured by its nominal year of release in 1918. Though Protazanov had an interest in filming Tolstoy's posthumously published novella for at least two years, its portrayal of the tsar and sexuality in monastic life would have been impossible to show in tsarist Russia. Upon the tsar's abdication, Protazanov and Ermolieff rushed into shooting the film as early as the first weeks of March 1917 with Ivan Mozzhukhin in the main role. However, power shortages prevented the completion of *Sergius* until the fall. By then, movie theaters had ceased regular operation, and Bolshevik orders closed them entirely for November and December 1917. Ermolieff held off the release of the film in the hopes that the exhibition situation

would improve. When *Sergius* finally premiered on May 14, 1918, the studio was already beginning evacuation.

Tolstoy's novella tells the life story of a talented but proud young prince, Stepan Kasatsky, who gradually transforms into an admired monk, Father Sergius. After his father's death, Kasatsky attends a military cadet school to train to be an officer and seems primed to make his way in Russian society. He gets engaged to a young countess, Mary Korotkova, but on the eve of their wedding, she tells him that she has been the mistress of Tsar Nicholas I, whom Kasatsky had so worshipped. Out of wounded pride, he abandons his fiancée and career to become a monk, taking the name Sergius. He advances in the church but cannot shake off his previous social connections and expunge remaining feelings of lust. Sergius gains a reputation as a faith healer and attracts pilgrims, yet it only aggravates his pride and awareness of his moral failings. He takes sexual advantage of a merchant's mentally troubled daughter. At his lowest point, he remembers his cousin Pashenka, whom he and other boys had mercilessly mistreated when they were young, and resolves to seek her out. He finds her and learns that she went on to an unfortunate marriage and financial ruin. Her unaccomplished life as a servant to her family provides Sergius with an ideal of true humility; he abandons his post and wanders the countryside doing good works before being arrested and sent to Siberia. Throughout the novella, Tolstoy pairs the physical description of events with the penetration of Kasatsky/Sergius's subjective experience to set up a contrast between his superficially pious behavior and his prideful motivation for it.

Soviet film historian Semen Ginzburg claimed that Protazanov's film version of *Father Sergius* was "the greatest achievement of Russian bourgeois cinema."[24] Due to its origins in commercial cinema, however, the film attracted little attention during the Soviet era.[25] Post-Soviet writing focuses on its relationship to Tolstoy's original. Denise Youngblood most recently finds that a preoccupation with sexuality in Protazanov's version overshadows the criticism of monastic life in Tolstoy's.[26] Critics who first wrote about the film in 1918 had similar doubts. Director Vyacheslav Viskovsky claimed the film was ineffective at conveying the prideful motivation for Sergius's actions, which might lead audiences to believe they stemmed from genuine piety.[27] But the new possibilities after the elimination of tsarist censorship were central to the choices Protazanov made when adapting Tolstoy's novella. Past writers have not recognized how the film's images of the intricate rituals conducted in Sergius's monastery, the spectacles of power presented in tsarist society, and indeed, the very appearance of a monk on screen held meanings less salient for today's viewers. Rather than neglecting the story's themes, Protazanov chooses a more roundabout strategy for conveying them through the repetition and variation of similar sequences to

FIGURE 1. The opening shot of *Father Sergius*, directed by Yakov Protazanov (1918; Moscow: Ermolieff).

draw visual comparisons between church life and the now-despised monarchy. In what follows, I argue that while the film provides an experience quite different from the novel, Protazanov still conveys its Tolstoyan condemnation of hypocrisy and vanity.

The newly permissive censorship context is apparent in the very first scene (Figure 1). In the novella, Tolstoy briefly and indirectly reports that Kasatsky became an orphan when his father died. Yet Protazanov chooses to visualize the funeral in an elaborate tableau. We see the father's body laying horizontally in the bottom foreground with carefully positioned characters crowding every visible point behind it in the midground and background. A priest approaches the body and stands in the central foreground, carrying a large cross angled directly toward the camera. He retreats, and one child walks in front of the body to the left foreground and kisses its hand while the priest leafs through a Bible behind them. The priest returns to place a candle in the body's hands. Already in the first scene, Protazanov has included four different categories of previously forbidden images: clergy, religious funeral services, crosses, and holy scriptures. The first scene also introduces what will become a repeated narrative motif in its lengthy dwelling on the religious rituals that will come to define Kasatsky's life.

The film similarly expands the ending to criticize the regime that had just collapsed. At the end of the novella, police stop Sergius when he is living as a wandering monk. When he cannot produce his passport, they exile him to Siberia. In contrast to the novella, where this event transpires in a single sentence, Protazanov elaborates on this incident in a lengthier scene. Sergius sits reading a passage to a group of peasants in a hut before the police burst in. After a long shot of the group, an insert shows Sergius's finger as it moves along the religious text in Church Slavonic that would have been forbidden under censorship as a holy image. Protazanov and company could have never expected more than a fraction of the audience to be capable of reading this as an intertitle yet included it for its sheer iconic value. The last shot in the film shows Sergius outside, marched away by the authorities. Though the depiction is consistent both with the description in the story and with Tolstoy's anticlericalism, the three-shot sequence lends it more weight than it has in the novella. Moreover, the juxtaposition of the holy image with political oppression intensifies the latter, pitting the state against the piety of simple believers. The final scene portrays the tsar, nominally the religious leader of the Orthodox church, as an antagonist to religious sentiment.

On three separate occasions, Protazanov uses a figure moving forward through a crowd from the far background to make a thematic comparison at different points of Kasatsky's life. The first case comes in the scene when Tsar Nicholas visits the military school. In the bottom left foreground, Kasatsky's (Mozzhukhin's) face is just visible in the opening frame among the other cadets. They snap into formation. A long line of at least twenty boys recedes from the left foreground to the center far background. Starting in the far distance in the right background, Nicholas begins inspecting them as he gradually approaches the camera. He raises his hand to release them from formation, and the boys from the background rush to crowd around him in the foreground, rotating the straight line parallel to the camera. The young Kasatsky's face (Mozzhukhin's) becomes visible frame left, owing to his somewhat taller stature, and we see him grab the tsar's hand and kiss it. The other cadets suddenly freeze to direct more attention to the tsar as he rebukes Kasatsky with the familiar wag of a finger and leaves frame right. The others follow the tsar and leave Kasatsky, crushed, alone in an evacuated frame. Mozzhukhin as Kasatsky retreats to the background, and a cut brings us to him standing in front of the tsar's portrait. He turns toward it and raises his hand in protest, then turns right and brings his hand to his mouth in despair.

Protazanov repeats this basic pattern when the tsar visits a ball where Kasatsky is attempting to win over his love interest, the countess Korotkova (Figure 2). Both move closer to the camera to obstruct the view of the other ballgoers, then retreat into the crowd. Upon the tsar's entrance, all of the ballgoers

FIGURE 2. *Father Sergius*: The tsar works his way from the far background to the foreground, and he addresses the crowd of ballgoers.

stand, bow, and freeze in place like their cadet counterparts in the earlier scene. Kasatsky quickly exits the frame. This time, Protazanov shows the line of people from two separate angles at a similar shot scale. One of them repeats the basic framing at the school. The tsar walks from the background to the foreground along the ballgoers, who are positioned in a diagonal line on the left. Korotkova stands in the foreground. When Tsar Nicholas reaches Korotkova, he pauses and exchanges some words with her. The two approach the camera and repeat the initial configuration of Kasatsky and Korotkova earlier. The visual similarity of the two comportments suggests a rivalry between two suitors. The tsar leaves the frame in the foreground right, and the other partygoers begin moving again. A group moves toward Korotkova out of a seeming curiosity about her and the tsar's earlier exchanges; in doing so, they rotate the straight line forward in a way that repeats a similar kind of crowding that occurred among the military cadets. In Tolstoy's original, one sentence informs the reader that they are having an affair without describing any particular incident. In contrast, Protazanov indirectly conveys this detail through a visual comparison that repeats Kasatsky and the tsar's earlier antagonism.

Protazanov repeats a similar staging strategy years later after Kasatsky, now Father Sergius, has garnered a reputation in the countryside for his alleged,

FIGURE 3. *Father Sergius*: The staging of Sergius approaching his parishioners echoes earlier sequences of the tsar.

but in fact fictitious, powers of healing (Figure 3). Inside the chapel, a crowd gathers in expectation of Sergius's arrival. A fence cordoning off his cell is visible in the foreground, and a window in the background looks onto a staircase. The crowd freezes and looks backward to draw attention to Sergius in his habit, visible through the window as he descends the stairs. The worshippers bow as he walks slowly toward the camera and lays hands on a few who approach him. An axial cut enlarges our view of the background, then another returns to the first framing. Sergius mounts a platform behind the fence in the bottom-right foreground and addresses the crowd that stretches from the foreground to the far background on the left side of the frame. He bestows a blessing with a crossing gesture onto each of several worshippers who approach him in a queue. He suddenly faints. A cut isolates a group of about ten panicking worshippers in the background, then another returns to the previous framing. The entire crowd pauses to draw attention to Sergius as he shakes his head after returning to consciousness. He stands while they return to their fevered activity. After an intertitle reports his statement that the crowd will have to wait until the next day, two young boys enter frame in the right bottom foreground. He blesses the crowd with another wave of his arms, and they bow in response (one bowing worshipper is even visible very far in the background through the arched doorway)

before an assistant waves them off. A cut enlarges their attempts to force the crowd of disappointed believers out a door to the right. A view slightly closer than the wide establishing shot then shows the assistant approach Sergius, now in an empty chapel.

The latter two of these three scenes use more editing, but there are strong formal similarities among them. They are alike in their uses of a figure slowly approaching from the background amid a crowd, in their alternation of stasis and motion to direct attention, and in their contrast between a frame full of figures and then empty. The group of boys that appears toward the end of the third scene also ties it to the young students in the first. Ultimately, their shared form draws a subtle comparison from which viewers might produce many meanings. Certainly, one implication is that the rituals of worship are not unlike rituals of tsarist adoration, whether conducted by adults or children. The repeated formal similarities undercut Sergius's ascent to fame with the suggestion that he has become like someone he once despised. In doing so, it opens up a critical reading of the superficial rituals surrounding Orthodoxy in line with the themes of the novella.

The ballroom sequence implies the affair between Korotkova and the tsar but might not register with some viewers, especially if they do not know the original story. Protazanov invents an additional sequence that clarifies their relationship while indulging in his new freedom to paint an unflattering portrait of the monarch. Away from the main gathering, Tsar Nicholas warns Korotkova that their affair is becoming too noticeable to outsiders. A curtain parts to show the two lovers shot in a moody lighting scheme, then at the end closes to formally demarcate the scene from the subsequent action. The curtain holds some narrative significance, as it signifies the private nature of their conversation. It is a relatively common device in the silent cinema of the 1910s and can be found in Bauer's *A Life for a Life* (1916), among other films. Its use in this case, however, takes on additional significance in the context of the prior restrictions on representing the tsar. One exception to the ban on the tsar's image in films existed for documentaries. Cinemas could show images of the royal family in newsreels under stringent conditions. They had to be segregated from other images or films in the program to prevent them from imparting a derogatory meaning. Projectionists had to use special care to project the film at the precisely correct speed so as to not render them in comical fast-motion. Typically, to meet these requirements, cinema programs would close a curtain to interrupt the normal flow of one-reelers and then open it again to unveil the royal family.[28] The curtain in this scene adds a layer of ironic meaning by comically associating the pomp and circumstance the tsar had received prior to February 1917 with his profane appearance here as one of countless silent film rakes.

The most celebrated, and obviously rhetorical, comparison drawn through film editing appears in the penultimate scene when seeing a group of peasants dancing prompts Sergius to reflect upon his life. In a long shot, we see Sergius, with his long beard and tattered robe, standing by a window. He looks into the building, and a cut brings us to the interior. Three peasants, two men and one woman in traditional dress, dance in the center midground, cheered on by a balalaika player and a clapping person visible frame left. Sergius looks back and nods slightly. A fade in and out returns us to the ballroom sequence from earlier in the film. In an exact copy of an earlier shot, we see Tsar Nicholas enter and Kasatsky stand. The decision to base Sergius's epiphany on this moment, which does not appear in the novella, is one of the film's most salient departures. It replaces the thematic weight of Sergius's observations of Pashenka in Tolstoy's version. As Youngblood suggests, the absence of Pashenka secularizes the story and reveals where Protazanov's attitudes as a committed atheist parted ways with Tolstoy's.[29] His ending locates moral strength in the simple folkways of the peasantry rather than the presence of God. The moment at the window is more ambiguous than Tolstoy's version too. The juxtaposition of peasant and royal dancing invites the viewer to make many possible comparisons between the two, whether it be the scale of the surroundings, the liveliness of the dancing, or any of the numerous associations a viewer might have with their respective social milieu. Yet it is certainly not incidental that he chooses a shot of the ball when the tsar passes, which in 1917 would hold negative associations. The comparison would not be to the favor of the nobility. Tolstoy himself likely would have considered Protazanov's variant of the ending a failure. As is well known, the writer had begun to adhere to an increasingly didactic understanding of the role of art. In *What Is Art?* he faults texts that do not convey moral messages in the clearest, least ambiguous way possible. The brevity and precision with which Tolstoy transmits his theme in the novella are certainly impressive, but Protazanov's ambiguous approach also has its own aesthetic virtues. In the film version, he opens up a richness and complexity of possible meanings of *Father Sergius* at a key moment.

Whether *Father Sergius*'s attitude is best considered "bourgeois" or not, it is intricately connected to the atmosphere of the early interrevolutionary months. Using film form to draw comparisons between scenes of religious authority and state power, Protazanov's film channels popular attitudes unleashed by the tsar's abdication and directs them toward Tolstoyan themes of humility. Protazanov may have miscalculated, however, in assuming an audience that would be relieved at the chance for their long-simmering resentment of past authorities to be expressed in visual form. One suspects that, by the time of its long-delayed appearance on screen in 1918, much of the novelty of its subject matter would

THE DEPARTURE AND RETURN OF LITERARY
CLASSICS IN THE SOVIET UNION

The fate of *Father Sergius* is instructive in showing how much attitudes toward adaptations of classic literature had changed by the late 1920s. After its official 1918 release, the film had staying power across Europe for many years and bolstered Protazanov's reputation as he searched for work. Its admirers included Louis Delluc, known today as a pioneering film theorist and a central figure in the emergence of the French cinematic avant-garde.[30] The events that had brought *Sergius* and its Russian creators abroad lent a new significance to its Tolstoy literary source, Russian Orthodox settings, and critique of tsarist power. Advertisers in Europe marketed it as a nationalist celebration and sometimes shamelessly exploited anti-Bolshevik sentiment. One German ad claimed that "under threat of death, three copies managed to make it across the border"[31] and another that it had been "snatched from the horrible Bolshevik maw."[32] These promotional stunts built on the past tradition of films billed as "banned in Russia." One French reporter, too, noted how the film had been a success "despite being shown on a poor quality print."[33] News of the political catastrophe in Russia rendered technical defects as signs of courage rather than amateurism.

Though it is difficult to document, *Sergius* probably continued to play in Soviet Russia with some regularity during the civil war and New Economic Policy, with its attempts to expand moviegoing in the countryside despite a dearth of films to show. Around 1928, aggressive calls for a cultural revolution prompted another look at the film. The Party intensified its antireligious campaign, which had been mostly abandoned after 1917 out of concerns they alienated much-needed support in the countryside. Film administrators searched for appropriate films to support the campaign and, while religion was hardly portrayed favorably across Soviet films, were disappointed by the number of fiction films dedicated to antireligious topics. N. Shagurin wrote two full years later that despite the 1928 All-Union Conference on Cinema's demand, "unfortunately, there are almost no strong, well-made, purely antireligious films that make a strong impression."[34] That same year, the cultural bureaucracy launched a variety of programs centered on Leo Tolstoy for the centenary of his birth in the first Soviet-sponsored event celebrating a prerevolutionary writer. William Nickell describes "an elaborate interpretive apparatus" that accompanied all related new publications and events. A battery of accompanying prefaces, forewords, lectures, and other contextualizing

remarks—invariably citing Lenin's writing on Tolstoy—discouraged from taking the writer's religiosity and nonviolence too seriously.[35] *Father Sergius* was an obvious choice for rerelease, having garnered a reputation as the premiere film adaptation of Tolstoy's work and showcasing star Mozzhukhin, as popular as ever among Russian audiences who occasionally caught a glimpse of him in French imports. Cinema administrators no doubt hoped that the film's anticlerical themes and unflattering images of the tsar would complement the messages of more straightforwardly propagandistic films.

Yet its reappearance on Soviet screens prompted an immediate backlash. A journalist in *Kino* described how screenings had attracted "godfearing sectarians" and "old men in faded silk caps" rather than proletarian audiences.[36] The controversy sparked a round of reassessment of the film's value among a new generation of Soviet critics in a meeting of the Society of the Friends of Soviet Cinema (ODSK). A certain Rissenberg hesitantly concluded that while the film ought not to be shown in rural areas, more class-conscious worker audiences would understand its antireligious themes. In contrast, a certain Sberanovsky thought the film's nuance was an asset rather than a liability: "In the countryside, if you show a church being blown up with dynamite, it will not serve antireligious goals. *To shake faith in God, one needs a very subtle approach.* This film shows effectively how Father Sergius loses faith in God. *It agitates against religion*" (emphasis in original). Yet the majority of attendees voted that the film was in fact proreligion and ought to be banned from the screen.[37] In 1918, its lengthy scenes of religious rituals would have had an inherently blasphemous underpinning, but in 1928, they seemed outright reverent in the context of increasingly shrill Party rhetoric on religious matters. The incident took the film out of Soviet distribution for decades. The attacks on *Father Sergius* revealed the increasing antipathy some critics had for adaptations of classic literature and even representations of nonrevolutionary times and spaces as such, which they deemed irrelevant to "contemporary socialist reality."

Protazanov's arrival in France and subsequent return to the Soviet Union of the New Economic Policy correspond with dwindling attention to Russian classics in his filmography. In Europe, he seems to have downplayed his origins and embraced his Francophilia in his choice of projects, such as his adaptations of Émile Zola, *Pour une nuit d'amour* (1922), and of Paul Bourget, *Le sens de la mort* (1923), both lost today. For the remainder of the 1920s, he selected contemporary Soviet works for his film projects, including Boris Lavrenyov's story for *The Forty-First* and Ivan Shmelyov's story for *Man from the Restaurant*. For *The White Eagle*, Protazanov retreated some from the present in his selection of the story "The Governor," published in 1906, but its focus on the uprising of the previous year brought it closer to the concerns of the moment. Its author, Leonid Andreyev, also had a close, if complex and stormy, friendship with the newly canonized Maxim

Gorky that granted his work political credibility. Yet it is a testament to Protazanov's personal interest in literary adaptations that, despite the unfavorable atmosphere, he finally returned to pre-Soviet sources in his 1929 adaptation of *Ranks and People*. This omnibus film includes adaptations of three of Chekhov's best-known short stories, *Anna on the Neck* (1895), *Death of a Government Clerk* (1883), and *The Chameleon* (1884). The author was receiving a state-sponsored celebration in honor of the twenty-fifth anniversary of his death, though with far less fanfare than Tolstoy or, later, Pushkin. Yet critic Khrisanf Khersonsky—no Stalinist hack—claimed the beautiful sets, costumes, and makeup whitewashed the deprivations of the tsarist past: "It all yields merely a corpse—lisping liberalism. It calls forth neither fury, nor new thoughts about tsarist Russia, and only good-natured pity for it. Today this is, to put it mildly, an anachronism."[38] Two years later, administrator Francesco Misiano had to make a formal request to the NKVD to rehabilitate Mikhail Doller, who had been purged on the basis of playing a "class-foreign" character in the film (in fact, he had codirected the film but did not appear in it).[39] The incident illustrates the capricious nature of the Cultural Revolution, where reality and representation were increasingly intermixed.

Protazanov's Chekhov adaptation proved premature, but a reorientation toward Russian traditions gained steam. At the Seventeenth Party Congress in 1934, Joseph Stalin declared that socialism had been achieved. The corrupting blandishments of capitalist consumer society could now be perceived as the hard-earned products of the working class's labor. With Old Bolsheviks and "class-foreign elements" mercilessly eliminated, the ideas of the cultural past no longer posed the same threat to party ideology. As the Soviet party-state consolidated power, it hoped to temper the iconoclastic impulses of the 1920s and promote a culture that would encourage orderly behavior and social cohesion. Moreover, one year later saw a realignment of attitudes toward Russian culture. At a Kremlin reception for Tajik and Turkmen collective farmworkers, Stalin declared that Soviet rule had overcome the "Great Russian chauvinist" prejudices of the tsarist era and succeeded at fostering mutual trust between Russians and the national minorities. In breathtakingly direct contradiction to this alleged lack of prejudice, Russian culture was promoted as a more "civilized" example for other national cultures to follow under the new "Friendship of the Peoples" policy. Cultural administrators embarked on an ambitious project to rewrite history to celebrate Russian accomplishments and portray cooperation with other nationalities.[40] Russian literature and art could connect the current social order to a universal, timeless tradition. As Soviet critics and cultural bureaucrats formulated an official notion of socialist realism to guide artists of the present, they created a canon of official works of the past, energetically popularized them, and promoted interpretations that would reconcile them with official ideology. Historians often point to the Pushkin Celebrations of 1937 as a watershed of

The Politics of Literary Adaptation 65

this new orientation. Like the upper strata of the intelligentsia's Pushkin com-
memorations in 1880, and then the tsarist state's in 1899, in 1935, the Party began
to put its full weight behind marking the centennial of the death of Russia's
national poet. Soviet publishers released lavish editions of his works and new
biographies that portrayed him as a prerevolutionary rebel, however implausibly.
They hosted festivities and "Pushkin readings" to bring the author's works to the
Soviet people and make him, in effect, the *Soviet* national poet.[41] The Pushkin
Celebrations forcefully conveyed that the cultural achievements of the imperial
past could and would be made available to all Soviet citizens of every nationality.

The film industry's thematic plan for 1935 marked a new emphasis on clas-
sics for the masses. It included three major literary adaptations: the Pushkin
adaptation *Dubrovsky* (*Dubrovskii*, Vladimir Petrov, 1935) and two adaptations
of plays by Alexander Ostrovsky, *The Storm* (*Groza*, also Petrov, 1935) and Pro-
tazanov's *Without a Dowry* (1936). Two biopics about the poet's life, *The Youth
of the Poet* (*Iunost' poeta*, Abram Naroditsky, 1936) and *Journey to Arzrum*
(*Puteshestvie v Arzrum*, Moisei Levin, 1936), were also released. Protazanov
claims that as he was completing work on the unfortunate *On Love's Strangeness*,
which would ultimately be banned, Mezhrabpom suggested three subsequent
projects, including an adaptation of Alexander Ostrovsky's 1878 play *Without
a Dowry*, which interested him the most.[42] The project paired him and regular
screenwriter Vladimir Shveitser, several of his regular actors, including Anatoly
Ktorov and Mikhail Klimov, and the talented cinematographer Mark Magidson.
It took far longer to shoot than Protazanov's typical film, with numerous days
on set lost due to poor weather and bad planning; the group went through at
least four different assistant directors.[43] Perhaps excusing the protracted produc-
tion phase, a report in *Kino* described constant interruptions during filming due
to unexpected noises. The omnidirectional, overly sensitive microphones could
not avoid any stray sound, whether it be hissing lamps or set workers still not
accustomed to remaining quiet while rolling film.[44] The final result sees Protaza-
nov returning to many of his motivating instincts when adapting similar works
in the prerevolutionary era, especially his comfort in significantly reworking
plots and his emphasis on the sensuous impact of the image over narrative and
thematic complexity.

Critics consider *Without a Dowry* one of Ostrovsky's best plays. In the open-
ing act, we learn about the frustrated romance of Larisa, a beautiful young
woman who does not have a dowry. She fell in love with a rich man named Para-
tov, who abandoned her abruptly and without explanation. Impatient, desper-
ate to assume her role as a faithful wife, and tormented by her mother, Larisa
marries the first available bachelor who shows interest, the vain and opportunis-
tic Karandyshev. In the opening scene set at a coffeehouse, Larisa's childhood
friend Vozhevatov discusses her predicament with Knurov, a local millionaire.

They are joined by Paratov, now a merchant carousing an extended binge on his steamship before he marries a wealthy woman to advance his career. Also joining them is Karandyshev, who immediately wants the wealthier Paratov's approval and decides to host a party honoring his and Larisa's imminent marriage. The other men disdain the pretentious Karandyshev but attend to ridicule him for their own amusement. At the party, they goad him to drink too much and leave him behind when they take Larisa on an impromptu nighttime picnic. There, Larisa confronts Paratov and asks him to marry her; he refuses. In despair, she contemplates suicide while the merchants Knurov and Vozhevatov flip a coin to decide who will ask her to accompany him to Paris as his mistress. Knurov wins and makes the offer, but Larisa refuses. The drunk and furious Karandyshev arrives, having finally tracked down the group. He brandishes a pistol—shown earlier when he attempts to impress his guests—and shoots Larisa. In her last moments, she takes the pistol and tries to fabricate a suicide and absolve the men of any wrongdoing, telling them "You are all good people . . . and I love you all."

In bringing this play to the screen, Protazanov had to attend to not only the difference in medium but a growing interpretive apparatus surrounding this work similar to that of Pushkin and Tolstoy. In the heavily politicized cultural environment of 1936, no less important than the play text itself was the analysis of Ostrovsky's work by literary critic Nikolai Dobroliubov. Along with critics like Vissarion Belinsky and Nikolai Chernyshevsky, he had been included in a canon of nineteenth-century intellectual forebears of the Bolsheviks due to their belief in art as a form of social criticism and a tool for political progress. Dobroliubov was associated with the beginnings of realism in Russia and advocated assessing literary works on their "trueness to life" or the extent to which they "express the [natural] strivings of a given period and nature."[45] He championed works that "for the sake of naturalness sacrifice even abstract logic, fully confident that life, like nature, has its own logic, and that this logic may turn out to be far better than the one that we impose on it,"[46] a criterion recapitulated in socialist realism's endless refrain that artists "learn from real life" (though in fact there was always a logic imposed on it). His two influential articles, "Realm of Darkness" and "A Ray of Light in the Realm of Darkness," had been endorsed as the official interpretation of Ostrovsky's work. Dobroliubov valued Ostrovsky's plays for their unflinchingly negative image of then-contemporary Russian society. He ascribed his talent to his ability to convincingly depict how this "realm of darkness" shaped the psychology of his characters, whose inextinguishable desire for freedom from it was distorted and channeled into self-destructive behavior. This argument harmonized with the typical Soviet rationale for the value of prerevolutionary works, which originated in Friedrich Engels's assessment that Honoré de Balzac's aesthetic orientation as a realist chronicler of social life overcame his prejudices as a bourgeois.[47] Protazanov announced the centrality of this sociopolitical

interpretation in his remarks to the press that he intended for the film to "help in the struggle with the 'remnants of capitalism in people's consciousness,' and above all in the struggle against the sense of ownership in relations to women, as a 'crown, which must have its owner' (Ostrovsky's words)." To do so, he thought it necessary to "shift the emphasis, so that the love sentiment that underlies the play becomes the motif of a social drama."[48]

From today's vantage point, it is hard not to see this "social drama" interpretation as flattening, coarsening, and simplifying the richness of the original text. Evgeny Dobrenko discusses Protazanov's film in his broader argument that Stalinist-era literary adaptations did not attempt to translate meanings of the original works but instead used them to represent the historical past *as such*. For him, *Without a Dowry* provides among the best examples of "the organized and consistent transformation of a piece of literature into a Soviet historical narrative" within socialist realism's Procrustean bed.[49] Classical adaptations became "negative monuments" that vividly represented a dark, flawed past in contrast to the ostensible achievements of the socialist present. A Stalinist administrator would indeed find much to like in the film's "realm of darkness." The screenplay eliminates several scenes that render some characters a little more sympathetic, especially Karandyshev and Paratov. It plays up or invents a number of scenes with schematic oppressors and victims based on social class, such as when we see the deprivations of the barge haulers working under the yoke of Paratov. In the opening scene, which recalls *Father Sergius* and *St. Jorgen's Day*, Protazanov similarly indulges in another of his many unflattering portraits of Russian Orthodoxy. We witness a wedding ceremony where even the clergy leading the ritual cannot refrain from gossiping about the bride and groom. The film thus encourages viewers to see the relevant social classes—merchants and petit bourgeois that populate Ostrovsky's plays—in unambiguously negative terms appropriate for the Manichean orientation of socialist realism.

Protazanov's peers and Soviet critics at the time of the film's release did not assume this was the only viable portrayal. In fact, they faulted Protazanov's *Without a Dowry* for many of the same reasons as today's do. Grigori Chakhirian and Iosef Manevich, writing in *Kino*, criticized Protazanov's simplification of the characters. According to them, Ostrovsky's Paratov is also intended to be a romantic archetype as a man of great will, strength, and passion; in Protazanov's version, we never see reason to think his love is sincere. Similarly, Protazanov's Karandyshev is simply pretentious and unbearable, in contrast to Ostrovsky's social climber tormented by contradictory desires.[50] In the minds of many, the Party's imperative for the classics to be attentive to the sociocultural norms of their era did not and should not necessitate reducing their complexity or nuance. Vladimir Volkenstein complained in *Iskusstvo kino*, "What is left of Ostrovsky in the film? Only the outward amusement of situations and events, only a number of touching moments,

only individual vivid remarks."[51] The film received similarly negative reviews based on its adaptation of the source text in publications for a mass audience.[52]

However, I would argue that, rather than the governing ideology, the film's departures from the play text stem more from Protazanov's sense of popular tastes and goal of conforming to mass-entertainment genres. Many of the changes in the plot structure from the original play text have a rationale in their different media. Ostrovsky's play consists of four continuous acts and opens with Vozhevatov and Knurov's lengthy expository discussion of Larisa's marriage to Karandyshev. We only learn of her and Paratov's romantic entanglement later in the dialogue. At the beginning of the film, Protazanov invents a wedding between two incidental characters where Larisa and Paratov meet. After it ends, in a scene well remembered by Soviet viewers but not in the original play, Larisa's mother calls her to their departing carriage, but she hesitates to walk over a big mound of snow and an icy, wet street. Paratov appears and, in a moment of flamboyant chivalry, removes his fur coat and lays it over the snow to make a path for Larisa, as witnessed by the crowd of wedding-goers. We see the early stages of their romance together before he leaves, and an intertitle brings us one year later. Similarly, Protazanov reworks the play text in shorter, more cinematic sequences that he sometimes intercuts. We see the final confrontation between Paratov and Larisa where he abandons her, juxtaposed with merchants Knurov and Vozhevatov flipping a coin to decide who will proposition her. Much as Protazanov removed the lengthy flashback prompting Sergius's visit to Pashenka, he similarly linearizes the Ostrovsky play, showing more on screen and using less dialogue. The biggest effect of the reordering of the plot is to turn the film version into a star vehicle for actress Nina Alisova as Larisa, by now the director's personal love interest. Though Larisa is ostensibly the focal point of the narrative and titular bride without a dowry, the play is designed for an ensemble cast. She does not appear until halfway through the first act. In the film version, we see her within the first few minutes of the running time, and the plot structure favors including her in most scenes. This refocusing around a star would have been taken for granted in both a contemporaneous Hollywood film and in one of Protazanov's films for Ivan Mozzhukhin, Olga Gzovskaya, or later, Igor Ilyinsky. But stardom was a perennial sensitivity in the Soviet film industry, as it was associated with commercial considerations of advertising and seemed to promote a cult of individualism. Yet it proved difficult for studios to resist the popularity of actors who appeared in their films.

Was Protazanov rendering the original literary text more accessible to a mass audience by making it more like a Hollywood film? He may not have needed to look that far. Just two years earlier, Grigori Alexandrov's musical comedy *Jolly Fellows* had been released to universal delight and acclaim. Its female lead, Lyubov Orlova, received the title of "Honorable Actor of the RSFSR" and the

The Politics of Literary Adaptation 69

personal admiration of Joseph Stalin, who began to "recommend" her to the film studios for regular roles. Protazanov's version of a classic play owes something to this musical-comedy model of socialist realism. *Without a Dowry* has eight musical sequences with singing and/or dancing, lending the film something like the narrative-and-number structure of the traditional musical film. It thus offered a satisfying aural experience to Soviet viewers, for many of whom sound would have still been a novelty. Even by the late 1930s, many theaters, especially in rural areas, still had not been wired, and studios were still producing silent variants of sound films to accommodate them. The film version of *Without a Dowry* is probably best known for its repeated use of the music of Pyotr Tchaikovsky. The composer gets his own main credit at the beginning of the film, and lengthy interludes of his compositions accompany images shot without synchronized recorded sound. If these sections provide the "high culture" part of the soundtrack, its proliferating folk songs and popular music return to his mixture of cultural registers in Protazanov's earliest prerevolutionary films. Ostrovsky's original play text has two major songs, both by Larisa, and makes reference to a gypsy chorus that might motivate some additional music when staged. These include solo performances with a guitar by both Larisa and Paratov, folk songs such as the ubiquitous "Volga Boatmen," and gypsy music. In the best-known musical performance, we see Alisova as Larisa perform a song in a lengthy take. Protazanov replaces the play text's song *"Ne iskushai menia bez nuzhdi"* by Evgeni Baratinsky with *"Net, ne liubil on"* by Mikhail Medvedev, a song written after the composition of the play and its first performance. This change is consistent with one made to the play during its staging in 1896, with Vera Komissarzhevskaya as Larisa, and follows Protazanov's regular habit of borrowing from established performances when adapting to the screen.

Protazanov cast Alisova despite protest that she was too inexperienced to handle a leading role and after she had attracted criticism when she debuted in Protazanov's previous film, *On Love's Strangeness*, where they first met.[53] That film ran into trouble and was eventually banned, purportedly for vulgarity and lack of sociopolitical relevance. Critics subsequently heaped negative remarks on her allegedly sexually suggestive performance. In a report from a committee on the film excerpted in Mezhrabpom's studio news publication, *Rot-film*, Vsevolod Pudovkin remarked, "Fundamentally, what's most felt about her is sex. She works in the frame with the flirtatious movements of her body." Nikolai Ekk agreed that "there's a strong sensation of sexuality from Alisova."[54] No doubt the film's ban encouraged critics to add their voices to the chorus; nevertheless, this frankness on matters of sex appeal was unusual—even refreshing—in the context of the general puritanism of Party ideology and public rhetoric. Oleg Leonidov, Protazanov's friend and regular screenwriting collaborator, more delicately claims that Protazanov chose Alisova for her ability to convey "naïveté."[55]

This background information finds some visual correspondence in the lengthy close-ups of Larisa throughout the film and her revealing, low-cut dress. Her casting and performance in the film come across as inappropriate, to say the least, for a character who declares, at the play's moment of greatest tragic intensity, "A thing . . . yes, a thing! They're right, I am a thing, and not a person." The disharmony between the circumstances surrounding Alisova's casting and the role's tragic femininity has encouraged some to see the film's perspective as deeply ironic, even sarcastic.[56] Contrary to Dobrenko's claim that Stalinist-era adaptations eliminated all possibility of interpretation from both the filmmaker *and* the audience, Protazanov's offers some room for a more caustic, cynical reading—or one that implicates a male viewer in ongoing objectivation of women.

A cherished work of Russian theater, with its characters simplified, its plot significantly altered, and its main female role inappropriately eroticized: Could this have really been the deliberate work of an authentic member of the old Russian intelligentsia, in as good standing as was possible in 1936? Future chapters of this book will continue to explore the ironical perspective Protazanov often brought to his works, so it is not inconceivable that he adapted *Without a Dowry* with tongue in cheek. But this view has mostly been deduced from today's critics. Writers in the past always testified to the seriousness of Protazanov's approach to literature. The few anecdotes we have about him off-set suggest that this film was deeply meaningful for both him and Alisova, who named her future daughter, actor and director Larisa Kadochnikova, after the character she played. A charitable interpretation of Protazanov's efforts would be that his films were never meant to replace the literary version.

Without a Dowry was a sound production directed by someone who honed his craft in the silent era and conceptualized it based on its ability to transmit powerful, memorable images to the spectator, just as he did for *Father Sergius*. But whereas he selected those parts of Tolstoy's story that played to the iconoclastic impulses of his audience, Protazanov sought to create a visual monument to the Russian past in images and sounds, whose power would endure notwithstanding the narrative and thematic transformation of the play. It is perhaps these that are intended to provide the "ray of light" in the story's "realm of darkness." Monumentalism is literal in the opening shot of the film, where the camera pans up over a statue of Alexander Ostrovsky—either the original or exact replica of the one erected in Moscow in the square in front of the Maly Theater. We see them accompanied by a melody from Tchaikovsky's fifth symphony. Probably the most celebrated aspect of the film is its cinematography by Mark Magidson, who, according to a review in *Kino*, "found the ideal styles for the visual depiction for the works of the realist Ostrovsky."[57] That ideal style, unsurprisingly, draws from the work of the classic Russian realist art of the nineteenth century, particularly the work of the *peredvizhniki*. The opening springtime landscape resembles Alexei

Savrasov's *The Rooks Have Returned* (1871), and the images of the barge haulers on the Volga resemble their famous depiction in Ilya Repin's *The Volga Boatman* (1870–1873). The wedding sequence added to the beginning of the film consciously imitates both the premise and appearance of Vasili Pukirev's *The Unequal Marriage* (1862). *Without a Dowry* is perhaps a return to the reproductive impulses of Protazanov's earliest works in the 1910s that simply replicated performances. It propagates the classic Russian culture that he cherished and that the party-state currently promoted in the most blunt and straightforward manner possible.

Anatoli Golovnya, Pudovkin's regular collaborator, dedicated an article to cinematographer Mark Magidson's "outstanding results, especially considering the technical limitations of the equipment at Soiuzdetfilm," including the consistency of the cinematographic style and striking landscapes and portraits in individual shots. Golovnya, meanwhile, accused Protazanov of lacking a feeling or care for Magidson's work. While the mise-en-scène was "very cultured [kul'turnyi]," its sensibility was "theatrical or sculptural" rather than cinematographic in its spare movement in the frame. Yet he found the combination of these two sensibilities fitting, particularly in the sequence when Larisa performs at the party: "Each composition in the film is permitted to remain static. The shot is not full of movement; it only presents a space for the arrangement of figures, almost leading to a 'neutralization.' The compositions in this bustle are particularly successful precisely because they are not designed for movement. In these frames, especially their chiaroscuro, Magidson's art reaches true mastery. The light is alive, it sounds out [zvuchit'] like music, all in service to the construction of the episode."[58] Golovnya's description of a static, unmoving image of Larisa singing, rendered into a visual spectacle by means of the aesthetic effects of lighting, calls to mind Laura Mulvey's writing about the "male gaze" of the cinematic apparatus in her influential article, "Visual Pleasure and Narrative Cinema," especially her notion of "fetishistic scopophilia." Under her psychoanalytical schema of film spectatorship, the (male) viewer must reconcile the inherent pleasures of looking at the female form with the castration anxiety that it raises by "build[ing] up the physical beauty of the object, transforming it into something satisfying in itself."[59] Mulvey was diagnosing the particular approach to the female body in films from Hollywood's studio era, so her remarks suggest some of the affinities that *Without a Dowry*, made in the Soviet Union in those same years, still had with this other tradition of popular cinema.

Protazanov's inclination toward parody and his eclectic mix of styles will be examined throughout this book. In its deliberate stylization based on historically congruent sources, *Without a Dowry* has more in common with the pastiche that Frederic Jameson claims dominated the aesthetics of the later postmodern era. He characterizes it as a "blank parody" recycling of the aesthetic styles of the past in a manner that connotes a generalized "pastness" rather than historical

specificity, based only on the knowledge of the codes and fashions associated with the period rather than lived experience or deep knowledge. Generalized "pastness" accurately describes the image propagated in the Stalin era that neatly conformed to the historical narratives offered by Marxist-Leninist principles. *Without a Dowry* might qualify as one of the "nostalgia films" that Jameson sees as one of the exemplars of this cultural mode, if in a negative variant that accentuated past traumas and deprivations.[60] But even a dark, negative past can be a source of nostalgia offering a comforting familiarity for exiles out of step with their place and time. *Without a Dowry* offers a Russian-historical variant on Protazanov's tendency to set his stories outside of Soviet modernity in an archaic, visually seductive vision of the Russo-European cosmopolitan culture of his youth, to be discussed more in chapters 4 and 5.

Kul'turnyi adaptations of classic Russian literature would remain a staple of the Soviet film industry for the rest of its existence, comprising something like a Russian variant of the French "tradition of quality" scorned by François Truffaut. As Goskino worked to plan its yearly output within a capricious and inefficient system of oversight, adaptations were a useful way to fill out the slate of new releases—works that had been approved in the past did not need initial approval by censors to begin production.[61] But as my analysis of both *Father Sergius* and *Without a Dowry* has shown, for Protazanov, adapting works was as much about the mass audience as cultural administrators. Decades later, Eldar Ryazanov, the postwar director of beloved Soviet comedies such as *Carnival Night* (1956) and *The Irony of Fate* (1975), wrote about his experience watching *Without a Dowry* on its release with a massive, delighted audience: "Protazanov's film had an improbably happy fate. The people unconditionally accepted the picture and, as happens so rarely, loved it with all their heart. And I, too, was part of this mass audience. The strength of the influence of Protazanov's film overshadowed the original source, as if replacing it. [...] A host of nuances, details, observations, and turns of phrase that, naturally, could not make it into the film, were lost, and forgotten by countless viewers and readers."[62] As he worked on his 1981 adaptation of the same Ostrovsky play, *A Cruel Romance*, he had to constantly resist images from the decades-old film that had taken up residence in his mind. His reflections testify to the power that films had in shaping the Russian culture of yore in the minds of Soviet audiences. Yet Ryazanov's admiration for the film—Nina Alisova's son was the director of photography for *A Cruel Romance*, and they went to visit her while preparing to shoot—also suggests the continuity of tradition between the two directors. Protazanov's work in the Stalinist era set up the basis for a "middlebrow" experience of the classics for a mass audience that undoubtedly vulgarized but also genuinely entertained.

Ryazanov also suggests that while the stories lost some of their complexity, their images maintained ambiguity and impact. The constant religious and royal

imagery in *Father Sergius* held a special meaning for its intended audiences at the time of its release. The visual spectacle that *Without a Dowry* makes of its leading actress will strike many viewers as tasteless in a story literally about the objectification of women, but others might find it amusingly subversive in the context of the prudish Communist Party. Protazanov began directing when film directors could only control the visual aspect of the experience, and his approach retained a central orientation toward the powerful, memorable individual image. In the next chapter, we turn to the development of that style across his decades of experience.

3 · REVOLUTIONARY(-ERA) TRADITIONALISM

In the 1920s, leading filmmakers, industry administrators, and critics devoted constant attention to cinematic style in the pages of newspapers and magazines. These debates were fraught, as they were for every aspect of culture in the new revolutionary socialist society. Everything about how to dress and speak to where and how to live could not be taken for granted, including assumptions about making movies—whether they ought to have a single or mass hero, be fiction or documentary, last a long or short time, and serve as entertainment or propaganda. A younger generation of politically conscious avant-gardists challenged techniques of conventional filmmaking, particularly those of the European popular cinema that Protazanov exemplified. They championed the lowbrow American culture that had been pure anathema to Russian intellectuals prior to the revolution. Intricate sets and staging, literary adaptations, extended virtuosic performances, and an emphasis on mood and expressivity lost favor to slapstick comedy, manic chase scenes, and frequent cutting from shot to shot. Rapid stylistic change is practically axiomatic in how Soviet cinema is understood today. But this narrative requires stylistic comparison involving an inevitable process of selection and generalization. A comparison between two films may say more about their respective filmmakers' contrasting sensibilities than it does about the broader trends at the time they worked—not to speak of their different stories, genres, companies, stars, or other crucial factors shaping their style. We would expect a broader stylistic transformation to be better evidenced in a run-of-the-mill filmmaker who followed typical trends. Protazanov's career provides a unique sample of films to understand the contours of the changes in film art under Soviet power. No other holdover from the prerevolutionary industry made as many films or maintained relevance for as long as he did.

As shown in the case of Soviet filmmakers reinterpreting the raucous American movies they loved, style is also an important facet of transculturation among

different cinematic traditions, whether conceived nationally or ideologically. Directors like Protazanov, who crossed borders and worked in different industries, have a uniquely relevant vantage point in this process. Writing about more recent migrant, exilic, and diasporic filmmakers, Hamid Naficy argues that their approaches to cinema are, to varying degrees, impure, imperfect, or otherwise "accented" in comparison with the normative ones of their period and location. They are "created with awareness of the vast histories of the prevailing cinematic modes. [...] From the cinematic traditions they acquire one set of voices, and from the exilic and diasporic traditions they acquire a second."[1] It may seem strange to speak of "vast histories" of style merely decades after the formation of the medium itself. Yet history does not move according to the linear flow of time but in irregularly spaced ruptures. The first three decades of cinema saw more stylistic transformation than any subsequent period. Protazanov provides an intriguing case when these histories of film style were actual lived experiences. He is the rare example of a director who reappropriated styles of the past that he himself had a major hand in shaping in the first place. When we examine the formal features of his films, we see a director who closely followed the works of his peers and sometimes even anticipated future trends. But he was not about to abandon aspects of his craft that were his strengths. His style grew more expansive as he accumulated additional techniques without ever completely jettisoning older ones.

This persistence of certain stylistic features reflects a related truth about the ideological roots of the aesthetic experimentation of the period. While the Communist Party could make recommendations in broad spheres of culture, its ideology was rarely so coherent that it could outright close off avenues for exploration. Political leaders' and cultural administrators' interests in artistic form were largely incidental; they were interested in what films meant and the messages they conveyed, not in how they looked. Stylistic possibilities in the cinematic medium never died out but went dormant, sometimes to return again in a new niche in what Katerina Clark has called an "ecology of revolution."[2] In contrast, Hollywood's well-ordered narrative system after the transition to sound reigned in some of the diversity of the 1910s–1920s. Paradoxically, Soviet cinema maintained an experimental streak because it was more conservative than other national cinema industries.

Protazanov's style is a far cry from the respectable, Stanislavskian realism that Moisei Aleinikov emphasized in his first study of his work.[3] He in fact pursued a more moderate and accessible variant of contemporary modernist movements reflected in the work of his avant-garde peers. His films' eclecticism and diversity also stem from his orientation as a maker of popular cinema who saw each project as a particular confluence of story and collaborators and considered any technique that might prove useful to realizing its potential. Analyzing both well-known

FIGURE 4. A carefully arranged tableau of prisoners in the opening shot of *The Convict's Song*, directed by Yakov Protazanov (1911; Moscow: Gloria).

films and many that have never been discussed in print before, this chapter traces the development of Protazanov's visual style. While a full discussion of how the new audio component was incorporated after 1931 will appear in chapter 6, this chapter covers visual style across his work, emphasizing its transformation in the silent era but not neglecting it after the transition to sound. It begins by situating Protazanov's approach to cinematic images in the broader tableau style that dominated European filmmaking in the 1910s and which I argue remained a foundation for Protazanov's incorporation of later techniques. It examines how, during his stint in France and Germany, Protazanov began to use montage in a way that built on, rather than displaced, this earlier visual approach he mastered. After discussing staging and cutting, I then discuss the logic of the cinematic "trick" analogous to today's "special effect" as an engine for the development of new techniques and argue that Protazanov had a particular fondness for flamboyant deployments of style that showcased new cinematic technologies and possibilities. Despite these commonalities, however, the style of each individual Protazanov film was shaped by the particular genre, story, and collaborators. The chapter argues that, as a result, his most encompassing and representative film in stylistic terms is *Aelita*, where the major strands of his entire body of work are most visible in a single film due to its heterogenous, collage-like

ARRANGING THE TABLEAU, IN SPACE AND TIME

Rarely does the first shot of a director's first film showcase their best-known skill as vividly as Protazanov's *The Convict's Song* (1911; Figure 4). We see a convict labor team stop to rest in a forest, and a young prisoner, Ilya, begins recounting the crime that brought him to prison: when his sweetheart, Alena, married a rich merchant for money, he burned their house down, killing both.[4] The staging shows remarkable confidence in arranging numerous figures in the frame. A path stretches in a zigzag shape from the foreground left frame to the midground right and then to the background left where the prisoners begin the scene. They travel to the end of the path in front of the camera and stop. Early filmmakers often framed exterior shots in this fashion with strong diagonals that receded into the far distance and lengthy journeys by the actors from the background to the foreground. This arrangement showed off the new medium's capability to render a depth impossible to emulate onstage.[5] Ilya drops his sack in the right foreground, and all of the others as far back as the midground arrange themselves carefully around him. As he begins speaking, more than a dozen heads of different characters are visible somewhere in the frame. Protazanov had a remarkable talent for cramming numerous bodies into a frame while keeping the most narratively important ones most prominent.

Starting with the earliest films and lasting well into the 1910s, filmmakers typically staged the action in a relatively wide framing and maintained that same position until it was time to switch to a new location. American filmmakers were the first to stitch together scenes from shots taken from different angles to direct the viewer's attention. They developed techniques of continuity editing such as matches on action, eyeline matches, shot-reverse shot sequences, and the 180-degree rule to reduce the jarring effect of cuts and encourage easy narrative comprehension.[6] By the end of the 1910s, these techniques cohered into the Continuity Editing System.[7] Yet other filmmakers insisted on using lengthy takes without cutting as a matter of stylistic preference, especially many in Europe. When asked about his influences during his early career, Protazanov cited some of the firms best known for their elaborate uses of the single-shot scene, including France's *films d'art* and Denmark's Nordisk. Protazanov was one of the major adherents of what has come to be known as the "tableau style" of silent cinema.[8]

As films' stories grew more complex, they presented challenges in how to arrange incidents onscreen from a single vantage point. Rather than stitching together different camera angles to follow the ongoing action, tableau stylists

managed the action with increasing precision. By carefully moving characters around the small pyramidal space created by the camera's lens, they could direct attention without changing the camera angle. David Bordwell has thoroughly itemized the tricks of the trade. They could place an important detail to the center of the frame or balance or unbalance figures to direct more attention to the edges. They could use empty spaces in the frame or visual apertures created by the set design (doorways, windows, etc.) to suggest where future details might appear. Characters could turn toward the camera to attract the viewer's gaze or turn their backs to direct it away from them; or they could suddenly move or remain still. Directors could stage minor characters in the background and occlude them with characters in the foreground, only to reveal them later when they became relevant.[9] Even without the aid of a viewfinder to see the precise composition, early directors developed an intimate understanding of the way the lens rendered space on the screen and the psychology of attention in their viewers.

The scene in *The Convict's Song* where we see Ilya confront the rich merchant flirting with Alena offers an example of Protazanov deploying these techniques in a visually busy marketplace (Figure 5). Ilya and Alena begin in the background less distinguished from the many others in the bustle of action. Alena takes one of the merchant's shawls, walks to the center, and unfurls it so that it drapes parallel to the frame and attracts the viewer's gaze. A space opens up in the right foreground; the merchant steps out of his stall behind her to fill it. Ilya remains in the background obscured by the merchant and another passing market-goer. As the merchant draws closer to Alena, however, Ilya steps to the right background out of the merchant's view so that the audience can observe his growing suspicions unoccluded before he then inserts himself between them. He leads her off-screen left, then the merchant draws attention to a "cursing" gesture he makes by stepping back into the middle of the frame. With numerous people in the frame, directing a film is not unlike directing traffic.

As the merchant's gesture shows, silent film actors, lacking the spoken word, had to use their bodies. European acting traditions already emphasized the cultivation of gesture, pose, and movement to portray emotional states. Whole lexicons of such poses are available in acting manuals, which often include reproductions of famous paintings and advice to aspiring thespians to practice imitating such exemplars of beauty. Scholars of early cinema have long noted a pantomimic, self-conscious aspect of early silent film acting, whereby characters used stereotyped gestures to signify emotional states and communicate with one another nonverbally.[10] Protazanov's actors often employ a set of stock poses that quickly convey the sense of their interaction. In *The Convict's Song*, when the merchant visits the peasant family to ask for the daughter's hand, he signifies that he will provide for her by producing a billfold and showing it to her

FIGURE 5. *The Convict's Song*: Carefully directing attention in the scene in the marketplace.

father ("Look! Money!"), who then indicates consent by vigorously shaking the merchant's hand ("It's a deal!"). The two men kiss to signify their agreement. The gestures here not only convey that the two will be married without using an intertitle but also emphasize the transactional nature of the agreement.

Actors within this style often performed not to further action but to delay it. Within a single take's duration, a scene accumulates intensity and subtlety. To extend moments of pronounced emotion, actors modulated between intricate series of poses in "gestural soliloquies."[11] Feature films that unfolded in multiple reels permitted a more leisurely presentation of a film's story and gave incentive to "fill out" sections with dance-like variations of an actor's comportment. One such scene occurs in *The Departure of a Great Old Man* (1912), a unique variant of a minor genre of early Russian cinema, the "Tolstoy film." The celebrated author was sympathetic to filmmaking due to its appeal to uneducated viewers, and while he never produced a film himself, he permitted studios to photograph him for films that proved very popular. *Departure* works this popular subject into a "docudrama" about the last days of Tolstoy's life using footage gathered at the writer's estate in Yasnaya Polyana. The intricate makeup job that transformed actor Vladimir Shaternikov into Tolstoy took several hours every day and attracted a crowd on its own.[12] The film is also a vehicle for Shaternikov to deliver extended performances conveying the author's spiritual distress, such as during a scene in which Tolstoy attempts suicide (Figure 6). From frame right, Shaternikov as Tolstoy enters his room in a medium long-shot framing. A table and chair stand on the left; bookcases in the background on the right and left surround a passageway in the center background demarcated with a curtain. Throughout this roughly three-minute scene, Shaternikov pauses briefly to accentuate particular poses as his Tolstoy deliberates. He pulls on a wooden bar over the curtain to test its strength and finds a rope hanging by one of the shelves. Turning toward the camera, he ties a noose with the rope. Upon finishing, he turns slightly frame left and stretches out his hands, each holding a portion of the rope, as if uncoiling it to show the audience. He freezes and holds the rope in his two outstretched arms in an especially pronounced pose. He turns around again to tie the rope so that it hangs from the wooden bar, then once again tests its weight. He walks screen left to a desk, sits in a chair at a frontal angle so that his face is still visible, and begins writing a suicide note. Frustrated, he crumples the sheet of paper and brings it up to his face. He freezes for a moment, pulls his hands apart as if tearing it in half, then freezes again with his arms lower and the two halves in his hands. A peasant woman appears through a dissolve and ends his soliloquy. For the early cinema actor, performance prolonged a discreet incident in the plot into its own miniature drama.

Two actors performing together conceived of their poses in relationship to each other. In some cases, one can see them pause briefly in a group pose that

FIGURE 6. Vladimir Shaternikov's "gestural soliloquy" as Tolstoy during his attempted suicide in *The Departure of a Great Old Man*, directed by Yakov Protazanov (1912; Moscow: Thiemann & Reinhardt).

renders a still encapsulation of the narrative incident. These are shorter and subtler than in theatrical traditions such as the *tableau vivant* but nevertheless salient.[13] A little later in *Departure*, after Tolstoy's failed suicide attempt, Sofia Tolstaya, played by Olga Petrova, asleep on the bed in the adjacent room, wakes up and enters Tolstoy's study where he sobs, bent over the table frame left. She sees the rope dangling from the board between the shelves center frame, walks over to it, and grabs it in disbelief. The two then synchronize the adoption of two poses: Tolstoy looks up with a contorted face and rigidly deployed limbs, looking more in the direction of the sky than directly at Sofia; she stretches her arms out to show the rope to Tolstoy and in doing so turns toward the camera to make it especially prominent in the frame (Figure 7). They freeze in position for two seconds, and their shared poses create a highly legible and expressive still illustration of the action.

In contrast to the ostentatious crowds of extras in *The Convict's Song*, this protracted solo performance followed by a duet suggests the more minimal, focused possibilities of the tableau style. Protazanov was unusually insistent

FIGURE 7. *Departure*: Shaternikov and Petrova in a simultaneous group pose.

on sustaining the single take, but he had a remarkable range in how he would employ it. His films vacillate between extremes. One shot will cram the frame with dense detail and numerous moving actors, while the other evacuates the frame to focus on one character. Some of his images emphasize extensive depth and realistic details in crisp focus, while others use shallow set designs and place characters only along one plane. Often, examples of each will occur in the same film. Protazanov's variety of long-take sequences speaks to his eclectic style and the kind of dynamism he often achieved through contrasts.

DISSECTING THE TABLEAU

More than practically anyone, Protazanov insisted on the one-scene-one-shot ideal of directing. But such directors typically did not forgo editing entirely. Bordwell has described a "roughened" or "attenuated" form of continuity editing coming into use in the mid-1910s among filmmakers predisposed to precision staging. They used occasional cuts to add punctuation to certain events, highlight a particular actor's performance, or show a character that had become occluded in the frame. Yet when doing so, they typically used axial cuts that enlarged a

Revolutionary(-era) Traditionalism

TABLE 1. The average shot length of Protazanov's surviving films, 1917–1927

Film title	Date of production	Location of production	Average shot length (ASL)
No Bloodshed!	1917.07.27	Russia	32.34
Little Ellie	1918.01.06	Russia	26.57
Jenny the Maid	1918.02.28	Russia	31
Hero of the Spirit	1918.03.25	Russia	17.47
Father Sergius	1918.05.14	Russia	23.86
Child of Another	1919.12.10	Odessa	15.31
Member of Parliament	1920.06.06	Yalta	12.45
A Narrow Escape	1920.11.19	France	8
Justice d'abord!	1921.10.28	France	6.84
Toward the Light	1921.12.09	France	5.97
Pilgrimage of Love	1923.01.01	Germany	8.88
Aelita	1924.09.25	USSR	6.24
His Call	1925.02.17	USSR	9
The Tailor from Torzhok	1925.10.25	USSR	6.5
The Case of Three Million	1926.08.23	USSR	4.4
The 41st	1927.03.04	USSR	5
Man from the Restaurant	1927.08.12	USSR	7.8

SOURCE: Data are taken from the Cinemetrics database (https://cinemetrics.uchicago.edu/) plus my observation of additional films.

detail by moving the camera closer but keeping the same angle. Or a cut might bring us to the camera pointed at a different angle but almost never from a different position.[14] While other filmmakers were starting to cut more, Protazanov was insistent on not interrupting the unfolding of a single shot.[15] There are very few examples of him cutting to closer detail all the way into 1916. He did not begin to use editing to complement the tableau style until *Father Sergius*. Yet despite this seeming restriction on his stylistic options, he achieved a remarkable diversity of effects through varied layouts of the space through its set design, arrangements of characters, and their performances.

The move away from the tableau style toward cutting in Europe is typically understood as a reaction to the popularity of American imports.[16] Table 1 presents the average shot length of Protazanov's silent films from 1917 to 1927. He insisted on long takes even as American films began to appear with regularity on Russian screens during the late years of World War I. But between 1918 and 1920, the average shot length in his films dropped by more than one-third—from as high as twenty-seven seconds to about eight seconds. This transformation corresponds to his departure from Russia and his arrival in France. The cutting rate fluctuates some for the rest of the silent era but stays in the same range of about nine to four seconds. With a few exceptions, his Soviet films are not cut more quickly than his emigration films. Protazanov did not begin to cut scenes

FIGURE 8. Boris and Vladimir's duel in a lengthy, unedited shot in *Child of Another*, directed by Yakov Protazanov (ca. 1918–1919; Odessa: Ermolieff).

regularly and consistently until his move abroad, but he adapted his style swiftly when he did.

This sudden, radical shift in Protazanov's work is especially apparent in two comparable scenes. Similar duels between the main characters in *Child of Another* (ca. 1919) and *Toward the Light* (1921) illustrate how Protazanov's editing adds a new layer of expressivity to the characteristics of his earlier work. In *Child of Another* (Figure 8), Boris (Nikolai Rimsky) has challenged a close friend, Vladimir (Evgeni Gaidarov), to a duel out of the mistaken belief that he slept with his wife, Olga (Olga Iuzhakova). The sequence opens with a brief three-shot intercutting pattern between Olga agonizing at home and the two men beginning their duel. (This device is atypical for Protazanov before 1920, although if more duels were present in his surviving prerevolutionary work, it might show that he had used this device before in this context.) In a wide framing, the two men stand in position: Boris in the background screen left, Vladimir in foreground screen right facing away from the camera. Vladimir fires his gun into the air. A cutback to Olga tastefully takes us away from the violence while building anticipation for Boris's response. After these shots of nine-, ten-, and five-second durations, we see the rest of the duel in a single protracted take of seventy seconds. In the same wide framing, Boris raises his gun into the air, slowly lowers it to aim at Vladimir, then fires. Vladimir grimaces, holds his chest with his hand, then turns and collapses out of the bottom of the frame. Four attendants rush from off-screen toward the body and leave the frame when they kneel. Vladimir's falling prompts Boris to approach the camera from an extreme long shot to a medium long shot and put his face in a closer view. We see Rimsky perform an extended gestural soliloquy. He kneels until his head is near the bottom frame line and covers his hand with his face. He raises his head again, removes his hand, and stares off-screen while clutching his jacket. The isolated framing of Boris fixates viewers' attention on his performance and forces them to imagine Vladimir's prospects for survival based solely on Boris's reactions. The shot changes shot scale and performance style without a single cut.

Toward the Light (1921) reprises this scene with constant dissection from different angles through jarring, fragmented cuts—twelve shots in contrast to *Child of Another*'s four (a three-shot excerpt is visible in Figures 9–11). The narrative situation is exactly the same as in *Child of Another*, this time involving Albert (Vladimir Strizhevsky-Radchenko) in the position of Boris, the aggrieved husband, and Hubert (Andrei Zhilinsky) in the position of Vladimir, the allegedly cuckolding friend.[17] It is as if new editing strategies have been layered onto the form of the first scene. Both use a similar composition of the duelists staged in-depth and a cutback to the wife at the moment the first gun is fired. *Toward the Light*, however, opts for a more elliptical presentation of events. Instead of Gaidarov's grieved performance as Boris that ends the first duel, *Toward the Light*

FIGURE 9. Excerpt of the duel between Albert and Hubert in *Toward the Light*, directed by Yakov Protazanov (1921; France: Thiemann), shot 1.

skips over Albert's immediate reaction to the duel, even though his relationship with Hubert is more developed in the plot generally than the analogous relationship in *Child of Another*. An astute viewer might deduce that since Albert's gun was the last to fire, and the duelists exchanged shots in succession, he must have won, but the result is left in some doubt. After the shot of Irene at home, we only see the other men packing up the cars and leaving.

The editing in the second duel is remarkably disjunctive. It avoids smooth matches on action and repeats the exact same shot of the duel supervisor, even though the character has moved to an entirely different part of the frame in the interim between these two shots. These two dislocated shots, rather than providing separate views of a profilmic space, function like units in a syntagmatic chain of signs each signifying stages of the duel in a way that is spatially ambiguous but narratively clear. The major difference in shot scales makes it difficult to determine which figure onscreen is receiving an enlarged view. Perhaps most breathtaking is the shot-reverse shot sequence of the duelists, which breaks the required screen direction according to Hollywood's 180-degree rule. We see Hubert facing screen right, then Albert facing screen right, even though Albert faced left in the wide shot prior. It seems that the camera might be on the

FIGURE 10. *Toward the Light* duel sequence, shot 2.

opposite side of the field until he turns left and reestablishes the screen direction. In these short, fragmented shots, Protazanov in France gestures to the kinds of constructive editing that Kuleshov and others were exploring in the Soviet Union at the same time. The dynamic relationship of cinematography and editing in *Toward the Light* imparts emotional punctuation of this event that *Child of Another* conveys through a lengthy performance. Continuity editing this is not. It is visually disorienting and narratively obscure. By the standards of the emerging conventions of the Hollywood film, the duel in *Toward the Light* is a failure. But there is no reason to apply those standards to this scene. Whether due to self-conscious stylistic exploration or creative misinterpretation, Protazanov's films in emigration hint at some of the possibilities of editing that later Soviet filmmakers would deploy more systematically and aggressively.

As individuals delivered heroic speeches to a crowd with increasing frequency in Soviet films after the transition to sound and the coalescence of socialist realism in the 1930s, Protazanov's carefully arranged, static tableaux continued to make regular appearances. In *Salavat Yulayev* (1940), when the Cossacks debate joining the Pugachev uprising in the aftermath of a fire, Protazanov returns to the axial cutting strategy he used constantly in silent films like *Father Sergius* (1918). In a wide shot, we see eight heads of audience members in the low foreground,

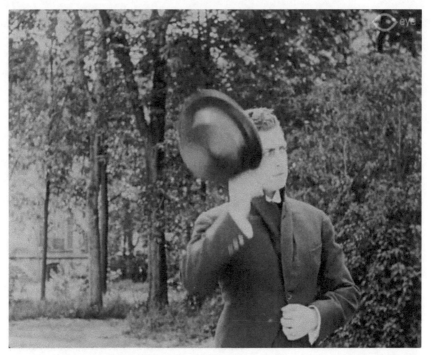

FIGURE 11. *Toward the Light* duel sequence, shot 3. The cut from Albert to Hubert, both facing right, departs from continuity editing's emphasis on maintaining clear screen directions.

the Cossack leader in the left middle ground, with about a dozen other audience members to his right (Figure 12). Three skeptics comment on the speech immediately behind him in the background, while about a dozen more look on from the distant background. From there, Protazanov cuts into a middle shot of the speaker as someone from the crowd joins him, taken from the same angle, and alternates between those two shots and a third middle shot of the three skeptics behind him—also from the same angle but this time unoccluded by the foreground details. When Salavat arrives, a cut brings us to a spatially ambiguous new part of the countryside, where we see him dismount. When he interrupts the speech from off-screen, the crowd turns to the right of the frame to establish the screen direction, then Salavat enters the frame on the right. We never see the two spaces together; they are constructed with his glance. This routine sequence is thus an aesthetic descendant of the "imaginary landscape" experiment conducted at the Kuleshov Workshops in 1920. In one of the short films produced, officially titled *The Created Surface of the Earth*, a man (Leonid Obolensky) and a woman (Ekaterina Khokhlova) meet somewhere in Moscow, as visualized in an assemblage of shots taken in completely different parts of the city with recognizable landmarks. The geography would thus be saliently

FIGURE 12. A tableau in *Salavat Yulayev*, directed by Yakov Protazanov (1940; USSR: Soiuzdetfilm).

impossible for Muscovite viewers. After they meet, the woman points off-screen, and we then see an image taken in Washington, DC—either the White House or the Capitol building—that renders the space even more absurd. The experiment demonstrated that montage can construct spatial relationships out of disparate footage based on cues from within the shots such as screen direction and characters' glances; an establishing shot that shows all parts of the geography together is ultimately a matter of preference rather than a necessity.[18] By *Salavat Yulayev*, these techniques were routine and simply one option to show a coherent space onscreen rather than create avant-garde dynamism through fragmentation. It is not so much that Protazanov "learned montage," or adopted a particular system of representation through editing, as it is that he came to incorporate certain cutting patterns as they came into common use.

CINEMATIC TRICKERY

Filmmakers first used techniques such as cutting, close-up framings, camera movements, and superimpositions due to the novel impression they had on early film audiences, not unlike what we think of today as a "special effect." Tom Gunning and other film scholars call such visually striking moments "attractions,"

following Eisenstein himself; Protazanov's Russian contemporaries often called them "tricks" (*triuki*, derived from the French *trucs*). Gunning and others have argued that, late in the first decade of the twentieth century, a "narrativization of devices" began. Filmmakers came to deploy "tricks" as part of a film's narrative armature rather than for their inherent spectacle.[19] This feature of the era persists in Protazanov's films. It is true that his "tricks" in the 1910s typically have some narrative function, if only in the vaguest sense of "expressing" a character's emotional state or creating atmosphere. But even after, Protazanov still gravitates toward tricks for their own sake; their ties to the specific narrative design in a scene are sometimes tenuous.

The Queen of Spades is practically an encyclopedia of "trick" effects that European filmmakers had explored for more than a decade. None are particularly novel in their use, but the film makes up for this in its systematic and consistent deployment. Critics, both at the time and in retrospect, credited the film with motivating all "tricks" as representations of Hermann's deteriorating psychology. After his first visit to the countess's estate, a single shot portrays him performing the "thinking" gestures common in European films of this period. Frame right, a superimposition shows his fantasies of winning at the gambling table with the other officers, thus signifying his intentions. In another scene, a fade between two similarly composed shots, one with the young countess, the other with the old, signifies her fantasy of her young lover returning. These camera effects serve as an alternative device for demonstrating character psychology; American films would likely use editing to convey these ideas, but Protazanov's quintessentially Russian insistence on lengthy takes with uninterrupted performances leads him to devise an alternative method. A similar trick is the camera movement in the final scene. When Hermann visits the casino for the third time, the framing used during his first two visits changes somewhat. As he walks to the gambling table, the camera tracks at a backward-left diagonal to return to the framing used on the previous evenings and punctuate this dramatic moment. The earliest makers of "actualities" regularly placed the camera on a boat or train to create the effect of motion. By the mid-1910s, it had become fashionable to move the camera in narrative features. Giovanni Pastrone is usually credited with pioneering the technique in *Cabiria* (1912), a film distributed in Russia to great success. The prestige of this technique partially lay in the difficult means; filmmakers typically had to design a special contraption to move the camera, for example, using bicycles.[20] For *The Queen of Spades*, art director Vladimir Ballyuzek and cameraman Evgeni Slavinsky describe mounting the camera on a "lady's shopping cart" to convey his state of agitation upon encountering an unfamiliar environment.[21]

The Queen of Spades's use of "artistic" lighting is perhaps its most novel trick for its time. By the mid-1910s, filmmakers were beginning to exploit electric

theatrical spotlights to do more than simply provide sufficient light for exposure. While the first "dark" studios (those not relying on any natural daylight) were appearing in America, European studios still generally used mercury-vapor lamps to produce the general illumination for a scene, then added arc lamps—or "Jupiters"—to accent particular areas.[22] *The Queen of Spades* borrows a lighting effect from the contemporaneous opera version. Actor Mozzhukhin is positioned very close to a wall behind him. There is no real "action" in this sequence—rather, Mozzhukhin strikes a number of poses to fill the duration of the sequence with a "gestural soliloquy" that expresses Hermann's obsession. A strong artificial light casts a looming shadow of him to his right (Figure 13).[23] Light and shadows are, of course, loaded with associations other filmmakers liked to use to convey a hint of spiritual. But here, like a rebus, the shadow visualizes the most famous line from Pushkin's story known to many viewers then and now: Tomsky says that Hermann has "the soul of a Mephistopheles and the profile of a Napoleon." While a strong shadow brings with it associations with the supernatural and demonic, its shape is also literally a profile. Protazanov and the studio hoped to solicit many audience members' familiarity with the story.[24]

No less than his approach to cutting, Protazanov's move to Europe intensified his use of "tricks." His most extensive experiments with flamboyant special effects would occur in his only German film, *Pilgrimage of Love* (*Der Liebe Pilgerfahrt*, 1923), one of his few surviving films based on an original story rather than an adaptation.[25] In an opening prologue, we follow two childhood friends, Egil (played by Protazanov's son Georgi) and Karin (Erika Schubert), who become orphans when both their parents succumb to a ravaging plague. They run away from cruel foster parents. In the first act, the film brings us to an adult Egil (Gustav von Wangenheim), who now has a respectable career as a doctor. A one-on-one birthday celebration with his friend Dr. Daniel Bornemann (Viktor Schwanneke) prompts a recollection. We learn how Egil and Karin, his lost first love, were separated when he found a benevolent foster father to care for him. That same night during the birthday dinner, Karin (Grete Diercks) shows up at Egil's clinic with a heavy fever and an infant child. In a series of dreams, we learn of her hard times and abuse at the hands of a high-society family. Egil recognizes her and hopes to rekindle their love. However, in an undermotivated and unsympathetic turn, he claims that the child is a disgrace and insists Karin give it up. Daniel, paying a visit to the clinic, notices her leave and follows her to a river, where she attempts to drown herself and the child. He pulls her to the shore and learns of Egil's cruel ultimatum. Daniel brings Karin to the family of Solveig (Charlotte Ander), a young woman he has been courting, to care for her and refuses to let Egil visit. Karin's arrival in the household prompts a minor domestic conflict that is resolved when Daniel asks for Solveig's hand in marriage. Egil,

FIGURE 13. Hermann's "Napoleonic profile" in *The Queen of Spades*, directed by Yakov Protazanov (1916; Moscow: Ermolieff).

meanwhile, having been estranged from both his first love and best friend, sits in a restaurant drinking himself into oblivion. In another unsympathetic turn, his despair prompts him to get a revolver and attempt to murder Karin. However, the sight of her and the child prompts him to reconsider. The film ends with the hope that they will be reconciled at last.

The story of *Pilgrimage of Love* may be an unremarkable melodrama, but the resources available at UFA far exceeded anything Protazanov had worked with before or would see again until the Stalinist 1930s. One can almost sense his delight. A disproportionate number of scenes are shot in the "dark" studio in moody low-key setups that would have been impossible in Russia or France. Many of these occur during rain, with wet sets and costumes reflecting the light in an expressive way. In one repeated shot, Egil watches Daniel, Karin, and Solveig's family through a set of blinds. The key light passes onto his face, lighting the outline of his body while the blinds cast thin lines of shadow across it. The shot could have come from a 1940s Hollywood film noir (Figure 14). This enthusiasm for newly possible lighting effects, however, coexists with some old techniques we remember from Protazanov's past films. A scene of Egil brooding resembles the repeated shot of Hermann fantasizing about the Secret of the Three Cards in *The Queen of Spades*. Egil sits against a plain wall with a candle on

Revolutionary(-era) Traditionalism 93

FIGURE 14. Expressive lighting in *Pilgrimage of Love*, directed by Yakov Protazanov (1922–1923; Berlin: UFA).

a table screen left, which motivates a massive, looming silhouetted profile of his face to appear on the right of the frame. Just like Hermann's "Napoleonic profile," the scene comes at a moment when he commits to a disturbing plan—in his case, to encourage his old sweetheart to abandon her child by another man (Figure 15).

Protazanov's most aggressive tricks, however, come in Daniel Bornemann's extended dream sequence in the clinic's garden, which contains a fountain and four life-sized statues of aristocratic personages seemingly from the recent imperial past (Figure 16). After he sits on a bench and falls asleep, three of the statues spring to life. An overcranked camera creates a slow-motion effect as a man-statue on the far left leaps from his pedestal and skips toward a woman-statue on the far left. The slow motion renders the water spurting from the fountain and the actors' ballet-like leaps uncanny. A cut-in taken from the other side of the fountain shows the two figures doing a sort of pas de deux that becomes a violent exchange. Another man-statue enters from frame right and pulls him away from the woman-statue, casting him onto the ledge of the fountain. As they move, specialized lighting equipment creates a strobing effect. Another woman-statue enters the frame and seems ready to join the fray before Daniel awakens. We see the four statues frozen in poses from the struggle; a dissolve returns them

FIGURE 15. *Pilgrimage of Love*: A shadow of Egil's face in the background recalls a similar lighting effect in *The Queen of Spades*.

to their initial places on the pedestals. Much like *Pilgrimage of Love*'s numerous flashbacks and disjointed plot structure, this scene seems excessive in terms of its narrative payoff. It seems to portend, for Daniel, the conflict between Karin and Egil in which he will intervene for her safety, but that incident itself appears almost immediately after the dream. The resolutely archaic style of the garden and statues draws influence from high academicism and aestheticism; the statues' movements add a flavor of an environmental dance made fashionable by Isadora Duncan. Many scenes in *Pilgrimage of Love* recall Evgeni Bauer's prerevolutionary films or Rex Ingram's pictorialist blockbusters. Protazanov's sole German work indicates how more conservative strains in high culture, like the avant-garde better represented in film history, continued to be a source of inspiration for filmmakers.

As Soviet filmmakers mastered using familiar cutting patterns to direct attention, they also explored how montage could be a "trick" that stood out from the typical unfolding of a scene and solicit a more immediate response. Like nearly every other Soviet filmmaker, Protazanov occasionally unleashes a "montage flourish" of rapid cuts to punctuate a particular moment. Vince Bohlinger has described disjunctive, disorienting combinations of very brief shots at dramatic points in a film's plot as one way that many filmmakers with more moderate

FIGURE 16. *Pilgrimage of Love*: Daniel's garden nightmare.

sensibilities deployed techniques of the Soviet avant-garde. Such flourishes were a consistent aspect of Protazanov's silent films by the mid-1920s, roughly the time when the average shot lengths (ASL) of his films hit their lowest range.[26] A montage flourish occurs during the final sentencing in *The Case of the Three Million* (1926), Protazanov's film with the lowest ASL of his career (4.4). This scene is already cut briskly with close-ups and medium shots from the vantage points of more than a dozen different characters. Only after several shots of characters taking their seats do we see an establishing shot of the courtroom (shown in earlier sequences), which consists of two levels of seats with a modernistic design sensibility. The pace of editing picks up when, after the judge delivers the guilty verdict, master thief Cascariglia (Anatoly Ktorov) appears on the top balcony and announces that he, in fact, was the criminal. A police officer attempts to seize Cascariglia, but he points a gun, drops it, then swings onto the judge's platform. The officer discovers that the gun is in fact a novelty cigarette lighter. As he opens a suitcase and holds up the stolen money (which turns out to be counterfeit), cuts bring us to close-ups of the numerous spectators as they shout "Thief!" but simultaneously seem tantalized by the huge sum of money before them. The cutting accelerates and culminates in a flurry of shots under a second in duration, many only a few frames, that accentuate the subsequent long take when Cascariglia finally begins to toss the bills from the balcony into the crowd.

Protazanov was eclectic in his aesthetic choices from the beginning of his career and only became more so. As he accumulated experience, so too did he accumulate techniques and devices in an ever-expanding tool kit of options to consider. His "omnivorous" style was noted first by Boris Alpers in a contemporary review but made influential later by film scholar Neya Zorkaya.[27] Having quickly made dozens of films in the first five years of his career, he seems to have arrived at particular working methods. He used them as a foundation for later shifts in the art of film, such as the use of editing, the Soviet emphasis on documentary realism and "simplicity," and the arrival of sound. Protazanov could be considered a "weak" stylist rather than a "strong" one, in the sense of having loose preferences rather than a highly regularized systematic approach to filming a scene. Most of his films see him gravitate toward a particular contour of his style in accordance with their genre. His films on revolutionary topics look a lot different from his comedies from contemporary life, his classic literature adaptations, or his high-society melodramas and comedies. The defining exception is *Aelita* (1924), a science-fiction literary adaptation that is today his most famous film. There, Protazanov pursued his most radical experiment in combining disparate styles that form a summary statement of his career. The next section analyzes it in the context of New Economic Policy politics to clarify some of the defining strands in Protazanov's approach to filmmaking.

A COLLAGE OF STYLES IN *AELITA*

Along with *Marionettes* (1934), analyzed in chapter 6, *Aelita* represents Protazanov's most sustained attempt to realize modernist principles within a popular idiom—in particular, in its collage of heterogeneous, even discordant styles within the same work. He arrived at this approach as the film went through a protracted production in 1923–1924, an uncertain period in Soviet politics. At the moment Protazanov was under particular personal scrutiny, he attempted to rework the blockbuster literary adaptations of his prerevolutionary years. As he updated this formula, he was attentive to the new ideas circulating among the likes of Kuleshov, Vertov, and Eisenstein. The film is a tossed salad of genres, each in a particular style and with a particular emotional tenor, that challenges basic notions of aesthetic unity and harmony—both for us today and for the viewers at the time. As is well noted, the film provoked a backlash within the Soviet film industry as an embodiment of the worst tendencies of "bourgeois," "commercial," and/or "foreign" cinema. Yet scholars have overstated this negative critical response in certain respects; in fact, much of this assessment of the film did not crystallize until later in the decade, particularly after the 1928 All-Union Conference on Cinema. Upon its initial release, critics were more accurately

ambivalent, and often favorable, and focused more on the film's unusual style and story than its ideological presuppositions.

Despite Rus''s shaky finances and institutional problems in 1923, it put colossal sums into *Aelita* in an attempt to deliver a big-budget blockbuster—a strategy with a track record as good as any. As Hollywood films strengthened their presence in Europe in the early 1920s, local firms countered by making features with monumental scale and pan-continental appeal, such as the French megaproduction *The Three Musketeers* (1921). Regular trade press articles on *Aelita*'s production highlighted its impressive scale and the investments in studio technology that advanced the impoverished film industry. For example, Rus' purchased state-of-the-art German lamps that gave "the full illusion of light from the sun"[28] necessary for the giant Martian sets that exceeded the current equipment's ability to provide sufficient illumination.[29] These reports and the film itself thus both fit IAH propaganda's recent emphasis on Soviet Russia's successful reconstruction and growing industrial prowess, though the solidarity organization exercised little control over the production of the film itself.[30] After Protazanov returned to Moscow on September 26, 1923, the company began shooting exterior sequences while Rus' constructed a massive new studio. Weeks later, Protazanov and company shot footage of the annual celebration of the October Revolution to incorporate into the scenes before the spaceship's launch.[31] The space flight sequences also presented an opportunity to show students from the Red Army's Aviation Academy doing maneuvers at the Central Aerodrome.[32] By March 1924, the production team finished the bulk of the interiors and exteriors set on Earth and began shooting the Martian sequences.[33] Internal documents at Mezhrabpom showed that production of the film was in "full swing" by May 1924. Yet despite the increased resources, the company faced a constant shortage of film stock. Several times, the supply ran out and forced the company to halt production until more could be procured.[34] The team worked without any oversight from the IAH, the leadership of which had not seen a version of the film as late as September 1924.[35] It played for the first time for political leaders, including five representatives of the Communist International, on September 27 and premiered in Moscow in October after being in production for over a year.[36]

Science fiction was not an established film genre in 1924; the preferred Russian term for the literary genre, *nauchnaia fantastika* (scientific fantasy), would not come into use until later in the 1920s. Protazanov and company would have approached the project as, essentially, an adaptation. Stories of interplanetary travel had grown popular with Soviet readers but had still not garnered respect among the literary intelligentsia.[37] Alexei Tolstoy's novel *Aelita* draws from popular adventure novels and Edgar Rice Burroughs's pulpy Nick Carter books far more than the philosophical speculation of Yevgeny Zamyatin's novel

We (1924). Word of *Aelita* first appeared in *Kino-gazeta* on September 11, 1923, which described it as a production "in the style of an artistic *detektiv* and scientific romanticism," the former term referring to Russian variants on crime and murder mystery serials that freely borrowed from many Western popular literature genres.[38] The first reports already claimed it would make dramatic changes to the Tolstoy novel; the story would occur half on Mars and half on Earth in the era of the New Economic Policy.[39]

In the opening pages of Tolstoy's original, we meet Los', an engineer who boasts about his plan to fly to Mars in an egg-shaped spaceship he has constructed by himself. Gusev, a bold Red Army veteran, decides to accompany him to the red planet, where they encounter an oppressive foreign civilization on the verge of collapse. Los' begins a romance with Princess Aelita, but an armed rebellion of Martian proletarians forces him and Gusev to return to Earth. At the end of the novel, Los' seems to receive radio signals that Aelita is still alive and waits for him. This basic outline comprises less than a fifth of the film version, which adds several entirely earthbound intrigues and numerous earthling characters. In Moscow, Los' and his (now added) wife, Natasha, become estranged when his friend, Spiridonov, loans an adjacent apartment to Viktor and Elena Ehrlich, a conniving bourgeois couple engaged in an illegal speculation of goods. It also introduces the resonances of different genres that nuance Tolstoy's straightforwardly juvenile adventure in both content and tone. Coming at a period of great uncertainty in the direction the Soviet Union would take in 1922–1924, *Aelita*'s complex, contradictory narrative and, eventually, its troubled reception stemmed in part from the ambition with which it attempted to represent this society in transition.

The most criticized departure from the novel was the decision to transform Los''s journey to Mars into a dream. This narrative structure was a carefully considered creative choice, not an afterthought. The screenwriters tried a number of different ways of handling Los''s fantasy but ultimately chose to do so in a way that made the initial distinction between dream and reality ambiguous.[40] At the beginning of the film, Los' becomes obsessed with radio signals containing the mysterious phrase "Anta, Odeli, Uta." These specific words do not appear in the novel at all, which only mentions radio transmissions at the very end. Intertitles mention Los' "dreaming" or "imagining" things before scenes set on Mars, but there are never strong visual cues—fades, dissolves, or other devices used in Protazanov's other films—that signify that what we see is in fact his subjective experience. Without a cue, the plot enters Los''s imagination entirely when he seems to catch Natasha in an act of infidelity, fires a gun at her, and then rushes to a train station. After this event, more than halfway through the film, he begins building the spaceship—the novel's starting point. Los' and Gusev land on Mars and spark a rebellion, as in Tolstoy's novel, but

Revolutionary(-era) Traditionalism 99

this time accompanied by a new character, the stowaway and wannabe detective Kravtsov (Igor Ilyinsky). Aelita betrays the proletarians by declaring herself their new Martian ruler. Suddenly, as the uprising morphs into a palace intrigue, Los' wakes from his reverie and finds himself back at the train station. The mysterious signal "Anta, Odeli, Uta" is revealed to be an American brand name for tires he saw in an advertisement. At the end of the film, he abandons his dreams of interplanetary conquest to serve his country and wife, Natasha, who—remarkable woman that she is—forgives him for attempted murder without hesitation.

Though the changes to the novel add present-day relevance, they complicate its thematic tidiness. The novel's Los' is a proto-socialist-realist hero defined by little more than his ambition for space travel. In the film, the subplots on Earth, especially those related to his marriage, transform him into a far from morally exemplary character. The appearance and brooding, pensive comportment of Nikolai Tsereteli also recall the now much-loathed aristocratic protagonists of prerevolutionary films. After NEPman Viktor Ehrlich attempts to seduce Natasha, Los' becomes obsessed with her potential infidelity, though the film reveals early that she has remained faithful. Los''s persistent distrust—and hypocrisy, given his own interest in Aelita—is likely to come across as unfair. The novel's proletarian-veteran hero Gusev retains his revolutionary fervor in the film but no longer in the context of the former's adventure genre with caricatured characters. The more realistic-dramatic framework of the film makes him stand out as cartoonish. Earlier versions of the script use Gusev as the mouthpiece for more direct political messaging and in doing so push him into self-parody.

The film further complicates the neat Los'/Gusev dichotomy by adding a third term: the comic faux-detective Kravtsov, who, by the Martian journey, gets screen time equal to the main characters. No such character appears in the novel. Protazanov's invention and expansion of this character's role probably stemmed from a desire to incorporate the talents of Igor Ilyinsky, a stage actor whose profile was rapidly rising in the film industry due to his role in Vsevolod Meyerhold's productions and with whom Protazanov would collaborate in many of his celebrated comedies discussed in chapter 5. Another pair of characters, Natasha and Masha, both bear the burden of their husbands' shortcomings and provide the film's moral center. The film is particularly attentive to Natasha's labor, including her job at a station checkpoint, then later at an orphanage, then in her domestic duties, such as washing clothes and cooking in Los''s presence. Yet even she is vulnerable to the temptations of NEP-era society. Despite rebuffing Viktor Ehrlich's advances, Natasha still capitulates to his invitation to a secret NEPmen party furnished with luxuries—a decision that would be unthinkable for a Soviet heroine just a few years later. Masha receives less screen time, but the film hints at her resilience in one scene at home with Gusev. When he announces his plans to join the Martian adventure, he explains that he is going

stir-crazy without a grand revolutionary mission to devote his energies. Thus, the film suggests the challenges of her daily drudgery. The film questions—even ridicules—characters who take on more heroic duties, contrasting them with those who make modest contributions to rebuilding Russia with little fanfare. In the final scene, Los' destroys his blueprints for a spaceship in favor of strengthening his marriage. While the film criticizes the NEP generally, it valorizes the everyday struggles of people to stay the course. It also expresses some skepticism about the more aggressive components of the Soviet mission, including its international expansion and its more radical challenge to traditional gender norms.

The divergent styles of the film contribute to this fundamental ambiguity. Philip Cavendish calls attention to this heterogeneity in his discussion of its cinematography. He distinguishes between four photographic styles it brings to a respective setting in the film: a "theatrical principle" for the studio sets of Mars, a "melodramatic" style for the various human intrigues on Earth, a "semi-documentary" style for the streets of Moscow, and a "documentary proper" style for the scenes of Earth as viewed from Mars.[41] One could take issue with these specific categories, but they capture the distinct but overlapping approaches to style in all aspects of the film's form, not just their cinematography. They indicate Protazanov's familiarity with a broad range of trends in the visual arts and cinema and the general eclecticism of his "omnivorous style."

Without a doubt, the best-known component of *Aelita*'s form is the stylized sets and costumes in the Martian sequences designed by Alexandra Ekster and her protégé Isaak Rabinovich. Ekster had spent considerable time in Europe during the 1910s and became familiar with Cubism and other trends in the fine arts. To Protazanov, a close follower of the Moscow theater world, she would have been most familiar for her work with Alexander Tairov at the Kamerny Theater. Her designs for Tairov's renditions of *Thamyras Cythared* (1916), *Salomé* (1917), and *Romeo and Juliet* (1921) resemble her work on *Aelita*. As Ian Christie points out, these decorations are more famous than the film itself, because images of them appeared in books about the Russian avant-garde for decades while the film itself was out of distribution.[42] Christie ties these aspects of *Aelita* to other attempts across "Film Europe" to create big-budget spectaculars with unique national artistic styles, such as *The Cabinet of Dr. Caligari* (1919), *Metropolis* (1927), and *L'Inhumaine* (1924). Superficially, Ekster and Rabinovich's designs on Mars seem radically different from the bourgeois opulence of Protazanov's earlier sets. But this monumental-pictorialist strand of *Aelita* nevertheless conveys scale in the traditional terms derived from the big-budget European films of the late 1910s and early 1920s, including Protazanov's own. One of the most deliberate tableaux can be seen when Gusev, pursued by Martian soldiers, encounters Aelita and Los' during their elopement, throws a smoke bomb, and delivers a revolutionary speech. After the bomb explodes, all of the several dozen

characters in the frame, arranged on multiple platforms of varying heights, suddenly freeze (Figure 17). While most salient in the Martian sequences, this pictorialist approach also appears on Earth. The telecommunications office has a number of shots staged in deep space so that characters are visible in both the foreground and background. The scene when Los', disguised as Spiridonov, visits Natasha's funeral is reminiscent of the opening of *Father Sergius*. Protazanov incorporates Ekster and Rabinovich's avant-garde contributions as a series of striking static images he relied on in prerevolutionary times.

Aelita's actors similarly base their performance on a series of static poses. The aspect of the film most indebted to *The Cabinet of Dr. Caligari*, which Protazanov himself cited as an influence, is the self-consciously exaggerated arrangements of actors' bodies and gestures to reinforce visual components of the set design.[43] Yuliya Solntseva's later recollections suggest that this was a central approach to her performance as Aelita:

[Costume designers Nadezhda] Lamanova and Ekster were sitting in the depths of the room, casting glances at me and quietly conversing. I understood at once that they were talking about me, my costume, and my appearance. They were waiting for someone. Finally, Yakov Alexandrovich [Protazanov] arrived and headed straight towards me.—Separate your arms, place them like this, turn, again, again, now don't move. I fulfilled his requests without understanding the sense of what was happening, but then suddenly Protazanov stepped to the other side, called Limanova and Ekster, and placed me in the last pose that he had showed me.[44]

This Expressionist approach is most visible in the Martians—both authorities and "proletarians"—who contort their bodies in unnatural positions. The Martian guards and slaves wear masks that obscure their faces and use gestures to convey their behavior. They move in a plodding lurch, pausing between each step, often in synchrony. Probably the most stylized performance comes from Alexandra Peregonets as Ikhoshka, Aelita's maid, who typically stands in an unnatural (and uncomfortable-seeming) squat that causes rigid portions in her pants to stick out in a dramatic, ninety-degree corner. Tsereteli as Los', too, notably shifts his performance style in the Martian scenes to make broader gestures and hold poses for longer. Shortly before his dream on Mars is interrupted, when Aelita declares victory, he stands in a static pose. With one leg on a platform below her, the other bent on the next rung, he stretches out his arms as far as possible, like a stereotypical young lover from a 1910s film.

When Martians and earthlings interact, their different comportments are a source of comedy. Take the first scene when Los' and Gusev encounter Aelita and Ikhoshka. Aelita and Los' freeze in place and hold poses. Gusev, in contrast,

FIGURE 17. A spectacular tableau as Gusev delivers his speech to the Martian proletarians in *Aelita*, directed by Yakov Protazanov (1924; Moscow: Mezhrabpom-Rus').

energetically attempts to introduce himself to Aelita. While she is transfixed at the sight of Los', Gusev steps toward her and attempts to shake her hand, but she refuses to break her pose. Later, Kravtsov makes a similar joke when Martian soldiers march him and Ikhoshka to the council. The two follow the guards down some steps leading diagonally toward the bottom left of the frame. The soldiers in front of them descend in their typical lumbering steps. Their glacial pace causes Kravtsov, frustrated, to have a seat on the steps, stand and catch up, and then have another seat as he awaits them to make some progress. Ilyinsky's manic energy thus butts heads with Expressionist ponderousness.

In the more melodramatic sequences, Protazanov returns to his "tricks" celebrated in films like *The Queen of Spades*. Los' returns home after his business trip and waits for Natasha below the stairs with some flowers. On the wall in the background, a square of light appears to signify a door upstairs being opened off-screen. Two silhouettes resembling Viktor Ehrlich and Natasha appear within it and embrace (it later turns out that it is actually Elena Ehrlich's shadow rather than Natasha's; they have similar hairstyles), echoing the "Napoleonic profiles" of both *The Queen of Spades* and *Pilgrimage of Love*. When Los' subsequently fires a revolver at her, the shots break a mirror situated on the wall opposite the stairs. Then another mirror

appears during Los' and Natasha's reconciliation that thematically ties it back to the earlier murder attempt. The Ehrlichs observe Los' kneeling before Natasha under a moody lighting setting with a mirror in the background doubling the couple's image. As Protazanov made a Soviet blockbuster, he returned to many of the ostentatious effects of his prerevolutionary ones.

By 1923–1924, the abstract designs and static arrangements on Mars had given way to more explicitly political and realistic avant-garde movements. Protazanov was no less attentive to them, though their presence in *Aelita* attracted little acclaim. He was familiar with the early writings on Soviet film theory that began appearing prior to *Aelita*'s release, including Kuleshov's first writings on montage and Dziga Vertov's early essays on the all-seeing "Kino-Eye." In an interview just a few months after *Aelita*'s release, he "happily noted the work of two antipodes–Comrade Kuleshov and Comrade Dziga Vertov (unfortunately, the less understood and appreciated of the two)."[45] Protazanov's encounter with Kuleshov's theories prompted the new editing techniques in *Aelita*. Editing to analyze a larger space became a regular part of Protazanov's style during his stint abroad. In *Aelita*, he first explores the possibilities of editing to *construct* nonexistent spaces, following the principle of Kuleshov's "imaginary landscape" experiment. Many scenes forgo a broader establishing shot and instead rely on close-ups linked through eyeline matches. Probably the best example of constructed spaces is a quasi-exchange between Los' and Aelita. While working on his designs for the spaceship in his workshop, Los' writes "ANTA ODELI UTA" on a frosty windowpane. In a subsequent reaction shot, Aelita appears in the scene for the first time, observing from Mars through Gor's apparatus. We return to Los', and he wipes off the words. Thus the power of montage collapses whole planetary distances.

Protazanov's nod to Vertov in the quote above might come as a surprise, as the documentarian's ideas initially seem less amenable to the fictional feature film. Yet there are clear attempts to build on his insights and participate in his enthusiasm for cinema as a technology to expand human faculties. The plot of the film includes many elements of communications and observation technology that do not appear in the novel; the film's Los' is specifically a specialist in "interplanetary communication." Though there are a few references to radio signals in Tolstoy's novel, the mysterious signal "Anta, Odeli, Uta" is Protazanov and the company's creation. Technology's ability to enhance the senses receives further emphasis in Gor's Earth-surveying apparatus and Aelita's telescope, neither of which appear in the novel. Aelita's look into the telescope prompts the appearance of disjunctive images from around the globe. This stylistic choice encourages a thematic comparison between the possibilities of this device and those of cinema itself that so preoccupied Vertov. A subtle stylistic cue further encourages this reflexive investigation of cinema's representational

possibilities. A two-shot sequence first shows Aelita looking from the observation center, then Los' against the Moscow skyline. In the first shot, Aelita adjusts a lever-like object that controls the machine. Then the second shot begins out of focus and quickly readjusts to present Los' clearly. These combined stylistic elements establish that what we see is a literal point-of-view shot created by Gor's device and emphasize the shared technological role of lenses in both telescopes and cameras.

Another loosely Vertovian element is *Aelita*'s regular incorporation of documentary images. The script specifies the use of nonfiction footage in two moments: first, in the opening shots that portray the radio waves traveling across the globe; second, when Aelita first surveys the world with Gor's apparatus. Later, the film takes an outright detour into documentary filmmaking in lengthy sequences with little narrative significance. The first occurs on Los''s business trip, which includes footage of a construction site that would not be out of place in a newsreel or actuality film. The second occurs in a scene showing Natasha's new job in an orphanage, where we see extensive images photographed at a real-life one (Figure 18). These sequences' awkward position in the plot and excessive time onscreen interrupt the flow of the narrative. These documentary interludes are probably the aspect of *Aelita* least appreciated in the present but most salient for audiences on its initial release. Reviews noted that the documentary footage "left a strong impression. Russia is strengthening, building."[46] It is not clear why Protazanov decided to insert them at this particular moment, but they suggest an attempt to work in some of the IAH's general rhetoric visible in other materials at the time. In 1922–1923, the IAH was shifting from providing famine relief to the "productive assistance" of Soviet Russia's general economic reconstruction, using its resources to rebuild factories and other infrastructure in areas such as Kazan, Chelyabinsk, and the Ural Mountains. It had also founded a number of orphanages for the many children displaced by war and famine—one of these may very well have been the site of the documentary footage in *Aelita*.[47] It would be hard to justify these inclusions from a storytelling perspective, but as evidenced by the film's use of monumental sets and modern special effects technologies, the creators were thinking as much about the evidentiary value of the images in the current political environment as their narrative significance.

Fusing Vertov's and Kuleshov's insights, Protazanov constructs scenes out of these documentary images in combination with shots with his actors. Just before the launch of the spaceship, Kravtsov rushes to arrest Los' (disguised as Spiridonov) in the hangar before takeoff. A Moscow parade in honor of the launch blocks traffic and requires both Kravtsov and the tardy Gusev to rush to make it in time. Staged sequences of each appear among documentary footage taken from the actual 1923 celebration of the anniversary of the October Revolution on Red Square, which the crew shot itself. Ilyinsky's madcap performances

FIGURE 18. *Aelita*: Documentary footage used in the scenes of Masha's orphanage.

and details, such as Gusev bumping into a peasant woman, add much of the physical comedy that dominated Kuleshov's *The Extraordinary Adventures of Mr. West in the Land of the Bolsheviks* (being produced almost concurrently with this film). More importantly, though, the editing in this scene itself draws from Kuleshov's central insight: an event that never happened can be created in cinematic space from images taken in different places. Protazanov situates images to exemplify the possibilities of cinematic montage praised by early Soviet theorists.

Thus the style of *Aelita* was far from a retrograde throwback to prerevolutionary Russian cinema, even if it incorporated and reinterpreted many of its elements. More than anything, the intended propaganda value of the film was based on this style. The massive scenes on Mars testified to Mezhrabpom-Rus''s filmmaking prowess; the documentary images testified to the IAH's global impact. This was precisely the attitude that IAH chairman Francesco Misiano took in correspondence with Glavrepertkom, the relatively lenient board that controlled censorship. He did not attempt to defend *Aelita* on ideological grounds and stressed that Rus' completed it before the IAH had gained any influence over the company. But he asserted its one central merit: its massive scale, whatever its message, inevitably would reflect well on the Soviet economy. He wrote, "We venture to declare that *Aelita*, despite all its faults, will serve as great propaganda for Soviet Russia abroad. One cannot forget that, above all,

Aelita is the best proof that the current Soviet industry is on the same level with foreign film industries and the best refutation of the lies spread abroad that the Soviet economy has not developed, that it lacks creativity, and that its industry is in a worse state than before the war." He hoped that the film would show an "image of the pulsing life in Moscow" to curious foreigners.[48] Like many critics, he thought more in terms of the value of its images, whether documentary or constructed, as a form of visual evidence rather than the film's textual coherence as a conveyor of a desired message.

But Mezhrabpom-Rus''s privileged standing in the film industry in 1924 made a backlash against its first major production inevitable. Younger, more radically inclined cinéastes eager to promote their theories and advance their careers, unsurprisingly, were the harshest.[49] However, most critics rarely identified any ideologically questionable theme and focused more on compositional aspects of the film's script. Vladimir Erofeyev articulated a basic story that others repeated: the filmmakers had set out to make a Soviet point of view more salient than in the original novel, but somewhere along the way, considerations for foreign audiences rendered the final product incoherent. In contrast to the centrality of Ekster's designs to the interests of today's viewers, contemporary critics said little about the Martian Constructivist sets. Sh. Eliava, for example, wondered in passing why Mars resembled a production at the Kamerny Theater.[50] At a time when resources were scarce, much of the discussion of the film deployed a rhetoric of efficiency to criticize the film's scale. One critic calculated that with *Aelita*'s budget, it would be possible to make no less than ten films of roughly 1,200–1,500 meters in length (about one to one and a half hours), which would also leave more room in the screening program for newsreels and other edifying content.[51] One senses industry-wide resentment for the funds that Mezhrabpom-Rus' was able to gather due to its special relationship with the party-state and international organizations.

However, in contrast to industry trade publications, reviews in mass periodicals for a general audience were relatively positive. Even when they identified similar shortcomings, they did so in a more optimistic tone. Both *Trud* and *Izvestiia* appraised the sets and costumes highly.[52] Critics outside of the industry seemed to appreciate the film's entertaining qualities. "What does the new Soviet film *Aelita* give from the point of view of our cause?" wrote a critic in *Vecherniaia Moskva*. "Practically nothing. [...] But here is a strange matter: the nine reels of the film are easy to watch, with a gripping interest, inspire a certain strong cheerfulness, and give moments of an extremely gladdening sensation."[53] Nor were their ideological assessments universally negative. *Krasnaia zvezda*, the official newspaper for the Ministry of Defense, went as far as to recommend the film for Red Army veterans; the reviewer approved of the film's lighthearted treatment of

Gusev as humanizing, despite thinking the film sometimes took the *detektiv* elements in the Earth sequences a bit too far.[54]

But how did *Aelita* fare with actual audiences, Soviet or otherwise? Past scholars have reached opposite conclusions depending on their scope of inquiry and evidence, with some claiming *Aelita* was a massive success and others a total failure.[55] The best evidence shows that in Russia, the film garnered impressive ticket sales—it was definitely not a failure. A number of theaters in Moscow and Petersburg held the film over for more weeks than expected, a fact visible in a cursory look at advertisements in the trade press.[56] Internal documentation also bears out some success. A report on the state of the film industry by the Soviet secret police (OGPU) from November 4, 1924, noted that the film was selling out theaters in Moscow, but it faulted the IAH for negotiating a minority share of the gross returns—40 percent for IAH, 60 percent for Rus'—instead of a 50/50 split. Presumably, this would only be a sore point if the film was generating significant income.[57] But *Aelita* was undeniably more popular in the Soviet Union than it ever was farther west. The major staff at the IAH were unprepared for the complex task of finding the appropriate exhibition venues in Europe for a blockbuster film and cutting the best deals with distributors there, not to speak of the challenges of passing censorship boards politicized against anything Soviet. Four separate high-ranking staff—including Friedmann, Pfeiffer, Aleinikov, and even Münzenberg himself—were simultaneously negotiating the rights for the film in multiple countries, sometimes on its own and sometimes as part of a package deal with other productions. They disagreed on strategy, did not coordinate their activities, and accidentally sold the rights multiple times to different distributors. On one occasion, they had to withdraw from a deal with DAFU, a major German distributor, due to miscommunication.[58] By October 1925, one year after the film premiered in Moscow, *Aelita* had not been shown anywhere in Germany, the biggest European market. A review in *Lichtbildbühne* suggests that the film had made it to Berlin by February 1926 but with little fanfare.[59] *Aelita* ultimately was "sold for a sandwich" as part of a package deal of thirteen films over a year after it first played in Russia.[60] There is no way to judge Soviet critics' regular refrain that *Aelita* played to the tastes of foreign audiences—it failed to reach them due to mismanagement.

Aelita represents Protazanov's style at its most expansive point in his career. It redeployed the techniques he already knew well, incorporated the trends of nascent Soviet cinema, and predicted many still to come. It also corresponded with a critical moment in his biography in the immediate aftermath of his decision to return to the Soviet Union and announce, if not his complete conversion, at least his reconciliation. Forced to adapt and change, his style became more chameleonlike and, as so frequently joked later, Protean. Though at first glance,

it seems instrumental and practical, this aspect of his approach to cinema in the Soviet era is inseparable from his personality and position. In the ambivalent character of Los', himself a "technical specialist" akin to Protazanov itself, and the story of his interplanetary border-crossing journey, the content he added to the film was also directly relevant to his own experience of migration, as would have been apparent to his peers. The next chapter turns from the style of his films to their content and their consistent thematics of migration and dislocation.

4 · ABROAD AT HOME

Protazanov's decision to leave Russia and then return to the Soviet Union catalyzed major changes in his work. While his specific trajectory was unique, film directors crossing borders is, if anything, common. They have talent and attention that win them opportunities outside of their native country; their work is visible and influential in the mass culture industry, thus making them early targets of changes in political power. It is the prevalence of such biographies and the recurring tropes of these experiences that led Hamid Naficy to draw broader conclusions about the work of dislocated and mobile directors of the late twentieth century. He uses a linguistic metaphor to emphasize the resulting hybridity of their films. If not necessarily working in different languages, émigré filmmakers must work with different cultural material and in consideration of different audiences, leading Naficy to characterize these "accented films" as "mulatta texts [. . .] created in a new mode that is constituted both by the structures of feeling of the filmmakers themselves as displaced subjects and by the traditions of exilic and diasporic cultural productions that preceded them."[1] The previous chapter showed how Protazanov's approach to film form involved increasingly mingling the voices of the prerevolutionary commercial cinema where he had learned his trade with the coalescing Soviet culture he both adjusted to and shaped. But Naficy is interested in not only the aesthetic hybridity of these accented films but how they "signify and signify upon exile and diaspora by expressing, allegorizing, commenting upon, and critiquing the home and host societies and cultures and the deterritorialized conditions of the filmmakers."[2] However multifaceted, the "commentary" Naficy is speaking of refers specifically to the content of these films, including their characters, settings, plot structures, and themes.

So far, this book has examined aspects of Protazanov's working practices, adaptation of texts, and style. It has for the most part portrayed him as a collaborative craftsman able to sustain his creative energies on a variety of material in contrast to an artist "working through" deeper personal conflicts or attempting to express a coherent vision of the world. This chapter turns to this topic. It argues that

there is indeed a theme of exile and emigration in Protazanov's films that begins with his departure from Russia. Most interestingly, though, this thematic continues upon his return to his ostensible homeland in 1923; in fact, in many respects, it is stronger in his Soviet films than in his Western European ones. Though more prominent in some films than others, exilic topics are consistent enough to be core features of the "author code" of his oeuvre. The way Protazanov's films subtly refer to experiences of geographical movement, to home and host country, and to uncertainties of identity and allegiance betray how they are products of not a faceless engineer of propaganda or escapism but a flesh-and-blood human being who experienced the revolutionary era.

This chapter traces the fluctuations in this commentary, starting in 1919 when Protazanov left Russia, with particular emphasis on *A Narrow Escape* (*L'angoissante aventure*, 1920), his film with the most explicit commentary on emigration and most mobile production circumstances. In contrast, his other French and German films attempt to be indistinguishable from typical products of those nations' culture industries, even as he had to grapple with the social and cultural prominence of Russian migrants in each. The exilic commentary then forcefully reappears in his first works upon repatriation, *Aelita* and *His Call*. From there, exilic themes are more dispersed and subtle in his Soviet films, but several regular tropes persist, including settings with a salient duality, plots involving traveling and border crossing, characters with ambivalent loyalties, sympathetic outcasts of the Soviet vision, and recurring transformations of identity. Protazanov then reprises his experience as a migrant in his final film, *Nasreddin in Bukhara* (1943), made during his evacuation in Uzbekistan under a quite different kind of compulsory migration.

ASSIMILATION AND EXOTICISM IN THE EUROPEAN FILMS

Naficy emphasizes how exilic filmmaking often involves alternative modes of production, including highly collaborative arrangements of artists and under-capitalized material means. One would be hard-pressed to find a 1920 film that better exemplifies these conditions than Protazanov's first properly exilic film, *A Narrow Escape*, which came together as he continued working during the journey from Yalta to Paris as the Ermolieff company fled the civil war. It is a truly mobile production, in contrast to Protazanov's later films at Ermolieff and Thiemann when they had permanent bases of operations. Despite being exceptional in this regard, it is the best known of Protazanov's films of the period and the only one discussed in the last full-length study of his work (Arlazorov's, 1973).[3] Some additional ones from 1919 to 1923 that have reemerged in recent years shed additional light on how exilic themes first appeared in his work.

Naficy argues that exilic films often focus on crossing borders, whether in a sense of geography or identity. *A Narrow Escape* takes the form of a journey. The film follows a carefree bachelor, Octave Granier (Ivan Mozzhukhin), who abandons his wealthy family in pursuit of Yvonne (Natalie Lissenko), a music hall and movie actress. The two travel abroad, eventually reaching Paris and taking a variety of jobs to get by. The film includes memorable exterior shots of the Blue Mosque in Istanbul, the port of Marseilles, and the Eiffel Tower, reflecting the Ermolieff company's stops along its way.[4] Yvonne restarts her acting career in Paris. One day, Octave substitutes for a missing actor in the background of one of her films, leading the director to discover his talent. The two performers advance in their careers and have a daughter, but their ascent comes to an abrupt halt when Octave is disgraced in a gambling scandal. Their relationship falls apart, and they end up working as circus performers with their daughter, who dies in an accident. At his lowest point, Octave suddenly wakes up and rejoices to learn that his marriage and disastrous journey abroad were all a dream. Thus, the melodramatic trajectory of the couple's decline abroad is suddenly cast away by a return to the lighter frame story at home. The film ends with the comically misogynist "moral" that no woman is worth such sacrifice and that upper-class bachelorhood has many things going for it. *A Narrow Escape* provides a vivid example of how films made in an exilic context can represent an experience of dislocation while hiding their immediate ethnic or national origins. As several critics have pointed out, the film makes veiled references to the Russian émigré experience in its emphasis on the different locations and change from a wealthy to an impoverished lifestyle. There is even a specific reference to working as a movie extra, a then-common stereotype of White Russian émigrés due to their lack of practical skills but refined physical comportment.[5] Natalia Nusinova focuses in particular on the prominent device of the dream. The metaphor of a nightmare was common among White Russian émigrés to signify their disastrous circumstances in combination with what they assumed would be a brief period of Bolshevik rule.[6] *Nightmare* (*Koshmar*) was even used as the film's title in Russian distribution.

A contrast between appearance and reality also defines the film's most famous shot. We see Octave and Yvonne romancing outdoors in a medium shot with the Paris cityscape behind them. A cut brings us to a long shot of them standing on an outdoor patio, screen left. Suddenly, it seems that the camera begins to shake erratically. We see a man's face and upper body come into the frame on the left, followed by an exact double of it, as he carries away a large mirror that was previously covering our view. Behind him is a movie camera and two men, a cinematographer turning its crank and a director pointing off-screen, with another Parisian skyline behind them—this one including the Eiffel Tower (Figure 19).

A cut returns us to the couple, who are now shown to be performing. This is not the first or last time Protazanov deploys mirrors for a spectacular effect, but it is the most flamboyant one in his surviving films. The duplication of our two central characters—once as a seemingly real couple, then as performers—the spatial confusion of seeing in front of and then behind ourselves, and the revelation of being in a constructed, artificial situation prove both literally and thematically disorienting. *A Narrow Escape* sets up many recurring motifs of Protazanov's work in emigration, though they never again crystallized in quite such an overt fashion.

White Russians in Europe were among the first sizable ethnic groups to experience the conflicting pressures of assimilation and "self-orientalizing" for commercial benefit—think Orthodox crosses, bulb-shaped domes, balalaikas, and dancing bears. The visibility of exiles in Paris sparked a craze for a particular fantastical vision of Russia. Fashionable Parisians who were skeptical of the emerging *garçonne* (flapper) turned to *la mode russe* for a more refined, aristocratic type of feminine beauty.[7] The fascination with exotic (and often fabricated) aspects of Russian culture emerged in the wake of the success of Sergei Diaghilev's Ballets Russes, which began in 1909 and, by the early twenties, was universally known, if somewhat passé. Ballets such as *Prince Igor, The Firebird, Scheherazade*, and *Le Sacre du printemps* whetted a French appetite for orientalist spectacle that was more than apparent in films headed by Russian émigrés such as *A Thousand and One Nights* (1921), *The Song of Triumphant Love* (1923), and *The Lion of Moguls* (1924). As these titles alone indicate, Russian exoticism was imbricated with exoticism in general, freely intermixing cultures from practically every part of Asia and the Middle East. Of course, one did not need to actually be Russian to indulge in what they called *kino-kliukva*, "cine-cranberry," a term derived from *razvesistaia kliukva*, "branching cranberries," which refers to false Russian stereotypes.

Protazanov resisted this tendency. His decision may stem from his own sense of pride in his ability to comfortably integrate into France. An excellent French speaker, he had spent several years of his youth using a family inheritance to finance a bohemian lifestyle in Paris. The majority of his emigration-era films play down any salient national origins in favor of generically European settings and characters. Like *A Narrow Escape*, the central characters are explicitly French in *Justice d'abord!* and the lost films *Pour une nuit d'amour* (1921) and *L'ombre du péché* (1922). *Member of Parliament*, a Mozzhukhin and Lissenko star vehicle shot primarily in Yalta but not appearing on European screens until 1923, is set entirely in England.[8] While perfectly English in setting and characters, its story similarly speaks to uncertainties and transformations of identity in its basic premise of a doppelgänger. A member of Parliament's (Mozzhukhin) growing dependence on morphine is interfering with his official duties. Stumbling home

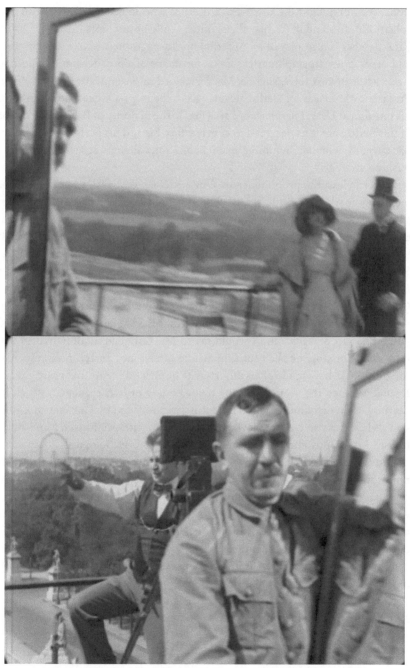

FIGURE 19. Performance gives way to reality as a crew member suddenly moves a mirror in front of the camera in *A Narrow Escape*, directed by Yakov Protazanov (1920; Paris: Ermolieff).

from work one night, he discovers a derelict who looks exactly like him and solicits him to stand in for his official duties while he attempts to kick his habit. (The derelict is also played by Mozzhukhin through the use of matte printing and other cinematographic tricks, in one instance of a broader trend of putting a star actor in two roles, such as Mary Pickford in *Stella Maris* [1918].) When Protazanov left Paris for Berlin, he changed to appropriate German settings for his one film at UFA, *Pilgrimage of Love* (1923). The majority of Protazanov's films of this period are thus designed to largely efface his and his performers' Russian background, whether stemming from a conscious attempt at assimilation or a business strategy.

Nevertheless, the prominence of White Russian émigrés in popular culture inevitably marked their films. Distributors emphasized the national origins of Ermolieff productions, even if not salient in the actual film. One German distributor, for example, advertised Protazanov's 1917 film *Satan Triumphant* as "a legend of the Volga,"[9] despite it having non-Russian characters and imitating Scandinavian films. Even a hint of Russianness could prompt critics to read a film in narrowly nationalistic terms. Critics understood the end of Protazanov's *Child of Another*, in which all four main characters die, as a return to the "Russian endings" of the prerevolutionary industry. "All this dead flesh is a tad excessive," wrote one sardonically, "and I would say to Mr. Ermolieff in all frankness that if he does not stop, he shall turn the whole screen into a necropolis, much as the Bolsheviks have made of his unfortunate homeland."[10] Another critic, Lucien Doublon, noted the same about the tragic ending of *Justice d'abord!*, which he deemed "a French film designed by a Russian and acted by Russians in a Russian style."[11] Russian culture inevitably was tied up with pessimism. More ambitiously, Protazanov attempted to rework his earlier "psychological" adaptations of Russian literature with French material in an adaptation of Paul Bourget's philosophical novel *Le sens de la mort*. The film is lost, but one review in *Cinéa-ciné pour tous* called it "probably the most developed of the films made here, and what's more, the work of a Russian!"[12] The visibility of White émigrés and the broader ramifications of the Russian Revolution across European politics led critics—and probably many audiences—to map whatever stereotypes or beliefs were at hand onto films, even as the Russians responsible were rapidly assimilating into French society.

The closest Protazanov came to proper "cine-cranberry" is a 1921 film from Paul Thiemann's company in Joinville with a number of different titles: *Toward the Light, The Return,* or *Behind the Monastery Wall*. Despite the film's obscurity, it has a surviving print as complete, if not more so, than other, better-known French Protazanov films. It has usually been credited to another Thiemann director, Alexander Uralsky. However, Natalia Nusinova has determined that Protazanov replaced Uralsky during the production of this film on the basis of a variety

of sources—most importantly, remarks made in Protazanov's surviving letters. After the film did not sell to any distributors, Thiemann handed it to Protazanov, who reedited it substantially and changed its plot.[13] Protazanov therefore came to this project late, so the visible influence of *la mode russe* on the film is unlikely to be a product of his own initiative. The unclarity surrounding the production history at Paul Thiemann's studio has left the crew of the film unknown with the exception of the cinematographer, celebrated animator Władysław Starewicz. It was almost certainly largely émigrés, like most of its performers. These included Varvara Yanova, who played the female lead in *The Broken Vase* (1913), and Vladimir Strizhevsky-Radchenko, who had worked at Khanzhonkov but collaborated occasionally with Protazanov.

Toward the Light takes place in two spaces: a Russian Orthodox convent and the local Russian high-society monde. The convent hires a painter, Albert de Bonni, to restore the frescos in its chapel, where a young initiate, Irene, captures his attention. After much effort, he convinces her to abandon taking her vows and move with him to Moscow. Irene adjusts to life among Moscow's artistic elite and is well on her way to becoming a socialite when a melodramatic love quadrangle develops among her, Albert, their friend Hubert, and a villainous social climber named Mentikoff. After Albert loses trust in Irene and Hubert, he challenges the latter to a duel and kills him. News of Hubert's death crushes Irene, who decides to return to monastic life. The "half-Russian" plot makes the film an intriguing precursor of later, better-known émigré films—especially Mozzhukhin's—with a similar dual-identity structure, such as *The Lion of Moguls* (1924). The two spaces also make it something of a companion piece to *Father Sergius*, where images of tsarist society give way to detailed depictions of monastery rituals. The varied visual environments also foreshadow Protazanov's turn toward mixing different styles in his later Soviet films such as *Aelita* (1924) and *His Call* (1925). Here, the two worlds are divided by the walls of the monastery; in his Soviet films, they would increasingly be divided by literal borders between nations. Some of the features hinted at in these films and regularly associated with migrant filmmakers of the past and present also become more salient, including stories about journeys and transformations of identity. That a homecoming in Moscow made Protazanov *more* like a migrant director speaks to the paradoxes of exile and his separation from the dominant identities of the Soviet project.

THE REPATRIATION MOMENT: *AELITA* (1924) AND *HIS CALL* (1925)

Protazanov's first two films after his Russian return, *Aelita* and *His Call*, were crucial in reestablishing both his talent and political reliability. Of all his films,

they deal most explicitly with the topics of emigration, border crossing, and the contrasting representations of the capitalist vs. socialist worlds. Like *A Narrow Escape*, his first European film, they crystallize exilic tropes in his work, this time for the Soviet variant of his career. The more personal of the two, *Aelita*, is an ambitious attempt to represent the presence of people like himself in the modernizing society that left room for doubt about their ability to adapt. In response to the criticism of this film, he followed it up with *His Call*, which follows a more Manichean schema and explicitly promotes the Lenin Enrollment (*Leninskii prizyv*). It represents the same experience of emigration and repatriation so as to disavow it.

As first mentioned in chapter 3, Protazanov bolstered *Aelita*'s credentials by making extensive changes to the novel, perhaps out of concern that Tolstoy's space-adventure tale lacked political depth. The idea to split the story between Mars and Earth and use the latter space to represent contemporary Soviet life seems to have been conceived early in the project and at Protazanov's initiative. So too is the remarkable difference in the character of Los'. In contrast to the scientist-übermensch of the novel, the film's Los' is unmistakably meant to represent a member of the "technical specialist" (*spets*) class that included Protazanov himself. Los' is a capable engineer but resolutely apolitical in his interests and aspirations. His fascination with space travel and a possibly imaginary Martian princess marks him as somewhat estranged from daily Soviet life. This estrangement is particularly salient in a scene in an early draft of the script, when he returns home from a business trip:

> Dissolve: An automobile speeds through the streets of Moscow. Los', in a fur coat, sits inside.
> Los' looks out the window with interest:
> Moscow certainly has changed.
> The chauffeur responds:
> NEP...
> The car travels further.[14]

The scene speaks to a palpable sense of expected homecoming interrupted by the unfamiliarity of a place after years away. Yet Protazanov camouflages the topic by associating this estrangement with the New Economic Policy rather than revolutionary events themselves. Note that it is the chauffeur that does so here rather than Los' himself: the sentiments thus ostensibly reflect those of a committed socialist upon noticing the encroachments of private enterprise. Given Los''s status as a border-crosser, upper-middle-class professional, and politically ambiguous figure, *Aelita* seems to beg viewers to read its central character autobiographically.

The other major change to the story reprises one of the novelties of *A Narrow Escape*: an uncued dream that unexpectedly renders Los''s Martian visit imaginary. Close to the end of Protazanov's first French film, an awakening whisks Octave away from his troubled life and romance abroad back to his comfortable aristocratic home. There, finding out that "it was all a dream" literalized a fantasy for many émigré viewers who desired to return to the monarchist Russia they knew. But coming in *Aelita*'s more optimistic, forward-looking Soviet milieu, the political valence of this fantasy is more complex, even discordant. Ostensibly, the dream is a relief to both Los' and the viewer because the revolution on Mars has taken a turn for the worse, with Princess Aelita having revealed herself to be a feared Napoleonic usurper unconcerned with the fate of the Martian proletarians. Yet it is not hard to imagine a viewer—including one of the expatriate Russians who might have seen it—reading this fantasy according to a different interpretation of who was betrayed in 1917 or as a negation of revolutionary events as such. The final sequence of the film also encourages a more subversive reading. Los' returns home and finds that his attempted murder of his wife, Masha, was unsuccessful. Masha, whom we have seen taking traditional feminine roles throughout the film and deferring to the questionable desires of her husband, greets him and bears no grudge. The final shot of them sitting together by a roaring fire provides a comforting domestic image and reassertion of traditional gender norms at a time when they were being challenged by NEP-era cultural experiments, including many radical attempts to promote gender equality, eliminate the traditional family, and reshape sexual behavior.

In the novel, Los' and Gusev's journey across interplanetary borders is not particularly salient. They launch the egg-shaped spaceship early in the plot and do not return until the end in a brief coda to the main action on Mars. Protazanov and the company's decision to add multiple subplots bound solely to Earth, delay the launch until well into the second half of the film, and alternate the plot between the planets makes a contrast between them into a main structuring principle. *Aelita* represents a continuation of this "dual-world" structure with an intermediary character (Los') who connects the two, first seen in *Toward the Light*. Alexandra Ekster's abstract, Constructivist-inspired Martian mise-en-scène is unique in Protazanov's oeuvre, and indeed in 1920s Soviet cinema generally, which favored a simple, unadorned realism akin to documentary filmmaking. The Martian designs themselves are rightly products of Ekster's sensibility and Protazanov's collaborative orientation, but their incorporation into the narrative structure of the film is quintessentially his. *Aelita*'s oppressive, monarchist Mars represents the first instance of a Euro-capitalist heterotopia regularly visible in his films. This space is not an explicitly nationalistic one but a vision of the cosmopolitan and urban spaces of the late Russian Empire before 1917 or outside of the Soviet Union in contemporary times. Naficy argues that

works by directors in exile often construct "chronotopes of imagined homeland," referring to Mikhail Bakhtin's term for a text's "organizing centers" of space and time, where "the knots of narrative are tied and untied."[15] Protazanov's is a space of hyperbolic leisure and corrupted but seductive culture. The intricacy with which mise-en-scène reconstructs it, often in line with the conventions associated with his prerevolutionary films, betrays a degree of nostalgia not unlike the glamorous settings among European high society in Ernst Lubitsch's Hollywood films that he affectionately dubbed "Paris, Paramount." It corresponds to the "closed form" Naficy associates with many exile films' representations of their host countries as oppressive, using "interior locations and closed settings, such as prisons and tight living quarters, a dark lighting scheme that creates a mood of constriction and claustrophobia, and characters who are restricted in their movements and perspective by spatial, bodily, or other barriers. Tight shot composition, static framing, and barriers within the mise-en-scene and in the shots' foreground suggest closedness."[16] Many of these stylistic features are familiar from Protazanov's prerevolutionary films, with their emphasis on carefully arranged tableaux and actors' static poses. The closed form is also "often conspicuous, [. . .] self-conscious and deliberate, and may be associated with formalism. In closed forms, mise-en-scène gives the impression that space and time are predetermined by an agency external to the diegesis."[17] While certain moments betray a kind of affection for things past, it is a space of disavowal, filled with despicable people, garish and exaggerated in its visual delights, ready-made to be contrasted with a vibrant, healthy, "open" proletarian existence now propagated in official culture.

Transformations of identity also return as a theme in Protazanov's work in *Aelita* and will continue in his later Soviet films. After what Los' believes to be his wife's murder, we see him disguise himself as his friend Spiridonov, another recently returned émigré, complete with a farcical false beard. (He selects this friend because he has left Russia again after only informing Los'.) That a "technical expert" would disguise himself as someone from the same class—not as someone with proletarian origins, who could receive preferential treatment in many aspects of NEP society—is a joke in itself. Los' stays in this disguise for most of the second half of the film, including the whole visit to Mars, only to have his cover blown when the equally farcical Kravtsov pulls off Los''s false beard in a moment straight out of a vaudeville skit. Kravtsov is an impersonator himself who is pretending to be a police investigator. Nor is the upstanding Gusev, a veteran of the civil war, immune to appearing to be something else. On the day of the launch, he oversleeps, then frantically puts on his wife's clothes as he rushes out the door. The notion of self-fashioning starts in Protazanov's films with Mozzhukhin, such as *Father Sergius*, with its ostentatious changes in makeup and appearance as we see the young Kasatsky age over the course of the

film. It reemerges later in *A Narrow Escape* with the importance of performance in its plot. But in his Soviet films, it starts to more frequently involve a willful deception of others, whether for protection or dishonest advantage.

After *Aelita*'s unenthusiastic reviews and the ensuing backlash, Protazanov's next project, *His Call*, was a blunt attempt to reaffirm his competence and political loyalty. This film appears in a few accounts of the industry in the 1920s with some note of its success on foreign screens, yet it is fair to say that it is among Protazanov's least-seen films.[18] Such obscurity is somewhat surprising for the first feature-length Lenin film in Soviet history. Both Protazanov and his first biographer, Aleinikov, are quiet concerning his state of mind at this moment, but this interpretation of his behavior was and is commonplace. Vsevolod Pudovkin, for example, claimed that the failure of *Aelita* forced Protazanov "to more vigilantly search his surrounding reality and find the new artistic means for revealing the great ideas troubling his people."[19] He adds that in *His Call*, one can see "that hidden, seemingly fragile trend which subsequently, after many stages of development, became the full-fledged school we call Socialist Realism."[20] This includes some of its most noxious elements, such as the demonization of "enemies of the people," encouragement of suspicion, and the creation of leader cults. Protazanov now simplifies the intermixture of styles seen in *Aelita* into a simple pair that counterposes the old and the new. Today's critics tend to describe *His Call* as a mixture between an agitational film and an adventure film but overstate the influence of the latter.[21] Some critics at the time even found the film a bit boring, such as one in *Der Film*, who, in an otherwise positive review, complained that the first two reels could be shortened.[22] *His Call* proceeds more often through a rhetoric of comparison rather than a succession of exciting plot incidents, with its ultimate purpose of promoting the Lenin Enrollment and providing an organizing logic to the events represented in its plot. More than any of Protazanov's past work, *His Call* embraces a highly collective form of identification with social groups rather than individual characters.

The basic plot structure alternates between the lifestyles of the Soviet proletariat at home and Russian émigré reactionaries abroad. The first reel begins during the October Revolution, where we meet Katya and her father, who is killed in the struggle. Workers seize the factory of Zaglobin, who hides the family riches and flees the country with his son, Zaglobin Jr. The next two reels are essentially essayistic in construction rather than a causal chain of incidents. The film draws visual associations between the old and the new with dissolves and graphic matches that contrast the energy of the Russian proletariat versus the decadence of carousing émigrés. After this extended comparison between the lives of these two groups of Russians, the film presents a similar binary within Soviet borders between committed proletarians and their internal enemies, now well established in Bolshevik demonology. This turn in rhetoric corresponds to

the younger Zaglobin's return to Russia to retrieve the treasure buried underneath their old estate, which now serves as an orphanage. Like Los' in *Aelita*, Zaglobin Jr. serves as a border-crossing intermediary between the two worlds. In a world defined by social groups and largely schematic characters, this role grants him a structural salience as a central protagonist atypical for a villain. Zaglobin is the main impetus for the narrative developments and the focal point of most scenes, in contrast to the Russian proletarians busy with the unglamorous daily affairs of building socialism. Masquerading as a peasant, Zaglobin seduces Katya and murders her grandmother before a young worker, Andrei, exposes him. Zaglobin dies from a bullet in the ensuing struggle. *His Call*'s main conflict is thus premised on the imposture in a conventional melodramatic story of a villain unmasked at the climax. Though not part of an elaborate political conspiracy, Zaglobin is, essentially, a spy—an archetype that would only grow more common in Soviet films and become ubiquitous in the paranoid, xenophobic cinema of the Stalinist era. Andrei's vanquishing of Zaglobin, and the victory of the Soviet system that it signifies, is further marked by his "reclamation" of Katya as contested territory. Tellingly, though, we never see Katya and Andrei get together. Instead, the film's final reel covers the community as they receive news of Lenin's death. The Lenin Enrollment—the Russian word for "call" in the title, *prizyv*, is used to mean "Enrollment" in this context—replaces what would have been a marriage or other social event in a more conventional film. Katya overcomes the shame of her disgrace at the hands of Zaglobin Jr. and joins the Party. The film ends with an *apotheosis* sequence of the departed leader discussed in more detail in chapter 6.

To establish the two competing worlds of *His Call*, Protazanov returns to two of the dominant styles in *Aelita*. The scenes set abroad blend the stylized sets of *Aelita*'s Mars with Protazanov's prerevolutionary films. He uses depth staging and the careful movement of figures for scenes in Zaglobin's office. Coming after a dynamic representation of revolutionary events in the first reel, the relative lack of editing in these scenes stands out immediately. The Zaglobins attend a comically exaggerated émigré party shown primarily in extreme long shots with countless extras visible in the frame (Figure 20). A group of massive columns dominates the human figures in the frame. Wallpaper with an ostentatious, diamond-shaped pattern evokes the jagged Constructivist sets of *Aelita*. There are also references to the prerevolutionary films' interest in pleasing comportments of human bodies. The party contains a trio of women who serve as decorative human statues looming over the rest of the partygoers from an elevated dais. They hold completely still in the background and intermittently strike new poses. The moment when "His Excellency" (a White leader) enters the party, which resembles the ball in *Father Sergius* (chapter 2), partygoers at a table in the foreground stand, turn away from the camera to bow, and freeze in place. A line

FIGURE 20. A gathering of Russian émigrés in *His Call*, directed by Yakov Protazanov (1925; Moscow: Mezhrabpom-Rus'), is visualized as a "Euro-capitalist heterotopia" common in his Soviet films.

of similarly posed figures stretches from the table in the left foreground to the right background in a diagonal configuration. "His Excellency" enters the frame from the right background, just as the tsar did when inspecting the students and later when visiting the ball. He walks toward the table in the foreground, shakes a few hands, and kisses the hand of a woman in the right foreground, who bows in response. After he finishes acknowledging the partygoers, they return to the frenzied movements of various Western popular dances. The more westernized tuxedos and looser-fitting dresses mark the European settings, but the staid staging suggests the rigidly traditional morays of the imperial elite. Thus, aspects of the old regime appear intermixed with aspects of European popular culture.

The archaic style of the scenes with émigrés alternates with a different style used for the Russian village the Zaglobins left behind. Protazanov returns to the simple, unadorned style of *Aelita*'s scenes in Moscow. Most are shot on location and lack the kind of stylization seen among the émigrés. Protazanov, however, does return to certain aspects of the émigré style to portray reactionary elements and other targets of Soviet campaigns against "backwardness," such as in one scene when Zaglobin visits a sympathetic contact at the village's remarkably

opulent *traktir* (tavern). As Protazanov devised a visual rhetoric for this propaganda piece, he never abandoned aspects of his earlier films—he recontextualized them. Protazanov's second Soviet film cemented his relevance and reliability in the Soviet film industry. It succeeded in doing so, in part, because it left no room for ambiguity about how its viewers ought to regard the Russians from his class background who had not returned.

DOUBLED WORLDS AND AMBIVALENT PROTAGONISTS IN THE SOVIET FILMS

Protazanov never made another film as explicitly agitational as *His Call* and instead tried to strike a balance between political content and the pleasures of popular film genres. Yet exilic features nevertheless persist in his work. The hypertrophic capitalist space in both *Aelita* and *His Call* was well suited for moments when his later Soviet films chose to represent "a certain kingdom in a bourgeois state," as introduced in the opening intertitle of *The Case of the Three Million*, shot one year after *His Call*. Perhaps partly in consideration of the mixed foreign audience accessible to Mezhrabpom-Rus', text in this film's mise-en-scène appears in multiple languages, creating a generalized cosmopolitan European space corresponding to no nation in particular. Protazanov retains the characters' Italian names from the original play by Umberto Notari, and the exteriors shot in Yalta on the Black Sea prove a convincing-enough stand-in for the Italian coastline. But there is no Italian on a shop sign purveying wine in three languages—"Vin, *Vino* [in Cyrillic], Wein"—to an unlikely group of potential customers that Mezhrabpom must have considered its three biggest linguistic markets. Later, in contrast to *Three Million*'s Russo-Mediterranea, *St. Jorgen's Day* constructs a Russo-Scandinavia. A fan letter surviving in Protazanov's collection of correspondence heaped praise on the film but wondered, "Why are the intertitles and signs in Russian, if the plot does not take place in Russia?"[23] The looser connection between silent cinema and language, plus the fungibility of film prints, which could be reedited or have their intertitles replaced with ease when distributed abroad, created regular linguistic dissonances. *Marionettes* once again returns to "a certain capitalist nation," this time the fictional country of Bufferia, with some resemblance to Romania under the Iron Guard. Protazanov thus never lost an attachment to this mythical space, even after the transition to sound discouraged it. Of course, he was hardly the only Soviet filmmaker to delight in representing the decadence of declining capitalist states. But he gravitated toward these kinds of stories and was an outlier in doing so. Setting one's entire film in "a certain capitalist nation," as he did multiple times, had some precedents in the mid-1920s, perhaps most memorably in Lev Kuleshov's *The Death Ray* (1925), but became rarer with each passing year. Even then, Soviet

filmmakers who chose to represent foreign spaces tended to focus on America and its idealized mechanical modernity, in keeping with the *Amerikanshchina* of the 1920s. Later in the 1930s, foreigners often appeared within Soviet borders in "production" films so as to demonstrate the superiority of the modernizing socialist economy, as in *Men and Jobs* (1932) and *The Return of Nathan Becker* (1932), but few filmmakers actually attempted to represent America itself. Protazanov seemed to have a particular attachment to those spaces where he had a personal connection: European places peopled by upper-middle-class bourgeois not unlike the Paris he was desperate to visit in his youth and from which he had only recently returned.

In other Protazanov films from the Soviet period, a journey drives the narrative, but crossing a border is not salient. Instead of the non- or prerevolutionary *heterotopia* common in his comedies, his dramas are often set in natural settings evacuated of immediate signs of politics or social activity. If his capitalist dystopia is depicted in Naficy's "closed form," these films in turn correspond to his "open form," which tends toward the natural settings and mise-en-scène, wider framings, and more prosaic cinematography seen in the Russian sequences of *His Call*. For Naficy, the "open form" typically represents an exile's cherished homeland as a dehistoricized, uncorrupted natural space suffused with nostalgia.[24] Protazanov's variant, however, is more ambiguous. The most memorable natural spaces in his film are abstract and severe, with landscapes as threatening as they are beautiful. The two most salient works in this space are both set in the Russian civil war—for Protazanov, an imagined rather than directly experienced event—where the natural environment, rather than enemy soldiers, is the central obstacle to a military group we follow. Both of these films, like *Aelita* and *His Call*, also feature the mutual encounter of opposed identities as a main plot element.

The first of these is *The Forty-First*, produced a year after *His Call* and adapted from Boris Lavrenyov's novel. It follows Maryutka (Maria, Masha), a young female proletarian and expert sharpshooter in a partisan detachment in Central Asia fleeing the Whites. No special allowances are made to glamorize lead actress Ada Voitsik, whom Protazanov casts in her first role. In the opening scenes, we watch her pick off a White soldier, then a White officer, adding them as her thirty-ninth and fortieth kills that she tallies on her rifle. Ivan Straukh, as the commissar Evsiukov, gives a subdued performance, suggesting some hesitancy and doubt in the partisans' prospects. He orders the group to traverse the desert. Instead of the looming threat of the Whites, the film emphasizes the struggle against hunger and the elements, including a desert storm that stops them in their tracks. The time in transit has left a clear mark on the ragtag troops. Rather than the stoic or cheerful confidence and discipline of more typical depictions of Red Army soldiers, they are clearly

desperate. When one of their clay jugs of water is broken in the storm, one throws his rifle on the ground and stomps on it in protest of the decision to enter the desert.

The film is thus a far cry from later, more whitewashed depictions of war in the era of socialist realism, among which I would include Grigori Chukhrai's 1956 adaptation of the same novel. Protazanov's film also resists portraying the war as a Manichean struggle between good and evil that falls neatly along class lines. The detachment captures a lieutenant, Govorukha-Otrok (Ivan Koval-Samborsky), who has been sent to relay a message from White General Kolchak's forces in the far east toward Anton Denikin's in the west. He is a well-educated aristocrat and therefore trustworthy to handle this communication. The troops immediately jump on him, tearing off his boots and anything useful from his uniform, then chugging water from the clay urns and cracking open the watermelons they have captured. The commissar Evsiukov assigns Mariutka to guard their new prisoner in transport, trusting that she is more disciplined than the others. We first see Govorukha-Otrok sinisterly wiping his mustache with his thumb like a stock silent movie villain. Yet he repeats this gesture several times as the film gradually humanizes him. We watch him give some of his bread to a hungry soldier eyeing it, then offer to help Mariutka write a letter, then lightly compliment some revolutionary verses she is composing. The detachment visits a Central Asian village where they are treated to some rare meat. Protazanov intercuts scenes of them feasting with a shot of two dogs eating meat off a bone to convey their existence as an animalistic struggle for survival. Govorukha-Otrok attempts to keep his composure in the situation and wipes his dirty fingers on the shirt of one of the other soldiers. Thus, the film acknowledges how the manners of his class come at the expense of others.

After the division's camels are stolen, they decide to send a smaller team by boat to bring Govorukha-Otrok to the Red Army base across the Aral Sea. A sudden storm wrecks the ship, and he and Mariutka wash up on a small island as the only two survivors. Thus, the desert gives way to the sea as the main landscape. Their provisions are ruined by the seawater, and she cares for him as he recovers from a severe illness. In one memorable shot that clearly pushed the boundaries of acceptable eroticism on the Soviet screen, we see the two from the back in a moody lighting setup, naked from the waist up, as they wait for their soaked clothes to dry. As they struggle to survive, the war, social decorum, and the two's class identities recede completely from their daily experience, and they fall in love. Then one day, a boat of White soldiers that Govorukha-Otrok recognizes approaches the island and shifts the film's conflict away from human survival against natural elements and toward a conflict between desire and duty. He begins to make his way toward them, but Mariutka notices and, ultimately choosing to fulfill her duty to the army, shoots him in the back, thus making him

her titular forty-first kill. The film ends abruptly as the White soldiers ask him who he is, leaving how she will be punished to the viewer's imagination.

For the Soviet viewer of the time, though, this ending is supposed to be a happy one, with our heroine resisting her disgrace and corruption at the hands of a seductive enemy (like Zaglobin Jr. in *His Call*). Yet her emotive reaction leaves plenty of room for audiences to feel not relief but sadness at the personal cost she has paid in the service of revolution. The film's affective focus on the two lovers and its more muted, ambiguous message about the nature of class conflict rendered the film's release controversial in early 1927. Initially, Glavrepertkom, then a relatively lenient body in charge of censorship, opposed the film's release. It charged that the film's representation of the partisan soldiers was too negative and decontextualized from the larger struggle of the civil war—what were they fighting for? But Anatoly Lunacharsky, leading Bolshevik and head of the People's Commissariat of Enlightenment (Narkompros), in one of his frequent interventions for the sake of Mezhrabpom, came to the film's defense and ordered the censorship board to authorize it.[25] Upon its release, the film provoked an angry letter from Lavrenyov, the author of the original short story, who had done some work on the script in the early stages and received an onscreen credit, along with Boris Leonidov, for the scenario. He now demanded that Mezhrabpom take his name off the film, saying that he had little influence over changes to his story, of which "according to his private information, Comrade Protazanov's share of the guilt is by no means small." He accused the adapters of his story and the studio in charge of them of rendering the film outright "counterrevolutionary, not in the petty vulgar sense of the word, but in its original depth."[26]

Films such as *Aelita* and *The Tailor from Torzhok* (*Zakroishchik iz Torzhka*, 1925) had received critics' objections primarily owing to their seeming triviality or a superficial resemblance to products made in foreign, capitalist states. *The Forty-First*, in fact, was Protazanov's first film they objected to out of concern that it was outright subversive to the new norms of a revolutionary society. This was on the basis of its representation of the civil war, and thus literally of revolutionary struggle, in tandem with the general consensus that the film had considerable entertainment appeal and might stimulate real pathos—that was precisely why it was dangerous. Yet the range of responses different critics and viewers felt comfortable publishing about the film shows the different possibilities still envisioned for Soviet cinema in the mid-1920s, even as politics was ascendent. On one hand, many objected to the film for the same reasons Glavrepertkom had initially hesitated to release it. They charged that the partisans were detached from any significance in the war and revolutionary struggle; the story and style of the film attenuated a sense of class conflict between Mariutka and Govorukha-Otrok up to, and perhaps including, the ending. The most strident critic, Arsen, in *Kino-front* took

deeper issue with the film, claiming that due to its emphasis on the struggle against natural environments and the isolation from the social world, "the whole meaning of the picture is reduced to a completely unambiguous, reactionary idea: there is only physiology, and the rest is fleeting and conventional."[27] Given the revolutionary topic, other critics faulted Protazanov for too much ambiguity in the film's thematics and in the psychology of its characters that left both to some interpretation by viewers. Khrisanf Khersonsky wrote, "Little is given about the people and their psychology. Thus, the theme is unclear and reduced. [. . .] It is completely unclear what relationship the director has to what he is showing—towards the people and 'the truth.' He approaches them not as an author carrying his own ideas, but merely as a photographer or sculptor conveying only the story and 'nature.' So he never convinces us of anything."[28] Without such convincing, viewers might even conclude that Mariutka *regretted* her decision to fulfill her duty.

Yet other critics—and it seems likely, many audiences—were receptive to this ambiguity. The civil war had been a major theme of Soviet films for many years at this point. During the conflict itself, short *agitki* needed to emphasize the strength of the Red forces and portray their victory as inevitable so as to encourage support. Later, films such as *Red Devils* (Perestiani, 1923) treated the conflict in the manner of the Hollywood Western or action film. Now years removed from the conflict itself, viewers were interested in films that turned attention to the sacrifices that had been made and the hardships endured, or that revitalized the kinds of genre formulas that had grown tiresome. Some reviewers praised the film precisely because it departed from these conventions. B. Gusman (who later penned *On Love's Strangeness*) wrote in *Pravda*, "These are not the stereotypes we are used to seeing in pictures depicting the civil war—not gilded heroes but real people, who truly live, love, laugh, cry, and, if necessary and without hesitation, give their lives for revolution."[29] The purportedly "counterrevolutionary" film also earned accolades as "a great step forward in the creation of truly revolutionary films"[30] and even "after *Potemkin*, the best film."[31] In this case, Protazanov's interest in a humanistic portrayal of war found many admirers and appreciative audiences.

Protazanov reprises many of the same elements of *The Forty-First* in *Tommy* (1931), his and one of the Soviet industry's first films with synchronized sound. The film is an adaptation of Vsevolod Ivanov's 1921 story *Armored Train 14–69*, which had enjoyed success as a stage play. Here the social and political body takes the form of a partisan division making its way through deep Siberia with captured artillery, accompanied by a Chinese sympathizer. Protazanov eliminates several major subplots in Ivanov's original in favor of focusing on this one in depth. The division receives an order to deliver the artillery within a day and must evade a contingent of British forces. The film emphasizes the environmental challenge of

moving the cannon through the thick snow. We watch it capsize and crush one soldier to death. Like *The Forty-First*, the conflict between two military forces is barely salient in the film. We instead alternate between scenes taken among the partisans and those taken among the British forces, both their rank and file and their leadership meeting with local White sympathizers. *Tommy* thus returns to an altered version of the "two worlds" plots that define *Aelita* and *His Call*.

The sole encounter between the two worlds occurs when the partisans capture a British soldier posted as a sentry on a bridge away from his detachment. Instead of executing him, the partisans opt to "propagandize the son of a bitch" (*upropagandirovat' etu kurvu*). In the film's most memorable scene, we see the group attempt to bring him to the light of Soviet ideology despite having no ability to communicate by language. As the British soldier pleads that he does not understand, the partisans repeatedly exhort him to "understand!" (*ponimai!*), then appeal to the name Lenin. As if by magic, these words bring their new British recruit to consciousness. He joins the partisans, and the film ends with a heroic image of Russian, Chinese, and English comrades cooperating to succeed in their delivery. As Julian Graffy notes, Protazanov considerably expands the role of the foreigner in Ivanov's original.[32] Interestingly, he changes the character from an American soldier to a British one, as if betraying his noted Europhilia. The title's reference to a term for a stereotypical British soldier—as clarified in the film's opening intertitle—is entirely Protazanov's initiative. He also includes scenes introducing this character at a mess hall, where we witness the camaraderie of British soldiers as they sing "It's a Long Way to Tipperary." Contrasting this scene with a later one of elite officers drinking champagne with local Orthodox priests, Protazanov puts more emphasis on class conflict existing in foreign societies. The British soldier plays a similar structural role as Zaglobin Jr. does in *His Call* as an intermediary between the interiors of the British camp and the snowy expanses of the partisans. There, set against the natural environment, the partisans' pleas for him to *understand!* on the basis of shared humanity and their shared need for survival seems to be more effective than their recitations of the magic word, "Lenin."[33]

But that is not all. When illustrating how he ended up as an isolated sentry in Siberia, Protazanov also repeats one of the most memorable features of both *Aelita* and *A Narrow Escape*: an uncued dream. As the soldier stands on the bridge on duty, we hear an "It's a Long Way to Tipperary" motif on the soundtrack as he casually glances around the stark white environment. A sudden, dissonant turn in the music matches a disorienting cut to a mostly empty shot of a dark factory, where only some luminous sparks in the bottom-right corner are visible. Its abstract black background contrasts with the pure white of the frozen tundra. We see him working in a foundry, where he glimpses an upper-class couple in front of newly hung propaganda posters, including the well-known

image created by the Parliamentary Recruiting Committee of John Bull pointing toward the viewer and asking, "Who's Absent?" We seem to be receiving exposition in a flashback about the circumstances that led this proletarian to the army. But then, in a medium long shot, we watch a crane approach him from behind and then push him off a ledge in what seems to be a factory accident. A quintessential "montage flourish" popular among Soviet filmmakers circa 1930 joins many very short snippets of footage of the foundry in different framings in a dynamic burst, where a white image from the tundra we saw previously suddenly appears, and we return to him standing on the bridge. We see one of the partisans push him off and onto the frozen riverbanks below. The viewer thus experiences his capture from his subjective perspective and not that of partisans we have mainly followed. What seems to be the narrative discourse breaking chronology to represent a moment in the past in fact is a representation of him daydreaming with an ambiguous if less hidden cue than when Los' stands at the train station in *Aelita*. This time, the awakening provides not a convenient solution for this proletarian's predicament but only another problem. *Tommy* thus spends considerably more screen time and narrative effort on the experience of a character who fights abroad rather than at home and one who receives, rather than propagates, the message of proletarian internationalism.

Protazanov's preoccupation with both Govorukha-Otrok and the unnamed "Tommy" is a key example of his attachment to the nonnormative characters of coalescing socialist realism rather than its heroes. To an uncommon degree, Protazanov's films take the perspectives of those out of place in the Soviet vision of the future, who may succeed or fail to convert—though none ever challenge the core Marxist basis for identity in social class. The protagonist of *The White Eagle* (1928) is by far his most daring exploration of this interest and practically qualifies the film as a narrative experiment on its own, given its year of release. With many salient departures, the film adapts Leonid Andreyev's 1906 short story "The Governor," which follows the assassination of a governor who ordered troops to fire on a weeks-long labor protest in the context of the 1905 uprising. Andreyev's narration begins after the violent response and emphasizes the governor anticipating his assassination, which it represents as a justified act of revenge—"an eye for an eye." In contrast, the film follows events leading up to the governor's decision to unleash that violence. He receives an explicit order to put down the strikers from his superior, who himself has received it from Nicholas II. The governor attempts to negotiate, but when strikers appear close to his home, he reluctantly gives the order to fire and later learns that three children were killed in the ensuing chaos. Later, he is awarded the titular "White Eagle" medal for this service to the tsar before being assassinated by—in contrast to community members in Andreyev's story—disgruntled agents of the secret police. The film covers the buildup of the protests and the governor's hesitance with an emphasis on

the limits of human agency within larger historical forces. Protazanov attempts to moderate the emerging norms of the historico-revolutionary narrative and its mass hero by Eisenstein, Pudovkin, and others with the traditional movie protagonist and psychological depiction.[34] In the scenes of the labor uprising and the final battle between strikers and soldiers, Protazanov borrows some of the rapid, discordant cutting of *October* while returning to his bread-and-butter emphasis on performance. Noted Moscow Art Theater actor Ivan Kachalov plays the governor, and Vsevolod Meyerhold, the legendary avant-gardist, plays his superior in his only surviving film role.

The White Eagle proved a disastrous miscalculation. Prior to its release, Protazanov was already striking an apologetic tone in one of his rare statements to the Soviet cinema press, in which he clarified that he "interpreted the past according to the outlook of a person of the pre-revolutionary period" as the basis for this "socio-psychological etude." Apparently responding to criticism the film had already received from his peers, he noted how his Soviet films had alternated between positive and negative responses: "I manage to make myself included among the promising Soviet directors, only to be excluded for my next picture. But they don't succeed in excluding me before I give them new reason to hope."[35] *The White Eagle* was prescient in one respect: the need for a central hero as an emotional locus for viewers would become a core demand in the coalescing norms of socialist realism. But it is hard to imagine how Protazanov could have concluded in 1928's intensifying political environment that an antagonist of the labor struggle was a suitable character for this role. Critic Pavel Blyakhin mocked the ideological implications of the film: "Having shot unarmed workers, the good governor sincerely repents, suffers, and enters into peace-loving conversations with the workers, only to perish in the end at the hands of an *agent-provocateur*. Having seen this film and suffered with our governor-hero, the viewer reconciles with the class enemy with a weakened will for the struggle and 'Christian' thoughts that 'all humans are people' deserving sympathy and forgiveness."[36] *The White Eagle* was either an uncharacteristically bad misreading of contemporary politics or an exceptional act of artistic courage.

TRANSFORMATIONS AND TRICKSTERS

Aelita and *His Call*, each in different registers, explored the distortions and transformations of identity that Naficy argues are common in works of exiles. Characters in the work of filmmakers who have experienced dislocation encounter differences in their host countries; retrospect on experiences of the past homeland; assimilate; cultivate new hybrid identities; test out those new identities in acts of performance; or masquerade as something else to get by in daily life.[37] In revolutionary-era Russia, far more than outsiders were confronted with this

challenge. As Sheila Fitzpatrick has described most extensively, the new norms around class in early Soviet culture, combined with immediate material benefits to people of proletarian origins, prompted widespread misattribution and falsification of backgrounds and life histories to join the new hegemonic proletarian class.[38] Protazanov's films are filled with characters pretending to be something they are not, whether as straightforwardly deceptive villains or as tricksters who disrupt identity itself.

Some of the most salient moments of his early films involve characters who physically transform in some way, all the way back to the detailed, documentary-like impersonation of Tolstoy by Vladimir Shaternikov in *The Departure of a Great Old Man* or Ivan Mozzhukhin's astounding change in appearance from the beginning to the end of *Father Sergius*. But upon returning to Russia, Protazanov picks up where he left off with a new regular collaborator in Igor Ilyinsky. We first meet Ilyinsky in *Aelita* as the detective-impersonator Kravtsov. In *The Case of the Three Million*, he plays the idiotic petty thief Tapioca who, in a case of a broader social misrecognition, is arrested and accused of a massive theft of businessman Ornano's wealth. The mistaken-identity plot is more a case of a comedy of errors than transformation as such and is also present in Notari's original novel. But Protazanov further emphasizes transformations in Tapioca's physical appearance in a sequence not in the original play. After he and Cascariglia escape from the trial, Cascariglia rewards Tapioca with a large share of the heist. After a break in time, we then see how these new means have altered Tapioca's social class and mentality. We see him well groomed in a top hat and tails, enjoying his newfound wealth and offering no sympathy to a pickpocket he encounters. No doubt, this epilogue was added in part out of consideration of Soviet censorship. Given Ilyinsky's status as a well-known star and the hilarity of his performance, censors likely worried that audiences might develop too favorable an attitude toward Tapioca who, if preferable to the self-satisfied bourgeois Ornano, is nevertheless a thief and loafer. Here Protazanov makes an orthodox Marxist variant on the theme of fluctuating identities that suggests not only the link between property holding and social ideology but also the transformative power of capital on the individual. It and clothes, in effect, make the man. Petelkin, Ilyinsky's character in *The Tailor from Torzhok*, is not so deceptive, but we nevertheless see him transformed under quite different circumstances. After he witnesses the lavish lifestyles of NEPmen, he falls asleep and dreams of similar riches. With a fine suit and elegantly coiffed hair, he greets some clients at his spacious haberdashery. As he examines the women's outfits, he imitates the refined gestures of the young aristocrats that populated Protazanov's prerevolutionary films. The ability to change someone by changing their clothes takes on its most political significance in *Marionettes*. After the prince of Bufferia has gone missing, the agents of big capital and the Catholic Church substitute him with

his barber, dressing him in the finest regal splendor and parading him in front of the parliament. The emphasis on disguises and costume changes pairs Protazanov's interest in the malleability of identity with other features of his work, including the silent-era need to put things in visual terms and the Soviet reliance on *typage* and stereotype.

Protazanov's interest in such deceptions represents the intersection of his personal interests with a broader trend in the Soviet culture he helped shape. Fitzpatrick discusses how the breakdown of traditional governing structures in the early Soviet Union also provided ample room for traditional con artists and grifters, a type that Protazanov's movies also explore.[39] The related figure of the trickster has received considerable interest in studies of literature and myth. Lewis Hyde defines him (they are almost always male) as a "creative idiot" who combines features of the fool and nonconformist on one hand and the hero and artist on the other. The trickster violates traditional social norms—sometimes out of foolishness, sometimes out of cunning, sometimes for material gain, sometimes for impish amusement—in a fashion that only calls attention to these norms' conventionality and thus deconstructs them. Mikael (Anatoly Ktorov) and Frantz (Ilyinsky) in *St. Jorgen's Day* exemplify these characters. When they arrive at Jorgenstadt, the site of a well-attended annual pilgrimage, these two thieves stumble on a scheme to evade the law. Mikael dresses up as St. Jorgen and appears to the crowd, with Frantz pretending to have his injured leg healed as a public demonstration of his powers. The manipulation of the norms of the pilgrimage rite is essential to their stunt. Indeed, the priests are well aware that the two are impostors but nevertheless must follow along or risk having the essential artificiality of the church rituals exposed for what they are. In turn, they conspire with the pretenders to create a new myth embodied in a portrait they commission of Frantz upon his purportedly miraculous hearing. The film ends with a comically reverent image of him as a continuation of the same ritual practice in a new form after Jorgen's alleged ascension into heaven.

Tricksters like Mikael and Frantz are almost universal in storytelling traditions across a variety of cultures of different historical eras. Mark Lipovetsky argues that they bear special relevance in Soviet culture, where they predominate despite having been relatively rare in Russian culture of the preceding imperial era. For Lipovetsky, tricksters helped justify "the mechanism of cynical survival and deception that existed behind the ideologically approved simulacra of the state-run economy and 'classless' society," particularly in the pervasive Soviet shadow economy.[40] The trickster reconciled the crass and materialistic meeting of individual needs and desires with the reverent, sacralized Soviet culture that could not acknowledge these banal, everyday departures from its ideals. Protazanov the director, similarly, was tasked with providing the narrative pleasures of popular filmmaking to viewers and the box office receipts to the

industry's overseers despite the lofty revolutionary propagation and uplift that was its stated rationale.

Protazanov's closest engagement with this character is in his final film, *Nasreddin in Bukhara*, which is unique in his filmography in several respects. It was his only film made at the Tashkent Film Studio, where Soiuzdetfilm evacuated during the Great Patriotic War. It was also his only film made with celebrated star Lev Sverdlin (like Ilyinsky, another alumnus of Meyerhold's productions) and attests to this continuity of interests across his collaborations with different actors. The source text, Leonid Solovyov's novel *The Tale of Hodja Nasreddin, Disturber of the Peace*, was published in 1939. (Solovyov wrote a sequel while imprisoned in the gulag, eventually published in 1950; since 1956, the two works have typically been published together as one work.) No thematic plan for the year 1942 survives, and there is little documentation available to clarify the genesis of the film.[41] The best evidence, however, suggests that Protazanov took the initiative in conceiving the project. Protazanov was reading and analyzing Solovyov's book in transit to Tashkent before he arrived in March 1942, when he mentioned in a letter working on the screenplay with his regular screenwriter Oleg Leonidov.[42]

Solovyov's novel is one of many Soviet appropriations of Eastern archetypes as part of the "folklorization" trend under Stalin. Writers were encouraged to put core socialist ideas into a familiar cultural form for non-Russian audiences and to reinterpret national legends in a socialist vein. This trend also presented the opportunity to naturalize such myths for European Soviets and satisfy their appetites for exotic settings and subject matter. Solovyov's story draws from the legendary Turkish figure of Nasreddin, who allegedly lived in Anatolia in the thirteenth century and appears in a diverse set of literature and folklore of the Middle East, Eastern Europe, and Eurasia. Nasreddin is regularly mentioned as an archetypical trickster and one of the key examples of their centrality in Soviet culture, though he is specifically referred to in both the novel and film as a *vozmutitel'*, "troublemaker."[43] Protazanov's film has often been seen in comparison to *The Adventures of Nasreddin*, another adaptation of the same Solovyov novel, released just three years later in 1946 and headed by veteran Uzbek director Nabi Ganiyev, who came to be called "the founding father of Uzbek cinema."[44] Both films in fact were shot by Danylo Demutsky, best known as the cinematographer and creative partner of Alexander Dovzhenko in the late 1920s and early 1930s. Cloé Drieu emphasizes Ganiyev's more local loyalties and argues that he and other formative Uzbek film directors deployed Aesopian language to "hide nationalism behind the Soviet flag." He had been targeted as a "socially foreign element" in the 1930s.[45] Uzbek critic Khanzara Abul-Kasymova claims that, in contrast to Ganiyev, who more closely interprets Nasreddin as an appropriately socialist hero, Protazanov's *Nasreddin* is more

Abroad at Home 133

superficial in its appropriation of traditions.[46] The easy comparison of the two films on the basis of the same source text provides ready clues for Protazanov's particular interests.

In Solovyov's novel, Nasreddin returns to his home Bukhara after many years, where he discredits a tyrannical local emir through his cunning tricks. (An early postcoital scene with a young woman suggests that Nasreddin is something of a Casanova, which may have been too risqué for the puritanical film industry.) Both films add a more defined plot trajectory to the more episodic novel. Ganiyev's version replaces the emir with a local landowning merchant who extorts the community for water rights. In exchange for his usual fee, he prepares to take a young man's fiancée. Learning of their predicament, Nasreddin agrees to help rescue her and exact revenge through an elaborate scheme involving his allegedly magical donkey that often accompanies him in this folkloric tradition. After they succeed, Nasreddin delivers a concluding speech exhorting the community to treat land and water as common property. In contrast, Protazanov's version is free of these kinds of quintessentially socialist realist moments. Instead of helping reunite a couple, Nasreddin himself becomes infatuated with a young woman, Guljan, in whom the emir has also taken an interest. He deploys a variety of tricks to rescue her, and they literally ride off into the sunset. The film's remarkably individualistic Nasreddin and quite muted politics probably stem from the lack of scrutiny in Tashkent and greater wartime tolerance for light entertainment, in addition to Protazanov's own sensibility.

Both Solovyov's novel and Ganiyev's film emphasize Nasreddin as a creator of chaos through unexpected behavior, often involving playing the fool. In contrast to the skilled deceptions of a confidence man, Nasreddin often benefits from dumb luck or improbable coincidences. One chapter is dedicated to one such incident when Nasreddin gambles, a similar version of which appears in Ganiyev's film. Seeing a redheaded man enthusiastically playing dice, Nasreddin decides to teach him about the dangers of gambling. He offers to join him and loses the first roll of the dice in what seems to be a ploy to appear as an easy target and poor gambler. But Nasreddin then wins eight rounds in a row. Aside from sheer luck, no trick is involved in this peculiar lesson. Protazanov's *Nasreddin*, in contrast, like Cascariglia in *Three Million* and Mikael in *St. Jorgen's Day*, works through deliberate machinations. The most elaborate addition to the novel is a subplot in which Nasreddin steals the identity of Hussein Hussliia, a court "sage, astrologer, and physician" who comes to town to visit the emir. Nasreddin convinces him that the emir has put a bounty on him and recommends impersonating a veiled woman to flee. Nasreddin, in turn, disguises himself as Hussein Hussliia, makes the anticipated visit to the emir, and mentions that Nasreddin, disguised, is attempting to escape him. When Hussein Hussliia is captured, he cannot prove their identities have been swapped and is imprisoned.

Nasreddin remains in this disguise for much of the film, with the humor of sequences deriving from Sverdlin's obsequious gestures and ludicrously inflated, scholarly religious language. While Nasreddin often works anonymously in his folk depictions, Protazanov emphasizes his taking on another specific persona as part of his trickery.

Is it possible that Protazanov's interest in Nasreddin stemmed from having himself been a wanderer who returned to his ancestral home after many years, only to find it unfamiliar as a result of a corrupt local leader? Lacking more documentation from this time, it is hard to say for certain. The final film certainly downplays Nasreddin's personal connection to Bukhara, which is more developed in Solovyov's original. Whatever the case, the film partakes of many of the common tropes in his work that became especially pronounced at the peak moments of his dislocation—first upon leaving Moscow in 1919, then upon his return in 1923, then in the mandatory evacuation far from the frontlines of the Great Patriotic War. Far from being a generic craftsman with talent and longevity, Protazanov's work contains consistent themes, if his films are viewed in relation to each other and each situated in its appropriate context. Protazanov's films suggest the perspective of an outsider—one convincing himself of the points of ideology represented in his films as much as their intended audience. His common themes of displacement, false identities, and trickery are also all ripe material for comic treatment. It is therefore no surprise that his detached, ironical perspective on the world around him found its most direct expression in his comedies. The next chapter turns to his work in this genre, which was appreciated immediately and whose appeal has proven especially enduring.

5 · MAKING COMEDY SERIOUS

Protazanov's status as a master of Soviet comedy has never been in doubt. Starting in the 1920s, the reviews that his comedies received ranged from genuine celebration to, at worst, moderate amusement. While films like *Aelita* were left on archival shelves for decades, his comedies always maintained good standing among Soviet administrators and critics. In his pioneering writing on film comedy, Rostislav Iurenev claims Protazanov's 1920s films "marked the beginning of Soviet satire."[1] These works of the New Economic Policy era, including *The Case of Three Million* and *The Tailor from Torzhok*, remained in distribution for his entire career, were revived in new prints in the 1950s, then later appeared on television, where a future generation of directors in the post-Soviet commercial Russian cinema first encountered the work of their silent-era precursor.[2]

In the Soviet Union, making a modest comedy, melodrama, or adventure film required its own kind of artistic courage. Leaders in the film industry and cultural bureaucracy needed to distinguish Soviet films from their foreign counterparts, and genre was seen as one of cinema's most "bourgeois" characteristics. Hollywood and other European industries were able to continue their commercial operations in large part due to their established formulae for the mass production of new films. For many critics, "genre" meant specifically low genres like serial melodrama or slapstick, much as the term in literature typically referred to pulp fiction. Hence even the less politically strident artists and administrators tended to see these films as reducing, rather than elevating, the tastes of the masses. But leaders nevertheless insisted the industry increase production each year and reduce its dependence on foreign imports. And whether they liked it or not, studies of Soviet audiences showed that genre films were what they wanted to see.[3] Comedy occupied the central fault line in this issue. On one hand, party elites insisted that their film industry provide mirth, laughter, and joy to bolster the spirits of the proletariat. Soviet filmmakers like Lev Kuleshov had seen the visceral response that American stars like Charlie Chaplin could provoke in

peasant and worker audiences and wondered if they could combine these films' irresistible appeal with the correct ideological themes.

Among its most prominent proponents was Anatoly Lunacharsky—leading Bolshevik; head of the Commissariat of Enlightenment (Narkompros), which managed cultural affairs from 1917 to 1929; and a major architect of Protazanov's studio Mezhrabpom. Lunacharsky wrote extensively about comedy in the 1920s and privileged satire as a mode of revolutionary popular culture, going so far as to form a "Commission for the Study of Satirical Genres" in the Social Sciences Division of the Soviet Academy of Sciences in 1927. Even as the iconoclastic atmosphere of the New Economic Policy gave way to the romantic mythmaking of the early Stalinist era, comedy continued to be the genre most desired by audiences and leadership alike. Subsequent industry manager Boris Shumyatsky continued to emphasize the need to produce comic films not as a way of "liquidating the remnants of the capitalist past" but as "another, more important and responsible task: the creation of a cheerful and joyful spectacle."[4] On the other hand, Soviet comedy demanded the requisite seriousness for promoting that revolutionary project. The irreverent tone of comedy risks trivializing any weightier subject matter it incorporates. When ridiculing deserving subjects, comedy can reassert particular social norms, but it also thrives on playfully disorienting or subverting them. Soviet comedians had little guidance on the acceptable boundaries for their practice and the appropriate targets for laughter. It was one thing to criticize the daily life of the declining capitalist states but another to criticize Soviet society—not to speak of the Soviet party-state—itself. Thus, even as numerous critics pointed to the essential role comedy ought to play in Soviet culture, individual comic films tended to attract the harshest criticism. Even when it could be justified as a helpful push in the direction of a socialist society, comedy inevitably was more sensitive and faced the most obstacles going from script to screen.[5]

Protazanov's comedies enjoyed popularity with audiences but received a more measured response from peers and leaders. Even when representatives of ideological scrutiny within the industry appraised his films as effective propaganda, they always expressed some skepticism. Their lingering doubts—or at least their desire to have some on the record—speak to the shifting and increasingly unmanageable demands made on film content. Yet one can still sense his relative success in much of the industry's discussion about him in the 1930s. As industry leaders fretted about the lack of good comedies, they sometimes called on him specifically to fill in the gap or criticized studio managers and bureaucrats for not encouraging him to work on them. An anonymous 1940 editorial in the trade paper *Kino*, decrying the plummeting film production and lack of comedies, lamented, "Can it really be normal that such an experienced master

of comedy like Protazanov for a long time has been working in other genres not as suited to his particular talents?"[6]

Because Lunacharsky's ideas underpinned much of the critical discourse enmeshing Protazanov's films, they are worth singling out for discussion. In contrast to mere generalized merrymaking that he dubbed "humor," Lunacharsky wrote extensively about "laughter." Laughter is "a critical tool, which can either serve the objectives of auto-discipline for a social class; or, alternatively, that can allow this class to exert pressure on other classes."[7] He frequently analogized it to a weapon that discredited, demoralized, or even destroyed its target: "This cruel laughter, translated into words, might be translated as 'You do not resemble what a person should be, but you cannot be held responsible for it to such an extent that you deserve to be destroyed. Therefore, although you trouble us, you do not deserve a serious reaction, and we only laugh at you.'"[8] The laughter of Soviet victors at the expense of their enemies thus clarifies revolutionary values. As the party-state turned its attentions away from the international movement toward constructing socialism within its own country, the use of comedy as an "auto-discipline for a social class" became more salient: "Often, in those situations, when elements of petit-bourgeois consciousness and behavior are internal or dispersed with someone close to us, we call forth shame, burning shame, which has great educational value."[9] Lunacharsky insisted that such laughter ought to be "gentle" but linked it to the theoretical foundation of the pervasive, often cruel Soviet practice of autocritique (*samokritika*). For example, Mikhail Koltsov, editor of *Pravda* and founder of the satirical journal *Krokodil*, who wrote a few positive reviews for Protazanov's films over the decades, claimed that in the context of the NEP, with its temporary retreat into private property and the free market, "to deny the existence and indispensability of Soviet satire would be analogous to negating the need for autocriticism for the dictatorship of the proletariat."[10] Thus it had particular intellectual significance for a film director whose political loyalties were under scrutiny. Among his community of filmmakers, Protazanov's films were in part public acts designed to indicate his continuous improvement and adjustment to revolutionary culture—his "struggle against internal backwardness," as Leonid Trauberg referred to it.[11] Comedy was a way to identify obstacles in the path to socialism, including those in one's own consciousness.

Protazanov alternated between the gently irreverent treatment of the Soviet project and the outrageous mockery of its designated villains. His films set in European states or other non-Soviet spaces, whether real or imagined, are done in the hyperbolic style of the *heterotopia* described in chapter 4. They exaggerate, parody, and ridicule forms of popular cinema associated with capitalist nations, including those genres Protazanov had mastered before his return. Their comedy

is directed at specific social groups that often appear in caricatures, and sometimes, positive characters are entirely absent. In contrast, his more restrained films set in Russia conform to the "realistic" norms appropriate for representing contemporary society. It proved harder for Protazanov to direct criticism at specific shortcomings in the caustic manner he did in films set in a foreign state, though he managed to do so on a few occasions. Even when they were at their most manic and cartoonish, his comedies set in Soviet spaces gravitate toward Lunacharsky's "humor" rather than the trenchant "laughter" of his films set in Europe.

Soviet comedy was not recreated whole cloth out of revolutionary principles but recycled many of the perennial concerns of comedy in general and Russian culture in particular. The two groups of Protazanov's comedies each continue approaches he had explored in his prerevolutionary films. Protazanov initially developed this mode of representation in his adaptations of European comedic stage traditions, such as the farce, that he produced regularly before the revolution. Upon returning to the Soviet Union, he used aspects of them as ready-made signifiers of the old regime and the corrupt bourgeoisie. This strategy allowed him to play to his strengths as a filmmaker while putting some ironic distance between his current and his past career. In contrast to a clearly dominant mode of comedy for foreign settings, his films set within Russia, and later the Soviet Union, have a more heterogenous group of approaches. As filmmaking became more and more politically fraught in the 1930s, he increasingly moved toward a more lyrical tone he first explored in his prerevolutionary dramas rather than his comedies.

THE EUROPEAN COMEDIES

All Soviet filmmakers drew from successful foreign models, but Protazanov was the only one to regularly set films in a foreign country. They evidence his European tastes in contrast to the more typical *Amerikanshchina* of the younger generation of Soviet filmmakers. The parodic style of these comedies returned to many of the emphases of Protazanov's prerevolutionary work. Starting at Thiemann & Reinhardt, he adapted many films from popular farces, some fairly direct recordings of stage performances. The names of the plays they originated from are mostly lost in the work of Soviet filmographies: *Do Your Duty* (*Sdelaite vashe odolzhenie*, 1914), *Amour, Arthur and Company* (*Amur, Artur i Ko*, 1914), *Defender of Morality* (*Bliustitel' nravstvennosti*, 1914), *The Living Manikin* (*Zhivoi maneken*, 1914), and *A Woman Who Wants to Can Fool the Devil* (*Zhenshchina zakhochet—cherta obmorochit*, 1914) are all based on "witty" or "piquant" plots "probably taken from a foreign comedy."[12] The sole surviving example of one of these films is the first half of *One Pays, One Plays* (*Odin nasladilsia, drugoi*

rasplatilsia, 1913), a two-reel farce about a lady, Chouchou, whose young lover, Vovo, impersonates a butler to get her older rich husband to write a check for a dress she bought. The visual style of *One Pays* is familiar from the numerous melodramas of the period. The decorative, high-society milieu in the apartment and restaurant are both amply decorated with flowers, statues, and mirrors reminiscent of Evgeni Bauer's future works in the comic genre, such as *Cold Souls/Showers* (*Kholodnie dushi*, 1914), perhaps owing to the fact that *One Pays* was shot by Bauer's regular cinematographer Alexander Levitsky. *One Pays* provides a brief glimpse at the kind of comedy Protazanov had made before 1917. His Soviet comedies of the NEP era set outside of Russia, *The Case of the Three Million* (*Protsess o trekh millionakh*, 1926) and *St. Jorgen's Day* (*Prazdnik sviatogo Iorgena*, 1930), are both similarly based on foreign literary sources but now with an accentuated political message appropriate for Soviet times. *Three Million* delighted audiences at home and abroad, but its farcical world received a muted response among critics because it did not direct audiences toward the specific merits of the Soviet way. *St. Jorgen's Day*, in contrast, maintained much of *Three Million*'s style but mobilized it to further the ongoing antireligious campaign. In both, Protazanov dispenses with positive exemplars in favor of broad, sardonic representations of capitalist society.

More than any of Protazanov's Soviet comedies, *The Case of the Three Million* was the one most indebted to the European stage and the one most criticized as a shallow recreation of "bourgeois" cinema. The film began production in May 1926, just a few months after *Potemkin*'s runaway success in foreign markets reaffirmed the huge profit potential there. It is based on *The Three Thieves* (*I tre ladri*), a 1907 comic novel by Umberto Notari, an Italian anarchist (eventually fascist) writer. Though the surviving intertitles credit this novel as the source, more relevant is Notari's theatrical version, which had found much success on European stages.[13] Collaboration with Igor Ilyinsky during *Aelita* and *The Tailor from Torzhok* likely brought the play to Protazanov's attention. In the summer of 1921, Ilyinsky had been in a short but successful performance at the Akvarium theater. Two years later, he had reprised his performance in a larger production at the Komissarzhevskaya Theater (best known as the site of many of Vsevolod Meyerhold's stagings), where it had been one of the theater's biggest money-makers that year.[14] *The Case of the Three Million* represents Protazanov's first attempt to link European comedy and Soviet politics.

The three thieves of the novel's title are Tapioca, a minor crook and vagabond played by Ilyinsky; Cascariglia, a stylish master criminal played by Anatoly Ktorov; and Ornano, a quintessential nouveau riche played by Mikhail Klimov. In Notari's original, Tapioca stumbles onto Ornano's estate and enters through a skylight. By coincidence, Tapioca's old acquaintance Cascariglia is already inside planning a burglary of his own. Cascariglia uses an incriminating letter to

blackmail Ornano's wife, Noris, into opening the safe containing his millions. Outclassed, Tapioca shuffles back up the rope through the skylight but forgets one of his shoes. The police find it and make it the basis for his arrest for Cascariglia's crime. The trial attracts numerous spectators, in part out of their incredulity that such a simpleton could accomplish a criminal masterstroke. His foolish testimony renders him a folk hero for the mockery it makes of the authorities. Just after the judge delivers a guilty verdict, however, Cascariglia appears in court and announces that he in fact was the perpetrator. He tosses the stolen banknotes throughout the courtroom and creates a frenzied mob. He escapes the chaos with Tapioca, reveals that the money was fake, and shares some of the rewards of the crime. As described briefly in chapter 4, the film ends with a brief coda where we see Tapioca transformed into a new member of the moneyed class lauding the virtue of private property.

While most reviews of the film dismissed it as only superficially political, Protazanov does make notable changes to Notari's version to enhance the role of the Soviet Union's stock villains. Protazanov changes the nature of Ornano's business: in the novel, he earns his fortune by selling phony pharmaceuticals; in the film, he is a commodities speculator who buys up grain after a terrible famine to sell at elevated prices. No doubt, such an enterprise would strike a chord with Russian audiences who had lived through such a famine a few years prior and call attention to the IAH's founding mission statement. Protazanov also elaborates on a criticism of religion that is only implicit in Notari's version. Ornano spends time bargaining over donations for a new church with Catholic priests, who convey their moral hypocrisy in several scenes. Protazanov also directs the generalized cynicism of Notari's original into a specific critique of the bourgeoisie. Notari's final trial scene includes a mixed audience delighted by Tapioca's antics. In Protazanov's, the spectators are all from the moneyed classes, and their admiration for Tapioca's alleged feat stems from sheer greed and the hope that their support might be rewarded. Whether drawing specifically from recent stage versions or not, *The Case of the Three Million* sees Protazanov returning to some of the more theatrical aspects of his directing style. Isaak Rabinovich, the designer most responsible for the Constructivist-influenced sets in *Aelita* (along with Alexandra Ekster), creates sleek, modern décor in Ornano's home. The set for the final courtroom scene, with its tower of vertically arranged judges and elevated stands for the spectators, fits as many extras into the frame as any of Protazanov's past work. The most ostentatious design, however, comes in a high-society ball (of course) that could be mistaken for something in *Aelita*. The partygoers carry shiny balloons that reflect ceiling-mounted lights all over the frame, creating something like the effect of a disco ball.[15]

In reviews, the film's similarity to foreign products dominated the discussion. Ippolit Sokolov thought this was sufficient to prove that it was inappropriate

for Soviet viewers. "On a technical level, the film is gorgeous," he wrote, "but on a formal and social level it is [. . .] typical eclecticism." He further complained that the lack of any positive models in the film might make the banker Ornano seem like a comparatively sympathetic character.[16] The film became a litmus test for how much a critic thought light entertainment was permissible in Soviet films. Lunacharsky counted it among a crop of recent "slight and superficial films" but had harsh words for those who saw it and other films only in terms of ideology: "When the greater and the lesser pedants of Soviet cinema start to teach us grandiloquently that all this is essentially trash and that we should pass as quickly as possible to films without a plot, without a hero, without eroticism, etc., they will be serving us very badly."[17] He and Mikhail Koltsov, two regular allies of Mezhrabpom, were decisive in getting the film shown despite the charges against it. Whatever critics thought, though, the film was one of Mezhrabpom's most profitable of the year. Its popularity attracted some suspicion, but Mezhrabpom, Sovkino, and other agencies needed the revenue it generated. The unusual combination of politics and profit comes into a particularly stark view in one exchange. In November 1928, F. Médard of the French IAH division reported to the central offices about financial difficulties starting another division in Belgium. He proposed, "Must we pay for the full value of the films, or will the Central Committee help us fulfill our promises? We believe that if the CC could give us the film 'The Case of the Three Million,' we could quickly bring our financial state into order."[18] It is not clear if the IAH ever followed through, but that he specifically mentioned *The Case of the Three Million* indicates how within a few years, it had the reputation as a surefire way to quickly raise funds. His request for a special distribution deal illustrates the regular intermixture of business and politics in the daily affairs of the IAH. So too did the debate over whether *Three Million* was criticizing commercial cinema or simply replicating it.

After *The Case of the Three Million* did not prove quite satirical enough to fully satisfy either critics or administrators, Protazanov explicitly tied his next European comedy to an ongoing propaganda campaign. *St. Jorgen's Day* reworked the template of *Three Million* to support the recent intensification of the antireligious campaign, which, while nominally still active, had lost much of its energy in the first few years after 1917. Antireligious films, such as *The Miracle Worker* (*Chudotvorets*, 1922) and *Bridge Commander Ivanov* (*Kombrig Ivanov*, 1922), had been a minor trend in the 1920s, but their number and effectiveness remained insufficient for the envisioned scale of a reinvigorated push to encourage atheism in the countryside. Perhaps as relevant for Protazanov, however, was the Soviet alarm about major religious institutions' increasing attention to the film industry in the late 1920s. Internal reports suggest that leaders of the IAH were preoccupied with the Catholic Church's increasing collaboration with film studios.[19] This may

explain why Protazanov chose to set his antireligious film abroad and empha-size the connection between the Catholic Church, big capital, and the culture industry. The convergence of these two campaigns initially might have seemed convenient, but for most Soviet critics, the foreign location of *St. Jorgen's Day* ultimately reduced its utility in the domestic campaigns, now considered more important in light of the turn toward "socialism in one country."

By the time of *Jorgen*, the Soviet industry had taken on a far greater role in Mezhrabpom's productions. The pressure reached its peak in the March 1928 All-Union Conference on Cinema, where major Bolsheviks repeated the now-common charge that studios, especially Mezhrabpom, recreated "bourgeois" cinema. Whether for creative reasons or due to increasing scrutiny of film con-tent, Protazanov took an unusually long time preparing the script. The studio had an antireligious film in the works from at least 1927 and brought in consul-tants from related campaigns a number of times. Beginning in the autumn of that year, he worked with at least two different screenwriters before deciding to write it alone. Meeting notes on Mezhrabpom's production plan indicate that by May 1928, the firm resolved that this "continuation of *The Case of the Three Million*" would be Protazanov's next project.[20] Despite all of the criticism that *Three Mil-lion* had attracted, Aleinikov and others at Mezhrabpom nevertheless thought its form would be effective for an antireligious satire set abroad. Yet by September 1929, a whole year later, the studio was still consulting various atheist organiza-tions on the film's content.[21]

St. Jorgen's Day is based on Danish writer Harald Bergstedt's novel *Jørgensfesten: Et aeventyr*, published in 1919 and translated into Russian as *The Factory of the Saints* (*Fabrika sviatykh*) in 1924. To an even greater extent than *Three Million*, Protazanov alters the original novel set in the fictional Scandi-navian town of Jorgenstadt. Bergstedt's version follows the town's annual holy pilgrimage through the eyes of its clergy, its mayor, and his daughter Oleandra, who is selected for the ceremonial position as Jorgen's annual "bride." Mikael, an exile from the town, as an act of revenge, returns with his partner Franz to imper-sonate a resurrected St. Jorgen, making his long-awaited return. He succeeds in deceiving the pilgrims and forces the clergy to participate in his charade before they help him escape to restore order. Bergstedt's novel portrays considerable nuance in both the priests' and Mikael's reactions to his impersonation. In an early scene, the mayor gets into an argument with Oleandra when she doubts the authenticity of the church's holy relics and criticizes the overly commercial focus of the event. Without explicitly confirming that the relics are fake, the mayor validates her dissatisfaction but defends the pilgrimage for its importance to the local economy; Bergstedt describes numerous inns and taverns that rely on annual pilgrims for business. Mikael's feelings during his stunt become increas-ingly conflicted. He is unable to resist megalomania and self-righteousness

prompted by the admiration of the pilgrims, but their fervor comes to disturb him. In one scene, Mikael's own parents, swept up in the mass hallucination, fail to recognize him. Consummating his relationship with his "bride" Oleandra further softens his feelings, and he comes to regret the prank. Casting Ktorov as Mikael and Ilyinsky as Franz, Protazanov changes them from past members of the village into crooks on the run from the law. Mikael comes to impersonate Jorgen due to not a prior scheme but rather a confluence of events as he and Franz hide among the pilgrims.

In contrast to Bergstedt's comic exploration of faith, Protazanov's version focuses on vilifying Jorgenstadt's priests as servants of the capitalist class. *St. Jorgen's Day* also represents Protazanov's most direct use of narrative cinema as a form of reflexive self-criticism of the film industry. (The novel in contrast is set in an ambiguous time period; there are no references to modern technology.) In doing so, it follows a minor tradition of Soviet comedy in the 1920s exemplified in films such as *The Cigarette Girl from Mosselprom* (*Papirosnitsa ot Mosselproma*, 1924) and *A Kiss from Mary Pickford* (*Potselui Meri Pikford*, 1927), both of which satirize the dynamics of commercial filmmaking. We open with Jorgenstadt's clergy sponsoring the production of a film about the martyrdom of St. Jorgen. The religious film consists of huge tableaux with numerous carefully arranged figures in the style of 1910s films. A shot where St. Jorgen's tormentors gather around one side of a table recalls a similar shot in *The Assassination of the Duc de Guise* (1908). When they burst in to capture him, the action periodically stops for the group to hold on pleasing arrangements of their bodies. These added plot events evidence Protazanov reflecting on, even disavowing, some of the past features of his craft while simultaneously strengthening the original novel's relevance to current collaborations between the church and the European film industry. The lengthy scene of archaic film production frames the viewer's experience for the rest of *St. Jorgen's Day*. It will not be the last time the film dwells on religious rituals in scenes reminiscent of *Father Sergius*.

Actors continue to invoke aspects of prerevolutionary tableaux in their performances. St. Jorgen's performance in the film-within-a-film involves holding on poses for a conspicuously long time. His hand caresses a lamb while he remains otherwise completely still; he then brings the lamb to his face affectionately. Later, when Ktorov as Mikael impersonates Jorgen, he repeats similar characteristics of this acting style. When he first appears to the crowd, he stretches out his arms in a mock-crucifixion pose. In a reverse shot, the crowd freezes in response. When one of the priests attempts to denounce him as an impostor, Mikael knocks him down with a scepter while comically maintaining this performance style—he freezes to hold the scepter in his hand, then brings it over his head in another pose, then swiftly slams it into the priests' back. Like in *Aelita* and *The Case of the Three Million*, Protazanov intensifies this performance style

by contrasting it with that of Ilyinsky, who, as Franz, remains hyperactive and constantly mobile. The film's use of similar stylistic markers for both a film performance and later in actual religious services lampoons the artificial manner by which rituals bestow solemnity.

The critical response to *St. Jorgen's Day* illustrates well how, for Soviet critics, whether satire was directed at "us" or "them" was a crucial factor to its perceived utility. The film mercilessly ridicules leaders of the Catholic Church and the usual suspects of Soviet ideology. Yet for those most connected to the antireligious campaigns, the more pressing concern was films that addressed not "them" but "us." V. Satyrin, writing in *Proletarskoe kino*, emphasized that satire must target not only villains but also the mentalities that provide the grounds for their influence in society. He pointed out that capitalist countries could make an effective comedy about members of the clergy no less than socialist ones; what distinguished the latter was their active commitment to atheism and their rejection of religious sentiment. For Satyrin, counterposing negative mentalities with a positive alternative was also crucial: "In fact, one cannot create a satire targeting religion without opposing it with atheism; one cannot create a satire targeting bureaucratism without opposing it to the fact of socialist construction."[22] Similar charges had been made during the revival of *Father Sergius* a few years prior, as discussed in chapter 2. Yet one wonders if critics actually would have responded more favorably if Protazanov had maintained the more thoughtful protagonist of Bergstadt's novel and its dramatization of his loss of faith.

Antireligious campaigners wanted to provoke and assist the self-criticism of Soviet viewers' own internal "backwardness," not commend their superiority over their capitalist counterparts. These topics dominated the discussion about *St. Jorgen's Day* upon its release, mostly to the film's disadvantage. *Kino*, which gave a positive assessment of the scenario early on during production,[23] was in the minority when it deemed the film a "deep satire of antireligious character."[24] S. Tsimbal expressed the more common sentiment when he wrote, "We all know very well that, in the West, the Church is one of the most powerful weapons in the hands of capitalists. We know just as well that miracles don't exist, that they are simply deception, and, it follows, that we should never believe in them. Thus, the satirical effect of this new picture is practically *nil*."[25] Thus, critics were more inclined to see its deployment of parody as an attempt to conceal straightforwardly bourgeois entertainment. "Here we see everything that would satisfy a well-intentioned Soviet viewer," Boris Alpers wrote sarcastically, "magnificent costumes, elegant costumes, beautiful southern landscapes, decorative mass scenes, special effects, elegant and handsome heroes in the latest fashions, sufficient laughs and comical moments, plus, a minimal dose of the obligatory agitational content—nothing too hurtful, but enough to render it essentially loyal."[26]

Protazanov's ironic recycling of past genres did not offer the bold new way forward for antireligious cinema that critics sought.

Nevertheless, Protazanov thought it was worth not one but two more tries. The first was in *Marionettes* (1934), a full analysis of which will appear in chapter 6. What is worth noting at this point is the film's continuation of Protazanov's Euro-capitalist *heterotopia* in its clearest form. This original script, written by Protazanov and his regular collaborator Vladimir Shveitser, is set in a fictional country called Bufferia, a constitutional monarchy with Catholic religious traditions, a visible fascist movement, and a preponderance of popular entertainment forms. His other attempt was his final comedy and film, *Nasreddin in Bukhara*, examined at length in the previous chapter and unique among his films for its setting in medieval Central Asia, which could nominally be considered a "foreign" environment, like the European comedies, or a representation of a pre-Soviet Uzbek "dark kingdom," as in *Without a Dowry*. As another comedy with non-Russian settings and an anticlerical/antireligious emphasis, it is more fitting to briefly discuss it here. More than anything, Protazanov's film is designed as a star vehicle for Lev Sverdlin, now the legendary comic actor who plays something like the role that Igor Ilyinsky plays in earlier films—a similar "disruptor of the peace." Protazanov takes particular aim at local superstitions, feudal customs, and religion, generally. Yet unlike the caustic *St. Jorgen's Day*, he does so with restraint and lightness that evidences how the comic norms that developed in the 1930s smoothed out the harsher satirical edges of his earlier works.

The treatment of veiling is a case in point. While practices varied considerably, by and large, Muslim women of Central Asia at this time wore a veil in the presence of unrelated males. After the Bolsheviks assumed power, these norms became a focal point of overlapping campaigns for women's liberation and secularization, culminating in the *hujum* (assault), an aggressive program in the late 1920s in which women were encouraged to remove and burn their veils in large public ceremonies. Yet this campaign had only limited effectiveness and in the short term may even have reinforced veiling as a symbol of ethnic nationalism before the Party abandoned the *hujum* in favor of a more lenient and ambivalent approach. In the long term, veiling declined in the Central Asian Soviet Republics during the 1930s and Great Patriotic War.[27] *Nasreddin* treats this feature of Central Asian Islamic culture as a matter of farce with little interest in promoting or discouraging it. In one scene after Nasreddin's love interest, Guljan, is captured, he arrives at the market in drag, concealing his face with a veil. He convinces the emir's scholar Hussein Hussliia, whom the emir believes is in fact the rogue Nasreddin himself, to cross-dress to escape detection by the emir's guards. After a tip that Nasreddin is hiding by impersonating a woman, the emir sends his guards to unveil women in the market, who cry out at this

disgrace and prompt a riot. By drawing attention to the market-goer's distress and sense of injustice at the emir violating these norms, Protazanov encourages us to regard this tradition with some sympathy. The delight in Nasreddin's trick stems more from his clever use of available cultural norms to foil the emir rather than mocking what the Party ideology would have seen as a barbaric and outdated custom. The scenes of the emir's judgments in the market square are full of the exaggerated pageantry and color of *St. Jorgen's Day*, but references to religion—such as the numerous times "By Allah!" is uttered by characters, including Nasreddin—come in the context of state power and seems directed more at local cultural traditions and superstitions rather than particular articles of faith. Perhaps due to the wartime tolerance for religious piety, the film actually goes quite light on ridiculing Islam.

THE RUSSIAN COMEDIES

If Protazanov's comedies set in Europe are "cruel," those set in Russia are "gentle." Lunacharsky justified comedy as a cultural mode that encouraged self-correction by identifying faults in a more protective environment among allies. Thus, satire directed at one's own was no less desirable than that used as a weapon against one's foes. But Protazanov was among only a handful of filmmakers who realized it in practice at some point. Any negative representation of contemporary Soviet life was vulnerable to the charge that it was a distortion. And as critics and cultural bureaucrats were well aware, a criticism of one particular person or institution could easily be interpreted as one of a more general category of people.

Protazanov's Russian comedies therefore are more varied and multifaceted in their humor than the European comedies. They fleetingly achieve autocritique through jokes at specific targets—including, sometimes, representatives of the party-state apparatus—but in moderation and with optimism. Just as often, however, they respond to the difficulty in identifying the appropriate subjects for humor by focusing on slapstick, clowning, and quotidian life without the satirical edge. Yet even this could prove difficult, as it could be charged with being politically disengaged or making light of serious topics. As the New Economic Policy receded and Stalin-era culture consolidated, the cultural politics of the film industry became more fraught, and generic cheerfulness became far more common than self-corrective examinations of social problems. Yet even avoiding difficult topics did not prevent comedies from being the target of official criticism and bans. Another strategic response to this dilemma was to make not full but partial comedies or add comic elements to more serious genres. Protazanov was a formative influence in this genre that would become a mainstay of Soviet cinema for decades, variously known as the lyrical comedy, tragicomedy, sad comedy, or comedy of everyday life (*byt*). Protazanov encouraged the

early comedic efforts of Boris Barnet, his colleague at Mezhrabpom who grew to be considered the era's paragon of lyrical comedy, and the two directors' work cross-pollinated over the years.[28] These films are part tragedy, drama, or even melodrama with a different approach to their central characters. Rather than comic "masks," clowns, fools, or "eccentrics" who prompt laughter through their unusual behavior, the protagonists of these films are cast in a more realistic mode with a greater range of emotional reactions. Humor, but also pathos, stems from seemingly normal individuals put into comical situations plausible in everyday Soviet reality. This approach became more common as the precepts of socialist realism started to insist on main characters who were positive role models for viewers.

Like the European comedies, Protazanov's Russian comedies redeployed his prerevolutionary work in a new mode. Yet their most clear precedent is not in his comedies but in his dramas. In some of his works, he attempted to either soften the brutal pessimism of prerevolutionary cinema with nuance or gentleness or mix it with genuine humor. *The Broken Vase* (*Razbitaia vaza*, 1913), based on Alexei Apukhtin's imitation of a poem by Sully Proudhomme that was "declaimed and sung on the *estrada* stage with such love," provides the earliest surviving example of this tendency in Protazanov's early work.[29] *The Broken Vase* presents a brief story about a romantic "comeuppance" for its main character that is tragic from the perspective of one of its characters but poignant from the audience's. A young man, played by Vladimir Maksimov, visits his love interest, played by Varvara Yanova, in her boudoir while she reads. He gives her flowers, which they place in a vase. They go to an outdoor party, where she flirts with another man; the young lover is crushed to discover them, signified by Maksimov's generally histrionic performance style that includes regularly gesturing toward the camera in asides that convey his shyness and anxiety. The couple travels back to her room and argues. The film ends with him fainting and knocking over the vase. Based on the conventions of other films adapted from poetry at this time, it is likely that the original intertitles presented lines from Apukhtin's poem as the story progresses. It stresses that the woman's behavior stems from immaturity or lack of experience in handling the volatile moods of young men rather than malice (the Russian synopsis in the trade press describes him as "naïve").[30] When the young man sees her flirting with another man, he rushes off and does not witness her eventually reject his rival. Yanova's character also seems genuinely conciliatory and regretful at the end. Contemporary writing about the film speaks to the ambiguity of its genre. Pathé's French advertisement called it "a charming comedy, that will appeal to both intellectuals, artists and sentimentalists for its poetry and the poignant beauty of its locations."[31] A Russian review in contrast deemed the film a "lyrical drama,"[32] while a German one it singled out its "tragic scenes."[33] In the absence of being able to view Protazanov's

numerous prerevolutionary films fully, how extensively he explored this lyrical mode of comedy at this time cannot be fully known. What seems clear, though, is that 1917 invigorated it. *Jenny the Maid* (*Gornichnaia Dzhenni*, 1918) follows a young countess, played by Olga Gzovskaya, who falls into a state of penury after the death of her father. The film opens with a funeral sequence not unlike the one that began *Father Sergius*, released the same year, or a number of Evgeni Bauer's films. It seems to set up the viewer for a tale of the hardships and gradual degradation of its heroine in a "fallen woman" melodrama. She needs to work to support herself and, using a false identity, finds it as a chambermaid for a baroness. She struggles at her new job but attracts the interest of the baroness's son, played by Vladimir Gaidarov, which turns into romance when she cares for him after he is wounded in a duel. The seeming social inequality that would prevent their marriage is solved when her true identity is revealed, and—shockingly, for a Russian drama of the time—everything ends well.

Jenny the Maid is traditionally categorized as a melodrama, but after being revisited in recent years, a consensus has emerged that would be better characterized as a comedy.[34] It may even be, as Marianna Kireeva claims, the *first* Soviet lyrical comedy.[35] Among those concurring is Frida Protazanova, who, in a 1921 letter, made some recommendations for her husband's next project and remarked in passing, "Your comedies, like *Jenny the Maid*, turn out quite well."[36] *Kino-gazeta*, in fact, previewed this film as a "tragicomedy,"[37] where reviewer A. Ostroumov praised the film as "a true reflection of life as it is, without ugly contrivances and unusual passions, and without pretense of deep ideas." He made special note of the happy ending, unusual for Russian films of the time: "It was curious to observe how passionately the public desired a happy resolution, how their senses perked up as they sensed melodrama near the middle of the film, and to hear the sigh of relief when the hero is recovering from his wound, and that the film, after all, would not end with the hoarse cry of a harmonium."[38] Peter Bagrov notes the comic portrayal of the situations Jenny passes through. To get her job, she must write a recommendation as herself for her false identity. We watch a scene where the estate's good-natured old butler teaches her etiquette that she surely already knows. One could imagine these scenes in a melodrama, where they would signify humiliation, but here they are humorous, with an eye to their absurdity. Despite the film's implicit disapproval of marriage across class lines, Bagrov celebrates its democratic sensibility, which he sees as symptomatic of revolutionary social transformation. Jenny is kind to her fellow servants, and her interactions with them ennoble her. In the wedding finale, we even see the young couple drinking champagne with the butler, an intersection of social class only imaginable after 1917.[39]

Jenny the Maid was not Protazanov's only 1918 drama with a happy ending. *Hero of the Spirit* (*Bogatyr' dukha*) references the contemporaneous political

struggle more directly. Stanis Martsinkovsky (Ivan Mozzhukhin), an unsophisticated young noble, grows up away from the influence of urban society. He goes to the city to visit his brother and mother, who make fun of his bumpkinish ways and introduce him to a young woman, Iza, who catches his fancy. Amused by his attention, Iza makes a bet with Stanis's brother that she can seduce him. When she succeeds and the scheme is revealed, Stanis is crushed and resolves to go abroad to become more sophisticated, leaving them to manage his estate. While he is gone, they host numerous parties and pay for them by taxing the peasants more. The peasants revolt, but Stanis returns just in time to negotiate peace and win over Iza. Perhaps the sensitive subject matter led Protazanov to provide a neater, more optimistic closure that suggested the conflicting class interests of the moment could be reconciled. A review praised the film in much of the same terms as *Jenny the Maid*: "A script without a single murder or clichéd dramatic situation, all imbued with a healthy, lifelike realism giving rich material for the actors."[40]

Protazanov's Russian comedies of the Soviet era draw from these lyrical, gentle tragicomedies to address contemporary topics. *The Tailor from Torzhok* and *Don Diego and Pelageia* (*Don Diego i Pelageia*, 1927) each examine discordances of the New Economic Policy but face the challenge of how to represent them at a time when it was being abandoned. *The Tailor from Torzhok* painted an optimistic picture of how the NEP had developed the countryside but was accused of merely superficial political engagement. For his next film on this topic, Protazanov made a genuine satire shrewdly tied to an ongoing official campaign against bureaucratism. *Don Diego and Pelageia* directed its criticism forcefully at specific negative effects of "NEPism" and rural "backwardness." It won accolades for how it maintained optimism while leveling criticism at representatives of the state and Party, but the potential for such negative depictions of Soviet life was short-lived. By the time Protazanov returned to comedy in a Russian setting over ten years later, the lyrical mode predominated again—ironically, leading the film to be banned for its triviality.

The Tailor from Torzhok was produced in the months just following *His Call* during a period of little oversight from state cinema organizations. It was not Mezhrabpom's first comedy; its first slate of films for 1924, along with *Aelita*, included *The Cigarette Girl from Mosselprom*, which similarly starred Igor Ilyinsky and treated NEP-relevant topics of commercialization and film stardom. Like *His Call*, *The Tailor from Torzhok* incorporates a specific promotional campaign, this time for state bonds sold as part of a lottery—not for the slim chance of receiving riches but for the inherent pride of participating in building socialism. The film represents Protazanov's attempt to combine the lyrical, quotidian comedies of his prerevolutionary years with "eccentric" comedy and slapstick. Ilyinsky plays Petelkin, a small-town tailor and ne'er-do-well who works with

an overbearing widow, Shirikina. Resisting her unsubtle suggestions that they marry, he takes an interest in the younger Katya. An early subplot involving a representative of the Trade Union Bureau (Uprofbiuro) establishes that Katya's master keeps her in a form of domestic servitude, shirking legal duties under the pretext of her being a family relation. Shirikina starts a rumor that she and Petelkin are betrothed to pressure him into marriage, but he rejects her. Katya, however, believes the rumor to be true and rejects him in turn. Petelkin rushes to the train station to commit an *Anna Karenina*–like suicide but fails, comically. He purchases a state bond from a young woman he meets there and heads to Leningrad without learning that his bond has the winning lottery number. The bond changes hands multiple times and prompts a chain of mishaps as the young woman, aware of its winning number, attempts to retrieve it. Petelkin eventually returns to Torzhok and marries Katya, only to learn that he has won the lottery when they visit the local ZAGS (Office of Civil Registry). Thus, the film ends as a rags-to-riches fairy tale that one could imagine in a film from a capitalist nation, but the main characters do not have to strive for personal enrichment in an ideologically problematic manner.

The influence of slapstick legends like Chaplin and Keaton, both wildly popular in the Soviet Union at the time, is more than apparent in Ilyinsky's combination of boisterous, rowdy action and seemingly effortless acrobatic stunts. In an early scene, Shirikina uses an impromptu fortune-telling session to pressure him into a betrothal. When she embraces him, he kicks his legs frantically as he tries to free himself, then slinks under a table and uses it as an implausible cover as he escapes the room. Invisible underneath the table, he spins it around and crawls across the screen to exit frame right while somehow managing to keep the objects on the table in place, including a samovar (only a few playing cards are whisked off). Later, after he sneaks out of their house, Shirkina shouts "thief!" and provokes a chase sequence. In a quintessential slapstick moment, seemingly everyone in the town joins in the effort to catch him. Petelkin runs through a road without noticing a car behind him, which eventually overtakes him and catches him in its front bumper. At first Petelkin panics and kicks his legs frantically, but he eventually settles down. He crosses his legs and props his head on his chin with his head in a kind of mock-genteel comportment as he adopts a more comfortable sitting position.

Protazanov situates this "eccentric" comedian in realistic settings not unlike those in the preceding *Aelita* or *His Call*. Institutions such as the Communist Youth organization (Komsomol), Uprofbiuro, and the local Worker's Cooperative appear as integrated components of everyday village life. None are central to the film's thematics and mostly function as background indices of realism. Nor does the situation change when we move from the provincial Torzhok to the city that had until recently been known as Petrograd, which might have been

depicted as a space of urban temptations or, alternately, a cradle of revolution. High-class settings associated with NEPmen and remaining bourgeois elements may prove to be the ripest targets for Petelkin's antics, but the political valence of the comedy proves more ambiguous elsewhere. Upon arriving in the city, Petelkin asks a pedestrian, "In what city am I, citizen?" The latter responds sternly, "I am in Leningrad. As for you, I don't know." The strident response pokes fun at the recent change of the city's name and a certain Soviet militancy while expressing some sympathy for Russians disoriented by the changes around them. In another scene, a police officer fines Petelkin for eating on the grounds of the Kazan Cathedral. These anarchic gags in the film target a more general sense of social decorum and the figures of authority enforcing it rather than conveying explicit ideological disapproval. Ilyinsky's Petelkin stands out in his cartoonishness, but the fully drawn world around him cannot but impart him with a degree of realism too. Therein lies the problem: as a politically disengaged minor shopkeeper, Petelkin is intended to be a *meshchanin* for the audience to ridicule—not unlike Ilyinsky's characters in *Three Million* and *St. Jorgen's Day*. But transported from those films' imaginary Europe to Russian soil, he becomes something different. It seems more likely than not that viewers will regard him with some sympathy, especially when Ilyinsky's popularity as a performer is added to the equation.

The Tailor from Torzhok fell into an ongoing aesthetic debate: Was it possible to insert appropriate ideological material into a genre derived from commercial cinema? Khrisanf Khersonsky characterized it as a mere "comic film" rather than the "serious comedy" urgently requested of filmmakers. The film "depicts the contemporary era but never unmasks the struggle of the old with the new in everyday life [*byt*], aside from a few anecdotal interludes thrown in intermittently."[41] For Khersonsky, an early scene, in which the local Komsomol flies a kite with a banner stating "Religion Is the Opiate of the Masses" exemplified this tendency. It could be completely removed without affecting the story. He insisted that no film could truly be Soviet without actively inculcating approved social values as integral elements of its plot and, in so claiming, reflected the growing importance of politics in setting the criteria for assessing films. As a belief in social engineering and radical transformation of social norms gained steam, political themes could not simply be "in the background" of depictions of quotidian matters. Here, *byt*—the particular Russian word for the sphere of dull, quotidian affairs—was gradually taking on a negative connotation for being trivial and apolitical.

The Tailor from Torzhok seems to have succeeded as an entertainment product without generating much enthusiasm among industry observers. Internal reports at Mezhrabpom credited the film's returns for stabilizing its tenuous financial position in 1925, and prints of it remained in distribution for decades.[42] The firm was confident enough in the film from an ideological perspective to cite

it in reports to the IAH as evidence of the increasing quality of their work.[43] It had its defenders too: Koltsov, who had praised *His Call* a year before, claimed *Tailor* was "the first time we've seen real laughter in a Soviet film."[44] Though most industry critics were tepid, their mixed response to *Tailor* did not prevent Mezhrabpom from attempting to make similar comedies in the future. Perhaps the best testament to *Tailor's* influence is in a similar, better-known film from a little over a year later: the first feature by Boris Barnet. *The Girl with the Hatbox* (*Devushka s korobkoi*, 1927) promoted the exact same promotional campaign to buy lottery bonds, was written by the same screenwriter, Valentin Turkin, includes some of the same actors, and similarly contrasts urban and rural life in the NEP era. The film essentially took *Tailor* and removed Ilyinsky and the film's comical hero, Petelkin, leaving only lyrical comedy in everyday settings. If *Tailor* attempted to wed Protazanov's lyrical comedy into slapstick, his next Russian comedy replaced the latter with the satirical and parodic elements of films like *St. Jorgen's Day*. *Don Diego and Pelageia* (1928) is a bureaucratic satire that focuses on social ills wrought by the NEP. After the comparatively gentle *Tailor*, Protazanov returned to the more Manichean elements of *His Call*. The vision of rural society in *Don Diego* distinguishes clear heroes and villains in a struggle to transform the countryside. This time, there was no denying that Protazanov had delivered the "serious comedy" that critics longed for. Yet a few remaining doubts in some corners suggested that demands on filmmakers were only growing more difficult to satisfy.

Don Diego and Pelageia is based on "The Letter of the Law," a 1926 *feuilleton* by Alexander Zorich (pseudonym of Vasili Lokot) that had recently appeared in *Pravda*. In Zorich's tale, an old peasant woman, Pelageia, is punished by a petty, incompetent stationmaster for unwittingly crossing railroad tracks. She goes to trial, but because she cannot pay the twenty-five ruble fine, she must serve five months in jail. Her husband seeks help from some local *komsomoltsy* (members of the Komsomol, the Communist Youth organization) who successfully get the court to reconsider the case. Zorich's piece criticizes officials' "blind, mechanical worship of the letter of the law" and persistent belief that "the people [*narod*] will only trust and respect strictness."[45] Protazanov expands on the details of Pelageia's case. The most important addition is the stationmaster, nicknamed "Don Diego" (Anatoly Bykov) for his passion for pulp literature about the era of chivalry. Protazanov spends more time characterizing Pelageia (Maria Blumenthal-Tamarina), whose complete naïveté of the Soviet cause is expressed in a scene where she tries to buy an icon from the Komsomol. Because an illiterate postman uses her summons for smoking paper, she does not appear in court and receives a lengthy jail sentence. The film elaborates on the complexity and inertia of the local bureaucracy that resists the Komsomol members at every turn. Former peasants such as the postman and local functionaries appear unable to live

up to their official duties. These antibureaucratic elements central to the film do not appear in Zorich's original and are Protazanov's own initiative. The film goes beyond critiquing the excessive complexity and inefficiency of bureaucrats and portrays an essentially unchanged relationship between the government and the governed in the village—between elite rulers and their subjects. While Pelageia is rescued, the film gives the impression that her good fortune is the exception to the rule and that random, senseless arrests are not uncommon. The village is portrayed in an unvarnished, documentary-like style of the Soviet avant-garde seen in *Aelita* or *The Tailor from Torzhok*. Denise Youngblood has gone so far as to call the film "the frankest depiction of rural life in the popular films of the twenties."[46]

The film bases its comedy on cartoonish portrayals of ignorant functionaries who know nothing except how to "speak Bolshevik." Protazanov's interest in language likely stems from Zorich's original piece, which contrasts Pelageia's peasant vernacular with bureaucrats' official rhetoric. The motif begins in the first scene at the station in the verbose, sternly worded sign that Pelageia cannot read. When the *komsomoltsy* petition for her, they enter an office full of doors with bewildering acronyms for various *otdeli* (divisions)—such as AKhO, AOO, and OU—that reflect the rapidly expanding bureaucracy during the NEP. Protazanov makes a scatological joke about this "alphabet soup" when the Komsomol members accidentally enter a room labeled "oo" (the abbreviation for a toilet). Meanwhile, a local committee dedicated to fighting bureaucratism denies the existence of the problem in a fog of Marxist jargon, and an inspector from the "Village Life Research Society" demonstrates absolutely no knowledge about basic agriculture. In contrast to these representatives of the state, though, the key leaders of the Komsomol and Party come off well. Once they make the local Party leader aware of the injustice, it takes little more than a phone call to extricate Pelageia and send all of the incompetent officials to the unemployment line.

Like *His Call*, *Don Diego* contrasts the grubby, realistic settings of a village with an inflated, decorative style that defines Protazanov's European comedies. *Don Diego* works in elements of his prerevolutionary films as comical signifiers of the ostensibly transcended past. Protazanov visualizes images from the stationmaster's book in a purposefully archaic cinematic style. A lascivious villain attempts to seduce the knight-errant's lady in a flat, frontal composition against a painted background characteristic of early cinema, the stage evacuated of any props or other realistic settings. The knight and villain both strike static, expressive poses: the villain in Renaissance-era costume, on the left, kneels and stretches out his arms on either side; the maid leans away and rebuffs him through a hesitant comportment of her arms. The text and pages of the book around the image grant it a picturelike frame that itself suggests a cinema screen.

154 THE CINEMA OF YAKOV PROTAZANOV

After the knight enters through a rear staircase—a quintessentially 1910s way of getting a character into the frame—he and the villain square off in a sword fight while maintaining the straight line of staged figures. This single-take moment is straight out of one of the *films d'art* Protazanov so admired twenty years earlier. One suspects that he elaborated on the stationmaster's interests—there is nothing about chivalry or pulp literature in Zorich's original—in part to indulge this ironic treatment of the cinematic past.

With this film, Protazanov achieved the level of "seriousness" that many critics in the industry desired. It received unprecedented acclaim for a comedy. The trade press reprinted comments by American writer Robert Wolf that *Don Diego* was "of the same caliber as *Battleship Potemkin* and *Mother*."[47] Soviet reviewers at this time had never bestowed the label of "satire" so quickly on a work. S. Ermolinsky wrote in *Pravda*, "*Don Diego and Pelageia* not only continues the search but deepens the goals of Soviet comedy and makes them more serious and responsible. The film is not so much a situational comedy [. . .] as a satirical comedy on contemporary mores."[48] According to a reviewer in *Young Leninist*, a newspaper associated with the Komsomol, whose liking for the film might be expected, "It would be difficult to show the mechanisms of the bureaucratic machine and the hypocrisy of Soviet 'bureaucrats' more vividly and mercilessly."[49] I. Kruti in *Vecherniaia Moskva* claimed that during a screening, he had overheard a viewer remark that "it was not a comedy, but a tragedy," which for him proved the film's ability to "elevate laughter to the heights of satire."[50] Critics perhaps singled out the film for praise because, in addition to heaping abuse on NEP-era villains, it also paired them with positive, sympathetic characters who represented the socialist construction that was occurring in the countryside, however modestly. While *The Tailor from Torzhok* was more than anything a star vehicle for Ilyinsky, *Don Diego* follows a broader range of characters with a more collective focus, perhaps drawing on successes like *Battleship Potemkin* that embraced a mass hero. The heroic Komsomol members are always shown in groups, or at least pairs, to suggest the centrality of collective action in the communist vision of progress. Most tellingly, however, the positive characters in the film are never sources of comedy. Pelageia and her husband's peasant simplicity is a source of pathos, while the *komsomoltsy* are essentially heroic and unhumorous in behavior.

But some doubts remained. *Don Diego's* sharpest critics came from the Association of Revolutionary Cinematography (ARK), who screened and discussed the film prior to its release. Many members had a similarly high estimation, but the film had detractors too. More often, though, they focused on subtle issues of its form or comic potential instead of politics. The satirical elements seem to have been unassailable, but some members worried that the picture lacked enough emphasis on the positive results Soviet campaigns had

achieved. Others thought that the portrayal of the stationmaster "Don Diego" was too grotesque to be believable.[51] Though the group ultimately published a positive review in *Kino-front*, a film journal associated with the avant-garde, they claimed it failed to achieve "a unified style," since it used "a firm, healthy, valuable realism in its positive images" but an "exaggerated caricature" for its villains.[52] In the end, though, ARK members ultimately had to acknowledge that Protazanov delivered a film that succeeded better than nearly any other according to their criteria. This "proletarian" organization's hesitance to endorse an otherwise universally acclaimed film suggests how their critical assessments were entangled with younger cinéastes' prejudice against its "old specialist" director. Viktor Shklovsky, for one, grudgingly admitted that "Comrade Protazanov, whose success I should not rejoice, covered everything we requested in the film, and we can't deny that it exists."[53] Despite its momentary acclaim, though, *Don Diego* proved to have a somewhat short shelf life. One common topic of debate at the ARK screening was whether or not members heard peasants or other "mass" audiences actually laugh during screenings. While there was a consensus that the film was "serious," there was also a sense that the film's satire was more effective at making audiences cry than laugh—viewers today can judge for themselves. The film does not seem to have been as popular as the lightly likable films with Ilyinsky and was mostly forgotten a decade later before specialists and critics reappraised the film well after Protazanov's death. Its removal from common circulation, though, may have as much to do with the severity of its critique of Soviet power as its popular appeal.

The lukewarm reception to *Don Diego*, which seemed to be everything that Soviet critics and cultural administrators had wanted a few years prior, reflected how attitudes were shifting against satire in the late 1920s. ARK changed its name to the Association of Workers of Revolutionary Cinematography (ARRK) the same year the film was released, and its fortunes and membership were increasingly tied to the Russian Association of Proletarian Writers (RAPP), a group of radical writers that gained influence during the cultural revolution. RAPP was against satirical treatment of Soviet society in broad terms; it saw comical representations of social problems as in *Don Diego* as essentially counterrevolutionary activity. In contrast, Lunacharsky, the most powerful and dedicated advocate of satire in the spheres of culture, was increasingly marginalized and resigned from his position at the Commissariat of Enlightenment by 1929. RAPP and other artists with "leftist" affiliations attacked satirical plays by Meyerhold, Mayakovsky, and Nikolai Erdmann, accusing them of "artificial magnification" of the alleged faults of Soviet socialism. The Theater of Satire, founded in 1924, which had performed many of their works, was reorganized to focus on a more optimistic rather than critical form of comedy.[54] If released just a year later, *Don Diego* might have fared ever worse. While the notion of socialist realism endorsed in

1934 was intended to moderate these iconoclastic impulses, serious criticism of Soviet society nevertheless remained vulnerable to charges of being "not true to life" (that is, the Party's view of it).

But this shift toward more optimistic forms of comedy in the late 1920s and 1930s was also capricious and unpredictable, as becomes apparent when we compare *Don Diego* with Protazanov's next comedy set in Soviet borders, *On Love's Strangeness* (*O strannostiakh liubvi*), completed about seven years later in late 1935 and banned in early 1936. Protazanov appears to not have had a strong emotional connection to this film and completed it in a one-for-you-one-for-me exchange with Mezhrabpom's management for approval of his Ostrovsky adaptation *Without a Dowry*, shot just after completion and discussed in chapter 2. It is therefore not viewed as a particularly important achievement among his works by past critics.[55] As his only film to be banned upon completion, however, it is crucial to mark the different attitude to comedy by the mid-1930s with particularly strong implications for films with contemporary settings. In contrast to the general accolades for *Don Diego*, the critical response to *On Love's Strangeness* could not have been more different, even though it was fairly well attuned to the preferred aesthetics and politics of its moment.

On Love's Strangeness, the title of which derives from Pushkin's *The Gabrieliad* (1821), is the rare original script in Protazanov's oeuvre, written by Boris Gusman. We meet two young Soviet women who are headed to Crimea for a vacation and primed for romance: Masha (Ekaterina Borisova) is infatuated with aviation and wants to marry a promising young pilot; Irina (Nina Alisova) is infatuated with poetry and wants to marry a promising young poet. Sure enough, they fall for two young men with those two passions but misaligned: poet Gribov (Igor Maleyev) feigns expertise in pilotry to impress Masha, while pilot Berg (V. Poptsov) feigns a talent for poetry to impress Irina. Comic situations arise from the two young men's attempts to cover for each other's absent talents before the ruse is eventually revealed and the romances consummated in spite of it all. The simplicity and seeming lack of ideological content responded to the recent emphasis on light comedy, but these same aspects of the film sparked a backlash and prevented its distribution. This paradoxical fate stemmed less from Protazanov's misreading of the demands made of comedy than the contradictions of late 1930s Stalinist culture.

By late 1935, when *On Love's Strangeness* was in production, the party-state was trumpeting successes in central planning, and Stalin, at the first All-Union meeting of Stakhanovites, marked the shift by claiming that "life has become more joyous, comrades. Living has become happier." With the promulgation of the Constitution of 1936 after the film's ban, he announced that socialism had in fact been achieved, and that "there are no longer any antagonistic classes in [Soviet] society." Comedies were called upon to express hard-earned joy

rather than encourage self-correction, even as the topics for humor were dwindling under the party-state's increasingly proactive role in overseeing film content. The opening song of *On Love's Strangeness*, text by Pavel German, boldly proclaims, "Never before has the world been so wondrous / the spring been so green / and never before have such joyous songs / been sung in any country." We meet Berg and Gribov repeating a couplet that becomes a regular refrain in the film: "Life is magnificent, honestly (*Zhizn' prevoskhodna, chestnoe slovo*)." Protazanov abandons the harshness of his previous comic successes in favor of the general merriment that Lunacharsky would have deemed as "humor." As he does so, he returns to some of the emphases of his earlier lyrical comedies and works from the dominant new models of comedy in the 1930s derived from Hollywood cinema. The opening song over the titles bears more than a passing resemblance to "The March of the Jolly Fellows," which ended Grigori Alexandrov's massively successful musical comedy *Jolly Fellows* two years earlier. That film created a successful cinematic model for the atmosphere of joy requested by the cultural bureaucracy. *On Love's Strangeness* takes that film as a starting point to a degree that past critics have not fully appreciated. While it is not nominally a musical, musical interludes repeatedly punctuate events of the story, including regular repetitions of its theme song, a performance of *chastushki* by a pair of old ladies, and a dance number. This lends the film a narrative-and-number alternation comparable to the traditional Hollywood musical that similarly influenced *Jolly Fellows*. *On Love's Strangeness* also follows a dual-focus structure common in musicals, where the plot alternates between the contrasting worlds of its two romantic leads. Protazanov had intuited this narrative structure prior to the musical genre, using it first in *His Call* when contrasting the worlds of Soviet proletarians and White Russian émigrés.[56]

The film completed production on the last day of 1935, but in January 1936, Mezhrabpom's administrator Samsonov, at a meeting of studio staff, stated that "while the film is great artistically, it must be completely changed ideologically." It is not clear how much additional work was done, and in February, the studio abandoned the film entirely, possibly after an article in *Pravda* had signaled a new campaign against "formalism" in the arts.[57] The studio solicited and then published denunciations of it in its trade publication, *Rot-film*, by its artistic section (*tvorcheskaia sektsiia*), including directors Vsevolod Pudovkin, Konstantin Eggert, and Nikolai Ekk. "In *On Love's Strangeness* Protazanov is unrecognizable. In his previous films there was mastery. You could study this mastery in films such as *His Call*, *The Forty-First*, and others," wrote cinematographer (future director) Vasili Pronin, who further speculated that the film was produced to make up for a financial shortfall. While some, including Pudovkin, echoed Samsonov that the film was decent technically but flawed ideologically, other directors were not so kind, finding the general story and style of the film vulgar (*poshlyi*).

Protazanov, for his part, focused on technical matters, especially the screen-play, in his response to the other directors' statements. He did not take strong issues with their criticisms or attempt to deflect onto other members of the creative team. Thus, the discussion failed to add much clarity to the reason it was banned.[58] Much of the discussion repeated what was already a cliché of criticism informed by socialist realism: "truth to Soviet life." Reviews found the characters in the movie insufficiently "Soviet," but this was not for lack of effort. The two youths' shared interests are carefully attuned to regular points of Soviet education. Masha and Berg's passion reflects the "cult of aviation" promoted by party leaders.[59] Indeed, the poster for the film includes images of an airplane, and Protazanov mentioned to the press that the film was designed, among other things, to encourage young people to have an interest in aviation.[60] Irina and Gribov's passion for poetry, especially the work of Alexander Pushkin, goes without saying. The film was basically complete by the time that the 1937 Pushkin Celebrations were officially announced to the masses in mid-December 1935, but Protazanov was likely aware that planning for it had been in the works among academics and the cultural bureaucracy since at least 1933, with the pressing goal of completing a new, Soviet-approved collection of Pushkin's works for the celebrations.[61] Chapter 2 discusses another possible contribution to the decision to ban the film: its purportedly erotic tone, particularly involving Nina Alisova in her first screen role. Protazanov's association with commercial cinema likely made critics particularly sensitive to any whiff of sexual enticement. I would argue that there is nothing more explicit in their costumes or movements than in Lyubov Orlova's better-known role in *The Circus* (*Tsirk,* 1936) the same year. But Orlova plays an American performer in that film—the rules for Soviet youth were clearly different.

Comedy represents the closest alignment between the logic of cultural production under Soviet power and Protazanov's sensibilities as not only a director but a person. As he sought ways to satisfy an ambitious slate of films each year, he looked to topics that had been successful on the stage and in popular literature—sometimes Soviet but just as often from European authors with sufficiently political topics. In the steadily intensifying political climate, he found it necessary in each film to accentuate material where socialist ideology was most salient. In a few cases, he either wrote or collaborated with screenwriters on original scripts. The norms for representation of his comic universe were ultimately determined by the setting, which encouraged him to look at different aspects of his prerevolutionary career. His works set outside of Russia drew from his instincts as a parodist as he reworked his imitations, stage farces, and operettas, while his films set within Russia accentuated the comic elements in his realistic genres. Both sets of films are infused with an ironic outlook on the affairs of life

that speaks to the perspective of an outsider who could never truly join the ranks of the archetypal participants in a revolutionary society.

True to his unique talents, Protazanov made a set of comedies more diverse than any other Soviet filmmaker of his era. The other contenders for master comedians had a more defined genre. Starting in the 1920s, Boris Barnet worked exclusively in the lyrical mode of Protazanov's Russian films, and there is good reason to think he tweaked Protazanov's own model for his signature work. The wildly popular Grigori Alexandrov based his reputation on musical comedy exclusively, which Protazanov similarly explored in *Marionettes* and, to a lesser extent, *On Love's Strangeness*. Alumni of his films similarly went on to long careers in the genre, whether it be Igor Ilyinsky's eccentric comedy or the more cheerful, tragicomic tales of Yuli Raizman, an assistant on some of his films. Protazanov's work, broadly conceived, always maintained this diversity even when the forces of the Stalin-era industry were encouraging more homogeneity. In its attention to how Soviet culture deployed comedy for a utilitarian social purpose, this chapter has also indicated some of its more broadly didactic elements. Soviet films were designed to teach, model, and exhort their viewers to participation. So, too, did Protazanov's. Yet a broad look at his career shows how this new goal of propagation itself started from a prerevolutionary Russian intellectual culture that was similarly steeped in a moral outlook. Protazanov's style always included elements of direct address and memorable, symbolic images to guide behavior. They found their strongest expressions, fittingly enough, in one of his comedies.

6 · THE DIDACTIC VOICE FROM TOLSTOY TO LENIN

Moving image and sound reproduction technologies were already well developed in Protazanov's childhood. As he began his career, the fundamental arrangement of the camera, projector, film, theater hall, screen, seat, and viewer came together as what is called "cinema" in popular usage, and he himself contributed to the feature-length narrative film's ascendance as the dominant content of this arrangement. He participated in both mainstream cinema's coalescence and Soviet filmmakers' subsequent attempts to adapt it to the revolutionary project. The field of film studies is premised on understanding not simply how films appear, how they are made, or the values they typically articulate, but cinema itself as an institution. Scholars labor to resist the assumption that the norms of cinematic discourse and spectatorship are ideologically neutral and to search for alternatives that might resist hegemonic norms and their underlying systems of oppression. Noël Burch, for example, influentially labeled the familiar cinema-viewing situation as the institutional mode of representation (IMR), which he argued was constituted from roughly 1895 to 1929 and replaced an earlier primitive mode of representation (PMR) prevalent until around 1910 and still evident for some time afterward. While noting a constant bourgeois presence in the development of cinema technology, Burch characterized the PMR as having a genuine connection with proletarian culture before cinema was eventually co-opted by the dominant class. The arrival of cinematic sound marked the final step in this process, as it permitted the easy inclusion of spoken language that wove ambiguous imagery into ideological discourse.[1]

Canonical Soviet silent films such as *Battleship Potemkin* and *Mother* attracted interest from liberally inclined European and American viewers upon their release, and intellectual critics of mass culture thereafter, because they seemed to offer a politically engaged and emotionally satisfying alternative to the Hollywood film—if one formulated by revolutionary intellectuals rather than organically emerging from the working classes. Many noted the affinity between

these aggressive, unadorned, disorienting Soviet achievements and the boisterous, roughhewn cinema of the fairground and vaudeville circuit of the PMR in its first years. Soviet avant-gardists, cinematic and otherwise, self-consciously looked to the vulgar entertainments of the masses to replace the respectable, realist theater ascendant in high culture. Tom Gunning, in his influential characterization of early cinema as a "cinema of attractions," deploying Eisenstein's own term, connected these two practices most explicitly of anyone.[2] Burch argues that conventions of the IMR emerged somewhat slower in Europe than in America and that "it was precisely because of the unfinished status of the representational system that Eisenstein and his fellow filmmakers found themselves in a relatively privileged situation for a rethinking of film practice."[3] Montage theorists could borrow techniques of the emerging Hollywood film piecemeal, using them for alternative effects. Given the continuity that scholars in film studies have traced from early cinema to the revolutionary avant-garde, it is surprising that none have considered it in relation to Protazanov, who maintained an outsized influence as a director across the entire period. Indeed, he is perhaps the only filmmaker who unquestionably succeeded during both the coalescence and reinterpretation of dominant cinema in Russia. In contrast to his younger peers in the 1920s, he came to the task of revolutionary filmmaking as a practitioner rather than an appropriator—a craftsman deepening his understanding of Marxism-Leninism, not a revolutionary artist learning how to use a camera. This chapter pursues the evolution of cinema as a mode of discourse by tracing out the most idiosyncratic aspect of Protazanov's style: his tendency to acknowledge and address the viewing spectator directly through the use of fragmented, free-flowing images. He started to deploy this technique almost as early as it is possible to document his career, at a time when it was akin to the regular use of emblematic shots and tableaux in early cinema. Analogous techniques continued to appear in his Soviet films if by now they bore more resemblance to avant-garde directors' use of nondiegetic inserts. After the transition to sound, these related techniques found a functional replacement in how he incorporated a narrating voice. The persistence and consistency of these strategies of direct address across Protazanov's work suggests an alternative genealogy of these techniques. In contrast to Burch, Gunning, and other critics, I argue that these seemingly "primitive" aspects of Protazanov's films have less to do with working-class spectacle and more to do with attempts to elevate cinema as a respectable—and later politically useful—form of entertainment.

Protazanov's forceful use of images to convey discrete ideas testifies to the strong moralizing strain in Russian, and later Soviet, popular media noted by cultural historians such as Richard Stites.[4] Leo Tolstoy's *What Is Art?*, which argues that art does not create objects of beauty but instead conveys moral lessons, is only one touchstone of a broad tendency toward didacticism in the

outlook of the Russian intelligentsia that was absorbed in more popular forms. Other synoptic—if inevitably reductive—accounts of both Russian and Soviet culture have emphasized a linguistic and communicative orientation to art. Mikhail Iampolski characterizes prerevolutionary Russian art as both "Platonic" and "antimodern" in its presumption that an artwork translates to its perceiver an idea emanating from beyond its surface appearance in the manner of the Russian Orthodox icon. For Iampolski, Soviet power ultimately recapitulated this premise in socialist realism. He characterizes Soviet cinema as a paradoxically antimodern variant of the quintessentially modern mass entertainment, even calling it a "cinema of backward progress."[5] Katerina Clark describes how in Stalin-era culture, even seemingly nondiscursive media such as architecture were tasked with developing a "language" that could convey ideology simply and effectively.[6] For Party cadres, culture was a channel that the revolutionary message passed through and one that could be made wider or narrower depending on the talent and aesthetic approach of the artists it employed to do so. According to these theorists, artistic culture stretching across the revolutionary continuum tended to foreground a relationship between author and viewer, understand artistic form as a means of communication, and encourage the inculcation of moral or political lessons. Protazanov began his career celebrating arch-moralist Tolstoy and then adapted his work to serve the party of Lenin with its similarly utilitarian view of culture.

This chapter first traces a group of stylistic techniques that acknowledge the film spectator from Protazanov's earliest films through the Soviet silent era. It then continues to describe how this tendency did not diminish with the coming of sound. Rather, many of Protazanov's early experiments with the new sonic medium were infected by much of the didactic logic of his silent films, turning his modes of direct address to the viewer from resonant, striking images toward words spoken by a narrator. The chapter concludes with an analysis of *Marionettes*, which represents Protazanov's most elaborate combination of didacticism and lowbrow popular entertainment. This mixture of antifascist essay pamphlet, puppet show, and musical revue suggests some of the possibilities that still existed for a modernist, anticlassical cinema that ultimately lost out to the more IMR-esque socialist realist cinema by the end of the decade—all at the initiative of one of Soviet cinema's alleged "traditionalists" redeploying consistent features of his films throughout his career.

TABLEAUX, EMBLEMATIC SHOTS, AND NONDIEGETIC INSERTS IN THE SILENT ERA

Perhaps it is appropriate that Protazanov's directorial signature is the most salient and memorable characteristic of his first film that survives in full, *The*

Departure of a Great Old Man (1912), discussed in chapter 3. In the final scene, Tolstoy dies, surrounded by his wife and three other men. An actual documentary image then punctures the fictionalized docudrama. After an intertitle announces the reality of the subsequent images, we see Tolstoy's body in bed in a medium long-shot framing; a cut brings us to a closer view from the same angle. As prerevolutionary viewers watched fiction give way to reality, they became witnesses to the writer's funeral through a filmstrip, now a death mask created through direct physical contact with him, like the metaphor André Bazin used to express the indexical traces of reality that he believed constituted cinema's essential power.[7] The documentary image of Tolstoy's literal death is then followed by a representation of his metaphysical ascent. The camera slowly pans left over a cloudy sky with no land below that might locate this moment in a particular spot in Yasnaya Polyana represented earlier in the film (Figure 21). When some sunlight comes through a thinner patch of clouds, the images of two figures—one Vladimir Shaternikov as Tolstoy, on the left, the other a Christ figure, on the right—appear by means of a dissolve and a double exposure. Instead of becoming fully opaque, they remain in partial transparency—or as sources of the time might have called it, as "ghosts"—created through partial exposure and superimposition of multiple shots. Ashamed, Tolstoy gestures toward his redeemer, who stretches out his arms in a cruciform pose to invite him into an embrace. Tolstoy approaches and leans into the chest of Christ, who comforts him with a kiss on the head. The two disappear into the clouds. The moral appraisal Protazanov is making with this combination of images surely could not be lost on viewers, either then or today. Yet in the year of the film's release, it was a provocative one. The final apotheosis sequence takes direct aim at the Orthodox Church that had excommunicated Tolstoy in 1901 due to his novel *Resurrection* and public critiques of church doctrine.[8] Through cinematic form, Protazanov reconciles the writer with his savior in a way that sets religious sentiment against religious institutions, much as he would do years later in *Father Sergius* (1918).

Epilogues like this one in *Departure* were common in the period of early cinema in the decade prior to Protazanov's career. Early films often included an individual shot unconnected to the literal action of the film, which Burch later called an "emblematic shot," that the exhibitor could choose to put at the beginning or end of the film, or even some other moment in the show. A classic example comes in Edwin S. Porter's *The Kleptomaniac* (1905), which Charles Musser deems the director's "most radical film." It narrates two thefts—one by a banker's wife of silverware and hosiery at a department store, another by a poor woman of bread left unattended by an errand boy—and their grossly unequal punishments—the rich woman is set free; the poor woman is sentenced to jail. The film print included a separate "tableau" based on the common iconography of blind justice. Set against a completely black background,

FIGURE 21. *Departure*: Tolstoy's apotheosis.

the woman representing justice's usual blindfold is partial, leaving one eye open. Her scales are unequal, with a bag of gold outweighing a loaf of bread. Thus, the film anchors its story on a basic point about the inequities of the American justice system.[9] Emblematic shots, like this parody of blind justice, often have plain, abstract, or somehow decontextualized backgrounds.[10] As Burch describes them, they have some thematic connection to the story but represent no literal event that occurred in it. They often have a strong symbolic or allegorical orientation that creates a summary statement about what the viewer just saw (or was about to see), usually involving the confirmation of traditional institutions or outright moralizing.[11] The emblematic shot first made salient a distinction between a film's story world and its telling by narrative discourse to a spectator.

The emblematic shot was a short-lived technique that, for Burch, evidences cinema's increasing need to anchor the meaning of its disparate images to an ideological "point." With the emergence of the short narrative film at the end of the first decade of the twentieth century, distributors standardized procedures for one-reel film rentals, and the constant change of programs at nickelodeons led exhibitors to stop tailoring the footage they rented. It is important to clarify, therefore, that the concluding sequence from *Departure of a Great Old Man* and

the examples I am pointing out in Protazanov's films are not literally emblematic shots; the first film he is certain to have directed comes in 1911, well after they had become a rare practice. More than any filmmaker Burch himself analyzes, though, Protazanov's work evidences the persistence of this feature of early cinema in a moderated form. Up to the end of the silent era, his films include shots that gesture toward a narrative's thematic significance but have an ambiguous relationship to the literal events in its imagined world, often with a stark, allegorical quality. They are one of the clearest continuities in his approach to filmmaking for the entire silent era. Even as late as the 1920s, Protazanov continued to start or end his films with a legible summary image.

It should already be apparent that both the image of corrupted justice in *The Kleptomaniac* and the apotheosis sequence in *Departure* are also connected to the theatrical tableau, a defining aspect of Protazanov's visual style discussed in chapter 3. Since the eighteenth century, numerous theatrical traditions constructed memorable and striking configurations of set pieces and actors onstage and had actors remain static to accentuate their visual effect. These often occurred at narrative moments of conflict or that "summed up" the premise of the play or its central characters. As Ben Brewster and Lea Jacobs have argued, the tableau remained in the tool kit of options when filmmakers sought ways "to punctuate the action, to stress or prolong a dramatic situation, and to give the scene an abstract or quasi-allegorical significance."[12] Early films tended to adapt theatrical tableaux to the new medium by pausing for much shorter durations, allowing actors some delimited motion, or using novel cinematic special effects.[13] The final image of *The Departure of a Great Old Man* exemplifies the continued presence of this stage tradition in silent cinema. In addition to the stock situation of a character's ascension to heaven that often called for this technique onstage, it has the moderated stillness of the two figures, the final narrative moment, and the deployment of superimpositions and special effects to render the image more striking. Roland Barthes notes the didactic quality of the tableau: "Everything that surrounds it is banished into nothingness, remains unnamed, while everything that it admits within its field is promoted into essence, into light, into view. Such demiurgic discrimination implies high quality of thought: the tableau is intellectual, it has something to say (something moral, social) but it also says that it knows how this must be done; [...] they are scenes which are laid out (in the sense in which one says the table is set)."[14] The deliberate selection and arrangement of objects in the tableau by their "demiurgic"—or authorial—creator are salient and thus construct a communicative scenario between the creator of the image, the viewer who is presumed to be in an ideal spot to receive it, and the image itself that has "something to say." It is worth noting that the images that prompt Barthes's remark are from Eisenstein's films, already suggesting their genealogy from nineteenth-century popular culture to

Soviet filmmakers' revolutionary didacticism. In this semiotic element, tableaux have an affinity with the emblematic shot, and indeed, Brewster and Jacobs have characterized the two as "functionally equivalent," if relying on different visual techniques to signal them.[15] The term "tableau" is associated not only with stillness but also with wide framings and spectacular arrangements of items and characters, hearkening back to their use during elaborate set pieces on stage. In contrast, emblematic shots are a more uniquely cinematic technique, perhaps resembling the frontispiece of a book cover. They are associated with sparer settings, an abstracted black or gray background, and close framings that capitalize on the medium's ability to magnify things on screen. What is important here is not how to categorize each example from Protazanov's work I describe in this chapter so much as how to note its relationship to these similar modes of discourse. They both involve *interpreting* the film itself in some manner, *telling* the film spectator something directly in a way that acknowledges his or her presence. Protazanov's films tended to do this long before he was recruited to make films for the Soviet regime.

In contrast to the multifaceted conclusion of *Departure*, the ending of *The Broken Vase* (1913) is a simpler, purer instance of an emblematic shot, which often involved cutting to a closer view of a final action, or a character's reaction, to render it an epitomization of the broader narrative.[16] After the young man sees his sweetheart flirt with another man at a garden party, the couple travels back to her room, where the flower he gave her stands in a vase in the right foreground. As they argue, he makes a broad gesture toward the vase and picks it up in a ham-handed metaphor for his devotion. He grasps his chest to signify a "breaking heart," throws down the vase, and then falls on the ground out of frame. A cut brings us to a slightly closer view of the fainted young man stretched toward the broken vase in the left foreground. The film ends with this completely static summary image that literalizes the extended metaphor of the film and the two versions of the poem it adapted, which the intertitles likely relayed to the viewer throughout the film.

The political ecstasy in the months immediately after February 1917 intensified the political dimension of this aspect of Protazanov's style. Protazanov's most political surviving film of the era, *No Bloodshed!* (1917), which Soviet-era scholar Veniamin Vishnevsky calls "one of the most substantive films created after the February Revolution, despite the naïveté of the director's and actors' treatment of the revolutionaries," is, like *Departure*, a biopic of sorts.[17] It works the story of a young female revolutionary, Olga Lobanov, played by Olga Gzovskaya, into a conventional melodrama. *No Bloodshed!* begins with an image that expresses the sense of liberation of the moment it was produced. Two arms in fetters tied together by a chain appear in a close-up against a black background. A flaming sword enters the frame and slices the chain in half. The idea the image

suggests is certainly a simple one but remarkable in the highly abstracted style and complete separation from the story's diegesis. The continuity between this moment and *Departure of a Great Old Man* is obvious, but by now it seems, if anything, less like a belated emblematic shot and more like a precursor of some of the canonical moments of Soviet silent cinema. Theorists of cinematic montage such as Pudovkin and Eisenstein were captivated by the idea that combinations of shots might convey abstract principles to the audience directly in a universal visual language by means that they called "intellectual montage." Discussing their techniques, Christian Metz coined the term "nondiegetic insert" to refer to a shot "having a purely comparative function; showing an object which is external to the action of the film."[18] He noted that the technique had become extremely rare by the time of his writing, the most notable exception being Jean-Luc Godard's revival of it in films such as *Pierrot le Fou* (1965).[19] It is unlikely Metz and other film theorists would have cataloged this technique had some of its instances not become so famous in Soviet silent cinema, where they functioned like linguistic signifiers more akin to intertitles than to a view of narrative space. Sergei Eisenstein and others often put these close-ups of objects against spare or even nonexistent backgrounds to detach them from a sense of diegetic space. Such cropped close-ups with coherent meanings but an ambiguous status in the story were a regular component of *October*. A statuette of Napoleon intercut with Kerensky conveys the latter's autocratic designs; a mechanical peacock suggests both his politics' lifelessness and his own vanity. The most famous employment of this device in the film comes in the "God and Country" sequence, where objects representing mythological and religious traditions appear in a flamboyantly edited procession that signifies their equivalence. As David Bordwell notes, however, it was more common for Soviet filmmakers to use objects actually present in the film's story to draw such comparisons, as in a scene in Pudovkin's *Storm over Asia* (*Potomok Chingiskhana*, 1928) in which the British commander and his wife prepare to visit a Buddhist temple. For Bordwell, this technique is among the most unusual features of the Soviet "historical-materialist" narrative mode that mixes political rhetoric and narrative discourse.[20]

Protazanov's predilection for summary images thus intersected with the interests of the ascendent avant-garde. Yet in contrast to images that Soviet filmmakers used for rhetorical effect, which tended to be small objects filmed from unusual angles, Protazanov's typically maintained some of the staged elaborateness of early tableaux. A monumental, heroic apotheosis interrupts the climax of *Aelita*, when Gusev joins Aelita to rally the Martian proletarians and seize power. At this significant moment, and with little cue, the camera suddenly leaves our central characters. We see a strapping, bearded proletarian pounding some neoclassical-style architectural models into a supple, claylike substance (Figure 22). Through the use of reverse-motion filming, he fashions the clay into a

sickle, then with a satisfied grin, lays the hammer across it to create the ubiquitous symbol of the USSR. Though the blacksmith's sudden appearance likely disorients viewers, it becomes clear fairly quickly that he is allegorical. Each of the shots is in an empty black room with no tie to the increasingly turbulent narrative on Mars, and we never see this character again. Considered in the lineage of such moments in Protazanov films, this seeming imitation of the cinematic avant-garde is actually a holdover—only the ideological orientation of the images was new.

The allegorical blacksmith directly addresses viewers' own loyalty to the cause in contrast to the more voyeuristic experience of looking onto narrative action in a conventional film that defines the majority of the experience of *Aelita*. In fact, the images were initially intended to literally visualize a speech Gusev is delivering, though the situation in the final version does not make this explicit. In earlier scripts for *Aelita*, at roughly the same part of the film, Gusev delivers a speech to the Martian workers, aided by a screen that shows images:

> 41/. A meeting. Gusev continues to speak:
> —Our children were saved from hunger and given the opportunity to study.
> 41a/. An orphanage. Fade to:
> 41b/. A kindergarten for workers' children.
> 41c/. Gusev continues:
> —Workers received the chance to live like human beings.
> 41d/. A communal home. Fade to:
> 41e/. A workers' apartment.[21]

Gusev's speech culminates with an image of Leo Trotsky delivering a speech. Rather than clarifying Protazanov and the company's political sympathies, the inclusion of the Bolshevik leader is probably invoking his reputation as a fiery orator. Given that *Aelita* began production in 1923 but did not appear on screens until September 1924, it is likely that this aspect of the script changed with the beginning of a public campaign against Trotsky, which revealed a rift in Party leadership. The simplicity—even banality—of the monumental blacksmith that replaces Gusev's rhetoric suggests that Protazanov and company wanted to scale back the specificity of the politics they advocated. The script also specifies documentary images to accompany the speech. Even after the content of the speech and newsreel was removed, this footage was apparently so important that it needed to be included regardless. The images shot in an orphanage appear in an earlier scene when Natasha takes a job at one, echoing the protracted footage of construction that appears when we see Los' at work at a construction site. The digressive quality of these sequences stems from their initial inclusion as part of a film-within-a-film where they had a rhetorical rather than a narrative function.

FIGURE 22. *Aelita*: The upheaval on Mars is interrupted by this sequence of an allegorical blacksmith fashioning a sickle.

Protazanov's most elaborate deployment of allegorical sequences of direct address comes in *His Call*, his most explicitly agitational piece released one year after *Aelita* and discussed at length in chapter 4. A few minutes into the second reel, an intertitle announces, "1918 approached. With a firm hand, the great captain (*velikii kapitan*) led us through the storm and foul weather." The intertitle borrows a common metaphor for Lenin as a captain of a ship, perhaps best known in Demyan Bedny's poem "A Worker's Greeting," published in *Pravda* in 1920 to commemorate Lenin's birthday. A following allegorical image then makes the metaphor literal: we see the hull of a ship and a sailor (not Lenin himself) turning a ship's wheel as a giant red RSFSR flag slowly rises in the background (Figure 23). Text on the front of the ship states, "We will build a new world," from the Russian version of "The Internationale." A cut brings us to another cropped, decontextualized shot against a black background, this one a close-up of a ship's telegraph. The dial turns sharply left (indicating rough waters), and a cut brings us back to the long shot of the ship, where the sailor rapidly turns the wheel to his left, thus signifying the allegorical ship captain's connection to the workers below. The sequence's heavy reliance on text and its combination of literal and symbolic imagery recall the forceful but simple aesthetic of agitational posters—an aesthetic that film critics at the time pejoratively called *plakatnyi*

FIGURE 23. *His Call*: the "Great Captain."

(posterlike) due to its association with the prosaic, even amateurish style of the short *agitki* films of the impoverished civil-war-era industry.

After this interlude, the film returns to the diegesis and characters but later universalizes both in a final apotheosis sequence recalling *The Departure of a Great Old Man*. The townspeople hear a rumor that a telegraph has arrived stating that Lenin has died. They send a messenger on horseback to the telegraph office. After confirming the rumor, the horseman rushes back to deliver the news. He arrives and announces, "Lenin is dead!" In an extreme long shot, we see what seems to be every villager collapse in mourning; the film holds on to one of the still tableaux so characteristic of Protazanov's style. Yet instead of portraying the reactions of the central characters to the event, the film cuts away to an artistically framed landscape shot, followed by well-known footage of Lenin in his funeral casket. The documentary image gives the viewer of the time an indexical, physical contact with the leader's presence and, like the images of Tolstoy's body that conclude *Departure* made thirteen years prior, impart a quasi-religious aura. The film then transitions to a mode of direct address—a kind of call to grief in place of the traditional call to action common in Soviet film conclusions. Intertitles lamenting the leader's death bookend a decontextualized image of a Soviet flag at half-mast. The editing renders the

FIGURE 24. *His Call*: Lenin's apotheosis.

images of the townsfolk in a more iconic light, as representatives for the working classes and peasants rather than specific characters. We see Andrei leading a rally, presumably a recruitment meeting in keeping with the emphases of the Lenin Enrollment concurrent with the film's release. As relayed through intertitles, he exhorts the crowd, "There is no place for despair. Lenin is gone, but he is still with us, in the heart of every worker! [...] Swear that you will remain faithful to his behest." In the foreground, we see masses of people in front of Andrei behind a table in the background. In the far background, a banner reads "Lenin is dead, but his cause lives on." Members of the crowd raise their hands, then approach the table to join the Party. We see closer framings of different types of villagers against stark black backgrounds that similarly decontextualize them from the general space: a pair of old women, then a pair of old men, then a younger man. We see Katya doubt her merit as a potential Party member due to her previous disgrace at the hands of Zaglobin, then summon her courage to join. The style of this sequence suggests a broader attempt to abstract the particular characters and setting into universal signifiers. Narration becomes a more generalized discourse at a moment when the events in the story would have matched real events in recent memory for spectators upon its release—or even, given that the film itself was used in similar recruitment meetings, at the very moment of

spectatorship. Proving even more *plakatnyi* than the previous sequence, this one is literally covered in slogans, whether relayed in the intertitles or covering parts of the mise-en-scène.

Then the image that concludes the film proves even more familiar. An intertitle, which in the surviving print has a noticeably different typeface from the others in the film, states, "At his call." We see an allegorical image remarkably similar to the one that closed *Departure* (Figure 24). Through a superimposition and matte printing effect, an extreme long shot in the bottom half of the frame shows a crowd of proletarians marching away from the camera and pointing to a heroic image of Lenin in the top half of the frame. Lenin serves the people; Lenin *is* the people. Protazanov once again returns to his predilection for visual apotheoses. In this respect, his personal stylistic preferences harmonized with the Soviet emphasis on conveying appropriate ideological messages and made concrete the connection between political mobilization and early cinema.

Not all of Protazanov's summary images are so solemn, however. Similar kinds of expressive, decontextualized images take on the different tones of his comedies. In *Don Diego and Pelageia*, Protazanov returns to his regular allegorical way of ending films on an explicit "point," this time in a comical mode. At the end of the film, the central Komsomol (Communist Youth) office sends the local division a shipment containing a bust of Mikhail Kalinin, nominally the head of the Soviet state. After they unpack the bust, we see its stern face in a close-up against a black background. The close-up and choice of background detach the bust from any of the surrounding context seen when it appears in the wider framings and recall the similar figurines sculpted by *Aelita*'s allegorical blacksmith. In a long shot, Pelageia and her husband enter the room. The *komsomoltsy* look up from the bust in surprise at the two peasants; everyone in the scene freezes. A shot-reverse shot sequence shows each of the two groups, then another cut brings us to the bust, as if he in effigy is participating in their conversation. We see Pelageia's husband state that they have come to enroll. A cut brings us back to Kalinin, his stony visage now contorted in a look of shock (Figure 25). The *komsomoltsy* laugh but gather around the two in approval. Intermittently, we see the statue, now animated, turning its head with a look of apprehension. In the last shot of the film, the Kalinin bust now smiles. While he and the Komsomol members seem to approve of the amusing request in spirit, the film does not explore the actual implications of the elderly couple applying to join a youth organization. In contrast to Protazanov's unreservedly serious sequences for Tolstoy and Lenin, he puts a lighthearted touch on this moment with Kalinin. The humor stems from not only the incongruous situation but also the way the style pokes fun at the highly reverent portrayal of Soviet leaders by now ubiquitous in official culture. One wonders, too, how much viewers would have understood that Kalinin's position was largely a ceremonial one rather than a seat of power.

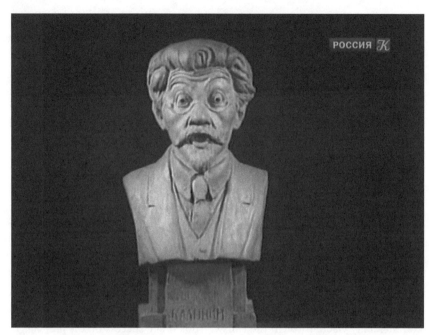

FIGURE 25. A bust of Mikhail Kalinin, detached from the rest of the sequence by means of a black background, expresses shock at Pelageia and her husband's desire to join the Komsomol in *Don Diego and Pelageia*, directed by Yakov Protazanov (1927; Moscow: Mehrabpom-Rus').

After the transition to sound, far from abandoning this diegesis-puncturing and bluntly rhetorical orientation of early cinema, Protazanov found functional replacements for silent-era techniques in the new sonically enhanced medium. Like other Soviet filmmakers, his first experiments with sound focused on how to impart images with a human voice rather than, as in Hollywood, music. Protazanov made particular innovations in how to combine a set of images with a spoken commentary that cast them in a new light. Contra Burch, then, the technological shift in the early 1930s therefore is not determinative of the IMR, or a similar Soviet analogue. At least for the first half of that decade, filmmakers there used the new possibilities of a spoken voice in films to make their metaphorical lectures into literal ones.

LITERALIZING THE VOICE IN THE SOUND ERA

The transition to sound beginning in the late 1920s typically marks the end of the lingering, variegated tendencies of early cinema. In addition to the volatile, more nationalistic politics of Depression-era Europe, this change in the cinematic medium corresponded with decisive shifts in the business structure

of major film industries. In America, the dominant "Big Five" and "Little Three" Hollywood studios achieved the "mature oligopoly" formation that would remain for more than three decades. Meanwhile, in the Soviet Union's brutal shift to industrialization, sound technology was but one component of the film industry's task of building infrastructure to sustain itself without foreign imports. Sound also accelerated the party-state's general desire across the 1920s to take a more active role in cultural affairs and accentuated the sharpening politics of the Cultural Revolution. As Burch notes, Party cadres were more capable of judging the content of films if they were centered around speech and language, which they had more than enough experience regulating, than around silent imagery, with its greater potential for ambiguous meanings.[22] Though considerable diversity in the style of Soviet films existed throughout the 1930s, much of the diverse experimentation of the New Economic Policy era narrowed.

Despite these analogical developments, however, there were differences in the Soviet Union's underlying industrial logic for adopting sound cinema from its counterparts in America and Western Europe. In Hollywood, the shift to sound cinema was taken for granted as inevitable as soon as it was shown to be commercially viable through the runaway box office success of *The Jazz Singer* (1927). Recorded sound offered the ability to reproduce popular musical performances that previously could not be distributed on so wide a scale, like those of Al Jolson in that film or the numerous performers that appeared in Warner Brothers' wildly popular Vitaphone series. Of course, there is no reason to think that sound films with popular musicians would be any less successful with Soviet audiences, but adopting sound there stemmed only indirectly from audience preference. In the context of the Party's stated goal of rapid industrialization for "socialism in one country," Hollywood's impressive move to all-sound production in just three years seemed to both Soviet political leadership and film industry management like an implicit challenge and demonstration of the supremacy of its culture industry in a blunt, technical way that refuted the confidence that Soviet film artists had in the superiority of their ideas and talents. The development and distribution of sound film technology was one area in which they aspired to "surpass and overtake" their ideological rivals. The Soviet industry had been developing a sound system since 1926 but was given a greater push to bring it into widespread use as soon as possible. Two sound systems were developed, one by Alexander Shorin in Leningrad and the other by Pavel Tager in Moscow at Mezhrabpom, both using the "sound on film" optical track technology that converted sound waves into a series of lines on the film strip, which could then reproduce the sound waves when projected. As part of Mezhrabpom with Protazanov, Tager no doubt drew from German technology and other resources that the studio could procure due to its foreign connections. Protazanov's reliability

The Didactic Voice from Tolstoy to Lenin 175

and efficiency of the filmmaker no doubt underlaid his selection to work on *Tommy*, one of the first fully synchronized features using Tager's Tagefon. Both Tager's and Shorin's systems were functional by 1929 and demonstrated in public screenings by 1930, but distribution of the technology in theaters and production of films using it required extensive resources and therefore lagged.[23]

The Soviet Union's different underlying ideology also shaped different visions for sound cinema's eventual use. In contrast to Hollywood producers' enthusiasm for recorded music, Party leaders and administrators of culture were more intrigued by the possibilities of recorded speech. The ultimate material that they wanted to transmit (ideology) was intellectual in nature and might be most effective if presented in a direct rapport with an audience member in the form of the human voice. Such potential had underlined Lenin's continual (and in comparison with cinema, far stronger) fascination with radio. The People's Commissariat for Posts and Telegraphs of the RSFSR (Narkompochtel) had spent considerable resources connecting even the most remote rural villages to a radio network, often using lengthy wires when transmitters lacked sufficient strength. Stephen Lovell has traced a more collective viewing experience that this infrastructure encouraged. Personal radios were rare and reserved only for the most elite figures of power, so typical Soviet citizens listened to the radio in groups in public spaces.[24] Evgeny Margolit has argued that Soviet radio, in contrast to musical or live theater, is the closest analogy to recorded cinematic sound there. He notes that the first Soviet sound films were agitational-propaganda pieces, which preceded by some time the canonical first Soviet "talkie," *Road to Life* (1931).[25] As Soviet sound films conveyed official pronouncements, they assumed a "frankly sacral function" with pronouncements appearing "nameless, faceless, and disassociated with any concrete speaker; it was the word as divine utterance, as directive, and as a slogan."[26] With the endorsement of socialist realism and narratives centered around heroic individuals, sound films gradually abandoned this more direct approach in favor of placing those official words in the mouth of a sympathetic protagonist. Margolit sees Vladimir Gardin's performance as the engineer Babchenko in *The Counterplan* (*Vstrechnyi*, 1932) as the first successful softening of official pronouncements by this method and Alexei Dikii's performances as Stalin in perfect, unaccented Russian as its perverse culmination.[27]

A recent wave of scholarship has examined the centrality of the voice in early Soviet sound cinema and explored how it catalyzed stylistic experimentation with a different emphasis.[28] In the first half of the 1930s, Soviet filmmakers and studios were not under as strict commercial pressures as their Hollywood counterparts and had considerable room to try new approaches. The relatively slow conversion of existing theaters also necessitated many different hybrids of sound and silent filmmaking, and silent versions of sound films continued to be

distributed until the Second World War. In addition to the official, impersonal voice of state ideology, filmmakers also explored the dynamics of more embodied human speech, such as accents, linguistic differences, and vocal imperfections so as to grant characters some individuality and resist the increasingly schematic types of socialist realism.[29] Dziga Vertov's *Three Songs about Lenin* (*Tri pesni o Lenine*, 1934), which includes recordings of uncomposed, unrehearsed proletarian speeches, with all of their grammatical mistakes and mispronunciations, represents the most radical extreme of this interest, though it proved to be too potentially subversive.[30] Other filmmakers reinforced the push for modernization by recording and transmitting its mechanical and industrial sounds. All faced the question of the ideal relationship between the soundtrack and the image examined in Eisenstein, Pudovkin, and Alexandrov's pioneering "Statement on Sound," which criticized the "mere addition of sound to montage fragments" and endorsed its use as "counterpoint" to the image.[31] What "counterpoint" meant in a clearly nonmusical context, however, remained for filmmakers to develop.[32] Yet while passionate debates about aesthetic form became more strident over the decade, there was no disagreement that sound cinema should continue to be didactic.

Among the intermediate hybrids that the Soviet studios produced during the long transition to sound cinema were silent films rereleased with a soundtrack recorded and synchronized later, a notable example of which is *St. Jorgen's Day* (discussed in chapter 5), initially released silent in 1930, then sonified and rereleased in 1935. Protazanov's approach to adding sound to this film was unique but follows some of the recurring emphases of the voice and "counterpoint." Evgeny Margolit and Peter Bagrov have even claimed that it is an "innovative and unprecedented" synthesis of silent- and sound-era filmmaking that would be unthinkable just a few years later.[33] Some of the additions are typical of sonified silent films of its era. It includes a running nondiegetic musical soundtrack that parodies liturgical motifs and includes Russian-language chanting, which accentuates the *heterotopia* of the setting by conflating the ostensibly Catholic Church ridiculed in the film with more local Russian Orthodox traditions. Synchronized sound effects are scarce among the additions and usually are machine noises, such as the train where Mikael and Frantz make their escape, perhaps reflecting the interest in mechanical noise visible in other Soviet films of the era. Available recording technology prevented more precise jobs, such as postdubbing dialogue, so synchronized dialogue is scarce, with the exception of a few yells, grunts, and shouts by the Jorgenstadt crowd in later scenes.

St. Jorgen's Day most innovative and radical additions center on a human voice delivering speeches to the viewer in a direct fashion rather than in dialogue with other characters. These come in scenes that were filmed well after the silent version was released and inserted into the new sound version. The opening credits

include a series of introductory portraits that accompany the title cards for the main players, based on new synchronized sound footage. After each of the chief characters recites an encapsulation of their worldview in a pithy sentence, an abrupt cut brings us to new synchronized-sound footage of Mikhail Klimov, as the priest Arkadin, delivering a sermon, which continues as we return to footage from the silent version. He begins a narrative rife with lofty, liturgical language about a pilgrimage. We return to another synchronized shot of the sermon that continues over the first images of Mikael escaping from jail in a getaway car driven by Franz, then again after the two thieves slip away from the train, dressed as nuns. Arkadin describes "the breath of the Lord invisibly sweeping over Jorgenstadt" prior to a new scene set there, then in his next appearance, specifies that the events that we see depicted in the main plot occurred three years ago as he himself appears among the pilgrims for the first time. Arkadin's voice-over has a delaying function that builds anticipation for narrative events while also layering it with a gravitas that seems incongruous with the caper-like antics of Mikael and Franz. The basic premise of the new voice track is therefore a kind of counterpoint, in the sense of thematic contrast.

This counterpoint eventually becomes an outright discrepancy when Klimov's voice-over starts to describe the simultaneous images we see on screen. Mikael, disguised as St. Jorgen, appears before the crowd. Arkadin's voice-over states that he "fell to Jorgen's feet" out of awe—but we see the impostor Jorgen hit him on the back, sending him to the ground. As it accompanies a visual representation of the same events, the hyperbolic admiration we hear Arkadin bestow on Jorgen in the voice-over becomes transparently false, sometimes even directly contradicting the intertitles on the screen. The implication that the viewer should distrust Arkadin's claims reinforces a basic theme of the film and of the antireligious campaigns: the false and constructed nature of religious myths. Soviet viewers, of course, would have been well trained to not take a priest's words at face value, but Protazanov's unique approach to the voice in this film nevertheless carries some subversive potential. If, as Margolit claims, the voice in early Soviet sound cinema became a "sacral" object, the sonified *St. Jorgen's Day* in effect desacralizes it, telling audiences to believe what they see, not what they hear. One wonders if people with lived experiences of the revolutionary era, or the contemporary collectivization of agriculture, now described by official accounts, might have found this discrepancy familiar.

During roughly the same period when Protazanov was reworking *Jorgen*, he was also preparing his most elaborate combination of direct statements, summary images, and visual allegory in the new sound medium. While *Jorgen* reshaped a silent film on the basis of spoken narration, *Marionettes* (1934) builds a movie from the ground up based on this interest in the spoken voice. The film opens with a master of ceremonies who introduces "a political comedy

in the puppet theater, or, if you like, a puppet comedy in the political theater." The orientation of the film becomes plainly allegorical as this puppet show's host starts a curtain call for the film's main characters, each in puppet form and named according to the Russian phonetic transcriptions of the musical scale: Do (a prince, played by Anatoly Ktorov), Re (an archbishop, played by Nikolai Radin), Mi (a singer, played by Valentina Tokarskaya), Fa (a fascist, played by Konstantin Zubov), Sol' (a barber, played by Sergei Martinson), Lya (a liberal minister, played by Mikhail Klimov), and Si (a socialist, played by Sergei Tikhonravov). This one-to-one correspondence between notes and characters does not end up playing an argumentative role in the content of the film, and the presence of additional characters in the story not introduced in this fashion undermines the premise's seeming unity. It seems it is intended to showcase the presence of sound and music in this film. Released before both Alexandrov's seminal musical comedy *Jolly Fellows* (1934) and even the first Soviet musical, Igor Savchenko's *The Accordion* (*Garmon'*, 1934), *Marionettes* would have been quite novel for the contemporary Soviet viewer in this respect. The names of the characters also reinforce the sense of artifice in the film's representational approach. As the film moves to a realistic, photographed depiction of the events with actors rather than puppets, the discordance of their names reminds the viewer of the puppet show conceit and, in turn, the story's ultimately constructed nature.

Based on an original concept by Protazanov and screenwriter Vladimir Shveitser, *Marionettes* is a cautionary pamphlet on the rise of fascism set in a fictional country called Bufferia that makes literal the generalized, heterotopic capitalist Europe common in many of Protazanov's silent films (*His Call*, *The Case of Three Million*, *St. Jorgen's Day*; see chapters 4 and 5). A group of big businessmen, potbellied and stovepipe-hatted as always and concerned about an imminent Soviet invasion, plots designs for a fascist overthrow of Bufferia's parliamentary monarchy, aided by the similarly archetypal Catholic archbishop Re, who could have been a character in *St. Jorgen's Day*. They summon Prince Do of Bufferia, a philandering, alcoholic idiot with a diva girlfriend Mi, back to the capital to assume the throne, dissolve the Social Democratic Party–led parliament, and empower the fascist "Iron Hand" movement. Accompanied by his barber, Sol', Do sets off by plane but falls out during its journey. Upon the plane's arrival, the capitalist agents discover the prince is missing and elect to have the similarly dull and pliable barber impersonate him. They present him with much fanfare to the parliament. Meanwhile, Bufferian border control apprehends the prince and, interested in playing up the Soviet threat, dresses and photographs him as a fearsome Comintern agent. After the stage is set for a fascist takeover, the prince, barber, and diva are eventually reunited in the capital. The prince attempts to

reclaim his title but not before the story ends with a "shot," signifying the beginning of the coup. The events depicted no doubt recall the Nazi assumption of power, as do the swastika-like insignia that the "Iron Hands" wear. However, the story draws more directly from developments farther east in Romania and Yugoslavia, both of which had pro-Monarchist fascist movements, the respective Iron Guard and Yugoslav National Movement. The film's political comedy presages later, more famous ridicule of fascism in René Clair's *The Last Billionaire* (1934) and Charlie Chaplin's *The Great Dictator* (1940). The latter's comedy of errors involving a misidentified barber bears a particularly uncanny similarity to Protazanov's film, but it seems unlikely that *Marionettes* actually influenced it.

The film alternates among different diegetic layers that interpret the ongoing events. The opening master of ceremonies initiates a frame story to which we occasionally return and see arrangements of the same characters in puppet form, signifying that both the puppet show and the realistic, cinematic depiction are separate representations of the same thing. After introducing the puppets in the film's opening, the master of ceremonies commands the viewer to "please pay attention to how all of these puppets are manipulated by these hands" pointing to those of the puppeteer shown in close-up. Then a graphic match cut takes us to a similarly framed image of the white-gloved hands of the main capitalist plotter holding paper telegram tickers matching the strings of the previous shot. We then see a scene where they announce their fear of Soviet invasion and their plan to sponsor the coup. The film follows a consistent pattern of intercutting between the affairs of prince Do and barber Sol' and the big-business schemers who provide commentary on their plans coming to fruition. Both it and the occasional reminders of the puppet show premise recapitulate the standard Marxist understanding of the relationship between the base and superstructure—the outrageous political antics we see are manifestations of class conflict in the mode of production—made literal by the conceit.

The visual comparison between strings and ticker tape is the first of several instances of "intellectual montage" throughout the film, where Protazanov cuts from an event to a semantically linked object. He deploys these with particular enjoyment as we hear the capitalists scheme, accompanied by images from a variety show. "We are balancing on the edge of an abyss," one capitalist announces as a cut brings us to a trapeze artist doing the same in a long shot with the stage curtain in the background and a silent-film-like black circular vignette. A cut returns us to their conversation. "We must have in Bufferia a government with an iron fist!" responds another; a cut then brings us to a circus strongman hoisting an iron ball. His hand matches the raised one of a capitalist visible in the previous frame, then, more comically, another's in the subsequent shot as it lowers a tiny teacup into its saucer. Finally, they announce their plans, and a cut brings up an

image of circus artists doing backflips in a particularly rebus-like visualization of the concept of "overthrow" (the analogous Russian verb *oprokidyvat'* can be used for movements like somersaults). These images add little explanatory value but reinforce the notion that all of these political events are "for show," like the strongman's ostentatious performance of strength. The pairing of an image with their words undercuts the latter, comparing their alarmist rhetoric to the spheres of trivial entertainment. The variety-show images are technically set in the same theater where we subsequently see Do, Mi, and Sol' backstage in the next scene, but at this moment, they seem to emanate from a nondiegetic space or perhaps even the frame story itself with the master of ceremonies. They therefore represent a continuation of Protazanov's delight in interrupting actions with emblematic images, as in *Aelita*.

Protazanov also works his earlier stylistic interests into the new medium of sound and spoken language. These flourishes are more genuinely experimental, in the sense that they are less patterned, and create a more straightforwardly humorous effect instead of a rhetorical one. One sonic "pun" is worthy of similar techniques made famous by René Clair (an admirer of Protazanov, with whom he worked during the latter's stint in France).[34] When border control apprehends Do, his arrogant claim that he is their king prompts a punch in the face from the official. A sudden cut brings us to a volleyball synchronized with a satisfying rubber *thwack* on the soundtrack. As Do flies backward, shots from the players, in a prison hall, are intercut with images of him being tossed among the guards and chief official. The *thumps* of the volleyball cartoonishly soften the violent interrogation to match the tone of a comedy film. Protazanov also uses the cuts to construct motion not apparent in any individual shot of Do, creating the appearance that he is being tossed back and forth among the guards like a volleyball. In the latter third of the film when the fascist overthrow is imminent, a recurring gag involves characters mishearing various loud noises as gunshots that signal the beginning of the coup. Other jokes are more straightforwardly linguistic and reflect the Soviet interest in language and the spoken voice. Barber Sol', dressed as the prince before Parliament, passionately responds to a call that they "chop" (*strich'*) the Communists by repeating the same Russian word, which is also used for cutting hair: "Yes, yes, we must give him a chop! [*strich'*]." In a telephone conversation, one member of Parliament mishears "revolution" instead of "resolution" in the message that "the resolution will be inevitable in a few hours." Later, when barber Sol', as monarch, awards a medal to the prime minister, he accidentally commands him to continue to rule "in moderation" (*umerenno*) instead of "confidently" (*uverenno*), thus rankling the archbishop Re for revealing their authoritarian intentions too overtly. Like the sonified *St. Jorgen's Day* and like many early Soviet sound films, *Marionettes* is preoccupied

The Didactic Voice from Tolstoy to Lenin 181

with the linguistic aspects of recorded sound but often in a way that undermines the spoken authority of an official voice.

Protazanov's sound gags evidence the logic of the "attraction" prompting the first experimentation with cinematic style during the era of early cinema and, similarly, the novel technical possibilities of synchronized recorded sound. The most overt case of a sound attraction is in the musical number seen in the first section of the plot, starring diva Mi. Do, sitting backstage with barber Sol', mentions seeing ex-king of Spain Alphonse and calls the thought of an unemployed monarch a "disgusting spectacle." Whether the viewer is supposed to find the ensuing musical number disgusting is not obvious, given its elaborate presentation. The phrase cues a literal spectacle as Mi goes onstage to perform "Let's Go to Paraguay" (*Poedem v Paragvai*), an original song written for the film by Leonid Polovinkin, which characters will refrain periodically for the rest of the film ("a country of lovers and monks"). Valentina Tokarskaya dances with a puppet, no doubt signifying Mi's pliable royal boyfriend, accompanied by dancers showing no small amount of leggy flesh. The choreography draws heavily from the abstract configurations of moving female bodies for the camera already made famous by Busby Berkeley in Warner Brothers musicals of the early 1930s, the most obvious reference to which is an overheard shot as the dancers encircle Tokarskaya. The movements' obvious erotic appeal and her revealing costume find an alibi in the act's situation in a decadent capitalist state and Tokarskaya's Mi representing an unsympathetic character; this strategy would become integral to occasional musical numbers with this flavor in Soviet cinema, most famously in more "capitalist" sequences in Alexandrov's *The Circus*, permissible due to actress Lyubov Orlova playing an American starlet.[35]

As this is the only proper Hollywood-style musical number in *Marionettes*, Protazanov's film does not take full advantage of this viable representational strategy. But its disavowal cuts deeper and more insightfully. The film's regular comparisons of elite machinations with tawdry entertainment suggest the political dimensions of the latter. *Marionettes* presages more systematic critiques of the culture industry beginning to be formulated at this time. Indeed, in its cast of musical note characters, the film includes diva Mi among royalty, parliamentarians, and religious authorities, suggesting an analogous role in the capitalist power structure. This musical's "backstage" is the sociopolitical logic of the performance, not the leads' romantic foibles or creative aspirations. It is hard not to see the preoccupation with intentional design and creative manipulation, in both political and aesthetic spheres, reflecting back on the film itself. The puppet show analogy that opens the film no doubt points to the invisible puppeteer of the film, director Protazanov himself, and his situation in the economic and political logic of the film industry. *Marionettes* is an heir to Soviet comedies appropriating

capitalist cinematic genres of the 1920s, such as *Mr. West in the Land of the Bolsheviks* or *The Cigarette Girl from Mosselprom* (both 1924)—this time with a new layer of reflexivity. One could imagine the film's design appealing to Bertolt Brecht and Erwin Piscator and their notions of an "epic theater." The puppet representations of characters, their strange names, the appropriations of the theatrically derived styles of early cinema, and the film's aggressive audiovisual "tricks" all foreground artifice and puncture a sense of illusionistic realism we see in the actions of the main actors in their scenes. Protazanov might have come into contact with some of these ideas during Brecht and Piscator's collaborations with Mezhrabpom or perhaps absorbed an interest in these creative distortions from Russian formalist notions of *ostranenie* (making strange).[36] The musical number and discrete "gag" sequences gesture toward a structure based on modular, self-contained units that Brecht advocated instead of an absorbing central line of action linking scenes through causality. The puppet show conceit and frame story also fragment the film into separate spheres of reality that resist the pull of a coherent narrative diegesis. And on a more basic level, the universally dislikable characters in the film are unlikely to elicit audiences' sympathies. As Brecht was only beginning to write his main texts on these ideas and Protazanov was unlikely to be aware of them, their affinity owes more to their shared Marxist backdrop and *Marionettes* being an explicitly politically themed drama.

The ending of the film, too, likely would appeal to Brecht for its explicitly rhetorical force. Do, Re, and Mi have been reunited in the capital as the "Iron Hand" and their political allies await a signal to seize power. Meanwhile, Do attempts to wrest his stolen royal identity from his barber. He seizes a formidable tome titled *Fascism as a Philosophy* gifted to him by the fascist Fa earlier, wrestles Re to the ground, and raises the book over his head, preparing to knock him out. A cut brings us to a cannon firing, signaling the beginning of the coup, then another brings us back to the master of ceremonies and a tableau of the puppets in an arrangement similar to that of the characters we have just seen. The puppets drop to the floor as the puppeteering hands let go of the strings, and the master of ceremonies concludes the film: "Dear audience! You have watched a fantastic, but probable story. You've heard a gunshot, but for the time being, it hasn't been fired in reality. But it may happen. [. . .] You yourself can easily guess the meaning of our comedy." The scene produces a powerful "pulling back of the curtain" effect and resituation of the previous ninety-seven minutes of entertainment in the political realities of 1934 with an almost instantaneous transformation from farce to solemnity. This is a far more elaborated point than the conventional moment of direct address common at the end of Soviet films exhorting vigilance in the face of foreign aggression, energetic work to fulfill production quotas, generalized revolutionary pathos, or discrete actions like buying

The Didactic Voice from Tolstoy to Lenin 183

bonds (as in *The Tailor from Torzhok*). *Marionettes* ultimately concludes as an essay on a topic that remains relevant, even if one takes issue with its coarsely Marxist interpretation. It is even easier for us today to appreciate the enduring connection it draws between authoritarian power-grabs and sheer buffoonery.

Marionettes was a stylistically bold experiment in didactic cinema that arrived when elite preferences were moving toward monumental mythmaking. The film attracted little attention or celebration when it appeared on Soviet screens, though Stalin himself quite liked it.[37] The theatrical traditions so essential to the film's concept proved to be its central weakness. As a healthy, conventional realism became dominant, Soviet critics were growing more superficial in their assessments of films, less inclined to look for the subtleties of critique and autocritique in an ironical work like *Marionettes*, and more inclined to see simply crass imitation of bourgeois entertainment. Protazanov and co-screenwriter Shveitser made no secret of what the film owed to stage artifice. In a presentation before the film's release—later reprinted in *Rot-film*, Mezhrabpom's in-house newspaper—they dubbed the film's style "conventional (*uslovnyi*) realism," a particularly contradictory attempt to graft one's aesthetic interests onto the accepted label. (The term *uslovnyi*, a favorite of Vsevolod Meyerhold and other avant-gardists, connotes being arbitrary and simply agreed upon; it was preferred for describing matters of artistic convention.) Calling the film one of "high tendentiousness," they claimed that "the material demands apparent generalization, its own kind of *plakatnost'*," appropriating a term of abuse that had been used by critics of his films in the past. But as for the film's numerous borrowings from bourgeois European stage traditions, Protazanov and Shveitser simply apologized; they considered it an unfortunate necessity due to the lack of a strong native political comedy tradition, especially for foreign settings. For critic and screenwriter Nikolai Otten, though, this strategy of appropriation was just a fig leaf for light entertainment. In his negative review of the film, he rehashed the common charge against Protazanov's works that they took "Western" entertainment and added some superficially political elements that viewers could easily ignore: "Instead of a pamphlet, it is a salon farce, accompanied by politically correct [*politgramotnyi*] slogans." Otten, however, was equally attuned to the centrality of stage traditions like the still tableau and the allegorical image in Protazanov's work. He claimed that one of the defining features of Protazanov's style for his whole career was its *fotografichnost'*, or its "immobile construction of the shot," presumably referring to specifically a still photograph. Noting the unusual visual rebuses, such as the trapeze artist and circus strongman intercut with the capitalist speech, Otten's problem was not with this unusual stylistic choice so much as the superficiality of its relationship with the content. The images he claimed did not so much reveal a subtext as simply reiterate the literal meaning of the words as an image.[38] *Marionettes* appeared at the

time when the room for Soviet experimentation with the new sound technology that marked the first half of the 1930s was shrinking. It offers an intriguing other possibility for Soviet musical comedy closed off by the wild success of Grigori Alexandrov's films, beginning with *Jolly Fellows* later that year.

Protazanov never attempted anything as bold as *Marionettes* again, but some vestiges of the techniques he inherited from early cinema can still be seen in *Without a Dowry*. In its opening dedication to playwright Ostrovsky, Protazanov once again selects a monument, this time in a more valorizing tone for Tolstoy and Lenin rather than the lighthearted one for Kalinin. The famous final sequence is another example of the detached emblematic shot living on in more conventional sound cinema. During Larisa and Karandyshev's final confrontation, she rebukes his command that she return to him and walks away. He produces the pistol and fires at her as she passes by an ornamental fence consisting of iron posts, each connected by a dangling chain. After the shot hits her, she begins to fall and grabs a chain in a desperate attempt to maintain her composure. As she thanks Karandyshev, she attempts to lean on the chain before she finally falls down. In a close shot taken from the ground, we see a small section of the chain dangling above her, doubled in shadow below. The final shot tracks backward away from the wavering chain, eliminating Katya herself from the frame entirely. It is a widely comprehensible signifier for a woman trapped by the strictures of the "dark kingdom" of nineteenth-century rural Russia that simultaneously recalls Marx's line that the proletariat "has nothing to lose but its chains." The chain also echoes an exchange in dialogue in the scene prior to this one, when she pleads for Vozhevatov to abandon his fiancée. He refuses, and she asks if he is "in chains" (*v tsepiakh*). He concurs, telling her he is enchained by "his merchant's word of honor." The image of Larisa grabbing hold of the chain appeared in many production stills for the film and even posters at the time of its release due to the simple way it summarizes her predicament: she is confined not only by the physical constraint itself but also by her own mental attachment to it. Along with the opening scene of her and Vozhevatov's courtship at the wedding, *Without a Dowry*'s finale represents the filmmaker's best-known addition to Ostrovsky's play.

Protazanov's interests in word-like images, direct address, and nondiegetic commentary thus remained vital well into the sound era. These related techniques testify to the direct genealogy between early cinema and the first twenty years under Soviet power in its stylistic experimentation, its less voyeuristic interpellation of the viewer, and its reference to a lived reality outside of a fictional universe. A director like Protazanov, steeped in commercial genre works for the first decade of his career and fashioning himself as an entertainer, could make didactic films for the Soviet state that challenged mainstream norms while never really departing from the techniques he had cultivated beforehand. It is

The Didactic Voice from Tolstoy to Lenin 185

also clear that the diminishing number of stylistically adventurous films made in the late 1930s stem less from the transition to sound itself than the increasing interest in matters of film content by the cultural bureaucracy and its official sponsorship of socialist realism. The Soviet transition to sound cinema in the first half of the 1930s was a period ripe with stylistic diversity and open to a range of approaches to the new sonic medium, many of which ultimately did not find favor.

Protazanov's example, though, casts a different perspective on this genealogy than the dominant one in the history of cinema as a mode of expression. Critics have emphasized the iconoclastic streak of the younger generation of Soviet avant-gardists, who looked to the brash energy of early cinema in part to fashion themselves as proletarians and assault the tastes of respectable intellectual society. But the most unusual features of Protazanov's style, even though they bear much resemblance to new explorations in montage, emerged not from his pursuit of chaotic sensation but of focused statement. Soviet filmmakers were descendants of the Russian intelligentsia who similarly conceived of culture as a means to educate, even if they now taught very different lessons than those before 1917. There was also much that was bluntly didactic about the Russian popular culture they were familiar with. When we look at Protazanov's expansive career, we can see the continuities that the theorists of montage were quick to disavow.

CONCLUSION

True to his passion for his profession, Protazanov continued working on another film project as his health declined. But rather than being compelled by death, had he himself chosen to retire on August 8, 1945, it might have been one of his characteristically strategic decisions. After the more permissive years of wartime production well evidenced in his cheery final film, *Nasreddin in Bukhara*, under postwar High Stalinism, what little room artists had in the film industry was almost eliminated entirely. Likely in response to more than two decades of declining production, in 1948, Stalin stated that it was unnecessary for the Soviet film industry to produce films with the scale—and diversity—of Hollywood production. The industry reoriented itself around quality rather than quantity with a new plan of a smaller number of more excellent films (according to their criteria). A "film famine" (*malokartin'e*) set in, with few new releases each year and many rereleases of previously successful films. It is hard to imagine an old but healthy Protazanov finding room for his cinema of light entertainment, irony, and visual eclecticism. But this cinema he exemplified proved to have more longevity than what dominated at the moment. The cultural "Thaw" that succeeded Stalin's death in 1953 provided opportunities for filmmakers, many of them young, to gently explore contemporary Soviet life in an unadorned style, much as Protazanov had done in his comedies and in *Aelita*'s sequences set on Earth. Filmmakers returned to the Russian classics he had first popularized in prerevolutionary times. Even the numerous films made about the war now reflected its human costs, like *The Forty-First*, rather than the constant need for vigilance against enemies.

But Protazanov was of a different temperament than the best-remembered directors of that era, such as Andrei Tarkovsky, Alexei German, and Kira Muratova. They took their cue from the growth of the international film festival circuit, movements such as the French New Wave, and the paradigm of the individualistic auteur director whose style and concerns suffused a film. Their virtue was in their intransigence, whether refusing to compromise on the films' content, spending years attempting to realize an ambitious project, or simply

Conclusion 187

completing films that would be banned or extremely limited in distribution. In contrast, openness and accessibility defined Protazanov's ethos. His closest descendants are the proponents of a genuinely popular cinema for the domestic Soviet audience, which grew in importance in the 1960s and 1970s as the film industry was given more commercial incentives. This book has already mentioned one such heir in chapter 1: Eldar Ryazanov, who consulted *Without a Dowry* when making his own adaptation of the same Ostrovsky play, *A Cruel Romance* (1984). Ryazanov was unparalleled in his time as an entertainer whose poignant comedies—such as *Carnival Night* (1956), *The Irony of Fate* (1975), and *The Garage* (1980)—delighted massive Soviet audiences with their humorous observations about postwar Soviet life. Another might be Nikita Mikhalkov, who began his Soviet career with unusual twists on literary classics before gaining outsized influence as a commercial filmmaker after 1991. His drama *A Slave of Love* (1975), set among the film industry in exile in Crimea after October 1917, even took a few pages out of Protazanov's life itself. The example set by the pioneer of Russian commercial cinema gained relevance with each year after 1991, when economic pressures to find an audience were unleashed on a younger generation of directors, who had earlier been protected by the Soviet industry's semicommercial, semi-ideological basis. Now Russian filmmakers must take up the challenge of how to appeal to a sizable native audience who always have the option to see better-promoted and better-financed Hollywood films. As the Putin administration has asserted more presence in media industries, so too has the question of compromise with state power.

Protazanov offers a success story in a political experiment that is today typically defined by narratives of failure, both regarding the collapse of the Soviet Union itself and Soviet cinema as a project. The latter never proved a serious rival to the products of the Hollywood studios on the international market. A wave of avant-garde political films in the 1920s is remembered today for suggesting a promise that Soviet filmmakers were ultimately unable to fulfill. Moreover, they enjoyed success primarily with discerning intellectual viewers rather than proletarians and, therefore, did not achieve their stated purpose. Since 1989, historians have mostly confirmed the complaints Soviet critics made at the time: Soviet montage films were too difficult for uneducated viewers to understand, much less enjoy. Nor was the Soviet film industry's record within its borders particularly impressive in economic terms. Even in its more productive years, much of its output was "gray"—offering neither delightful entertainment nor effective agitation. The few Hollywood films that made it to Soviet screens were embraced with an enthusiasm that suggests they satisfied some need that the domestic industry could not. But sometimes, Soviet cinema *did* work. The studios released films that, despite their salient ideological content, struck a chord with audiences and that they remembered for years to come. The films offered

complex emotional experiences in which political content was one ingredient, not the defining element—just as it is in popular cinema around the world. And some filmmakers, including Protazanov, managed to do so as consistently as any of their counterparts in America, Western Europe, or Japan. His career suggests that, at its foundation, the reconciliation of popular entertainment with revolutionary ideology was indeed possible in principle, if difficult. The enduring successes were the exception rather than the rule—but the same might be said of commercial film industries worldwide that mostly produce films forgotten soon after their release.

Many auteur studies end in anticipation of the director's future career with the excitement of how they will adapt to a changing world and film market. A few especially untimely books have been made irrelevant by a subsequent masterwork or a sudden left turn in a director's creative interests. This is not one of those books. It is hard to imagine a director whose career is more finished. He died before all but the oldest directors working today were born, and he has no descendants in his main family line. It is unlikely that any new substantive information about his life will emerge. Arlazorov, at work on his 1973 biography, interviewed the last friends and family members who knew Protazanov personally. The only extended relatives with any connection surviving today have only the haziest memories of the director. It seems no more likely that archivists receive another suitcase, like the one left by the death of Frida Protazanova, containing a large collection of personal documents and correspondence that provide a glimpse of their lives.

But while there has been relatively little for this book to add about Protazanov's biography, it has benefited considerably some of his works thought lost but rediscovered by film archivists. The retrospective of prerevolutionary films at the 1989 Pordenone Silent Film Festival was unique in (non-Russian) scholars' sudden discovery of an entire national cinema tradition. Nothing of this scale is likely to happen again, but films previously thought lost continue to be identified regularly in archives around the world. In fact, very late in the publication process for this volume, I received word of some additional Protazanov films that have resurfaced. The Jérôme Seydoux-Pathé Foundation recently sponsored the restoration of two films at the Cinémathèque française, which are likely to have been directed, or at least codirected, by Protazanov. *The Love of a Japanese Woman* (*Liubov' iaponki*, 1913) and *Better Death Than Dishonor* (*Luchshe smert', chem beschest'e*, 1913) both star the noted Japanese model and actress Ōta Hisa, known as Hanako and famous for her intensely emotional performances in Europe at a moment when audiences there were becoming fascinated with Japanese art and theater. These films add a new layer of transnational exchange quite distinct from the one I have explored in this book. Moreover, there also appear to be some additional films listed in Protazanov's filmography with extant

Conclusion 189

materials in the archives of the Cinémathèque française but that I have been unable to survey: *The Bought Husband* (1913) and *How a Child's Soul Wept* (*Kak rydala dusha rebenka*, 1913). No doubt, Protazanov developed his craft quickly during the first few years of his career, and these, along with more films from this early period, might help us understand this evolution better and add nuance to my account. There are also some crucial films in his career trajectory that are absent. Perhaps the most important is his 1913 blockbuster adaptation of *The Keys to Happiness*, the bestselling novel by Anastasia Verbitskaia now considered a canonical work of late imperial popular culture. Only a tantalizing one-minute fragment of this film survives, taken from a 1945 compilation film celebrating the career of Vladimir Gardin, Protazanov's prerevolutionary collaborator by then better known for his performance as the redeemed alcoholic factory worker Babchenko in *The Counterplan* (1932). Protazanov's later feature-length adaptation of Dostoevsky, *Nikolai Stavrogin* (1915), represented his first attempt at a prestigious big-budget literary adaptation. It is therefore in some respects more important to his career than the extant and thus better-known *The Queen of Spades* (1916) and *Father Sergius* (1918). Protazanov's career outside of Russia also has a few particularly intriguing lost films. His brief period in Crimea directing projects for the White Army is a complete blank spot. How much did a film like *Women of Golgotha* (1919) resemble concurrent films made for the Red Army? How much did his later films with political themes, like *His Call*, draw from earlier techniques he used to articulate a completely different ideology? Another unique film is his 1921 adaptation of Paul Bourget's *Le sens de la mort* (1915), a *roman à thèse* probing the minds of a believer and an atheist at the moment of their deaths so as to illustrate Catholic doctrine. Protazanov gravitated toward these kinds of psychological topics that gave an opportunity to visualize subjectivity on screen, but Bourget's work is considerably more modernist than Protazanov's typical sources. The discrepancy between the author's Catholicism and the director's avowed atheism would also presumably be a source of tension. As the film was well received by French critics, it could lend insight into how French national culture adapted to Russians' visibility at that time.

While his life has receded into the past and seems more distant with each new year, his work lives on and remains vibrant. His films are easier to see now than they ever were for those who actually lived in the Soviet Union. The majority of his extant filmography now has reasonably complete, if flawed, variants circulating widely on the internet and have been shown in a variety of retrospectives in recent years. Silent cinema itself has proven to have a robust if niche audience one hundred years after it dominated visual culture. Multiple film festivals dedicated to films before 1930 are held each year from San Francisco to Bologna to Manila and attract a healthy audience—not only scholars in film studies but

enthusiasts. Yet while digital distribution has enhanced access, it is also ephemeral, with the underlying data capable of disappearing without notice. The same film stock on which these works were passed down to us remains the most durable form of long-term preservation, and their survival depends on how we care for the physical reels—at least until a better option is available. As Protazanov's numerous lost films show, the survival of even famous feature films is never guaranteed. Recent changes in the leadership and restructuring of Russian film archives have been worrisome in this regard. The Russian state has been attracted to a neoliberal approach toward these "resources," treating such cultural agencies as potential revenue-generating engines. A profit-maximizing attitude toward Russia's—and the world's—cinematic heritage is shortsighted. The twentieth century's vicissitudes of power and ideology well evidence how our beliefs in what is valuable change over time.

That includes what critics and viewers find valuable about these films. For a time, the revolutions of 1917 were considered the most important and consequential events of the twentieth century, and cinema was considered its "most important art" without qualification. In the twenty-first, neither has this centrality. We have a far greater set of examples of sociopolitical transformation to draw from and a far more complex array of mass media forms and technologies to consider. Both historians and critics have also turned their attention beyond the First and Second Worlds of the Cold War. I am among the first generation of scholars who do not have any living connection to the Soviet Union and do not even remember its end in 1991 as a media event. But now that the seeming revolutionary urgency of Soviet history has subsided, we also can view the films of the era with more nuance and complexity. We can ask questions other than to what extent 1917 represented a Marxist historical development and whether or not that is a good thing. We can see the films as things other than radical challenges to the dominant commercial cinema or noxious propaganda. And we can assess filmmakers according to more varied criteria than whether or not they dissented or toed the Party line. We are in a better position than ever to appreciate Protazanov's mission of making genuinely entertaining and edifying movies, always refracting the shifting cultural and political circumstances with an eye to how they might have been experienced by the filmgoers who attended them.

Or maybe the political stakes of his time have not yet subsided. I currently write this on a university campus in Shenzhen, China, in the world's most populous country, run for more than seventy years by an avowed communist regime whose slogans and sickle-and-hammer iconography are salient on every street corner. Across the street, Beijing Polytechnic University has constructed a new campus in collaboration with Moscow State University—the first Sino-Russian cooperative university, expected to eventually offer courses in both Mandarin Chinese and Russian. Outside my window, its central building looms

over the Longgang District. It is constructed as a replica of Moscow State's original main building, one of the imposing "Seven Sisters" constructed under postwar High Stalinism and still considered the tallest educational building in the world. This university has appeared at the same time as the Chinese Communist Party has put particular energy into reasserting a particular variant of Marxist-Leninist-Maoist ideology in the educational curriculum. They have similar ambitions for a film industry that might serve as an alternative to Hollywood while its filmmakers struggle to find ways to appeal to audiences under increasingly stringent censorship and oversight. Because mass media are inherently a cultural, economic, and political phenomenon, the basic questions that define Protazanov's life and work will be relevant no matter what the future holds.

SELECTED FILMOGRAPHY

This filmography lists all known extant films directed by Yakov Protazanov in approximate chronological order of their date of production. It provides the title of each film in its original country of production and the most common English title in use. This information draws from the most exhaustive Russian-language filmography of his career, compiled by Peter Bagrov, Svetlana Skovorodnikova, Tamara Sergeeva, and Natalia Nusinova, with my additional information about archival copies that have been rediscovered since its publication in *Kinovedcheskie zapiski* in 2008.

SILENT FILMS

Pesnia katorzhanina (*The Convict's Song*). Produced by Gloria (Russian Empire), 1911. Print: British Film Institute (incomplete, 671 feet).

Ukhod velikogo startsa (*The Departure of a Great Old Man*). Produced by Thiemann & Reinhardt (Russian Empire), 1912. Print: Gosfilmofond (860 meters).

Kak rydala dusha rebenka (*How a Child's Soul Wept*). Produced by Thiemann & Reinhardt (Russian Empire), 1913. Print: Cinémathèque française (complete without intertitles, 205 meters).

Kuplennyi muzh (*The Bought Husband*). Produced by Thiemann & Reinhardt (Russian Empire), 1913. Print: Cinémathèque française (complete without intertitles, 708 meters).

Kliuchi schast'ia (*The Keys to Happiness*). Produced by Thiemann & Reinhardt (Russian Empire), 1913, codirected with Vladimir Gardin. Fragment preserved at Gosfilmofond.

Liubov' iaponki (*The Love of a Japanese Woman*). Produced by Le Film Russe (Pathé, France), 1913, likely directed by Yakov Protazanov, possibly codirected with Kai Hansen. Print: Cinémathèque française (complete without intertitles, 567 meters).

Luchshe smert', chem beschest'e (*Better Death Than Dishonor*). Produced by Le Film Russe (Pathé, France), 1913, likely directed by Yakov Protazanov. Print: Cinémathèque française (complete without intertitles, 318 meters).

Muzykal'nyi moment (*Moment Musical*) and *Noktiurn Shopena* (*A Chopin Nocturne*). Produced by Thiemann & Reinhard (Russian Empire), 1913. Preserved on the same reel at Gosfilmofond (170 meters).

Odin nasladilsia, drugoi rasplatilsia (*One Pays, One Plays*). Produced by Thiemann & Reinhardt (Russian Empire), 1913. Print: Gosfilmofond (incomplete, 230 meters).

Razbitaia vaza (*The Broken Vase*). Produced by Thiemann & Reinhardt (Russian Empire), 1913, distributed as *Le Cœur brisé* by Pathé frères (France), 1914. Print: Cinémathèque française (complete without intertitles, 390 meters).

Rozhdestvo v okopakh (*Christmas in the Trenches*). Documentary film produced by Thiemann & Reinhardt (Russian Empire), 1914. Print: Russian State Documentary Film and Photo Archive (RGAKFD; 223.8 meters).

Plebei (The Plebeian). Produced by Thiemann & Reinhardt (Russian Empire), 1915. Print: Gosfilmofond (incomplete, 207 meters).

Sashka-seminarist (Sashka the Seminarian). Four-part series produced by Ermolieff (Russian Empire), 1915, codirected with Cheslav Sabinsky. Chapter four is partially preserved at Gosfilmofond (480 meters).

Pikovaia dama (The Queen of Spades). Produced by Ermolieff (Russian Empire), 1916. Print: Gosfilmofond (incomplete, 1176 meters).

Podaite, Khrista radi, ei (Nishchaia) [*Give Her Something, for God's Sake (The Beggar Woman)*]. Produced by Ermolieff (Russian Empire). Print: Gosfilmofond (Two copies; 1,240 meters and 1,305 meters, from National Film Archive, Prague).

Ne nado krovi! (No Bloodshed!). Produced by Ermolieff (Russian Empire), 1917. Print: Cinémathèque française (missing the third and fourth of five reels, 1,220 meters).

Satana likuiushchii (Satan Triumphant). Produced by Ermolieff (Russian Empire), 1917. Print: Gosfilmofond (incomplete, 2,430 meters).

Gornichnaia Dzhenni (Jenny the Maid). Produced by Ermolieff (Russian Empire), 1918. Print: Gosfilmofond (1,429 meters).

Ditia chuzhogo (Child of Another), also known as *To nadezhda, to revnost' slepaia (Now Hope, Now Blind Jealousy).* Produced by Ermolieff in either 1918 or 1919. The two titles could reflect either alternate titles for one film or a reedited or rereleased version of a similar film. Print: EYE Filmmuseum (763 meters).

Otets Sergii (Father Sergius). Produced by Ermolieff (Russian Empire), 1918. Print: Gosfilmofond (2209.4 meters).

Bogatyr' dukha (Hero of the Spirit). Produced by Ermolieff (Russian Empire), 1918. Print: Gosfilmofond (1,421.6 meters).

Maliutka Elli (Little Ellie). Produced by Ermolieff (Russian Empire), 1918. Print: Gosfilmofond (incomplete, 1,263 meters).

Chlen parlamenta (Member of Parliament). Produced by Ermolieff (Yalta), circa 1919–1920. Print: La Cineteca Nazionale, Rome, viewed at Gosfilmofond (2184 meters).

L'angoissante aventure (A Narrow Escape). Produced by Ermolieff (France), 1920. Print: Cinémathèque française (1,450 meters and 1,673 meters).

Justice d'abord! Produced by Ermolieff (France), 1921. Print: EYE Filmmuseum (incomplete, 600 meters).

Vers la lumière (Toward the Light), also known as *Le Retour (The Return).* Produced by Thiemann (Joinville), 1921. Print: EYE Filmmuseum (840 meters).

Der Liebe Pilgerfahrt (Pilgrimage of Love). Produced at Universum-Film-aktiengesellschaft (UFA; Germany), December 1922, released early 1923. Print: George Eastman House (6,315 feet).

Aelita. Produced at Mezhrabpom-Rus', 1924. Print: Gosfilmofond (2,367.2 meters).

Ego prizyv (His Call). Produced at Mezhrabpom-Rus', 1925. Print: Gosfilmofond (1,850.5 meters).

Zakroishchik iz Torzhka (The Tailor from Torzhok). Produced at Mezhrabpom-Rus', 1925. Print: Gosfilmofond (1,860.8 meters).

Protsess o trekh millionakh (The Case of the Three Million). Produced at Mezhrabpom-Rus', 1926. Print: Gosfilmofond (1,815 meters).

Sorok pervyi (The Forty-First). Produced at Mezhrabpom-Rus', 1926. Print: Gosfilmofond (1,536 meters).

Chelovek iz restorana (Man from the Restaurant). Produced at Mezhrabpom-Rus', 1927. Print: Gosfilmofond (2,001.2 meters).

Don Diego i Pelageia (*Don Diego and Pelageia*). Produced at Mezhrabpomfilm, 1927. Print: Gosfilmofond (1,695 meters).

Belyi orel (*The White Eagle*). Produced at Mezhrabpomfilm, 1928. Print: Gosfilmofond (2,000 meters).

Chiny i liudi (Chekhovskii al'manakh) [*Ranks and People (Chekhovian Almanac)*]. Produced by Mezhrabpomfilm, 1929. Print: Gosfilmofond (1,855 meters).

Prazdnik sviatogo Iorgena (*St. Jorgen's Day*) [silent version]. Produced by Mezhrabpomfilm, 1930. Print: Gosfilmofond (2,384 meters).

SOUND FILMS

Tommi (*Tommy*). Produced at Mezhrabpomfilm, 1931. Print: Gosfilmofond (1,710 meters).

Marionetki (*Marionettes*). Produced at Mezhrabpomfilm, 1934. Print: Gosfilmofond (2,480 meters).

O strannostiakh liubvi (*On Love's Strangeness*). Produced at Mezhrabpomfilm, 1934–1936; unreleased. Print: Gosfilmofond (1,714.8 meters).

Prazdnik sviatogo Iorgena (*St. Jorgen's Day*) [sound version]. Produced by Mezhrabpomfilm, 1935. Print: Gosfilmofond (2,230 meters).

Bespridannitsa (*Without a Dowry*). Produced by Rot-front, 1936. Print: Gosfilmofond (2,407 meters).

Semiklassniki (*The Seventh-Graders*). Produced by Soiuzdetfilm, 1938. Print: Gosfilmofond (2,285 meters).

Salavat Iulaev (*Salavat Yulayev*). Produced by Soiuzdetfilm, 1940. Print: Gosfilmofond (2,055.4 meters).

Nasreddin v Bukhare (*Nasreddin in Bukhara*). Produced by Tashkent Film Studio, 1943. Print: Gosfilmofond (2,185 meters).

ACKNOWLEDGMENTS

This study of a film director is, in part, a biography, but after ten years of work, it has come to seem to me like an autobiography too. The same week that the dissertation prospectus that originated it was approved, I was diagnosed with stage III colorectal cancer. The assistance I received over the next three years as I fortunately made a full recovery and managed to complete the dissertation often blurred the line between the personal and the professional in a way that the brief mention I make here cannot fully capture. I relied on a loving family, many of whom took off from their own lives at short notice to ensure I was cared for: Mom, Dad, Franny, Eli, Jenna, Eastman, Melissa, and of course Emory and Nico. I also received practical and emotional support from friends in Madison and beyond: Alex Kopecky, Priya Ghosh, Amber Lee, Derek Long, Jenny Oyallon-Koloski, Leo Rubinkowski, Chelsea McCracken, Matt Connolly, Andrea Comiskey, Jonah Horwitz, Amanda McQueen, Casey Long, and Maureen Rogers.

Like most with an interest in Soviet cinema, I first encountered Yakov Protazanov's work through *Aelita*, a film that utterly bewildered me the first time I saw it—and still does, even after years of research and countless viewings. Yet this project truly began to take shape at the University of Wisconsin–Madison's Department of Communication Arts, when I encountered European cinema of the 1910s. While others found themselves nodding off during lengthy screenings of literary adaptations like *Father Sergius*, I was captivated by a feeling that I had become a spectator of the past, with a completely different idea about what a movie was supposed to be. In my dissertation, I wanted to explore the nature of the radical transformation of films across the silent era through one of its leading directors. I benefited from the guidance of so many experts in related areas in the film program who served on my committee: Vance Kepley, Lea Jacobs, Ben Singer, and Maria Belodubrovskaya. Other mentors shaped my ideas throughout this project, including Kelley Conway, Jeff Smith, J. J. Murphy, Ben Brewster, David Bordwell, and Kristin Thompson. Support from the university in a Chancellor's Fellowship, a Vilas Research Travel Grant, and a Mellon Wisconsin Dissertation Completion grant also enabled me to travel to three different countries to view the archival prints that form this book's foundation. I would also like to thank UW's broader community of Russianists in the History Department, Department of Slavic Languages and Literatures, and Center for Russia, East Europe, and Central Asia, many of whom read early versions of chapters in our Russo-Soviet history *kruzhok*: Fran Hirsch, Kathryn Ciancia, David Bethea,

Karen Evans-Romaine, Andrey Ivanov, Roberto Carmack, Heather Sonntag, Ben Raiklin, Athan Biss, Maya Holzman, Victoria Kononova, and Jennifer Tischler. I am especially grateful to David McDonald, who agreed to serve on my committee and treated my manuscript with his full attention and expertise.

Yet my interest in Protazanov took on an entirely new dimension after I accepted an offer to teach with the General Education Group at the Chinese University of Hong Kong, Shenzhen, while expanding the dissertation into a book covering his full career. In Shenzhen, I encountered a warm community of scholars who, whatever their field, treated Soviet history as an area of vital importance to understanding the present moment: Gregory and Laura Jones-Katz, Lucas Scripter, Christopher Kluz, Liu Kuanyuan, John Feng, John Robert Williams, Li Xueshi, Aurelian Boucher, Wang Qin, Thomas Carroll, Gautam Ghosh, Deng Yangzhou, Lü Chentong, Jiang Lili, and Chen Bin. Living far away from my home country and spending so many afternoons and evenings with foreign colleagues, some of whom had lived in China for decades, and Chinese scholars who had crossed borders multiple times attuned me to deep interconnections between our individual migrations, our identities, and how we understand the world around us.

This project also would not have been possible without the cooperation of a broader community of scholars and archivists. I would like to thank those who assisted me with seeing some unique artifacts: Mark-Paul Meyer at EYE Filmmuseum; Oleg Bochkov, Peter Bagrov, and the staff at Gosfilmofond; Laure Marchaut at the Cinémathèque française; Bryony Dixon and the staff at the British Film Institute; Rosemary Haines, Dorinda Hartmann, and Mike Mashon at the Library of Congress; Jared Case, Jeff Stoiber, and the staff at George Eastman House. Other scholars also provided guidance for my research and ideas along the way, especially Yuri Tsivian, Daria Khitrova, Birgit Beumers, Natalie Ryabchikova, Maria Vinogradova, Zdenko Mandušić, Oksana Chefranova, Karl Brown, Joan Neuberger, Anindita Banerjee, Vince Bohlinger, Colin Burnett, and Herb Eagle. The editors at Rutgers University Press, Nicole Solano, R. Barton Palmer, and Homer Pettey, and the anonymous readers have also helped make this book into the best version it can be, both in their substantive comments and in their accommodations of some of my more difficult requests. I am particularly grateful for Homer and Bart's subvention of extra funds to allow for the inclusion of more film stills.

The most important part of a journey, as writing this book has been, is the companions we share it with. I would like to give special thanks to Grace Allen, my partner, co-adventurer, and "real" historian colleague, who has been present at much of its writing—whether in a Paris library, Moscow apartment, or Taipei coffee shop.

NOTES

INTRODUCTION A PROTO- AND PROTEAN FILMMAKER

1. Iakov Protazanov, "Protazanov o sebe," in *Iakov Protazanov: O tvorcheskoi puti rezhissera*, ed. Moisei Aleinikov, 2nd ed. (Moscow: Iskusstvo, 1957), 288. Transcription of Protazanov lecture, 9 February 1945, RGALI 1921.1.9, 2.

2. Peter Kenez is credited with first using this term, which has become commonplace. *The Birth of the Propaganda State: Soviet Methods of Mass Mobilization, 1917–1929* (Cambridge: Cambridge University Press, 1985), 4.

3. Evgenii Margolit, *Zhivye i mertvoe: Zametki k istorii sovetskogo kino 1920–1960-kh godov* (Saint-Petersburg: Masterskaia "Seans," 2012), 9–18.

4. Moisei Aleinikov, ed. *Iakov Protazanov: O tvorcheskoi puti rezhissera* (Moscow: Goskinoizdat, 1948). A second edition of this volume with significant revisions was released by the publisher Iskusstvo in 1957. Moisei Aleinikov, *Iakov Protazanov* (Moscow: Iskusstvo, 1961).

5. Aleinikov, *Iakov Protazanov* (1961), 90.

6. Mikhail Arlazorov, *Protazanov* (Moscow: Iskusstvo, 1973).

7. Many of these scholars were also active in translating works so as to make them available in English to Western scholars, as in Richard Taylor and Ian Christie, eds., *The Film Factory: Soviet Cinema in Documents* (London: Routledge, 1988). Representative works include Richard Taylor, *The Politics of Soviet Cinema, 1917–1929* (Cambridge: Cambridge University Press, 1979); Denise J. Youngblood, *Soviet Cinema in the Silent Era 1918–1935* (Austin: University of Texas Press, 1991); and the works in Richard Taylor and Ian Christie, eds., *Inside the Film Factory: New Approaches to Russian and Soviet Cinema* (London: Routledge, 1991). For work specifically on Protazanov by this group, see Ian Christie and Julian Graffy's accompanying essay to a retrospective at the National Film Theater, *Protazanov and the Continuity of Russian Cinema* (London: National Film Theatre, 1993), 22; also available at the *KinoKultura* web journal, issue 5, 2005, http://www.kinokultura.com/articles/jul05-christie.html#_jmpo_.

8. Denise J. Youngblood, *Movies for the Masses* (Cambridge: Cambridge University Press, 1992), xiii, 120. The chapter on Protazanov primarily narrates his biography and focuses on the reception of his films in the 1920s.

9. For Western scholars' first reactions to these films, see Lorenzo Codelli, "Conference on Russian Cinema, Pordenone 1989," *Griffithiana* 37 (1989): 84–98. Yuri Tsivian, more than any scholar, has helped bridge the divide between these camps, and between scholars of Soviet cinema and the more film studies–based scholarship in early cinema. He discusses Protazanov most directly and regularly in *Early Cinema in Russia and Its Cultural Reception*, trans. Alan Bodger (London: Routledge, 1994).

10. It is not clear who first made this play on words, but Viktor Matizen, Naum Kleiman, and Yuri Tsivian have employed it at various points. Naum Kleiman et al., "Protazanov i avangard. 'Kruglyi stol' v NII Kinoiskusstva 9 noiabria 2007," *Kinovedcheskie zapiski*, no. 88 (2008): 165.

11. The conference produced a full issue (88) of the Russian-language journal *Writings in Cinema Studies* (*Kinovedcheskie zapiski*).

12. Kleiman et al., "Protazanov i avangard," 170.

200 Notes

13. Kleiman et al., 176.

14. Peter Wollen makes a full-throated case for Curtiz as an auteur in "The Auteur Theory: Michael Curtiz and *Casablanca*," in *Authorship and Film*, ed. David A. Gerstner and Janet Staiger (New York: Routledge, 2003), 61–76.

15. The section attributed to Protazanov himself, "Protazanov o sebe," in Aleinikov's collection of memoirs was in fact written and composed by the latter but based on "oral remarks" by the director. Aleinikov is probably referring to a speech Protazanov delivered at the Russian State Film School, VGIK, on February 9, 1945 (shortly before his death), a direct transcription of which is available at RGALI 1921.1.9. I have not found any serious discrepancies between these but have attempted to use direct words when possible. When using Aleinikov's sources, I have cross-referenced them whenever possible with other available archival sources.

16. "Nasha kino-anketa," *Na literaturnom postu*, no. 1 (1928): 71–76, and no. 2 (1928): 50–54.

17. Aleinikov, "Protazanov o sebe," 309.

18. See for example, Ia. Protazanov and Iu. Fogel'man, "V tvorcheskoi sektsii Soiuzdetfil'ma," *Kino*, no. 27 (867), June 11, 1938, 2.

19. I. Vaisfel'd, "Effekt Protazanova," *Iskusstvo kino*, no. 8 (August 1981): 131.

20. Peter Wollen, *Signs and Meaning in the Cinema* (Bloomington: Indiana University Press, 1972), 77.

21. Wollen, 104–105.

22. Protazanov's casual approach to the script and generally receptive attitude to his actors and other creative staff is among the most common traits his collaborators describe. See G. V. Aleksandrov, "Protazanov-komediograf," 165; I. V. Il'inskii, "Bogatoe nasledstvo," 198; V. Z. Shveitser, "Master (Zametki kinodramaturga)," 282–283, all in Aleinikov, *Protazanov*, 2nd. ed.

23. Ad for *The Queen of Spades*, Sine-fono, nos. 9–10, March 31, 1916, 25.

24. David Bordwell, *Figures Traced in Light* (Berkeley: University of California Press, 2005), 255.

25. David Bordwell, *Ozu and the Poetics of Cinema* (London: BFI, 1988), 17.

26. Petr Bagrov, Svetlana Skovorodnikova, Tamara Sergeeva, and Natal'ia Nusinova. "Ia. A. Protazanov: Fil'mografiia," *Kinovedcheskie zapiski*, no. 88 (2008): 346–409.

27. Edward Said, *Representations of the Intellectual* (New York: Pantheon, 1994), 36.

28. Mark Kushnirov, *Iakov Protazanov: Tvorcheskii put'* (Riga, 1971). Available at chapaev .media, accessed July 10, 2023, https://chapaev.media/articles/2778.

29. N. Lebedev, "Nash rezhisserskii kadr," cited in Arlazorov, *Protazanov*, 110.

30. L. Trauberg, "Kinosilueti," *Kino* (*Leningradskoe prilozhenie*), no. 39, September 28, 1926, 2.

31. Viacheslav Rebrov, "Za moe opozdanie s otvetom vini B.Z. Shumiatskogo,' Iz pisem Ia. A. Protazanova," *Kinovedcheskie zapiski*, no. 24 (1994): 205.

32. Kristin Thompson provides the most thorough stylistic analysis of Lubitsch in both nations in *Herr Lubitsch Goes to Hollywood* (Amsterdam: Amsterdam University Press, 2005).

33. Joseph McBride, *How Did Lubitsch Do It?* (New York: Columbia University Press, 2018), Kindle e-book sections 463–466.

34. Petr Bagrov, "Protazanov i stanovlenie vysokoi komedii v russkom kino," *Kinovedcheskie zapiski*, no. 88 (2008): 231.

35. E. Margolit, "Drugoi (k 130-letniiu so dnia rozhdeniia Iakova Protazanova," Cinematheque.ru, February 4, 2011, https://chapaev.media/articles/2713.

36. For a summary of trends in migrant cinema research and conceptual clarifications, see Daniela Berghahn and Claudia Sternberg, "Locating Migrant and Diasporic Cinema in Contemporary Europe," in *European Cinema in Motion*, ed. Daniela Berghahn and Claudia Sternberg (London: Palgrave Macmillan, 2010), 12–49. Deborah Shaw provides a more broadly conceived

overview of the term "transnational" in "Transnational Cinema: Mapping a Field of Study," in *The Routledge Companion to World Cinema*, ed. Rob Stone, Paul Cooke, Stephanie Dennison, and Alex Marlow-Mann (New York: Routledge, 2017), 290–298. For an influential programmatic essay, see Will Higbee and Song Hwee Lim, "Concepts of Transnational Cinema: Toward a Critical Transnationalism in Film Studies," *Transnational Cinemas* 1, no. 1 (2010): 7–21.

37. Hamid Naficy, *An Accented Cinema: Exilic and Diasporic Filmmaking* (Princeton, N.J.: Princeton University Press, 2001), 10, 39.

38. Edward Said, "Reflections on Exile," in *Reflections on Exile and Other Essays* (Cambridge, Mass.: Harvard University Press, 2003), 173.

39. For a discussion of these notions' effect on literary interpretation, see Reinhold Grimm, "In the Thicket of Inner Emigration," in *Flight of Fantasy: New Perspectives on Inner Emigration in German Literature, 1933–1945*, ed. Neil Donahue and Doris Kirchner (New York: Berghahn, 2003), 27–45.

40. Naficy, *Accented Cinema*, 53.

41. Melinda Szaloky, "Somewhere in Europe: Exile and Orphanage in Post–War War II Hungarian Cinema," in *East European Cinemas*, ed. Anikó Imre (New York: Routledge, 2005), 82–83.

42. Michael David-Fox argues for this view forcefully in *Crossing Borders: Modernity, Ideology, and Culture in Russia and the Soviet Union* (Pittsburgh: University of Pittsburgh Press, 2015), esp. 21–47. Katerina Clark portrays Stalinist culture as outwardly focused, using four exemplary careers, including Sergei Eisenstein's, in *The Fourth Rome: Stalinism, Cosmopolitanism, and the Evolution of Soviet Culture, 1931–1941* (Cambridge, Mass.: Harvard University Press, 2011). Willard Sunderland uses the career of Baron Roman Fedorovich von Ungern-Sternberg to narrate the revolutionary era with attention to the transnational dynamics of imperial rule in *The Baron's Cloak* (Ithaca, N.Y.: Cornell University Press, 2014).

43. For some recent narratives of the Russian Revolution focusing on its international context, see Catherine Merridale, *Lenin on the Train* (London: Penguin, 2017); S. A. Smith, *Russia in Revolution: An Empire in Crisis, 1890–1928* (Oxford: Oxford University Press, 2017).

44. Some analyses of Sergei Eisenstein's films have been the most attentive to his non-American connections, notably, Masha Salazkina, *In Excess: Sergei Eisenstein's Mexico* (Chicago: University of Chicago Press, 2009).

45. Andrew Higson and Richard Maltby, eds., *"Film Europe" and "Film America": Cinema, Commerce, and Cultural Exchange, 1920–1939* (Exeter: University of Exeter Press, 1999).

46. Stephen Kotkin, *Magnetic Mountain: Stalinism as Civilization* (Berkeley: University of California Press, 1997), 220–222.

47. Sheila Fitzpatrick, "Making a Self for the Times: Impersonation and Imposture in 20th-Century Russia," *Kritika* 2, no. 3 (2001): 469.

1 A MOBILE CAREER

1. Rebrov, "Za moe opozdanie," 203.

2. Louise McReynolds, *Russia at Play* (Ithaca, N.Y.: Cornell University Press, 2003), 1–10.

3. Many of the business associates of the Protazanovs and the Vinokurovs were Old Believers but not these families themselves.

4. Dmitrii Semenovich Aglitskii, "Semeinye khroniki ne goriat," *Hezavisimaia gazeta*, September 23, 2015, http://www.ng.ru/style/2015-09-23/16_style.html.

5. Alison K. Smith, "Honored Citizens and the Creation of a Middle Class in Imperial Russia," *Slavic Review* 76, no. 2 (Summer 2017): 327–349.

202 Notes

6. Arlazorov, *Protazanov*, 9.

7. Alexander Protazanov, letter to Yakov Protazanov, 5 August 1896, GTsMK 62.1.28; Arlazorov, *Protazanov*, 14.

8. Transcription of Protazanov lecture, 9 February 1945, RGALI 1921.1.9, 12.

9. Elizaveta Protazanova, letter to Yakov Protazanov, 23 June 1901, GTsMK 62.1.34.

10. Arlazorov, *Protazanov*, 15–19.

11. Arlazorov, 20–21.

12. Elizaveta Protazanova, letter to Yakov Protazanov, 24 October 1904, GTsMK 62.1.43.

13. Arlazorov, *Protazanov*, 20–25.

14. Petr Bagrov, Svetlana Skovorodnikova, Tamara Sergeeva, and Natal'ia Nusinova, "Ia. A. Protazanov: Fil'mografiia," 349.

15. Semen Ginzburg, *Kinematografiia dorevoliutsionnoi Rossii* (Moscow: Iskusstvo, 1963), 161.

16. Transcription of Protazanov lecture, 9 February 1945, RGALI 1921.1.9, 9–12.

17. Charles Musser, "Preclassical American Cinema: Its Changing Modes of Film Production," in *Silent Film*, ed. Richard Abel (New Brunswick, N.J.: 1996), 87–89.

18. The novel provided the title for Laura Engelstein's influential work of cultural history, *The Keys to Happiness: Sex and the Search for Modernity in Fin-de-Siècle Russia* (Ithaca, N.Y.: Cornell University Press, 1992).

19. Ginzburg, *Kinematografiia dorevoliutsionnoi Rossii*, 185–189.

20. Transcription of Protazanov lecture, 9 February 1945, RGALI 1921.1.9, 11; V. R. Gardin, *Vospominaniia. Tom I: 1912–1921* (Moscow: Goskinoizdat, 1949), 63–64.

21. Anna Kovalova, "World War I and Pre-revolutionary Russian Cinema," *Studies in Russian and Soviet Cinema* 11, no. 2 (2017): 97–101.

22. Ginzburg, *Kinematografiia dorevoliutsionnoi Rossii*, 192.

23. Vladimir Balliuzek, "Na s"emkakh 'Pivokoi Damy," *Iz istorii kino* 7 (1964): 100–101.

24. Transcription of Protazanov lecture, 9 February 1945, RGALI 1921.1.9, 17–18; Gardin, *Vospominaniia*, 63–64.

25. Protazanov, "Protazanov o sebe," 307.

26. *The Picture of Dorian Gray* (*Portret Doriana Greia*, Moscow: Thiemann & Reinhardt, 1915), and *The Strong Man* (*Sil'nyi chelovek*, Moscow: Thiemann & Reinhardt, 1917); a third film, *Phantom Spells* (*Nav'i Chary*) was never completed. None of the films survive.

27. Arlazorov, *Protazanov*, 72.

28. Rashit Iangirov, *Raby nemogo: Ocherki istoricheskogo byta russkikh kinematografistov za rubezhom 1920–1930-e gody* (Moscow: Biblioteka-fond "Russkoe zarubezh'e"—Russkii put', 2007), 28–33.

29. Katherine Foshko, "France's Russian Moment: Russian Émigrés in Interwar Paris and French Society" (PhD diss., Yale University, 2008), 93.

30. For general texts on the attitudes of Russian émigrés, see Foshko, 93; Robert C. Williams, *Culture in Exile: Russian Emigrés in Germany, 1881–1941* (Ithaca, N.Y.: Cornell University Press, 1972); and Natal'ia Nusinova, *Kogda my v Rossiiu vernemsia: Russkoe kinematograficheskoe zarubezh'e, 1918–1939* (Moscow: Eizenshteinovskii Tsentr Issledovanii Kinokul'tury, 2003).

31. Fonds Société des Films Albatros, La Cinémathèque française, ALBATROS 89-B 11.

32. Kristin Thompson, "The Ermolieff Group in Paris: Exile, Impressionism, Internationalism," *Griffithiana*, nos. 35–36 (October 1989): 51.

33. See, for example, Maurice Bourdet, "Une journée au studio de Montreuil avec la compagnie Albatros," *Ciné Miroir*, no. 55 (August 1924). Quoted in François Albera, *Albatros: Des russes à Paris, 1919–1929* (Milan: Mazzotta, 1995), 99–100.

34. Fonds Société des Films Albatros, La Cinémathèque française, ALBATROS 31-B2. See also Albera, *Albatros*, 102, 45n.

35. Frida Protazanova, letter to Yakov Protazanov, 1 November 1921, GTsMK 62.1.149; reprinted in Viacheslav Rebrov et al., eds., "'Tvoe zhelanie—Moskva ili Berlin.' Perepiska Ia. A. Protazanova s F. V. Protazanovoi. 1920–1923," *Kinovedcheskie zapiski*, no. 88 (2008): 117–118.

36. Yakov Protazanov, postcard to Frida Protazanova, 17 February 1920, GTsMK 62.1.106. Reprinted in Rebrov et al., "Tvoe zhelanie," 106.

37. Frida Protazanova, letter to Yakov Protazanov, 10 August 1921, GTsMK 62.1.147. Reprinted in Rebrov et al., "Tvoe zhelanie," 114; Frida Protazanova, letter to Yakov Protazanov, 6 December 1921, GTsMK 62.1.159. Reprinted in Rebrov et al., "Tvoe zhelanie," 140–141.

38. Frida Protazanova, letter to Yakov Protazanov, 1 November 1921, GTsMK 62.1.149; reprinted in Viacheslav Rebrov et al., eds., "'Tvoe zhelanie—Moskva ili Berlin.' Perepiska Ia. A. Protazanova s F. V. Protazanovoi. 1920–1923," *Kinovedcheskie zapiski*, no. 88 (2008): 117–118.

39. Albera, *Albatros*, 133.

40. *Poslednie novosti* (Paris), 27 October 1920, 15. Quoted in R. M. Iangirov, *Khronika kinematograficheskoi zhizni russkogo zarubezh'ia*, vol. 1, *1918–1929* (Moscow: Knizhnitsa: Russkii put', 2010), 38.

41. Natal'ia Nusinova, "Protazanov v emigratsii," *Kinovedcheskie zapiski*, no. 88 (2008): 100.

42. Yakov Protazanov, letter to Frida Protazanova, 4 August 1921, GTsMK 62.1.186.

43. L. Remnev, "Russkie v Berline," *Slovo* (Paris), February 9, 1923. Cited in Iangirov, *Raby nemogo*, 73.

44. Iangirov, *Raby nemogo*, 72–73.

45. Frida Protazanova, letter to Yakov Protazanov, 1 November 1921, GTsMK 62.1.149. Reprinted in Rebrov et al., "Tvoe zhelanie," 117–118. She is referring to Nikolai Evgen'evich Gobe, a Russian entrepreneur who had worked in cinema since before the revolution. The name is transliterated from Russian but presumably is derived from the French *Gaubert* or *Gobet*.

46. Yakov Protazanov, letter to Frida Protazanova, 19 November 1921, GTsMK 62.1.180. Reprinted in Rebrov et al., "Tvoe zhelanie," 131–132.

47. "Der Liebe Pilgerfahrt," *Lichtbildbühne*, January 13, 1923, 29.

48. Yakov Protazanov, letter to Frida Protazanova, 16 February 1923, GTsMK 62.1.202. Reprinted in Bagrov et al., "Tvoe zhelanie," 149–150.

49. Aleinikov, *Iakov Protazanov* (1961), 94–95.

50. Protazanov mentions having some good *bliny* at the restaurant The Bear (*Medved'*) two months before the meeting. Yakov Protazanov, letter to Frida Protazanova, probably February 1923, GTsMK 62.1.197. Reprinted in Rebrov et al., "Tvoe zhelanie," 145–146.

51. Yakov Protazanov, letter to Frida Protazanova, 7 April 1923, GTsMK 62.1.261. Reprinted in Rebrov et al., "Tvoe zhelanie," 152.

52. Protazanov, 7 April 1923.

53. Yakov Protazanov, letter to Frida Protazanova, 25 May 1923, GTsMK 62.1.205. Reprinted in Rebrov et al., "Tvoe zhelanie," 154.

54. Yakov Protazanov, letter to Georgi Protazanov, 20 July 1934, GTsMK 62.1.6. Reprinted in Rebrov et al., "Za moe opozdanie," 206.

55. Mezhrabpom-Rus' report, November 1926, RGASPI 538.3.80, 184.

56. Transcription of Protazanov lecture, 9 February 1945, RGALI 1921.1.9, 20.

57. Other *Smena vekh* journals included *Novaia Rossiia* (Sofia), *Novosti zhizni* (Harbin), *Put'* (Helsinki), and *Novyi' put'* (Riga). Kendall E. Bailes, *Technology and Society under Lenin and Stalin: Origins of the Soviet Technical Intelligentsia, 1917–1941* (Princeton, N.J.: Princeton University Press, 1978), 72–73.

204 Notes

58. Alexei Nikolayevich Tolstoy, "Otkrytoe pis'mo N. V. Chaikovskomu," reprinted in Aleksei Tolstoi, *Sobranie sochinenii*, vol. 10 (Moscow: Gosudarstvennoe Izdatel'stvo Khudozhestvennoi Literatury, 1961), 37.

59. Williams, *Culture in Exile*, 265–275.

60. Katerina Clark, "The 'Quiet Revolution' in Soviet Intellectual Life," in *Russia in the Era of NEP: Explorations in Soviet Society and Culture*, ed. Sheila Fitzpatrick, Alexander Rabinowitch, and Richard Stites (Bloomington: Indiana University Press, 1991), 214–224.

61. Several studies have examined the history of this studio and its relationship to politics and the film industry. Aïcha Kherroubi and Valérie Posener, eds., *Le studio Mejrabpom: Ou l'aventure du cinéma privé au pays des bolcheviks* (Paris: Documentation française, 1996); Günter Agde and Alexander Schwarz, eds., *Die rote Traumfabrik: Meschrabpom-Film und Prometheus (1921–1936)* (Berlin: Bertz + Fischer, 2012); Vance Kepley Jr., "The Workers' International Relief and the Cinema of the Left, 1921–1935." *Cinema Journal* 23, no. 1 (Autumn 1983): 7–23; and Jamie Miller, "Soviet Politics and the Mezhrabpom Studio in the Soviet Union during the 1920s and 1930s," *Historical Journal of Film, Radio and Television* 32, no. 4 (December 2012): 521–535. There is no general survey of Mezhrabpom-Rus''s films, though some the filmmakers employed there have received their own studies.

62. The famine already had attracted attention from other humanitarian organizations. Just weeks after Münzenberg embarked on his mission, the Soviet government completed a deal with the United States that would send aid through the American Relief Administration (ARA), whose assistance Lenin had refused two years prior. America, Britain, and other nations would contribute through the Red Cross's International Committee for Russian Relief (ICRR) and the International Save the Children Union. Though the IAH did raise significant donations for the famine, it was a fraction of what was provided by the previously mentioned organizations. Kasper Braskén, *The International Workers' Relief, Communism, and Transnational Solidarity: Willi Münzenberg in Weimar Germany* (New York: Palgrave Macmillan, 2015), 58–97.

63. Iu. A. L'vunin, "Organizatsiia 'Mezhdunarodnaia Rabochaia Pomoshch'' i sovetskoe kino (1921–1936 gg.)," *Vestnik Moskovskogo Universiteta*, no. 4 (1971): 28.

64. Natal'ia Riabchikova, "'Pervyi prodiuser na 'Rusi,'" *Menedzher kino* 50 (December 2008): 56–62. Aleksandr Deriabin, "Die verlorene Partie des Moisej Alejnikow," in Agde and Schwarz, *Die rote Traumfabrik*, 45–47; Booth Wilson, "From the Moscow Art Theatre to Mezhrabpom-Rus': Stanislavskii and the Archaeology of the Director in Russian Silent Cinema." *Studies in Russian and Soviet Cinema* 11, no. 2 (2017): 118–33.

65. Yakov Protazanov, letter to Frida Protazanova, 8 February 1928, GTsMK 62.1.217.

66. Mezhrabpom-Rus' meeting notes, 7 June 1927, RGASPI 538.3.93, 68–69b.

67. Mezhrabpomfilm meeting notes, 12 February 1930, RGASPI 538.3.126, 9.

68. Vladimir Nemoliaev, "Vospominaniia 'Skol'ko by ne proshlo let,'" GTsMK 179.1.100, 1–2. Ellipsis in original.

69. Review commission report on Mezhrabpomfilm, 30 June 1929, RGASPI 538.3.52, 76–81.

70. Freund, letter to Misiano, 17 November 1925, RGASPI 538.2.52, 168.

71. Oleg Leonidov, "Yakov Aleksandrovich Protazanov," in Aleinikov, *Iakov Protazanov*, 2:351.

72. Joseph McBride, *Searching for John Ford* (Oxford: University Press of Mississippi, 2001), 190.

73. Yuri Tsivian, "Early Russian Cinema: Some Preparatory Remarks," in Richard Taylor and Ian Christie, ed. *Inside the Film Factory: New Approaches to Russian and Soviet Cinema* (New York: Routledge, 1991), 16. Tsivian and other scholars debate the specifics of this practice in Kleiman et al., "Protazanov i avangard," 167–169.

74. Vladimir Nemoliaev, "Vospominaniia 'Skol'ko by ne proshlo let,'" GTsMK 179.1.100, 1.

75. Yakov Protazanov, letter to Frida Protazanova, 23 November 1927, GTsMK 62.1.212.

76. Mezhrabpomfilm meeting notes, 3 October 1928, RGASPI 538.3.104, 144–145.

77. Yakov Protazanov, 23 November 1927.

78. "You never write anything about your work or its challenges and still treat me like a child you must protect from all the difficulties and complexities of life," she laments in one surviving letter. 26 July 1940, GTsMK 62.1.24/1, 2.

79. After *Without a Dowry*, Georgi was concerned about Protazanov's decision to pursue another literary adaptation and cautioned him that it would be better to pick a "contemporary topic." 3 December 1936, GTsMK 62.1.60.

80. Georgi Protazanov, letter to Yakov Protazanov, 22 June 1936, GTsMK 62.1.25/1–3.

81. Richard Taylor, "Ideology as Mass Entertainment: Boris Shumyatsky and Soviet Cinema in the 1930s," in Taylor and Christie, ed. *Inside the Film Factory* (New York: Rutledge, 1991), 193–216; Jamie Miller, *Soviet Cinema, Politics and Persuasion under Stalin* (New York: I. B. Taurus, 2010), 20–22, 34–51.

82. Maria Belodubrovskaya, *Not According to Plan: Filmmaking under Stalin* (Ithaca, N.Y.: Cornell University Press, 2017), 24.

83. Miller, *Soviet Cinema*, 115–117; Belodubrovskaya, *Not According to Plan*, 100–105.

84. Excerpt of TsK VKPb meeting notes, 16 May 1930, RGASPI 538.3.129, 41; Mezhrabpomfilm purge commission final report, 1931, RGASPI 538.3.146, 55.

85. Misiano letter to TsK VKPb, 16 March 1930, RGASPI 538.3.129, 17.

86. Jamie Miller, "The Purges of Soviet Cinema, 1929–38," *Studies in Russian and Soviet Cinema* 1, no. 1 (2007): 6–7.

87. Miller, 9–12.

88. Belodubrovskaya, *Not According to Plan*, 30–31.

89. Belodubrovskaya, 76–9; Miller, *Soviet Cinema*, 44–46.

90. Jamie Miller offers the most complete record of the different staff whose careers ended at the time and the existing evidence of the reasons. *Soviet Cinema*, 81–90.

91. Miller, 60–61; Rebrov, "Za moe opozdanie," 208–215; Evgenii Margolit and Viacheslav Shmyrov, *Iz"iatoe kino: 1925–1953* (Moscow: Dubl'-D, 1995), 43–44, 58. Natacha Laurent, *L'œil du Kremlin: Cinéma et censure en URSS sous Staline, 1928–1953* (Toulouse, France: Editions Privat, 2000), 87.

92. RGALI 963.10.6, 17. Quoted in Belodubrovskaya, *Not According to Plan*, 181.

93. Miller, *Soviet Cinema*, 126.

94. Arlazorov, *Protazanov*, 253–263.

95. Nina Alisova personal diary, 8 September 1973 entry, GTsMK 65.1.20.

96. Nina Alisova personal diary, 23 September 1985 entry, GTsMK 65.1.52.

97. Viacheslav Rebrov and Alla Aglitskaia, "Vospominaniia o Diade Iashe," SK-Novosti, 2011, 12th ed. Available at https://web.archive.org/web/20120413075207/http:/unikino.ru/sk-news/item/1242-%D0%B2%D0%BE%D1%81%D0%BF%D0%BE%D0%BC%D0%B8%D0%BD%D0%B0%D0%BD%D0%B8%D1%8F-%D0%BE-%D0%B4%D1%8F%D0%B4%D0%B5-%D1%8F%D1%88%D0%B5.html.

98. Georgi Protazanov, letter to his parents, 16 March 1941, GTsMK 62.1.81.

99. L. N. Sverdlov and G. B. Zel'dovich, "Protazanov v Tashkentskoi kinostudii," in Aleinikov, *Iakov Protazanov*, 1:303–304. This chapter was eliminated in the 1956 second edition for unclear reasons.

100. Sverdlov and Zel'dovich, 305–311.

101. Yakov Protazanov, letter to Frida Protazanova, 10 June 1943. Reprinted in Rebrov, "Za moe opozdanie," 230.

2 THE POLITICS OF LITERARY ADAPTATION

1. O. L. Leonidov, "Iakov Aleksandrovich Protazanov," in Aleinikov, *Iakov Protazanov*, 2:361.
2. S. A. Smith, "The Social Meanings of Swearing: Workers and Bad Language in Late Imperial and Early Soviet Russia," *Past & Present*, no. 160 (August 1998): 177–178.
3. Vladimir Ilyich Lenin, "Party Organization and Party Literature," in *Marxism and Art*, ed. Maynard Solomon (Sussex: Harvester, 1979), 180.
4. Sheila Fitzpatrick, *The Cultural Front: Power and Culture in Revolutionary Russia* (Ithaca, N.Y.: Cornell University Press, 1992), 113–114.
5. Cultural historians have interpreted the shift in cultural priorities from the 1920s through the 1930s in a variety of ways. It remains an active area of dispute and inquiry, particularly regarding the dimensions of rupture and continuity with both prior Bolshevik policy and Russian intellectual values. Emigre sociologist Nicholas S. Timasheff first posited a "Great Retreat" toward tradition and away from revolutionary values in *The Great Retreat* (New York: A. P. Dutton, 1946). Boris Groys offers an alternative narrative that sees Stalinist art as in fact a culmination of the aesthetic values of the 1920s avant-garde in *The Total Art of Stalinism: Avant-garde, Aesthetic Dictatorship, and Beyond*, trans. Charles Rougle (Princeton, N.J.: Princeton University Press, 1992). For a recent interrogation of the terminology and events, see David-Fox, *Crossing Borders*, 104–132.
6. Vera Dunham first articulated this influential view in *In Stalin's Time: Middleclass Values in Soviet Fiction* (Durham, N.C.: Duke University Press, 1970).
7. Evgeny Dobrenko, "The Disaster of Middlebrow Taste, or, Who 'Invented' Socialist Realism?" in *Socialist Realism without Shores*, ed. Thomas Lahusen and Evgeny Dobrenko (Durham, N.C.: Duke University Press, 1997), 160. Note that his use of the term *middlebrow* is particular to this argument and does not draw from the extensive literature on this subject outside of the Soviet Union. For more favorable estimations of the term in a cinematic context, see Sally Faulkner, ed., *Middlebrow Cinema* (New York: Routledge, 2016).
8. Elsewhere, Evgeny Dobrenko claims that "there could be no interpretation in Soviet culture." This remark and similar others strike me as polemical excesses that would imply that these, and perhaps other films, have absolutely no polysemy. *Stalinist Cinema and the Production of History: Museum of the Revolution*, trans. Sarah Young (Edinburgh, UK: Edinburgh University Press, 2008), 114.
9. Ginzburg, *Kinematografiia dorevoliutsionnoi Rossii*, 459.
10. Denise J. Youngblood, *The Magic Mirror: Moviemaking in Russia, 1908–1918* (Madison: University of Wisconsin Press, 1999), 21–45, 63–74.
11. Youngblood, 115–127.
12. Yuri Tsivian, "Censure Bans on Religion in Russian Films," in *An Invention of the Devil? Religion and Early Cinema*, ed. Roland Cosandey, André Gaudreault, and Tom Gunning (Quebec City, Canada: Les Presses de l'Université Laval, 1992), 76–80.
13. Tsivian, "Censure Bans," 72.
14. Ts. Iu. Suleminskii, *Vsia kinematografiia: Nastol'naia adresnaia i spravochnaia kniga* (Moscow: Zh. Chibrario de Goden, 1916), 68.
15. V. Sudeikin, "Otnoshenie nachal'nika glavnogo upravleniia po delam pechati V. T. Sudeikina direktoru departamenta politsii ministerstva vnutrennikh del General-maioru E. K. Klimovichu," in *Istoriia otechestvennogo kino: Dokumenty, memuary, pis'ma*, ed. V. S. Listov and E. S. Khokhlova (Moscow: Materik, 1996), 16–17.
16. V. M. Dement'ev, "Kinematograf kak pravitel'stvennaia regaliia" (St. Petersburg: Tipografiia O. Osova, 1915), reprinted in *Sine-fono*, nos. 19–20, 1915, 59–60.

17. *Russkoe slovo*, October 5, 1916, n.p. Quoted in Ginzburg, *Kinematografiia dorevoliutsionnoi Rossii*, 207.

18. Arlazorov, *Protazanov*, 64; *Zhivoi ekran* 4, no. 7–8, January 25, 1916, 32.

19. O. L. Leonidov, "Pikovaia Dama," In Aleinikov, *Iakov Protazanov* (1957), 2:94.

20. Balliuzek, "Na s"emkakh 'Pivokoi Damy,'" 101.

21. Leonidov, "Pikovaia Dama," 92.

22. Richard Stites, *Revolutionary Dreams: Utopian Vision and Experimental Life in the Russian Revolution* (Oxford: Oxford University Press, 1988), 61–75, 101–119.

23. Kate Betz, "As the Tycoons Die: Class-Struggle and Censorship in the Russian Cinema 1917–1921," in *Art, Society, Revolution: Russia, 1917–1921*, ed. Nils Åke Nilsson (Stockholm: Almqvist & Wiksell, 1979), 217.

24. Ginzburg, *Kinematografiia dorevoliutsionnoi Rossii*, 459.

25. Peter Rollberg, "Tri 'Ottsa Sergiia,'" *Kinovedcheskie zapiski*, no. 88 (2008): 31–33.

26. Denise J. Youngblood, "The Swansong of Early Russian Cinema: Yakov Protazanov's *Father Sergius* (1918)," in *Tolstoy on Screen*, ed. Lorna Fitzsimmons and Michael A. Denner (Evanston, Ill.: Northwestern University Press, 2015), 23–41.

27. Vladimir Viskovskii, "Za dveriami ne vidno lesu," *Mir ekrana* 3, 1918, 4–6.

28. Oksana Chefranova, "The Tsar and the Kinematograph: Film as History and the Chronicle of the Russian Monarchy," in *Beyond the Screen: Institutions, Networks, and Publics of Early Cinema*, ed. Marta Braun, Charlie Keil, and Rob King (New Barnet, UK: John Libbey, 2012), 63–70.

29. Youngblood, "Swansong of Early Russian Cinema," 33.

30. "Ermolieff," *Paris-Midi*, November 8, 1919, n.p.

31. *Pater Sergius* ad, *Lichtbildbühne*, no. 26, June 24, 1922, n.p.

32. "Russkaia fil'ma za granitsei," *Kino* (Moscow), no. 8, 1923, n.p.

33. "Chez Ermolieff," *La cinématographie française*, no. 136, June 13–18, 1921, p. 31.

34. N. Shalgurin, *Bezbozhnoe kino v derevnia* (Moscow: Teakinopechat', 1930), 8.

35. William Nickell, "Tolstoi in 1928: In the Mirror of the Revolution," in *Epic Revisionism: Russian History and Literature and Stalinist Propaganda*, ed. Kevin M. F. Platt and David Brandenberger (Madison: University of Wisconsin Press: 2006), 18.

36. "'Otets Sergii' k rozhdestvu," *Kino* 52 (276), December 25, 1928, 2.

37. Elve, "'Ottsa Sergiia' iz'iat!" *Kino* 40 (264), October 2, 1928, 5.

38. Khrisanf Khersonsky, "Chiny i liudi," *Kino* 40 (316), October 8, 1929, 5.

39. RGALI 2497.2.7, 122–124.

40. David L. Hoffmann, *Stalinist Values: The Cultural Norms of Soviet Modernity* (Ithaca, N.Y.: Cornell University Press, 2003), 149–167.

41. Karen Petrone, *Life Has Become More Joyous, Comrades: Celebrations in the Time of Stalin* (Bloomington: Indiana University Press, 2000), 113–148; Jonathan Brooks Platt, *Greetings Pushkin! Stalinist Cultural Politics and the Russian National Bard* (Pittsburgh: University of Pittsburgh Press, 2016), 26–94; Hoffmann, *Stalinist Values*, 161–163.

42. "Soveschanie tvorcheskikh rabotnikov Fabriki 'Rot-front,'" *Rot-front* no. 2 (46), January 11, 1935, 2.

43. A. Rou, "Likvidirovat' proriv v gruppe," *Rot-film* no. 24 (118), December 25, 1935, 4.

44. Az. Mar, "Stop! Ostanovite s"emku!" *Kino* no. 3 (715), January 16, 1936, 2.

45. N. A. Dobrolyubov, "A Ray of Light in the Realm of Darkness," in *Selected Philosophical Essays*, ed. N. A. Dobrolyubov, trans. J. Fineberg (Moscow: Foreign Languages Publishing House, 1948), 563.

46. N. A. Dobrolyubov, "Realm of Darkness: The Works of A. Ostrovsky," in Dobrolyubov, *Selected Philosophical Essays*, 242.

47. Protazanov and Shveitser reiterate this orthodox point in Ia. Protazanov and V. Shveitser, "Ostrovskii na ekrane, 'Bespridannitsa,'" *Rot-film* no. 16 (110), October 5, 1935, 2.

48. Protazanov and Shveitser, 2.

49. Dobrenko, *Stalinist Cinema*, 77.

50. Gr. Chakhir'ian i I. Manevich, "Bespridannitsa," *Kino* no. 4 (778), January 22, 1937, 3.

51. V. Volkenshtein, "Bespridannitsa" *Iskusstvo kino* no. 4 (778), January 22, 1937, 31.

52. *Vecherniaia Moskva*, December 22, 1936; *Molodoi Leninets*, February 6, 1937.

53. Arlazorov, *Protazanov*, 237–240.

54. "Tvorcheskaia sektsia obsuzhdaet kartinu 'O strannostiakh liubvi,'" *Rot-film* no. 4, March 14, 1936, 2–3.

55. N. D. Volkov and O. L. Leonidov, "Bespridannitsa," in Aleinikov, *Iakov Protazanov*, 2:223.

56. Peter Bagrov goes as far as to claim that "the film shows her décolletage more often than her face." "Protazanov i stanovlenie vysokoi komedii," 229.

57. Gr. Chakhir'ian i I. Manevich, "Bespridannitsa," *Kino* no. 4 (778), January 22, 1937, 3.

58. A. Golovnia, "Masterstvo operatora," *Kino* no. 11 (785), March 4, 1937, 2.

59. Laura Mulvey, "Visual Pleasure and Narrative Cinema," *Screen* 16, no. 3 (1975): 14.

60. Frederic Jameson, *Postmodernism, or The Cultural Logic of Late Capitalism* (Durham, N.C.: Duke University Press), 17–25.

61. Belodubrovskaya, *Not According to Plan*, 60.

62. El'dar Riazanov, *Grustnoe litso komedii, ili nakonets podvedennye itogi* (Moscow: Prozaic, 2010), 397–398.

3 REVOLUTIONARY(-ERA) TRADITIONALISM

1. Naficy, *Accented Cinema*, 22.

2. Katerina Clark, *Petersburg: Crucible of Cultural Revolution* (Cambridge: Harvard University Press, 1995), 219–220.

3. Aleinikov, *Iakov Protazanov*, 202.

4. As Barry Salt notes, this plot structure using a frame story and flashbacks was well established at this point. *Film Style and Technology: History and Analysis*. 3rd ed. (London: Starword, 2009), 109–111.

5. Ben Brewster, "Deep Staging in French Films, 1900–1914," in *Early Cinema: Space, Frame, Narrative*, ed. Thomas Elsaesser (London: BFI, 1990), 45–46.

6. David Bordwell, Janet Staiger, and Kristin Thompson, *The Classical Hollywood Cinema: Film Style & Mode of Production to 1960* (New York: Columbia University Press, 1985), 246–310.

7. Kristin Thompson, "The Formulation of the Classical Style," in Bordwell, Staiger, and Thompson, *Classical Hollywood Cinema*, 245–329; Salt, *Film Style and Technology*, 149–162.

8. Bordwell, *Figures Traced in Light*, 64–93. I am using "tableau" in Bordwell's sense as a single vantage point for the action rather than a more multivalent term related to a variety of stage traditions. Ben Brewster and Lea Jacobs describe similar cinematic staging strategies and their dynamics with theater in *Theatre to Cinema: Stage Pictorialism and the Early Feature Film* (Oxford: Oxford University Press, 1997), 111–114, 129–162.

9. Bordwell, *Figures Traced in Light*, 47–64.

10. Roberta Pearson, in an influential formulation of the development of acting in cinema, defines this as a "histrionic" (in the sense of being "theatrical") code, in which actors were self-consciously performative, and counterposes it to a "verisimilar" code, in which they

attempted to mimic reality rather than a set of theatrical conventions. Pearson argues a general shift from the "histrionic" to the "verisimilar" codes occurred in the 1910s and entailed a rejection of discrete poses. See *Eloquent Gestures: The Transformation of Performance Style in the Griffith Biograph Films* (Berkeley: University of California Press, 1992), 18–52. In contrast, I would argue that the pose remained an important reference point in the art of film acting and in the many varied theatrical traditions that informed it. It does not seem useful to me to posit an evolution in acting styles in Protazanov's films, nor does a simple opposition between two "codes" capture their persisting diversity. For contrasting views on film acting, see Brewster and Jacobs, *Theatre to Cinema*, 65–68; Charlie Keil, *Early American Cinema in Transition* (Madison: University of Wisconsin Press, 2001), 101–102.

11. Tom Gunning's term. See Pearson, *Eloquent Gestures*, 41–43.

12. Ivan Kavaleridze, *Sbornik statei i vospominanii* (Kyiv: Mystetstvo, 1988), 50–51.

13. Brewster and Jacobs, *Theatre to Cinema*, 39–64.

14. Bordwell, *Figures Traced in Light*, 67–69.

15. Yuri Tsivian claims that a particular insistence on not cutting was one of the major components of the "Russian style." "Some Preparatory Remarks on Russian Cinema," in Taylor and Christie, *Inside the Film Factory*, 28–33.

16. Ginzburg, *Kinematografiia dorevoliutsionnoi Rossii*, 388–391. For analysis of the adoption of editing in Russia that emphasizes Kuleshov, see Yuri Tsivian, "Cutting and Framing in Bauer's and Kuleshov's Films," in *Kintop: Jahrbuch zur Erforschung des Frühen Films* 1 (1992); Yuri Tsivian, "Zhest i montazh: eshche raz o russkom stile v rannem kino," *Kinovedcheskie zapiski*, no. 88 (2008): 65–78.

17. According to the most complete Protazanov filmography, Zhilinsky's character is named Robert. See Petr Bagrov, Svetlana Skovorodnikova, Tamara Sergeeva, and Natal'ia Nusinova, "Ia. A. Protazanov: Fil'mografiia," 396. I am following the name given to him in the Dutch intertitles in the surviving print from the EYE Filmmuseum in Amsterdam.

18. For the most thorough examination of this sequence, both as described by different participants and in surviving footage, see Yuri Tsivian, Ekaterina Khokhlova, Kristin Thompson, Lev Kuleshov, and Aleksandra Khokhlova, "The Rediscovery of a Kuleshov Experiment: A Dossier," *Film History* 8, no. 3 (1996): 357–367.

19. Tom Gunning, *D. W. Griffith and the Origins and American Narrative Film: The Early Years at Biograph* (Champaign: University of Illinois Press, 1991), 10–30.

20. Salt, *Film Style and Technology*, 89.

21. Mariia Slavinskaia, "Odin iz pervykh," in *Zhizn' v kino: Veterany o sebe i svoikh tovarishchakh*, ed. O. T. Nesterovich, 2nd ed. (Moscow: Iskusstvo, 1979), 137; Balliuzek, "Na s"emkakh 'Pivokoi Damy,'" 102; see also Phillip Cavendish, "The Hand That Turns the Handle: Camera Operators and the Poetics of the Camera in Pre-revolutionary Russian Cinema," *Slavonic and East European Review* 82, no. 2 (April 2004): 216–217; Tsivian, *Early Cinema in Russia*, 205–208.

22. Slavinskaia, "Odin iz pervykh," 124–135.

23. Salt, *Film Style and Technology*, 136.

24. *Sine-fono*, nos. 9–10, March 31, 1916, 25.

25. It is not an adaptation of the Upton Sinclair novel of similar name released a few years earlier.

26. Vince Bohlinger, *Compromising Kino: The Development of Socialist Realist Film Style in the Soviet Union, 1928–1935* (PhD diss., University of Wisconsin–Madison, 2007), 84–106.

27. B. Alpers, "Prazdnik Sv. Iorgena," *Kino i zhizn'*, September 1930, 7–8; Neia Zorkaia, *Portrety* (Moscow: Iskusstvo, 1966), 150.

28. "Khronika," *Kino-gazeta*, December 11, 1923, 2.
29. "Khronika," *Kino-gazeta*, December 18, 1923, 2.
30. Braskén, *International Workers' Relief*, 58–67.
31. "Khronika," *Kino-gazeta*, November 13, 1923, 2.
32. Misiano letter to Commandant of the Higher Military Pilot Courses, 13 May 1924, RGASPI 538.3.36, 260; Misiano letter to Red Air Fleet, 27 May 1924, RGASPI 538.3.36, 287.
33. "Khronika," *Kino-gazeta*, November 13, 1923, 2; "K s"emkam 'Aelity' (Beseda s Protazanovym)," *Kino-gazeta*, March 4, 1924, 2; "Khronika Kino," *Kino-gazeta*, March 18, 1924, 2; "Khronika Kino," *Kino-gazeta*, April 1, 1924, 3.
34. IAH letter to People's Commissariat for Foreign Trade (Narkomvneshtorg), 20(?) May 1924, RGASPI 538.3.31, 83; IAH letter to People's Commissariat for Foreign Trade (Narkomvneshtorg), 28 June 1924, RGASPI 538.3.31, 85; IAH letter to People's Commissariat for Foreign Trade (Narkomvneshtorg), 30 July 1924, 538.3.31, 86–86b.
35. Meeting Minutes, 19 September 1925, RGASPI 538.2.17, 77–78.
36. IAH letter to Kino-Ars, 27 September 1924, RGASPI 538.3.37, 205.
37. Matthias Schwarz, "How Nauchnaia Fantastika Was Made: The Debates about the Genre of Science Fiction from NEP to High Stalinism," *Slavic Review* 72, no. 2 (Summer 2013): 233.
38. "Khronika," *Kino-gazeta*, September 11, 1923, 2.
39. "Khronika," *Kino-gazeta*, September 25, 1923, 2.
40. Aelita Script, Aleksandr Faiko copy, RGALI 2205.1.105–106.
41. Philip Cavendish, *Soviet Mainstream Cinematography: The Silent Era* (London: UCL Arts and Humanities Publications, 2007), 119.
42. Ian Christie, "Down to Earth: *Aelita* Relocated," in Taylor and Christie, *Inside the Film Factory*, 93–94.
43. Transcription of Protazanov lecture, 9 February 1945, RGALI 1921.1.9, 20.
44. Solntseva memoirs, transcribed sometime 1968, RGALI 2081.3.331, 7.
45. *Vecherniaia Moskva*, November 6, 1924. Quoted in Ekaterina Khokhlova, "Protazanov i Kuleshov: protivniki ili soiuzniki?" *Kinovedcheskie zapiski*, no. 88 (2008): 208.
46. *Krasnaia zvezda*, October 1, 1924. Cited in *Kino-gazeta*, October 21, 1924, 7.
47. Braskén, *International Workers' Relief*, 59–70.
48. Misiano/Friedmann letter to Glavrepertkom, 3 December 1924, RGASPI 538.3.33, 112–113.
49. "O proizvodstve 'na zagranitsu,'" *Kino-gazeta*, October 7, 1924, 1.
50. "Chto govorit ob Aelite," *Kino-nedelia*, October 14, 1924, 6.
51. "Blizhaiuschie zadachi kino," *Kino-gazeta*, October 14, 1924, 4.
52. *Trud*, October 2, 1924; *Samarskie izvestiia*, October 1, 1924. Cited in *Kino-gazeta*, October 21, 1924, 7.
53. *Vecherniaia Moskva*, October 1, 1924. Cited in *Kino-gazeta*, October 21, 1924, 7.
54. *Krasnaia zvezda*, October 1, 1924. Cited in *Kino-gazeta*, October 21, 1924, 7.
55. See, for example, two recent articles in the same issue of the *Slavic Review* that discuss the film's reception in passing. Schwarz, "How Nauchnaia Fantastika Was Made," 231; Muireann Macguire, "Aleksei N. Tolstoi and the Enigmatic Engineer: A Case of Vicarious Revisionism," *Slavic Review* 72, no. 2 (Summer 2013): 263.
56. See, for example, the *Kino Karnaval* ad in *Kino-gazeta*, December 2, 1924, 4.
57. OGPU report on Mezhrabpom-Rus''s activities, RGASPI 17.60.754, 108–127, in Listov and Khokhlova, *Istoriia otechestvennogo kino*, 65–74.
58. Misiano letter to Friedmann, 17 September 1925, RGASPI 538.3.51, 126.
59. *Lichtbildbühne*, February 26, 1926, 14.

60. Friedmann letter to Pfeiffer, 14 November 1925, RGASPI 538.3.48, 310; Pfeiffer letter to Friedmann, 19 November 1925, RGASPI 538.3.49, 24–26; Misiano letter to Pfeiffer, 5 December 1925, RGASPI 538.3.49, 99–99 *verso*; Misiano letter to Münzenberg, 9 December 1925, RGASPI 538.3.49, 110–110 *verso*.

4 ABROAD AT HOME

1. Naficy, *Accented Cinema*, 22.
2. Naficy, 4.
3. Nusinova, "Protazanov v emigratsii"; Thompson, "Ermolieff Group in Paris"; Lenny Borger, "From Moscow to Montreuil: The Russian Émigrés in Paris 1920–1929," *Griffithiana*, nos. 35–36 (October 1989): 28–39.
4. Jean Mitry first recounted the story of the film's multiple sites of locations, with further mention of footage from Athens, in his 1969 monograph on actor Ivan Mozzhukhin. However, it seems exaggerated when compared with the existing print. While there are some skylines of the different cities, most of the film seems to be shot in Marseilles and Paris. "Ivan Mosjoukine," *Anthologie du cinema* 48 (October 1969): 425.
5. Oksana Bulgakova, "The 'Russian Vogue' in Europe and Hollywood: The Transformation of Russian Stereotypes through the 1920s," *Russian Review* 64, no. 2 (April 2005): 225–226.
6. Nusinova, "Protazanov v emigratsii," 88–90.
7. Foshko, "France's Russian Moment," 153–158.
8. Hints that Protazanov was involved with the production evident in the trade press were proven conclusively by eyewitness testimony from memoir sources describing him directing the film. See Petr Bagrov and Aleksandr Deriabin, eds., "'Chlen Parlamenta.' Titry fil'ma," *Kinovedcheskie zapiski*, no. 88 (2008): 335–340.
9. *Lichtbildbühne*, March 3, 1923, 64.
10. "Production Hebdomadaire," *La cinématographie française*, July 5–7, 1920, 44.
11. *Cinémagazine*, October 28, 1921, 21.
12. *Cinéa-ciné pour tous*, August 12, 1921, 8.
13. Nusinova, "Protazanov v emigratsii," 97–98; This attribution has since gained broad acceptance. Petr Bagrov, Svetlana Skovorodnikova, Tamara Sergeeva, Natal'ia Nusinova, "Ia. A. Protazanov: Fil'mografiia," 354–355. Ads for *Toward the Light*, credit Uralsky. See *La cinématographie française*, June 5, 1921.
14. Aelita script, Faiko version, RGALI 2205.1.106, 38.
15. Naficy, *Accented Cinema*, 152–153, citing Mikhail Bakhtin, *The Dialogic Imagination: Four Essays*, ed. Michael Holquist, trans. Caryl Emerson and Michael Holquist (Austin: University of Texas Press, 1981), 11.
16. Naficy, *Accented Cinema*, 153.
17. Naficy, 154.
18. Mini Panayiota, "Pudovkin's Cinema of the 1920s" (PhD diss., University of Wisconsin–Madison, 2002), 43; Denise Hartsough, "Soviet Film Distribution and Exhibition in Germany, 1921–1933," *Historical Journal of Film, Radio and Television* 5, no. 2 (1985): 135; Kepley Jr., "Workers' International Relief," 13.
19. Vsevolod Pudovkin, "Ego prizyv," in Aleinikov, *Iakov Protazanov*, 2:129.
20. Quoted in Arlazorov, 134.
21. Denise J. Youngblood, "Return of the Native: Yakov Protazanov and Soviet Cinema," in Taylor and Christie, *Inside the Film Factory* (London: Routledge, 1991), 113.

22. "Vkratse," *Kino*, December 1, 1925, 1.

23. "Pochti retsenziia," n.d., TsGMK 62.1.27/1–3.

24. Naficy, *Accented Cinema*, 188–191.

25. S. Bochkova, "Ada Voitsik," *Lavry kino* 28 (2016): 72.

26. B. Lavrenev, "Pis'mo v redaktsiiu," *Krasnaia gazeta*, March 22, 1927, evening edition.

27. Arsen, "'Sorok pervyi,'" *Kino-front*, no. 6 (1927).

28. Kh. Khersonskii, "'Sorok pervyi,'" *Kino*, March 22, 1927.

29. B. Gusman. "'Sorok pervyi,'" *Pravda*, March 18, 1927.

30. A. G. "'Sorok pervyi,'" *Rabis*, no. 9 (1927).

31. Remarks by a certain Bergman of *Komsomol'skaia pravda*. "Na temy grazhdanskoi voiny (o 'Sorok pervom')," *Kino*, March 12, 1927, 4.

32. Julian Graffy, "The Foreigner's Journey to Consciousness in Early Soviet Cinema: The Case of Protazanov's *Tommi*," in *Insiders and Outsiders in Soviet Cinema*, ed. Stephen M. Norris and Zara M. Torlone (Bloomington: Indiana University Press, 2008), 16.

33. Evgeny Margolit, "The Problem of Heteroglossia in Early Soviet Sound Cinema (1930–35)," in *Sound, Speech, and Music in Soviet and Post-Soviet Cinema*, ed. Lilya Kaganovsky and Masha Salazkina (Bloomington: Indiana University Press, 2014), 122.

34. Frederick H. White notes that the film's substitution of a rogue tsarist secret police agent in the place of actual revolutionaries in Andreyev's story and the inclusion of a tsarist instigator who goads the crowd likely stem from the need to discredit the legacy of political violence by the Social Revolutionaries. "Interpreting History: Meaning Production for the Russian Revolution," *Adaptation* 9, no. 2 (2016): 205–220.

35. Ia. A. Protazanov, "O Belom orle," *Sovetskii ekran*, no. 39, September 25, 1928, 8–9.

36. P. A. Blyakhin, "K itogam kino-sezona 1927–28 goda," *Kino i kul'tura*, no. 2, 1929, 3, 10.

37. Naficy, *Accented Cinema*, 269–279.

38. Fitzpatrick, "Making a Self for the Times," 470–476.

39. Fitzpatrick, 480–483.

40. Mark Lipovetsky, *Charms of the Cynical Reason: The Trickster's Transformations in Soviet and Post-Soviet Culture* (Brighton, Mass.: Academic Studies Press, 2011), 27.

41. Laurent, *L'œil du Kremlin*, 106.

42. L. N. Sverdlin and G. B. Zel'dovich, "Protazanov v Tashkentskoi kinostudii," in Aleinikov, *Iakov Protazanov*, 1:304; Rebrov, "Za moe opozdanie," 228.

43. Lipovetsky, *Charms of the Cynical Reason*, 14–16.

44. Cloé Drieu, *Cinema, Nation, and Empire in Uzbekistan, 1919–1937* (Bloomington: Indiana University Press, 2019), trans. Adrian Morfee, 160–162.

45. Drieu, 131.

46. Kh. N. Abul-Kasymova, *Kino i khudozhestvennaia kul'tura Uzbekistana* (Tashkent: Izdatel'stvo "Fan," Akademiia Nauk Uzbekskoi SSR, 1991), 85.

5 MAKING COMEDY SERIOUS

1. *Sovetskii ekran*, no. 2, 1980, available at https://www.kino-teatr.ru/kino/art/kino/1935/; See also R. R. Iurenev, *Smeshnoe na ekrane* (Moscow: Iskusstvo, 1964), 70–72.

2. Vadim, Abdrashitov et al., "Rezhisser dlia rezhisserov," *Kinovedcheskie zapiski*, no. 88 (2008): 9–24.

3. Youngblood, *Movies for the Masses*, 35–68, 71–104.

4. B. Z. Shumiatskii, *Kinematografiia millionov* (Moscow: Kinofotoizdat, 1935), 148–176, 234–240. Quoted in Taylor and Christie, *Film Factory*, 368.

5. Past work on Soviet comedy has focused primarily on the Stalinist era. For relevant studies, see Denise J. Youngblood, "'We Don't Know What to Laugh At': Comedy and Satire in Soviet Cinema from *The Miracle Worker* to *St. Jorgen's Feast Day*," in *Inside Soviet Film Satire: Laughter with a Lash*, ed. Andrew Horton (New York: Cambridge University Press, 1993), 36–47; Richard Taylor, "A 'Cinema for the Millions': Soviet Socialist Realism and the Problem of Film Comedy," *Journal of Contemporary History* 18, no. 3 (1983): 439–461; Evgeny Dobrenko, "Soviet Comedy Film; or, The Carnival of Authority," *Discourse* 17, no. 3 (1995): 49–57; Anna Toropova, "'If We Cannot Laugh like That, Then How Can We Laugh?': The 'Problem' of Stalinist Film Comedy," *Studies in Russian and Soviet Cinema* 5, no. 3 (2012): 335–351.

6. "Zritel' zhdet!" *Kino*, March 17, 1940, 1.

7. Anatoly Lunacharsky, "O smekhe," in *Sobranie sochinenii v 8 tomakh* (Moscow: Khudozhestvennaia literatura, 1967), 533, cited in Anna Gérin, *Devastation and Laughter: Satire, Power, and Culture in the Early Soviet State, 1920s–1930s* (Toronto: University of Toronto Press, 2018), 30.

8. Anatolii Lunarcharskii, "Kinematograficheskaia komediia i satira," originally published in *Proletarskoe kino* 9 (1931), 4–15, available at "Nasledia A.V. Lunacharskogo," accessed October 27, 2020, http://lunacharsky.newgod.su/lib/o-kino/kinematograficheskaya-komedia-i-satira/.

9. Lunarcharskii, 9, 4–15.

10. Mikhail Koltsov, "Untitled," in *Pervyi vsesoiuznyi s''ezd: sovetskikh pisatelei, 1934: Stenograficheskii otchet*, ed. I. K. Luppol et al. (Moscow: Sovetskii pisatel, 1934), 221–222. Quoted in Gérin, *Devastation and Laughter*, 186.

11. Arlazorov, *Protazanov*, 136.

12. Veniamin Vishnevskii, *Khudozhestvennie fil'my dorevoliutsionnoi Rossii* (Moscow: Goskinoizdat, 1945), 33, 35, 36, 39.

13. The script for Umberto Notari's stage version is in *La prima sassata* (Milan: Instituto editoriale italiano, 1910), 9–144. Available at Internet Archive, "La prima sassata," accessed October 26, 2020, https://archive.org/details/laprimasassataoonotauoft.

14. Igor' Il'inskii, *Sam o sebe* (Moscow: Iskusstvo, 1984), 233.

15. Cavendish discusses this scene in *Soviet Mainstream Cinematography*, 169–170.

16. "Protsess o trekh millionakh," *Kino-front*, no. 4–5 (7–8), 1926, 31.

17. Anatoly Lunacharsky, "Cinema—the Greatest of the Arts" [A. V. Lunacharskii, "Kino—velichaishee iz iskusstv"], originally published in *Komsomol'skaia pravda*, December 15, 1926, reprinted in Taylor and Christie, *Film Factory*, 155.

18. Médard letter to IAH-Berlin, 13 November 1928, RGASPI 538.2.24, 85.

19. Weltfilm weekly report on Catholic film activities, 12 January 1930, RGASPI 538.2.60, 24.

20. Mezhrabpomfilm Literary Department meeting notes, 7 May 1928, RGASPI 538.3.104, 207.

21. Mezhrabpomfilm Literary Department meeting notes, 9 September 1929, RGASPI 538.3.117, 17.

22. V. Sutyrin, "O sovetskom satire," *Proletarskoe kino*, no. 10–11, 1931, 7, 8, 11.

23. "Kadry, ubivaiuschie boga," *Kino*, September 13, 1930, 2.

24. A. V., "Pervym ekranom—'Prazdnik sv. Iorgena,'" *Kino*, September 13, 1930, 4.

25. S. Tsimbal, "Prazdnik Sv. Iorgena," *Kino-front*, no. 47, September 26, 1930, 2.

26. B. Alpers, "Prazdnik Sv. Iorgena," *Kino i zhizn'*, September 1930, 7–8.

27. Shoshana Keller, "Trapped between State and Society: Women's Liberation and Islam in Soviet Uzbekistan, 1926–1941," *Journal of Women's History* 10, no. 1 (Spring 1998): 20–44;

Marianne Kamp, *The New Woman in Uzbekistan: Islam, Modernity, and Unveiling under Communism* (Seattle: University of Washington Press, 2006), 218–225.

28. For an account of Barnet's career in the 1920s that emphasizes the example of Protazanov, see Youngblood, *Movies for the Masses*, 125–138.

29. "Razbitaia vaza," *Sine-fono*, no. 25 (1913): 57.

30. *Sine-fono*, 57.

31. "Le Cœur brisé," *Bulletin Pathé*, no. 16, n.p.

32. "Razbitaia vaza," *Sine-fono*, no. 25 (1913): 57.

33. "Das gebrochenes Herz," *Pathe-Woche*, no. 16 (1914): 17.

34. See, for example, Masha Boston's biography of Protazanov in *Directory of World Cinema: Russia*, ed. Birgit Beumers (Bristol, UK: Intellectual Books, 2011), 29.

35. Kleiman et al., "Protazanov i avangard," 159.

36. Frida Protazanova, letter to Yakov Protazanov, 24 August 1924, GTsMK 62.1.146. Reprinted in Rebrov et al., "Tvoe zhelanie," 115.

37. "Atel'e Ermol'eva," *Kino-gazeta*, no. 4 (January 1918): 5.

38. A. Ostroumov, "Gornichnaia Dzhenni," *Kino-gazeta*, no. 8 (May 1918): 3.

39. Bagrov, "Protazanov i stanovlenie vysokoi komedii," 225.

40. *Kino-gazeta*, no. 8 (May 1918): 4.

41. "Komicheskaia i komediia," *Kinozhurnal ARK*, December 1925, 27.

42. Aufbau meeting notes, 25 October 1925, RGASPI 538.3.41, 153.

43. IAH Report on Film Activities in the USSR, February 1926, RGASPI 538.3.84, 12.

44. "Zakroishchik iz Torzhka," *Pravda*, October 31, 1925, 7.

45. The piece is republished in A. Zorich, *Bukva zakona, Fel'etony* (Moscow: Biblioteka "Prozhektor," 1926). Available online at http://az.lib.ru/z/zorich_a/text_01_bukva_zakona .shtml.

46. Youngblood, *Movies for the Masses*, 208.

47. V. Kulagin. "Don Diego i Pelageia (Delo Pelagei Deminoi)," *Molodoi Leninets*, November 22, 1927, 6. Quoted in Bagrov, "Protazanov i stanovlenie vysokoi komedii," 218.

48. S. Ermolinskii, "Don Diego i Pelageia (Mezhrabpom-Rus')," *Pravda*, March 6, 1928, 5.

49. A. P., "Don Diego i Pelageia (Mezhrabpom-Rus')," *Molodoi Leninets*, March 2, 1928, 6. Quoted in Bagrov, "Protazanov i stanovlenie vysokoi komedii," 218.

50. I. Kruti, "Don Diego i Pelageia (Mezhrabpom-Rus')," *Vecherniaia Moskva*, February 29, 1928, 3. Quoted in Bagrov, "Protazanov i stanovlenie vysokoi komedii," 218.

51. Stenogram of ARRK meeting on *Don Diego and Pelageia*, 1 December 1927, RGALI 2494.1.91, 119.

52. "Don Diego i Pelageia," *Kino-front*, no. 2, 1928, 20.

53. Stenogram of ARRK meeting on *Don Diego and Pelageia*, 1 December 1927, RGALI 2494.1.91, 119.

54. Gérin, *Laughter and Devastation*, 97–98; on RAPP and ARRK, see Youngblood, *Soviet Cinema*, 187–191.

55. Arlazorov, *Protazanov*, 228–229; Bagrov, "Protazanov i stanovlenie vysokoi komedii," 226.

56. Rick Altman, *A Theory of Narrative* (New York: Columbia University Press, 2008), 55–98.

57. Margolit and Shmyrov, *Iz"iatie kino*, 49.

58. "Tvorcheskaia sektsia obsuzhdaet kartinu 'O strannostiakh liubvi,'" *Rot-film*, March 14, 1936, 2–3.

59. Arlazorov, *Protazanov*, 228–229.

60. Ia. Protazanov, "S molodezhiu," *Rot-film*, no. 21 (29), September 1, 1934, 1.

61. Brooks, *Greetings Pushkin!*, 26–27.

6 THE DIDACTIC VOICE FROM TOLSTOY TO LENIN

1. Noël Burch intended "IMR" to replace earlier terms such as "classical" or "realist," though it covers a somewhat broader range of films. The essays collected in *Life to Those Shadows*, trans. Ben Brewster (Berkeley: University of California Press, 1990), are dedicated specifically to the question of the PMR and the relationship of the two modes.

2. Tom Gunning, "The Cinema of Attractions: Early Film, Its Spectator and the Avant-Garde," in Elsaesser, *Early Cinema*, 56–62. For a dissenting view of the relationship between attractions and narrative, see Charles Musser, "Rethinking Early Cinema: Cinema of Attractions and Narrativity," *Yale Journal of Criticism* 7, no. 2 (1994): 203–231.

3. Noël Burch, "Film's Institutional Mode of Representation and the Soviet Response," *October* 11 (Winter 1979): 91.

4. Richard Stites, *Russian Popular Culture* (Cambridge: Cambridge University Press, 1992), 1–9.

5. Mikhail Iampolski, "Russia: The Cinema of Anti-modernity and Backward Progress," in *Theorising National Cinema*, ed. Paul Willeman and Valentina Vitali (London: British Film Institute, 2006), 72–85.

6. Katerina Clark, *The Fourth Rome: Stalinism, Cosmopolitanism, and the Evolution of Soviet Culture, 1931–1941* (Cambridge: Harvard University Press, 2011), 113.

7. André Bazin, "The Ontology of the Photographic Image," in *What Is Cinema?* Vol. 1, trans. Hugh Gray (Berkeley: University of California Press, 1967), 9–12.

8. The newspaper clippings concerning Tolstoy's excommunication available in Protazanov's personal archive suggest that he, like many Russians, followed these events closely. RGALI 1921.1.53.

9. The image is called a "tableau" in intertitles of some versions in circulation. Charles Musser notes that Porter's image draws from broader media representations, such as political cartoons. *Before the Nickelodeon: Edwin S. Porter and the Edison Manufacturing Company* (Berkeley: University of California Press, 1991), 296.

10. Barry Salt, *Film Style and Technology*, 59; Livio Belloï, "Reconfigurations: La question du plan emblématique," in *La firme Pathé frères, 1896–1914*, ed. Michel Marie and Laurent Le Forestier (Paris: AfRHC, 2004), 179–192.

11. Burch, "A Primitive Mode of Representation?" in *Life to Those Shadows*, 193–196.

12. Brewster and Jacobs, *Theatre to Cinema*, 30.

13. Brewster and Jacobs, 34–37.

14. Roland Barthes, "Diderot, Brecht, Eisenstein," *Screen* 15, no. 2 (Summer 1974): 34.

15. Brewster and Jacobs, *Theatre to Cinema*, 43.

16. Brewster and Jacobs, 54.

17. Vishnevskii, *Khudozhestvennie fil'my dorevoliutsionnoi Rossii*, 133.

18. Christian Metz, *Film Language: A Semiotics of the Cinema*, trans. Michael Taylor (Chicago: University of Chicago Press, 1974), 125.

19. Metz, 179, 219.

20. David Bordwell, *Narration in the Fiction Film* (Madison: University of Wisconsin Press, 1985), 235, 244.

21. Fyodor Ozep script of *Aelita*, RGALI 2205.1.106A, 82–84.

22. Noël Burch, *To the Distant Observer* (London: Scholar, 1979), 147. Quoted in Taylor, "A 'Cinema for the Millions,'" 450–451. This section does not appear in the version of Burch's book edited by Annette Michelson and published by the University of California Press in the same year.

23. Ian Christie, "Making Sense of Soviet Sound," in Taylor and Christie, *Inside the Film Factory*, 175–192; Vince Bohlinger, "The Development of Sound Technology in the Soviet Film Industry during the First Five-Year Plan," *Studies in Russian and Soviet Cinema* 7, no. 2 (2013): 189–205.

24. Stephen Lovell, *Russian in the Microphone Age: A History of Soviet Radio, 1919–1970* (Oxford: Oxford University Press, 2015), 13–43.

25. Margolit, *Zhivie i mertvoe*, 85–88.

26. Margolit, "Problem of Heteroglossia," 120.

27. Margolit, *Zhivie i mertvoe*, 89–92, 136.

28. In addition to the collection of essays in Kaganovsky and Salazkina, *Sound, Speech, and Music*, see Lilya Kaganovsky, *The Voice of Technology* (Bloomington: Indiana University Press, 2018).

29. Margolit, "Problem of Heteroglossia," 124.

30. Kaganovsky, *Voice of Technology*, 239. For a thorough analysis of this film in its multiple versions, see John Mackay, "Allegory and Accommodation: Vertov's *Three Songs of Lenin* (1934) as a Stalinist Film," *Film History* 18 no. 4 (2006): 376–391.

31. S. Eisenstein, V. Pudovkin, G. Aleksandrov, "Zayavka," *Zhizn' iskusstva*, August 5, 1928, 4–5. Reprinted and translated in Taylor and Christie, *Film Factory*, 234–235.

32. Kristin Thompson outlines some of the many interpretations of this concept in "Early Sound Counterpoint," *Yale French Studies* 60 (1980): 115–140.

33. Margolit, *Zhivye i mertvoe*, 101; Bagrov, "Protazanov i stanovlenie vysokoi komedii," 227–228.

34. Arlazorov, *Iakov Protazanov*, 84–86.

35. Rimgaila Salys discusses the sexualization of Orlova's Marion Dixon in *Laughing Matters: The Musical Comedy Films of Grigori Aleksandrov* (Bristol: Intellect, 2009), 156–165.

36. The literature on Bertolt Brecht is vast. A standard collection of essays is *Brecht on Theatre: The Development of an Aesthetic*, ed. and trans. John Willet (London: Methuen, 1964). For a recent study of Brecht's writings, films, and the interpretations of "Brechtianism" among later filmmakers, see Nenad Jovanovic, *Brechtian Cinemas: Montage and Theatricality in Jean-Marie Straub and Danièle Huillet, Peter Watkins, and Lars von Trier* (Albany: SUNY Press, 2017). Brecht himself must have been aware of Protazanov's films given their overlapping stints at Mezhrabpom, but he does not seem to have paid much attention to him. In an interesting crossing of paths, Brecht's "The Monster" (*Das Bestie*) narrates the production of *The White Eagle*, but the director character appears to have no connection to the historical director of that film.

37. Transcription of the discussion after evening screenings, 23–24 June 1934, RGASPI 558.11.828, 41–2.

38. N. Otten, "Ustanovka na psevdonim, O Marionetkakh i Ia. Protazanove," *Sovetskoe kino*, no. 5 (1934): 4–8.

BIBLIOGRAPHY

PRIMARY SOURCES

Archival Sources

La Cinémathèque française. Paris.
 Fonds Société des Films Albatros
Russian State Archive for Literature and Art (RGALI). Moscow.
 f. 1921 Iakov Aleksandrovich Protazanov
 f. 2081 Aleksandr Petrovich Dovzhenko
 f. 2205 Aleksei Mikhailovich Faiko
 f. 2494 Assosiatsiia rabotnikov revoliutsionnoi kinematografii (ARRK)
 f. 2497 Vsesoiuznoe gosudarstvennoe kinofotoob"edinenie "Soiuzkino"
Russian State Archive of Social and Political History (RGASPI). Moscow.
 f. 538 Mezhdunarodnaia organizatsiia rabochei pomoshchi (Mezhrabpom)
 f. 558 Lichnyi fond I.V. Stalina
State Central Museum of Cinema (GTsMK). Moscow.
 f. 62 Iakov Aleksandrovich Protazanov
 f. 65 Nina Ul'ianovna Alisova
 f. 179 Frida Vasil'evna Protazanova

Periodicals

Bulletin Pathé
Cinéa-ciné pour tous
Cinémagazine
Iskusstvo kino
Kino
Kino (Leningradskoe prilozhenie)
Kino i kul'tura
Kino i zhizn'
Kino-front
Kino-gazeta
Kino-nedelia
Kinozhurnal ARK
Krasnaia gazeta
Krasnaia zvezda
La cinématographie française
Lichtbildbühne
Molodoi Leninets
Na literaturnom postu
Paris-Midi
Pathe-Woche
Pravda

Rabis
Rot-front
Sine-fono
Sovetskii ekran
Vecherniaia Moskva
Zhivoi ekran

SECONDARY AND REPUBLISHED SOURCES

Abdrashitov, Vadim, Dmitrii Astrakhan, Aleksei Balabanov, Aleksei Batalov, Aleksei German, Georgii Danelia, Igor' Maslennikov, et al. "Rezhisser dlia rezhisserov." *Kinovedcheskie zapiski*, no. 88 (2008): 9–24.

Abul-Kasymova, Kh. N. *Kino i khudozhestvennaia kul'tura Uzbekistana*. Tashkent: Izdatel'stvo "Fan," Akademiia Nauk Uzbekskoi SSR, 1991.

Agde, Günter, and Alexander Schwarz, eds. *Die rote Traumfabrik: Meschrabpom-Film und Prometheus (1921–1936)*. Berlin: Bertz + Fischer, 2012.

Aglitskii, Dmitrii Semenovich. "Semeinye khroniki ne goriat." *Hezavisimaia gazeta*, September 23, 2015. http://www.ng.ru/style/2015-09-23/16_style.html.

Albera, François. *Albatros: Des russes à Paris, 1919–1929*. Milan: Mazzotta, 1995.

Aleinikov, Moisei. *Iakov Protazanov*. Moscow: Iskusstvo, 1961.

———, ed. *Iakov Protazanov: O tvorcheskoi puti rezhissera*. Moscow: Goskinoizdat, 1948.

———, ed. *Iakov Protazanov: O tvorcheskoi puti rezhissera*. 2nd ed. Moscow: Iskusstvo, 1957.

Altman, Rick. *A Theory of Narrative*. New York: Columbia University Press, 2008.

Arlazorov, Mikhail. *Protazanov*. Moscow: Iskusstvo, 1973.

Bagrov, Petr. "Protazanov i stanovlenie vysokoi komedii v russkom kino." *Kinovedcheskie zapiski*, no. 88 (2008): 215–232.

Bagrov, Petr, and Aleksandr Deriabin, eds. "'Chlen parlamenta.' Titry fil'ma." *Kinovedcheskie zapiski*, no. 88 (2008): 335–345.

Bagrov, Peter, Svetlana Skovorodnikova, Tamara Sergeeva, and Natal'ia Nusinova. "Ia. A. Protazanov: Fil'mografiia." *Kinovedcheskie zapiski*, no. 88 (2008): 346–409.

Bailes, Kendall E. *Technology and Society under Lenin and Stalin: Origins of the Soviet Technical Intelligentsia, 1917–1941*. Princeton, N.J.: Princeton University Press, 1978.

Balliuzek, Vladimir. "Na s"emkakh 'Pivokoi Damy.'" *Iz istorii kino* 7 (1964): 99–103.

Barthes, Roland. "Diderot, Brecht, Eisenstein." *Screen* 15, no. 2 (Summer 1974): 33–39.

Bazin, André. *What Is Cinema?* Vol. 1. Translated by Hugh Gray. Berkeley: University of California Press, 1967.

Belloï, Livio. "Reconfigurations: La question du plan emblématique." In *La firme Pathé frères, 1896–1914*, edited by Michel Marie and Laurent Le Forestier, 179–192. Paris: AfRHC, 2004.

Belodubrovskaya, Maria. *Not According to Plan: Filmmaking under Stalin*. Ithaca, N.Y.: Cornell University Press, 2017.

Berghahn, Daniela, and Claudia Sternberg. "Locating Migrant and Diasporic Cinema in Contemporary Europe." In *European Cinema in Motion*, edited by Daniela Berghahn and Claudia Sternberg, 12–49. London: Palgrave Macmillan, 2010.

Betz, Kate. "As the Tycoons Die: Class-Struggle and Censorship in the Russian Cinema 1917–1921." In *Art, Society, Revolution: Russia, 1917–1921*, edited by Nils Åke Nilsson, 198–236. Stockholm: Almqvist & Wiksell International, 1979.

Beumers, Birgit, ed. *Directory of World Cinema: Russia*. Bristol, UK: Intellectual Books, 2011.

Bochkova, S. "Ada Voitsik." *Lavry kino*, no. 28 (2016): 70–75.

Bohlinger, Vince. *Compromising Kino: The Development of Socialist Realist Film Style in the Soviet Union, 1928–1935*. PhD diss., University of Wisconsin–Madison, 2007.

———. "The Development of Sound Technology in the Soviet Film Industry during the First Five-Year Plan." *Studies in Russian and Soviet Cinema* 7, no. 2 (2013): 189–205.

Bordwell, David. *Figures Traced in Light*. Berkeley: University of California Press, 2005.

———. *Narration in the Fiction Film*. Madison: University of Wisconsin Press, 1985.

———. *Ozu and the Poetics of Cinema*. London: BFI, 1988.

Bordwell, David, Janet Staiger, and Kristin Thompson. *The Classical Hollywood Cinema: Film Style & Mode of Production to 1960*. New York: Columbia University Press, 1985.

Borger, Lenny. "From Moscow to Montreuil: The Russian Émigrés in Paris 1920–1929." *Griffithiana*, nos. 35–36 (October 1989): 28–39.

Braskén, Kasper. *The International Workers' Relief, Communism, and Transnational Solidarity: Willi Münzenberg in Weimar Germany*. New York: Palgrave Macmillan, 2015.

Brecht, Bertolt. *Brecht on Theatre: The Development of an Aesthetic*. Edited and translated by John Willet. London: Methuen, 1964.

Brewster, Ben, and Lea Jacobs. *Theatre to Cinema: Stage Pictorialism and the Early Feature Film*. Oxford: Oxford University Press, 1997.

Bulgakova, Oksana. "The 'Russian Vogue' in Europe and Hollywood: The Transformation of Russian Stereotypes through the 1920s." *Russian Review* 64, no. 2 (April 2005): 211–235.

Burch, Noël. "Film's Institutional Mode of Representation and the Soviet Response." *October* 11 (1979): 77–96.

———. *Life to Those Shadows*. Translated by Ben Brewster. Berkeley: University of California Press, 1990.

Cavendish, Phillip. "The Hand That Turns the Handle: Camera Operators and the Poetics of the Camera in Pre-revolutionary Russian Cinema." *Slavonic and East European Review* 82, no. 2 (April 2004): 201–245.

———. *Soviet Mainstream Cinematography: The Silent Era*. London: UCL Arts and Humanities, 2007.

Chefranova, Oksana. "The Tsar and the Kinematograph: Film as History and the Chronicle of the Russian Monarchy." In *Beyond the Screen: Institutions, Networks, and Publics of Early Cinema*, edited by Marta Braun, Charlie Keil, and Rob King, 63–70. New Barnet, UK: John Libbey, 2012.

Christie, Ian, and Julian Graffy. *Protazanov and the Continuity of Russian Cinema*. London: National Film Theatre, 1993.

Clark, Katerina. *The Fourth Rome: Stalinism, Cosmopolitanism, and the Evolution of Soviet Culture, 1931–1941*. Cambridge: Harvard University Press, 2011.

———. *Petersburg: Crucible of Cultural Revolution*. Cambridge: Harvard University Press, 1995.

———. "The 'Quiet Revolution' in Soviet Intellectual Life." In *Russia in the Era of NEP: Explorations in Soviet Society and Culture*, edited by Sheila Fitzpatrick, Alexander Rabinowitch, and Richard Stites, 210–230. Bloomington: Indiana University Press, 1991.

Codelli, Lorenzo. "Conference on Russian Cinema, Pordenone 1989." *Griffithiana*, no. 37 (1989): 84–98.

David-Fox, Michael. *Crossing Borders: Modernity, Ideology, and Culture in Russia and the Soviet Union*. Pittsburgh: University of Pittsburgh Press, 2015.

Dobrenko, Evgeny. "The Disaster of Middlebrow Taste, or, Who 'Invented' Socialist Realism?" In *Socialist Realism without Shores*, edited by Thomas Lahusen and Evgeny Dobrenko, 135–164. Durham, N.C.: Duke University Press, 1997.

———. "Soviet Comedy Film; or, The Carnival of Authority." *Discourse* 17, no. 3 (1995): 49–57.

———. *Stalinist Cinema and the Production of History: Museum of the Revolution*. Translated by Sarah Young. Edinburgh: Edinburgh University Press, 2008.

Dobrolyubov, N. A. *Selected Philosophical Essays*. Translated by J. Fineberg. Moscow: Foreign Languages Publishing House, 1948.

Drieu, Cloé. *Cinema, Nation, and Empire in Uzbekistan, 1919–1937*. Translated by Adrian Morfee. Bloomington: Indiana University Press, 2019.

Dunham, Vera. *In Stalin's Time: Middleclass Values in Soviet Fiction*. Durham, N.C.: Duke University Press, 1970.

Elsaesser, Thomas, ed. *Early Cinema: Space, Frame, Narrative*. London: BFI, 1990.

Engelstein, Laura. *The Keys to Happiness: Sex and the Search for Modernity in Fin-de-Siècle Russia*. Cornell, N.Y.: Cornell University Press, 1992.

Faulkner, Sally, ed. *Middlebrow Cinema*. New York: Routledge, 2016.

Fitzpatrick, Sheila. *The Cultural Front: Power and Culture in Revolutionary Russia*. Ithaca, N.Y.: Cornell University Press, 1992.

———. "Making a Self for the Times: Impersonation and Imposture in 20th-Century Russia." *Kritika* 2, no. 3 (2001): 469–487.

Foshko, Katherine. "France's Russian Moment: Russian Émigrés in Interwar Paris and French Society." PhD diss., Yale University, 2008.

Gardin, V. R. *Vospominaniia. Tom I: 1912–1921*. Moscow: Goskinoizdat, 1949.

Gérin, Anna. *Devastation and Laughter: Satire, Power, and Culture in the Early Soviet State, 1920s–1930s*. Toronto: University of Toronto Press, 2018.

Ginzburg, Semen. *Kinematografiia dorevoliutsionnoi Rossii*. Moscow: Iskusstvo, 1963.

Graffy, Julian. "The Foreigner's Journey to Consciousness in Early Soviet Cinema: The Case of Protazanov's *Tommi*." In *Insiders and Outsiders in Soviet Cinema*, edited by Stephen M. Norris and Zara M. Torlone, 1–22. Bloomington: Indiana University Press, 2008.

Grimm, Reinhold. "In the Thicket of Inner Emigration." In *Flight of Fantasy: New Perspectives on Inner Emigration in German Literature, 1933–1945*, edited by Neil Donahue and Doris Kirchner, 27–45. New York: Berghahn, 2003.

Groys, Boris. *The Total Art of Stalinism: Avant-garde, Aesthetic Dictatorship, and Beyond*. Translated by Charles Rougle. Princeton, N.J.: Princeton University Press, 1992.

Gunning, Tom. *D. W. Griffith and the Origins and American Narrative Film: The Early Years at Biograph*. Champaign: University of Illinois Press, 1991.

Hartsough, Denise. "Soviet Film Distribution and Exhibition in Germany, 1921–1933." *Historical Journal of Film, Radio and Television* 5, no. 2 (1985): 131–148.

Higbee, Will, and Song Hwee Lim. "Concepts of Transnational Cinema: Toward a Critical Transnationalism in Film Studies." *Transnational Cinemas* 1, no. 1 (2010): 7–21.

Higson, Andrew, and Richard Maltby, eds. *"Film Europe" and "Film America": Cinema, Commerce, and Cultural Exchange, 1920–1939*. Exeter, UK: University of Exeter Press, 1999.

Hoffmann, David L. *Stalinist Values: The Cultural Norms of Soviet Modernity*. Ithaca, N.Y.: Cornell University Press, 2003.

Iampolski, Mikhail. "Russia: The Cinema of Anti-modernity and Backward Progress." In *Theorising National Cinema*, edited by Paul Willeman and Valentina Vitali, 72–85. London: British Film Institute, 2006.

Iangirov, R. M. *Khronika kinematograficheskoi zhizni russkogo zarubezh'ia*. Vol. 1, *1918–1929*. Moscow: Knizhnitsa: Russkii put', 2010.

———. *Raby nemogo: Ocherki istoricheskogo byta russkikh kinematografistov za rubezhom 1920–1930-e gody*. Moscow: Biblioteka-fond "Russkoe zarubezh'e"—Russkii put', 2007.

Il'inskii, Igor'. *Sam o sebe*. Moscow: Iskusstvo, 1984.

Iurenev, R. R. *Smeshnoe na ekrane*. Moscow: Iskusstvo, 1964.

Jameson, Frederic. *Postmodernism, or The Cultural Logic of Late Capitalism*. Durham, N.C.: Duke University Press, 1991.

Jovanovic, Nenad. *Brechtian Cinemas: Montage and Theatricality in Jean-Marie Straub and Danièle Huillet, Peter Watkins, and Lars von Trier*. Albany: SUNY, 2017.

Kaganovsky, Lilya. *The Voice of Technology*. Bloomington: Indiana University Press, 2018.

Kamp, Marianne. *The New Woman in Uzbekistan: Islam, Modernity, and Unveiling under Communism*. Seattle: University of Washington Press, 2006.

Kavaleridze, Ivan. *Sbornik statei i vospominanii*. Kyiv: Mystetstvo, 1988.

Keil, Charlie. *Early American Cinema in Transition: Story, Style, and Filmmaking, 1907–1913*. Madison: University of Wisconsin Press, 2001.

Keller, Shoshana. "Trapped between State and Society: Women's Liberation and Islam in Soviet Uzbekistan, 1926–1941." *Journal of Women's History* 10, no. 1 (Spring 1998): 20–44.

Kenez, Peter. *The Birth of the Propaganda State: Soviet Methods of Mass Mobilization, 1917–1929*. Cambridge: Cambridge University Press, 1985.

Kepley Jr., Vance. "The Workers' International Relief and the Cinema of the Left, 1921–1935." *Cinema Journal* 23, no. 1 (Autumn 1983): 7–23.

Kherroubi, Aïcha, and Valérie Posener, eds. *Le studio Mejrabpom: Ou l'aventure du cinéma privé au pays des bolcheviks*. Paris: Documentation française, 1996.

Khokhlova, Ekaterina. "Protazanov i Kuleshov: protivniki ili soiuzniki?" *Kinovedcheskie zapiski*, no. 88 (2008): 207–214.

Kleiman, Naum, Petr Bagrov, Irina Grashchenkova, Vladimir Zabrodin, Nikolai Izvolov, Sergei Kapterev, Marianna Kireeva, et al. "Protazanov i avangard. 'Kruglyi stol' v NII Kinoiskusstva 9 noiabria 2007." *Kinovedcheskie zapiski*, no. 88 (2008): 156–177.

Kotkin, Stephen. *Magnetic Mountain: Stalinism as Civilization*. Berkeley: University of California Press, 1997.

Kovalova, Anna. "World War I and Pre-revolutionary Russian Cinema." *Studies in Russian and Soviet Cinema* 11, no. 2 (2017): 96–117.

Kushnirov, Mark. *Iakov Protazanov: Tvorcheskii put'*. Riga, 1971. Available at Proekt Chapaev. Accessed June 3, 2022. https://chapaev.media/articles/2778.

Laurent, Natacha. *L'œil du Kremlin: Cinéma et censure en URSS sous Staline, 1928–1953*. Toulouse, France: Editions Privat, 2000.

Lipovetsky, Mark. *Charms of the Cynical Reason: The Trickster's Transformations in Soviet and Post-Soviet Culture*. Brighton, Mass.: Academic Studies, 2011.

Listov, V. S., and E. S. Khokhlova, eds., *Istoriia otechestvennogo kino: Dokumenty, memuary, pis'ma*. Moscow: Materik, 1996.

Lovell, Stephen. *Russian in the Microphone Age: A History of Soviet Radio, 1919–1970*. Oxford: Oxford University Press, 2015.

L'vunin, Iu. A. "Organizatsiia 'Mezhdunarodnaia Rabochaia Pomoshch'' i sovetskoe kino (1921–1936 gg.)." *Vestnik Moskovskogo Universiteta* 4 (1971): 20–40.

Macguire, Muireann. "Aleksei N. Tolstoi and the Enigmatic Engineer: A Case of Vicarious Revisionism." *Slavic Review* 72, no. 2 (Summer 2013): 247–266.

Mackay, John. "Allegory and Accommodation: Vertov's *Three Songs of Lenin* (1934) as a Stalinist Film." *Film History* 18, no. 4 (2006): 376–391.

Margolit, Evgenii. "Drugoi (k 130-letniiu so dnia rozhdeniia Iakova Protazanova." *Cinematheque.ru*. February 4, 2011. https://chapaev.media/articles/2713.

———. *Zhivye i mertvoe: Zametki k istorii sovetskogo kino 1920–1960-kh godov*. St. Petersburg: Masterskaia "Seans," 2012.

Margolit, Evgeny. "The Problem of Heteroglossia in Early Soviet Sound Cinema (1930–35)." In *Sound, Speech, and Music in Soviet and Post-Soviet Cinema*, edited by Lilya Kaganovsky and Masha Salazkina, 119–128. Bloomington: Indiana University Press, 2014.

Margolit, Evgenii, and Viacheslav Shmyrov, eds. *Iz"iatoe kino: 1925–1953*. Moscow: Dubl'–D, 1995.

McBride, Joseph. *How Did Lubitsch Do It?* New York: Columbia University Press, 2018.

———. *Searching for John Ford*. Oxford: University Press of Mississippi, 2001.

McReynolds, Louise. *Russia at Play*. Ithaca, N.Y.: Cornell University Press, 2003.

Merridale, Catherine. *Lenin on the Train*. London: Penguin, 2017.

Metz, Christian. *Film Language: A Semiotics of the Cinema*. Translated by Michael Taylor. Chicago: University of Chicago Press, 1974.

Miller, Jamie. "The Purges of Soviet Cinema, 1929–38." *Studies in Russian and Soviet Cinema* 1, no. 1 (2007): 5–26.

———. *Soviet Cinema, Politics and Persuasion under Stalin*. New York: I. B. Taurus, 2010.

———. "Soviet Politics and the Mezhrabpom Studio in the Soviet Union during the 1920s and 1930s." *Historical Journal of Film, Radio and Television* 32, no. 4 (December 2012): 521–535.

Mitry, Jean. "Ivan Mosjoukine." *Anthologie du cinema*, no. 48 (October 1969): 395–400.

Mulvey, Laura. "Visual Pleasure and Narrative Cinema." *Screen* 16, no. 3 (1975): 6–17.

Musser, Charles. *Before the Nickelodeon: Edwin S. Porter and the Edison Manufacturing Company*. Berkeley: University of California Press, 1991.

———. "Preclassical American Cinema: Its Changing Modes of Film Production." In *Silent Film*, edited by Richard Abel, 85–108. New Brunswick, N.J.: Rutgers University Press, 1996.

———. "Rethinking Early Cinema: Cinema of Attractions and Narrativity." *Yale Journal of Criticism* 7, no. 2 (1994): 203–231.

Naficy, Hamid. *An Accented Cinema: Exilic and Diasporic Filmmaking*. Princeton, N.J.: Princeton University Press, 2001.

Nickell, William. "Tolstoi in 1928: In the Mirror of the Revolution." In *Epic Revisionism: Russian History and Literature and Stalinist Propaganda*, edited by Kevin M. F. Platt and David Brandenberger, 27–38. Madison: University of Wisconsin Press, 2006.

Notari, Umberto. *La prima sassata*. Milan: Instituto editoriale italiano, 1910. Available at Internet Archive. Accessed October 26, 2020. https://archive.org/details/laprima sassataoonotauoft.

Nusinova, Natal'ia. *Kogda my v Rossiiu vernemsia: Russkoe kinematograficheskoe zarubezh'e, 1918–1939*. Moscow: Eizensthteinovskii Tsentr Issledovanii Kinokul'tury, 2003.

———. "Protazanov v emigratsii." *Kinovedcheskie zapiski*, no. 88 (2008): 87–103.

Panayiota, Mini. "Pudovkin's Cinema of the 1920s." PhD diss., University of Wisconsin–Madison, 2002.

Pearson, Roberta E. *Eloquent Gestures: The Transformation of Performance Style in the Griffith Biograph Films*. Berkeley: University of California Press, 1992.

Petrone, Karen. *Life Has Become More Joyous, Comrades: Celebrations in the Time of Stalin*. Bloomington: Indiana University Press, 2000.

Platt, Jonathan Brooks. *Greetings Pushkin! Stalinist Cultural Politics and the Russian National Bard*. Pittsburgh: University of Pittsburgh Press, 2016.

Rebrov, Viacheslav, ed. "'Za moe opozdanie s otvetom vini B.Z. Shumiatskogo,' Iz pisem Ia. A. Protazanova." *Kinovedcheskie zapiski*, no. 24 (1994): 202–231.

Rebrov, Viacheslav, and Alla Aglitskaia. "Vospominaniia o Diade Iashe." *SK-Novosti*. December 2011. https://web.archive.org/web/20120413075207/http:/unikino.ru/sk-news/item/1242-%D0%B2%D0%BE%D1%81%D0%BF%D0%BE%D0%BC%D0%B8%D0%BD%D0

%B0%D0%BD%D0%B8%D1%8F-%D0%BE-%D0%B4%D1%8F%D0%B4%D0%B5-%D1%8F%D1%88%D0%B5.html.

Rebrov, Viacheslav, Natal'ia Nusinova, Petr Bagrov, and Aleksandr Deriabin, eds. "'Tvoe zhelanie—Moskva ili Berlin.' Perepiska Ia. A. Protazanova s F. V. Protazanovoi. 1920–1923." *Kinovedcheskie zapiski*, no. 88 (2008): 104–155.

Riabchikova, Natal'ia. "'Pervyi prodiuser na 'Rusi.'" *Menedzher kino*, no. 50 (December 2008): 56–62.

Riazanov, El'dar. *Grustnoe litso komedii, ili nakonets podvedennye itogi*. Moscow: Prozaic, 2010.

Rollberg, Peter. "Tri 'Ottsa Sergiia.'" *Kinovedcheskie zapiski*, no. 88 (2008): 32–43.

Said, Edward. "Reflections on Exile." In *Reflections on Exile and Other Essays*, 173–186. Cambridge: Harvard University Press, 1994.

———. *Representations of the Intellectual*. New York: Pantheon, 1994.

Salazkina, Masha. *In Excess: Sergei Eisenstein's Mexico*. Chicago: University of Chicago Press, 2009.

Salt, Barry. *Film Style and Technology: History and Analysis*. 3rd ed. London: Starword, 2009.

Salys, Rimgaila. *Laughing Matters: The Musical Comedy Films of Grigori Aleksandrov*. Bristol, UK: Intellect Books, 2009.

Schwarz, Matthias. "How Nauchnaia Fantastika Was Made: The Debates about the Genre of Science Fiction from NEP to High Stalinism." *Slavic Review* 72, no. 2 (Summer 2013): 224–246.

Shalgurin, N. *Bezbozhnoe kino v derevnia*. Moscow: Teakinopechat', 1930.

Shaw, Deborah. "Transnational Cinema: Mapping a Field of Study." In *The Routledge Companion to World Cinema*, edited by Rob Stone, Paul Cooke, Stephanie Dennison, and Alex Marlow-Mann, 290–298. New York: Routledge, 2017.

Slavinskaia, Mariia. "Odin iz pervykh." In *Zhizn' v kino: Veterany o sebe i svoikh tovarishchakh*, 2nd ed., edited by O. T. Nesterovich, 131–148. Moscow: Iskusstvo, 1979.

Smith, Alison K. "Honored Citizens and the Creation of a Middle Class in Imperial Russia." *Slavic Review* 76, no. 2 (Summer 2017): 327–349.

Smith, S. A. *Russia in Revolution: An Empire in Crisis, 1890–1928*. Oxford: Oxford University Press, 2017.

———. "The Social Meanings of Swearing: Workers and Bad Language in Late Imperial and Early Soviet Russia." *Past & Present*, no. 160 (August 1998): 167–202.

Solomon, Maynard, ed. *Marxism and Art*. Sussex: Harvester, 1979.

Stites, Richard. *Revolutionary Dreams: Utopian Vision and Experimental Life in the Russian Revolution*. Oxford: Oxford University Press, 1988.

———. *Russian Popular Culture*. Cambridge: Cambridge University Press, 1992.

Suleminskii, Ts. Iu. *Vsia kinematografiia: Nastol'naia adresnaia i spravochnaia kniga*. Moscow: Zh. Chibrario de Goden, 1916.

Sunderland, Willard. *The Baron's Cloak*. Ithaca, N.Y.: Cornell University Press, 2014.

Szaloky, Melinda. "Somewhere in Europe: Exile and Orphanage in Post–World War II Hungarian Cinema." In *East European Cinemas*, edited by Anikó Imre, 81–102. New York: Routledge, 2005.

Taylor, Richard. "A 'Cinema for the Millions': Soviet Socialist Realism and the Problem of Film Comedy." *Journal of Contemporary History* 18, no. 3 (1983): 439–461.

———. *The Politics of Soviet Cinema, 1917–1929*. Cambridge: Cambridge University Press, 1979.

Taylor, Richard, and Ian Christie, eds. *The Film Factory: Soviet Cinema in Documents*. London: Routledge, 1988.

———, eds. *Inside the Film Factory: New Approaches to Russian and Soviet Cinema*. London: Routledge, 1991.

Thompson, Kristin. "Early Sound Counterpoint." *Yale French Studies*, no. 60 (1980): 115–140.

———. "The Ermolieff Group in Paris: Exile, Impressionism, Internationalism." *Griffithiana*, nos. 35–36 (October 1989): 50–57.

———. *Herr Lubitsch Goes to Hollywood*. Amsterdam: Amsterdam University Press, 2005.

Timasheff, Nicholas S. *The Great Retreat*. New York: A. P. Dutton, 1946.

Tolstoi, Aleksei. *Sobranie sochinenii*. Moscow: Gosudarstvennoe Izdatel'stvo Khudozhestvennoi Literatury, 1961.

Toropova, Anna. "'If We Cannot Laugh like That, Then How Can We Laugh?': The 'Problem' of Stalinist Film Comedy." *Studies in Russian and Soviet Cinema* 5, no. 3 (2012): 335–351.

Tsivian, Yuri. "Censure Bans on Religion in Russian Films." In *An Invention of the Devil? Religion and Early Cinema*, edited by Roland Cosandey, André Gaudreault, and Tom Gunning, 71–80. Quebec City, Canada: Les Presses de l'Université Laval, 1992.

———. "Cutting and Framing in Bauer's and Kuleshov's Films." *Kintop: Jahrbuch zur Erforschung des Frühen Films*, no. 1 (1992): 103–113.

———. *Early Cinema in Russia and Its Cultural Reception*. Translated by Alan Bodger. London: Routledge, 1994.

———. "Zhest i montazh: eshche raz o russkom stile v rannem kino." *Kinovedcheskie zapiski*, no. 88 (2008): 65–78.

Tsivian, Yuri, Ekaterina Khokhlova, Kristin Thompson, Lev Kuleshov, and Aleksandra Khokhlova. "The Rediscovery of a Kuleshov Experiment: A Dossier." *Film History* 8, no. 3 (1996): 357–367.

Vaisfel'd, I. "Effekt Protazanova." *Iskusstvo kino*, no. 8 (August 1981): 128–134.

Vishnevskii, Veniamin. *Khudozhestvennie fil'my dorevoliutsionnoi Rossii*. Moscow: Goskinoizdat, 1945.

White, Frederick. "Interpreting History: Meaning Production for the Russian Revolution." *Adaptation* 9, no. 2 (2016): 205–220.

Williams, Robert C. *Culture in Exile: Russian Emigrés in Germany, 1881–1941*. Ithaca, N.Y.: Cornell University Press, 1972.

Wilson, Booth. "From the Moscow Art Theatre to Mezhrabpom-Rus': Stanislavskii and the Archaeology of the Director in Russian Silent Cinema." *Studies in Russian and Soviet Cinema* 11, no. 2 (2017): 118–133.

Wollen, Peter. "The Auteur Theory: Michael Curtiz and *Casablanca*." In *Authorship and Film*, edited by David A. Gerstner and Janet Staiger, 61–76. New York: Routledge, 2003.

———. *Signs and Meaning in the Cinema*. Bloomington: Indiana University Press, 1972.

Youngblood, Denise J. *The Magic Mirror: Moviemaking in Russia, 1908–1918*. Madison: University of Wisconsin Press, 1999.

———. *Movies for the Masses*. Cambridge: Cambridge University Press, 1992.

———. *Soviet Cinema in the Silent Era 1918–1935*. Austin: University of Texas Press, 1991.

———. "The Swansong of Early Russian Cinema: Yakov Protazanov's *Father Sergius* (1918)." In *Tolstoy on Screen*, edited by Lorna Fitzsimmons and Michael A. Denner, 23–41. Evanston, Ill.: Northwestern University Press, 2015.

———. "'We Don't Know What to Laugh At': Comedy and Satire in Soviet Cinema from *The Miracle Worker* to *St. Jorgen's Feast Day*." In *Inside Soviet Film Satire: Laughter with a Lash*, edited by Andrew Horton, 36–47. New York: Cambridge University Press, 1993.

Zorich, A. *Bukva zakona, Fel'etony*. Moscow: Biblioteka "Prozhektor," 1926.

Zorkaia, Neia. *Portrety*. Moscow: Iskusstvo, 1966.

INDEX

Page references in *italics* indicate an illustration; page references in **bold** indicate a table.

Abul-Kasymova, Khanzara, 132
Accented Cinema, An (Naficy), 12
Accordion, The (film, 1934), 178
Adventures of Nasreddin, The (film, 1946), 132
Aelita (film, 1924): allegorical blacksmith in, 167–168, *169*, 172; budget, 97, 106; characters of, 98–100, 103; costume design, 100, *101*, 106; departure from the original story, 98, 99, 116, 117; depiction of NEP-era society, 99–100; documentary footage in, 104, 105, *105*; dream motif, 127; early script of, 168; eclecticism of, 76–77, 96, 99; editing techniques, 103, 105; exilic tropes, 116, 117; final shot of, 117; international screening, 107; Martian imaginary, 100–102, 117; montage, 105; plot of, 98–100, 103, 116–117; popularity of, 3, 106, 107; present-day relevance, 99; production of, 34, 96, 168; propaganda in, 105–106; reception of, 119; release of, 96–97, 168; reviews of, 17, 96–97, 98, 106–107, 119, 125; spaceship launch scene, 117; static poses, 101, 103; style of, 100, 105, 120; subplots, 117; tableaux style, 100, *102*, 167; themes of, 115–116; transformations of identity in, 118, 129–130; "tricks" in, 102
Aglitskaya, Alla, 45
Aleinikov, Moisei: memoirs of, 4, 6, 75, 200n15; Moscow apartment, 33; negotiating the rights for *Aelita*, 107; as production chief at Rus', 31, 36; target of the purges, 41
Alexandrov, Grigori, 43, 68, 157, 159, 176, 178, 181, 184
Alisova, Nina, 44–45, 68, 69–70, 72, 156, 158
All-Russian Exhibition in Nizhny Novgorod (1896), 20
All-Union Conference on Cinema (1928), 40, 62, 96, 142
All-Union State Institute of Cinematography (VGIK), 1

Alpers, Boris, 96, 144
Ambrosio's studio in Turin, 23
American Film Industry, The (Sarris), 11–12
American Relief Administration (ARA), 204n61
Amfiteatrov, Alexander: *The Destruction of Polotsk*, 50
Amfiteatrov-Kadashev, Vladimir, 27
Amour, Arthur and Company (film, 1914), 138
Andreyev, Leonid, 63, 212n34; "The Governor," 128
Apukhtin, Alexei, 147; "The Broken Vase," 50
Aristov, Mikhail, 32
Arlazorov, Mikhail, 4, 5, 6, 9, 20, 22, 44, 188
Assassination of the Duc de Guise, The (film, 1908), 143
Association of Revolutionary Cinematography (ARK), 154–155
Association of Workers of Revolutionary Cinematography (ARRK), 155
"author code," 8, 9
Azagarov, Georgi, 25

Babitsky, Boris, 42
Bacon, Lloyd, 6
Bagrov, Peter, 12, 148, 176
Bakhtin, Mikhail, 118
Ballyuzek, Vladimir, 90
Balzac, Honoré de, 66
Baratinsky, Evgeni, 69
Barnet, Boris, 147, 152, 159
Barthes, Roland, 165
Batalov, Nikolai, 7
Battleship Potemkin (film, 1925), 3, 160
Bauer, Evgeni, 26, 52, 60, 94, 139, 148
Bazin, André, 163
Bedny, Demyan: "A Worker's Greeting," 169
Beggar Woman, The (film, 1916), 28

226 Index

Beijing Polytechnic University: collaboration with Moscow University, 190–191
Belinsky, Vissarion, 66
Bergstedt, Harald, 142–143
Berkeley, Busby, 181
Better Death Than Dishonor (film, 1913), 188
Bloch, Noë, 29
Blumenthal-Tamarina, Maria, 152
Blyakhin, Pavel, 129
Bohlinger, Vince, 94
Bolshakov, Ivan, 42
Bordwell, David, 9, 78, 82, 167, 208n8
Borisov, Grigori, 8
Borisova, Ekaterina, 156
Bought Husband, The (film, 1913), 2, 23, 189
Bourget, Paul, 63, 189; *Le sens de la mort*, 114
Brasier Ardent, Le (film, 1924), 28
Brecht, Bertolt, 216n36
Brewster, Ben, 165, 208n8
Bridge Commander Ivanov (film, 1922), 141
Broken Vase, The (film, 1913), 115, 147–148, 166
Brown, Clarence, 6
Burch, Noël, 160, 161, 163, 164, 165, 173, 174, 215n1
Burgasov, Fyodor, 29
Burroughs, Edgar Rice, 97
Bykov, Anatoly, 152

Cabinet of Dr. Caligari, The (film, 1919), 100, 101
Cabiria (film, 1912), 90
camera movement technique, 89, 90
Carnival Night (film, 1956), 72, 187
Casablanca (film, 1942), 6
Case of the Three Million, The (film, 1926): cast of, 139; characters, 122, 130, 139–140; criticism of the church in, 21; departures from the original text, 140; editing of, 95; foreign audience, 122; modern décor in, 140; montage in, 95; plot of, 139–140; popularity of, 3, 135, 139, 141; production of, 122, 139; reviews of, 139, 140–141, 142; trickster in, 133
Catholic Church: collaboration with film studios, 141; criticism of, 142
Cavendish, Philip, 100
censorship of films, 27, 43, 51–52, 53, 54, 60, 125, 174
Central Asia: secularization campaign in, 145

Chakhirian, Grigori, 67
Chaplin, Charlie, 135, 150, 179
Chekhov, Anton, 43, 50, 51, 64
Chernyshevsky, Nikolai, 66
Child of Another (film, 1919): characters and plot, 114; duel scene, *84*, 85; editing strategies, 85; gestural soliloquy in, 85
Christie, Ian, 5, 100
chronotopes of imagined homeland, 118
Chukhrai, Grigori, 124
Cigarette Girl from Mosselprom, The (film, 1924), 143, 149, 182
"cine-cranberry" films, 112, 114
cinema, 14, 50, 77, 122, 161
Circus, The (film, 1936), 158, 181
Clair, René, 179, 180
Clark, Katerina, 34, 75, 162
classic literature: attitudes toward, 62
close-up framings, 89
Cold Souls/Showers (film, 1914), 139
comedy: antireligious propaganda in, 141–142, 144; common themes, 134; diversity of, 159; foreign models, 138; ideology and, 151; lyrical, 146–147; official attitudes to, 135, 146, 156–157; parodic style of, 138; popularity of, 136; portrayal of capitalist world in, 137–138, 146; promotion of, 135, 136; propaganda of socialism in, 136, 137–138; set in Europe, 138–146; set in the Soviet era, 146–159; social problems in, 146
Commission for the Study of Satirical Genres, 136
Communist Youth (Komsomol): cinematic depiction of, 150, 151, 152–153, 154, 172
"concentric circles" model of film form, 9
continuity editing, 77, 82, 87, 88
Convict's Song, The (film, 1911), 23; characters, 77; marketplace scene, 78, 79, 80, 81; opening shot of, *76*; plot of, 77, 78
Counterplan, The (film, 1932), 175, 189
Created Surface of the Earth, The (film, 1920), 88
Cruel Romance, A (film, 1984), 72, 187
Cultural Revolution, 35, 48, 62–63, 64, 174
Curtiz, Michael, 6
cuts in films. *See* editing in films

Danish cinema, 77
"dark" studios, 91, 92

Davidson, Paul, 11
Death Ray, The (film, 1925), 122
Defender of Morality (film, 1914), 138
Delluc, Louis, 62
Dement'ev, V. M.: "The Cinema as Imperial
 Regalia," 52
Demons (Dostoevsky), 52
Demons (film, 1915), 25
Demutsky, Danylo, 132
Departure of a Great Old Man, The (film,
 1912): cast of, 130; criticism of the Ortho-
 dox Church in, 163; documentary footage
 in, 163; final apotheosis sequence, 163, *164*,
 165, 170; gestural soliloquies in, 80–81;
 popularity of, 2; suicide attempt scene, 80,
 81; tableau style in, 81–82, 215n9
Deutsches Theater, 11
Diaghilev, Sergei: Ballets Russes, 112
Dickens, Charles: *Oliver Twist*, 44
didactic cinema, 183
Diercks, Grete, 91
Dikii, Alexei, 175
disaster of middlebrow taste, 49
Dobrenko, Evgeny, 48–49, 67, 70, 206n8
Dobroliubov, Nikolai, 66
Doller, Mikhail, 64
Don Diego and Pelageia (film, 1927): alle-
 gorical sequence in, 172; antibureaucratic
 satire, 149, 152–153; critics of, 154–156;
 depiction of rural life in, 152, 153; image
 of the bust of Mikhail Kalinin in, 172, *173*;
 Komsomol members in, 154; plot and
 characters of, 152–154; popular reception
 of, 155; satirical elements, 154; shelf life, 155;
 summary image, 172; visual style of, 153
Dostoevsky, Fyodor, 51, 52, 189
Doublon, Lucien, 114
Dovzhenko, Alexander, 3, 132
Do Your Duty (film, 1914), 138
Drieu, Cloé, 132
Dubrovsky (film, 1935), 65
Dukelsky, Semyon, 42, 44
Duncan, Isadora, 94

"ecology of revolution," 75
editing in films, 77, 82–83, 85–87, 88, 89,
 94–95, 103, 167
Eggert, Konstantin, 42, 157

Eisenstein, Sergei, 3, 5–6, 37, 43, 165, 167, 176
Ekk, Nikolai, 69, 157
Ekster, Alexandra, 100, 101, 106, 117, 140
Elizabeth Institute of Noble Maidens, 20
emblematic shots, 163, 164–165, 166, 167
émigré films, 13, 115
enfant du Carnaval, L' (film, 1921), 28
Engels, Friedrich, 66
Erdmann, Nikolai, 155
Ermolieff, Joseph: business trip to France,
 27, 28; film studio of, 2, 25–26, 54–55, 114;
 move to Berlin, 29; operations in Crimea,
 27; relationships with directors, 26
Ermolieff-Cinéma (film company), 17, 28, 29,
 30, 52–53
Erofeyev, Vladimir, 106
European films, 78, 110–115
exilic films, 110, 111, 118
*Extraordinary Adventures of Mr. West in the
 Land of the Bolsheviks, The* (film, 1924),
 105, 182

fascism: cinematic depiction of rise of,
 178–179
Father Sergius (film, 1918): ballroom scene,
 57–58, 60; cast, 2, 130; criticism of monastic
 life, 55–56, 115; editing of, 83; on European
 screens, 28, 62; exploration of religious faith
 in, 21; healing scene, 58–60; makeup in, 118;
 opening shot of, *56*; peasant dancing, 61;
 plot of, 55; portrayal of the tsar, 54, 55, 57,
 58; production of, 54–55; reception of, 62;
 relationship to Tolstoy's original, 16, 49, 55,
 57, 61; release of, 54–55, 61–62; religious and
 royal imagery, 56–57, 72–73, 143; reviews of,
 55, 62–63; sexuality in, 55; staging strategy,
 58–59, 60; stills from, *56*, *58*, *59*
February Revolution, 27
female body: cinematic depiction of, 71
fetishistic scopophilia, 71
film festivals, 189
filmmaking techniques, 89–91, 161
films: distribution companies, 36; formats, 50;
 impact of World War I on, 1, 24; modes of
 production, 110; studies of, 7–8, 9; transi-
 tion to sound, 42, 173–174; transnationality
 of, 12–13, 14–15. *See also* Hollywood films;
 Russian films; Soviet films

228 Index

Films Albatros, Les (film company), 29
First Five-Year Plan, 35
First World War, 24
Fitzpatrick, Sheila, 16, 130, 131
Fleming, Victor, 6
folklorization, 132
Ford, John, 38
Forty-First, The (film, 1926): criticism of, 125–126; depiction of civil war, 3, 124, 186; erotic scene, 124; plot of, 123–125; poster, 8; production of, 123; release of, 125; success of, 37
France: cinema, 29, 77; Russian émigré community, 27–28
Friedmann, Yuri, 36, 107

Gagra resort, 39
Gaidarov, Evgeni, 85
Gaidarov, Vladimir, 148
Ganiyev, Nabi, 132, 133
Garage, The (film, 1980), 187
Gardin, Vladimir, 2, 23, 24, 25, 175, 189
Gaumont (film company), 29
German, Alexei, 186
German, Pavel, 157
German Communist Party (KPD), 36
German films, 11, 24, 30
"gestural soliloquies" technique, 80–81
Ginzburg, Semen, 55
Girl with the Hatbox, The (film, 1927), 152
Glavrepertkom, 125
Gloria (film company), 23
Gobe, Nikolai, 203n44
Godard, Jean-Luc, 167
Golgotha of Women, The (film, 1919), 27
Golovnya, Anatoli, 71
Gorky, Maxim, 33, 63–64
Goskino, 72
Great Dictator, The (film, 1940), 179
Great Purges, 41–43
Groys, Boris, 206n5
Gunning, Tom, 89, 90, 161
Gusman, Boris, 126, 156
Gzovskaya, Olga, 27, 68, 148, 166

Hathaway, Henry, 6
Hero of the Spirit (film, 1918), 148–149
heterotopia, 137–138, 145

His Call (film, 1925): allegorical sequence in, 169–170; documentary images, 170; exilic tropes, 116; final reel, 120; on foreign screens, 119; Great Helmsman scene, *170*; Lenin's apotheosis in, 170–172, *171*; music in, 157; opposed identities, 123; plot structure, 119–120; production of, 17, 115–116; propaganda in, 3, 122; public reception of, 152; reviews of, 119; scenes with émigrés, 120–121, *121*; style of, 120, *121*; summary image of, 172; transformations of identity in, 120, 129–130; use of depth staging, 120
"histrionic" code, 208–209n10
Hollywood films: approach to female body, 71; on European screens, 97; influence of, 6, 15, 68, 118, 157, 181; music in, 174, 175, 181; Soviet alternative to, 191; standards of, 87; techniques of continuity editing, 77; transition to sound, 173–174
How a Child's Soul Wept (film, 1913), 189
Hungarian cinema, 14
Hyde, Lewis, 131

Iakov Protazanov (Arlazorov), 4–5
Iampolski, Mikhail, 162
Ilyinsky, Igor: early career of, 7; in Protazanov's films, 68, 99, 104, 130, 131, 144, 149, 150, 159, 177; theatrical roles, 139
"imaginary landscape" method, 88–89, 103
Ingram, Rex, 94
Inhumaine, L' (film, 1924), 100
"inner exile," 13–14
institutional mode of representation (IMR), 160, 161, 162
intellectual montage, 167, 179
International Arbeiter-Hilfe (IAH): aid to Soviet Russia, 104, 204n61; antireligious agenda of, 141–142; French division, 141; influence over Mezhrabpom-Rus', 35, 105–106, 107; mission statement, 35
International Committee for Russian Relief (ICRR), 204n61
International Save the Children Union, 204n61
Irony of Fate, The (film, 1975), 187
Iurenev, Rostislav, 135
Iuzhakova, Olga, 85
Ivanov, Vsevolod: *Armored Train 14–69*, 126

Jacobs, Lea, 165, 208n8
Jameson, Frederic, 71–72
Jazz Singer, The (film, 1927), 174
Jenny the Maid (film, 1918), 148, 149
Jérôme Seydoux-Pathé Foundation, 188
Jolly Fellows (film, 1934), 68, 157, 178, 184
Jolson, Al, 174
Journey to Arzrum (film, 1936), 65
Justice d'abord! (film, 1921), 2, 28, 112, 114

Kachalov, Ivan, 129, 130
Kadochnikova, Larisa, 70
Kalinin, Mikhail, 172, 173
Kamenka, Alexandre, 29
Keaton, Buster, 150
Kepley, Vance, 5
Keys to Happiness, The (film, 1913), 2, 24, 189
Khanzhonkov studio, 25
Khersonsky, Khrisanf, 64, 126, 151
Khokhlova, Ekaterina, 88
Kino (journal): film reviews in, 63, 65, 67, 136–137, 144
Kino-gazeta, 148
Kireeva, Marianna, 148
Kiss from Mary Pickford, A (film, 1927), 143
Kleptomaniac, The (film, 1905), 163–164, 165
Klimov, Mikhail, 139, 177, 178
Koltsov, Mikhail, 137, 141, 152
Komissarzhevskaya, Vera, 69
Könnecke, Karl, 23, 29
Koval-Samborsky, Ivan, 124
Kruti, I., 154
Ktorov, Anatoly: acting style, 143; roles of, 65, 95, 131, 139, 177, 178
Kuleshov, Lev, 3, 6, 103, 104, 105, 122, 135
Kuleshov Workshops, 88
kul'turnost' (culturedness), 47, 48, 49
Kushnirov, Mark, 10

Lamanova, Nadezhda, 101
Last Billionaire, The (film, 1934), 179
Latest News (émigré newspaper), 30
Lavrenyov, Boris, 63, 123
Lebedev, Nikolai, 1
Lenin, Vladimir, 48, 63, 162, 170, 172, 175
Lenin Enrollment, 116, 119, 120

Leonidov, Boris, 125
Leonidov, Oleg, 38, 47, 53, 69, 132
Levin, Moisei, 65
Levitsky, Alexander, 139
Life for a Life, A (film, 1916), 52, 60
lighting effects, 90–91, 92
Lion of Moguls, The (film, 1924), 112, 115
Lipovetsky, Mark, 131
Lissenko, Natalie, 111, 112
Little Ellie (film, 1918), 54
Living Manikin, The (film, 1914), 138
Loshakov, Alexander, 29
Lovell, Stephen, 175
Love of a Japanese Woman, The (film, 1913), 188
Lubitsch, Ernst, 11–12, 118
Lunacharsky, Anatoly: authorization of *The Forty-First*, 125; on comedy and laughter, 136, 137, 138, 146; on critics of Soviet cinema, 141; recruitment of Protazanov, 31
lyrical comedy, 146–147, 148, 157

Magidson, Mark, 65, 70, 71
Maksimov, Vladimir, 147
Maleyev, Igor, 156
Malkin, Boris, 36
Manevich, Iosef, 67
Man from the Restaurant (film, 1927), 63
Margolit, Evgeny (Evgenii), 4, 12, 15, 175, 176, 177
Marionettes (film, 1934): co-author of, 41; depiction of the rise of fascism, 18, 178–180, 182–183; didacticism of, 162; diegetic layers of, 179; ending of, 182–183; genre, 181–182; *heterotopia* of, 145; intellectual montage, 179; music in, 178, 181, 182; novelty of, 178; plot and characters, 122, 178–181; reviews of, 183–184; spoken voice in, 177–178, 180–181; style of, 182, 183
Martinson, Sergei, 178
Marx, Karl, 184
Maupassant, Guy de: screen adaptations of stories of, 51, 54
Mayakovsky, Vladimir, 34, 155
McReynolds, Louise, 19
Médard, F., 141
Medvedev, Mikhail, 69
melodrama films, 135, 148

Member of Parliament (film, 1919–20), 112
Men and Jobs (film, 1932), 123
Metropolis (film, 1927), 100
Metz, Christian, 167
Meyerhold, Vsevolod, 26, 99, 129, 155, 183
Mezhrabpom-Rus' (film studio): comedy films of, 149–150; commercial films of, 35–36; financial problems, 37, 38; formation of, 35; Moscow studio, 97; news publication, 69; privileged status of, 106; propaganda films, 35–36; Protazanov's work in, 15, 31, 32, 33, 34–40, 44; purges in, 41; reorganization of, 42; shortage of film stock, 97; staff of, 35–36, 37–38
middlebrow taste, 206n7
Mikhalkov, Nikita, 187
Miracle Worker, The (film, 1922), 141
Misiano, Francesco, 35, 64, 105
Mitry, Jean, 211n4
montage. *See* editing in films
Moscow Cinema Committee, 54
Moscow Commercial School, 21
Mother (film, 1926), 160
Mother (*Mat'*, 1926), 3
Movies for the Masses (Youngblood), 5
Mozzhukhin, Ivan: career of, 7; roles in Protazanov's films, 2, 28, 54, 68, 91, 111, 112, 114, 130, 149; salary, 25; screenwriting, 26
Mulvey, Laura, 71
Münzenberg, Willi, 35, 107, 204n61
Muratova, Kira, 186
musicals, 157, 181
Musser, Charles, 163, 215n9

Naficy, Hamid, 13, 75, 109, 110, 111, 117, 123; *An Accented Cinema*, 12
Nagrodskaia, Evdokia: *The Wrath of Dionysius*, 51
Nakanune (journal), 33
Naroditsky, Abram, 65
Narrow Escape, A (film, 1920): cast, 2, 28; critical reviews of, 111; dream motif in, 111, 127; exilic context, 111; filming locations, 211n4; performance in, 119; plot, 111; production of, 17, 113; release of, 110; Russian distribution, 111; spectacular effects, 111–112, 113
Nasreddin in Bukhara (film, 1943): folk depictions, 133–134, 145–146; genre of,

45, 133–134; plot and characters of, 145; production of, 110, 132, 186; screenplay of, 132
Nemirovich-Danchenko, Vladimir, 44
Nemoliaev, Vladimir, 37, 38
New Economic Policy (NEP), 31, 34, 149
Nickell, William, 62
Nielsen, Asta, 24
Nikolai Stavrogin (film, 1915), 52, 189
Nilsen, Vladimir, 43
No Bloodshed! (film, 1917), 28, 54, 166–167
nondiegetic insert, 167
Notari, Umberto, 140; *The Three Thieves*, 139
Nusinova, Natalia, 111, 114

Obolensky, Leonid, 88
October (film, 1928), 3, 167
Ohnet, Georges: *Serge Panin*, 52
ombre du péché, L' (film, 1922), 112
One Pays, One Plays (film, 1913), 138–139
On Literary Guard (journal), 6
On Love's Strangeness (film, 1934–36): ban of, 65, 158; cast of, 44, 69; critical reviews of, 156, 157–158; music and songs in, 157; plot, 156; production of, 43, 65, 156; script of, 156, 158
Orlova, Lyubov, 3, 68–69, 158, 181
ostranenie (making strange), 182
Ostroumov, A., 148
Ostrovsky, Alexander: film adaptations of plays of, 44, 65; *Without a Dowry*, 16, 49, 66; *Wolves and Sheep*, 44
OsvAg (Osvedomitel'noe Agentsvo; Informational Agency), 27
Ōta Hisa (a.k.a. Hanako), 188
Otten, Nikolai, 183

Parajanov, Sergei, 13
Pastrone, Giovanni, 90
Pathé (film company), 25, 29
Pearson, Roberta, 208n10
People's Commissariat for Posts and Telegraphs of the RSFSR (Narkompochtel), 175
People's Commissariat of Education (Narkompros), 54
Peregonets, Alexandra, 101
Petite Roque, La (Maupassant), 54

Petrov, Vladimir, 65
Petrova, Olga, 81, 82
Pickford, Mary, 114
Picture of Dorian Gray, The (film, 1915), 52
Pierrot le Fou (film, 1965), 167
Pilgrimage of Love (film, 1923): cast of, 39;
 characters, 91–92; garden nightmare scene,
 93–94, *95*; genre, 92; German settings, 114;
 lighting effects in, 91, *93*, 93–94, *94*; plot,
 91–92; producer of, 11; release of, 31
Platten, Friedrich (Fritz), 36
Polikushka (film, 1919/1923), 31
Pommer, Erich, 30–31
Poptsov, V., 156
popular cinema, 15
Pordenone Silent Film Festival (1989), 5, 188
Porter, Edwin S., 163, 215n9
Pour une nuit d'amour (film, 1922), 63, 112
primitive mode of representation (PMR),
 160, 161, 215n1
Production Code Administration, 12
Proektor (journal), 31
Proletarskoe kino (magazine), 144
Protazanov, Alexander, 20, 21, 22, 26
Protazanov, Georgi: birth of, 23; death of,
 6, 46; engineering career, 39–40; life in
 emigration, 27, 29, 30; military service, 45;
 roles, 39, 91
Protazanov, Yakov: approach to literature,
 70; "author code," 8, 9, 17; awards, 14;
 background of, 16; burial of, 46; career of,
 1, 2–3, 7, 8, 11, 22–26, 34–40, 189; cinematic
 techniques, 17, 26; culinary taste, 203n49;
 death of, 11, 43, 188; directorial work, 23,
 26, 27, 30, 38–39, 109, 200n22; early life of,
 19–22; emigration of, 2, 10, 11, 19, 26–31;
 experience of exile, 14; French language
 skills, 112; during the Great Patriotic War,
 134; health problems, 26–27, 39, 43, 46;
 lectures and speeches of, 1, 200n15; letters
 to Frida, 32–33, 39, 46; life in Berlin, 30; life
 in Paris, 28–29; life in Tashkent, 45–46;
 love affair, 44–45; marriage of, 23, 45;
 military service of, 26; Moscow apartment,
 33; *palochka* (conductor's baton) of, 38–39;
 personality of, 7, 8, 10, 12, 47; purges in
 film industry and, 42–43; reputation of, 7,
 8–9; return to the Soviet Union, 16, 31–34,

109; salary of, 25; Soviet regime and, 7, 10,
 14, 15–16, 40–45, 46; studies of life of, 4–5;
 travels of, 2, 22
Protazanov, Yakov Ivanovich, 20
Protazanova, Frida (neé Könnecke): cor-
 respondence of, 30, 32, 39, 46, 203n44,
 205n77; emigration to France, 27; personal
 archive of, 19, 188; on Protazanov's com-
 edies, 148; Russian filmmakers and, 23, 29;
 separation with husband, 45
Protazanova, Valentina, 22
Protazanov's films: allegorical sequences in,
 167–168, 169; antireligious, 21, 141–142;
 average shot length of, **83**, 95; border cross-
 ing motif, 123; camera motion, 93; capital-
 ist dystopia in, 123; "cine-cranberry" films,
 114–115; comedies, 136–137, 138, 146–149,
 158–159; critics of, 10–11, 19, 129; cutting
 and editing in, 83, 85–87, 88; didactic style
 of, 184; eclecticism of, 75–76, 82, 96; evolu-
 tion of, 184–185; exilic features, 109–110,
 122; genres of, 3, 17–18, 189; "gestural
 soliloquy" in, 80–81, 85, 91; influence of,
 46, 161, 187, 188–189; irony in, 70; literary
 adaptations, 2, 3, 16, 44, 49–51, 63–64; lost
 films, 9, 190; montage in, 76, 94–95; natural
 spaces in, 123; notion of self-fashioning
 in, 118; popularity of, 2, 15, 37; "primitive"
 aspects of, 161; production methods, 23,
 113; propaganda in, 3, 97; restoration of,
 188; set in non-Soviet spaces, 137; silent
 films, 2–3, 85, 165; sound films, 3, 162, 173;
 from the Soviet period, 115–122, 123; studies
 of, 9–10, 109; stylistic features of, 5, 17, 73,
 75, 107–108, 118, 183; tableau style, 77–78,
 82–83, 87–88, 165, 166, 167; transformations
 of identity in, 129–131; "tricks" in, 90–91,
 93; from UFA period, 11
Protopopov, Alexander, 52
Przerwa-Tetmajer, Kazimierz, 51
Pudovkin, Vsevolod, 3, 5–6, 37, 119, 157, 167,
 176
Pukirev, Vasili: *The Unequal Marriage* paint-
 ing, 71
Pushkin, Alexander: centennial of the death
 of, 64–65, 158; *The Gabrieliad*, 156; *The
 Queen of Spades*, 16, 53; screen adaptations
 of stories of, 65

Queen of Spades, The (film, 1916): approach to original text, 53; camera movement, 90; cast, 2; on European screens, 28; lighting effects, 90–91, 92, 93, 102; production of, 25, 52–53

Quo Vadis? (film, 1913), 24

Rabinovich, Isaak, 100, 101, 140

Rachmaninoff, Sergei, 53

Radin, Nikolai, 178

radio, 175

Raizman, Yuli, 159

Ranks and People (film, 1929), 43

Rapallo, Treaty of, 31

"Ray of Light in the Realm of Darkness, A" (Dobroliubov), 66

"Realm of Darkness" (Dobroliubov), 66

Rebikov, Vladimir: *The Christmas Tree*, 50

Rebrov, Viacheslav, 11

Red Devils (film, 1923), 126

Red Virgin Soil (journal), 34

Reinhardt, Friedrich, 23

Reinhardt, Max, 11

Repin, Ilya: *The Volga Boatman* painting, 71

Return of Nathan Becker, The (film, 1932), 123

Rimsky, Nikolai, 85

Road to Life (film, 1931), 42, 175

Romm, Mikhail, 45

Rot-film (newspaper), 157, 183

Russian Association of Proletarian Writers (RAPP), 155

Russian civil war, 27, 124–126

Russian culture, 48–49, 114

Russian émigrés, 30, 112, 114

Russian famine of 1921–22, 34, 35, 204n61

Russian films: budgets, 25; censorship of, 51–52, 53, 60; during civil war, 27; on European screens, 28; genres of, 24, 25, 80; history of, 5; impact on Russian culture, 47–48; literary adaptations in, 49–50, 52–53; production of, 2, 24; revolution and, 53–54; stars, 24; theme of exile and emigration in, 110; World War I and, 2, 24

Russian folk songs: screen adaptations of, 50

Russian literature: screen adaptations of, 49–50, 62, 72

Russian Orthodox Church, 51–52, 53, 62

Russian Revolution, 14, 54

Ryabchikova, Natalie, 36

Ryazanov, Eldar, 72, 187

Sabinsky, Cheslav, 25

Said, Edward, 10, 13

Salavat Yulayev (film, 1940), 44, 87–89, 89

Sarris, Andrew, 11

Satan Triumphant (film, 1917), 28, 114

satire, 146, 155

Satyrin, V., 144

Savchenko, Igor, 178

Savrasov, Alexei: *The Rooks Have Returned*, 70–71

Schubert, Erika, 91

Schwanneke, Viktor, 91

science fiction genre, 97–98

sens de la mort, Le (film, 1923), 63, 189

Shagurin, N., 62

Shaternikov, Vladimir, 80, 81, 82, 130, 163

Shibaev firm, 20

Shklovsky, Viktor, 7, 155

Shmelyov, Ivan: *Man from the Restaurant*, 63

Shorin, Alexander, 174

short narrative film, 164

Shumyatsky, Boris, 40, 42, 43, 44, 136

Shveitser, Vladimir, 41, 65, 178

silent films, 122, 160

Slave of Love, A (film, 1975), 187

Slavinsky, Evgeni, 90

Smena vekh (Berlin group), 33

socialist realism, 64–65, 119, 147, 155–156, 162

Society of the Friends of Soviet Cinema (ODSK), 63

Soiuzdetfilm (film studio), 71, 132

Soiuzkino (film studio), 40

Sokolov, Ippolit, 140

Solntseva, Yuliya, 101

Solovyov, Leonid, 46; *The Tale of Hodja Nasreddin, Disturber of the Peace*, 132–133

Sommerfeld, Yakov, 22

Song of Triumphant Love, The (film, 1923), 112

sound films, 173–175, 177–178, 180

Soviet culture: absence of interpretation in, 206n8; formation of, 15–16, 47–48; ideology and, 48, 75, 162; shift in priorities, 206n5

Soviet films: American movies and, 15, 68, 74–75, 138, 181, 187; antireligious, 141–142; audience of, 187; avant-garde works, 4, 18,

40, 75; call to action in, 170–171; celebrated filmmakers, 3–4, 5; censorship of, 27, 43, 54, 125, 174; emotional experiences, 187–188; European influence on, 135–136, 138–139; genres, 135; ideology and, 4, 41, 51, 138, 151; international influence of, 6, 160–161; literary adaptations in, 50, 65; NEP period, 5, 139; popularity of, 62; propaganda in, 2–3, 175; revolutionary didacticism of, 165–166; scholarship on, 4–6, 103, 199n9; silent, 69, 160; slowing of production, 41, 186; socialist realism in, 162; speech recording, 175; Stalin-era, 40–42, 146, 186; studios, 40; stylistic experiments, 74–75, 175; transition to sound, 126, 173, 174–178, 185; tricksters in, 131–132

Soviet Union: campaign against "formalism," 157; censorship, 35; foreign relations, 31; governance of, 131; intellectual life, 34

Spevak, Galina, 44

Stalin, Joseph: on achievement of socialism, 64; admiration of Orlova, 69; death of, 186; economic policy, 40; on "proletarian" culture, 48; Soviet film industry and, 2–3, 186; speech at All-Union meeting of Stakhanovites, 156

Stanislavski, Konstantin, 11, 20

"Statement on Sound" (Eisenstein, Pudovkin, and Alexandrov), 176

Stein, Gertrude, 29

Stella Maris (film, 1918), 114

Stites, Richard, 53, 161

St. Jorgen's Day (film, 1930): adaptation of Bergstedt's novel, 142, 143; cast of, 143–144; co-author of, 41; critical response to, 144; criticism of the church, 21; depiction of capitalist society in, 139, 141–142, 144; fan letter about, 122; plot and characters, 131, 143, 177; popularity of, 3; satire in, 144; script, 39, 142; sound version of, 176–177; trickster in, 131, 133

Storm, The (film, 1935), 65

Storm over Asia (film, 1928), 167

Straukh, Ivan, 123

Strizhevsky-Radchenko, Vladimir, 115

superimpositions, 89

Sverdlin, Lev, 145

Szaloky, Melinda, 13–14

tableau style, 76, 77–78, 81–83, 87–89, 163–164, 165–167, 208n8

Tager, Pavel, 174

Tailor from Torzhok, The (film, 1925): criticism of NEP in, 149; depiction of Soviet institutions in, 150–151; genre, 151; plot and characters, 130, 149–151; popularity of, 135, 151; production of, 149; reviews of, 125, 151–152

Tairov, Alexander, 100

Tale of Hodja Nasreddin, Disturber of the Peace, The (Solovyov), 132–133

Tarkovsky, Andrei, 186

Tashkent Film Studio, 45, 132

Taylor, Richard, 5

Tchaikovsky, Pyotr, 53, 69, 70

Thaw period, 186

Theater of Satire, 155

Thiemann, Paul, 23, 25, 30, 114

Thiemann & Reinhardt (film company), 2, 23, 24–25, 30, 52, 138

Thousand and One Nights, A (film, 1921), 112

Three Musketeers, The (film, 1921), 97

Three Songs about Lenin (film, 1934), 176

Tikhonravov, Sergei, 178

Timasheff, Nicholas S., 206n5

Tokarskaya, Valentina, 178, 181

Tolstoy, Alexei Konstantinovich: *Tsar Fyodor Ioannovich*, 33–34

Tolstoy, Alexei Nikolayevich, 33; *Aelita*, 34, 97, 98, 116

Tolstoy, Leo: anticlericalism of, 56, 57; celebration of the centenary of birth of, 62; cinematic depiction of, 80; excommunication of, 163; *Father Sergius*, 2, 16, 49, 54–55, 163; Lenin's writing on, 63; *Resurrection*, 163; *What Is Art?*, 161

Tommy (film, 1931), 3, 42, 126–127, 128

Toward the Light (film, 1921): cuts and editing, 85, 86, 87; duel scene, 85–86, 86, 87, 88; gestural soliloquy in, 85; plot, 85, 115; production of, 114

Trauberg, Leonid, 10, 45, 137

"tricks" in films, 89–91, 93, 102, 131–132, 133

Trofimov, Mikhail, 35

Trotsky, Leo, 168

Truffaut, François, 72

Tsar Fyodor Ioannovich (A. K. Tolstoy), 33–34
Tsereteli, Nikolai, 99, 101
Tsimbal, S., 144
Tsivian, Yuri, 6, 51, 199n9, 209n15
Turkin, Valentin, 152
Turzhansky, Viktor, 30

Universum Film-aktiengesellschaft (UFA), 2, 11
Uralsky, Alexander, 114
Ushakov, Nikolai, 21
Uzbekfilm, 45

Vasiliev brothers, 45
veiling tradition, 145–146
Verbitskaya, Anastasiya, 24; *The Keys to Happiness*, 2, 51, 189
"verisimilar" code, 208–209n10
Vertov, Dziga, 3, 103, 104, 176
Vinokurov, Sergei, 20, 22
Vinokurova, Elizaveta, 20, 21
Vishnevsky, Veniamin, 166
Viskovsky, Vyacheslav, 55
"Visual Pleasure and Narrative Cinema" (Mulvey), 71
Voitsik, Ada, 123
Volkenstein, Vladimir, 67
Volkov, Alexander, 25, 29, 30

Wangenheim, Gustav von, 91
War Communism, 34, 35
Warner Brothers, 174
Weimar Germany: economic situation, 30; film industry, 2
White, Frederick H., 212n34
White Eagle, The (film, 1928), 63, 128–129, 216n36

Without a Dowry (film, 1936): aesthetics of, 71; cast, 45, 65, 68, 69–70, 71, 73; characters, 67–68; co-author of, 41; departures from the original play, 48, 68, 69, 70; final scene, 43, 70, 184; monumentalism of, 70; music and songs in, 69, 70; as "nostalgia film," 72; opening scene of, 67; popularity of, 3, 16; production of, 65; reviews of, 65, 67–68, 70, 71–72, 73; as "social drama," 66–67; visual spectacle of, 70–71, 73, 184; wedding sequence, 71
Without a Dowry (Ostrovsky): plot and characters, 65–66, 68; screen adaptations, 72; theatrical staging of, 69, 70
Wolf, Robert, 138, 154
Wollen, Peter, 7–8
Wolves and Sheep (Ostrovsky), 46
Women of Golgotha (film, 1919), 189
Woman Who Wants to Can Fool the Devil, A (film, 1914), 138
Word, The (émigré newspaper), 30
Workers' International Relief. *See* International Arbeiter-Hilfe (IAH)
Wrangel, Pyotr, 27
Wrath of Dionysius, The (Nagrodskaia), 51

Yanova, Varvara, 115, 147
Youngblood, Denise J., 5, 51, 55, 61, 153
Youth of the Poet, The (film, 1936), 65

Zabrodin, Vladimir, 6
Zaitsev, Yakov, 42
Zamyatin, Yevgeny, 97
Zhilinsky, Andrei, 85, 209n17
Zlobin, Stepan, 44
Zola, Émile, 63
Zorich, Alexander, 152, 153
Zorkaya, Neya, 96
Zubov, Konstantin, 178

ABOUT THE AUTHOR

F. BOOTH WILSON is a lecturer in the Department of Film and Media at the University of California, Berkeley. He has published extensively on film history, theory, and aesthetics in a variety of scholarly journals.